Tudor Royal Iconography

Princeton Essays on the Arts

for a complete list of books in this series, see page 286.

Tudor Royal Iconography

Literature and Art in an Age of Religious Crisis

John N. King

PRINCETON UNIVERSITY PRESS

Copyright © 1989 by Princeton University Press

Published by Princeton University Press, 41 William Street,
Princeton, New Jersey 08540
In the United Kingdom: Princeton University Press,
Guildford, Surrey

This book has been composed in Linotron Sabon

Clothbound editions of Princeton University Press books
are printed on acid-free paper, and binding materials
are chosen for strength and durability. Paperbacks, although
satisfactory for personal collections, are not usually
suitable for library rebinding

Printed in the United States of America by Princeton
University Press, Princeton, New Jersey

Library of Congress Cataloging-in-Publication Data
King, John N.
Tudor royal iconography.
(Princeton essays on the arts)
Bibliography: p.
Includes index.
1. Great Britain—History—Tudors, 1485-1603. 2. Tudor,
House of, in literature. 3. Tudor, House of—Portraits.
4. Great Britain—Intellectual life—16th century. 5. Kings
and rulers in literature. 6. Kings and rulers in art.
7. Christian art and symbolism—Renaissance, 1450-1600—
Great Britain. 8. Christian literature, English—History
and criticism. 9. English literature—Early modern,
1500-1700—History and criticism. 10. Great Britain—
Church history—16th century. I. Title. II. Series.
DA315.K56 1989 942.05 88-18019
ISBN 0-691-06760-0

To Pauline

Contents

𝔍llustrations

Preface

THIS STUDY of the presentation of the Tudor monarchs (who reigned in England from 1485 to 1603) as devoutly pious rulers grows out of my earlier work on Reformation literature, where I disclosed the emergence of a coherent mid-sixteenth-century literary tradition. I have argued that this movement introduced Protestant themes, conventions, and techniques that influenced the Elizabethan flowering and the literature of seventeenth-century England.[1] The Edwardian period represents an important and discrete segment of Renaissance culture between the phases of court-inspired art and literature under Henry VIII (1509–47) and Elizabeth I (1558–1603). Here I extend my earlier argument concerning King Edward's royalist iconography (that is, the symbolic representation of meaning by the use of artistic and literary images) to demonstrate that the idealization of Tudor monarchs as exemplary religious figures is part of a continuous process that originated when Henry VII fashioned a new dynasty after the Battle of Bosworth Field in 1485, and includes contemporary praise of the ruler whom later generations vilified as "Bloody Mary." The literature and art produced under the auspices of Henry VII (1485–1509), Edward (1547–53), and Mary (1553–58) have received little attention from scholars, in large part because of the clearly evident richness of works produced under Henry VIII and Elizabeth. This book aims to redress this imbalance by analyzing pietistic images of the entire ruling family, including the founder of the dynastic house and the "Little Tudors," Edward and Mary. This is the first study to survey royal iconography across the entire Tudor period.

Tudor royal iconography rests upon a foundation laid by Henry VII, who modeled his self-image upon orthodox devotion to Christ, to the Blessed Virgin Mary, to England's patron St. George, and even to his royal "uncle" Henry VI as "saint and martyr." Although Henry VIII originally emulated his father's style, the royal image underwent a dramatic change during the Reformation, which was initiated during his

[1] John N. King, *English Reformation Literature: The Tudor Origins of the Protestant Tradition* (Princeton, 1982).

reign and largely implemented by the Protestant lords who controlled the realm during the minority of Edward VI. Henry VIII and the Protestant reformers attempted to unify secular authority with the religious authority by which it had traditionally been justified and on which it depended for authenticity. Henry VIII altered the political hierarchy by combining the roles of king and head of the church, necessitating a completely new regal style. In Reformation iconography, the Protestants' need to legitimize their cause through imagery explicitly parallels the Tudors' need to legitimize their dynasty. Mary Tudor and her apologists reverted to the "Catholic" style of her grandfather Henry VII during her brief effort to foster the Counter-Reformation. A "sacred cult" of Elizabeth did exist, but it stemmed from the "cults" of her father, Henry VIII, and her sibling monarchs Edward and Mary. John Bridges, as chaplain to Queen Elizabeth, acknowledged this point when he envisioned her "practise of godlie government" as a continuation of "the godlie government of youre Highnesse blessed Brother" Edward.[2] Elizabeth's reign produced a fusion of Catholic and Protestant imagery that must be seen as a continuation of the previous three reigns. The eclectic iconography of her time was employed to advance the religious settlement that the queen imposed, which combined Protestant theological doctrine with some forms of Catholic ritualism.

This study was completed with the assistance of a grant from the Penrose Fund of the American Philosophical Society (1983), an American Council of Learned Societies Grant-in-Aid (1985), the 1985 Summer Fellowship of the Center for Medieval and Renaissance Studies at the University of California at Los Angeles, and a Roger C. Schmutz Faculty Research Grant from Bates College. Thomas Hedley Reynolds, the president of Bates College, awarded a grant from the President's Discretionary Fund for Faculty and Curricular Development (Fund for Publication of Scholarly Work) to defray the expense of photography and permission fees. Some work was accomplished as an adjunct to a different research project funded by a National Endowment for the Humanities (NEH) Residential Fellowship and a Huntington Library–NEH Fellowship.

Much of the research and writing was accomplished at the Huntington Library in San Marino, California, where I profited from the fellowship and good counsel of Robert Middlekauff, Martin Ridge, William A. Ringler, Jr., Hallett Smith, John Steadman, James Thorpe, and many readers. The assistance and courtesy of Fredi Chiappelli, Mi-

[2] John Bridges, *The Supremacie of Christian Princes, over all persons throughout their dominions, in all causes so wel Ecclesiastical as temporall* (1573) ¶2ᵛ–3ᵛ.

chael Allen, and the staff of UCLA's Center for Medieval and Renaissance Studies aided substantially in the completion of this project.

Ruth Luborsky and Betty Ingram have been of particular assistance by making available the draft of their forthcoming census, index, and descriptive catalog, *English Books with Woodcuts: 1536–1603*. This definitive work continues where Hodnett ends (*English Woodcuts: 1480–1535* [1935]). I have adopted the following nomenclature, used by Luborsky and Ingram for sixteenth-century book illustration:

adaptation	an imitation that is changed by the addition and/or omission of significant pictorial elements
copy	a very close imitation of an original
emblematic	used strictly for emblem book illustration
narrative	used for illustrations that relay a sequential story
representational	used for things in themselves (e.g., illustrations of people, plants, buildings, etc.)
symbolic	used where "emblematic" is sometimes employed loosely for pictures of objects that conventionally represent other things or ideas.

I am grateful to Barbara K. Lewalski and the members of her NEH Residential Seminar for College Teachers at Brown University (1981–82) for useful advice on my early foray into iconographical analysis. The following scholars have offered helpful suggestions and assistance or have commented on various stages of the draft: Michael Allen, James Bednarz, David Bevington, Jeanie Brink, J. Scott Colley, Patrick Collinson, Rebecca Corrie, Craig Decker, Patricia Harris, Christine Hasenmueller, Thomas Hayward, Betty Ingram, Thomas V. Lange, Peter Lindenbaum, Jennifer Loach, Ruth Luborsky, Max Marmor, Janel Mueller, David Paisey, Geneva Phillips, Anne Lake Prescott, Dale B. J. Randall, Glyn Redworth, Lois Schwoerer, Dennis Sweet, Hugh Tait, Seth Weiner, George Walton Williams, and Richard Williamson. The rigorous reviews of the entire manuscript by S. M. Foister and John Shawcross were especially helpful. I am particularly indebted to the generous counsel of Gordon Kipling. Carl B. Straub has encouraged this project as Dean of Faculty at Bates College. Susan Bishop, Robert Brown, Julie Marvin, Marjorie Sherwood, and Sherry Wert have skillfully guided this book on its journey through the press. I am grateful, as ever, for the impeccable secretarial services of Julie Bourisk, and for the assistance of Susan McCulley.

Valuable assistance in research has been rendered by librarians and curators of the British Museum, British Library, Bodleian Library and English Faculty Library at Oxford University, University Library and

Fitzwilliam Museum at Cambridge University, Trinity College and St. John's College (Cambridge), National Portrait Gallery, American Bible Society, British and Foreign Bible Society, Folger Shakespeare Library, Huntington Library, Rockefeller Library at Brown University, University Research Library and Art Library at UCLA, and Ladd Library at Bates College.

Portions of Chapter 4 incorporate, in substantially revised and expanded form, the text of my article, "The Godly Woman in Elizabethan Iconography," *Renaissance Quarterly* 38 (1985): 41–84; reprinted by permission of the editor. Parts of this book have been delivered as lectures and papers at meetings of the Boston Reformation Colloquium at Harvard University, Brown University Renaissance Colloquium, Columbia University Renaissance Seminar, the Modern Language Association, Oxford University Renaissance Seminar, Renaissance Society of America, Sheffield University Renaissance Seminar, UCLA Renaissance Seminar (the Neo-Areopagus), University of California at Santa Barbara Renaissance Seminar, and a 1985 conference on The Tudor Courtly Ideal at Arizona State University in Tempe.

A vigorous effort is made in this study to identify and quote from manuscripts and printed books that were written, annotated, owned, or read by the Tudor monarchs. Unless otherwise noted, translations are my own, and reference is made to the earliest printed edition, manuscript, or entry in contemporary records concerning the works under study. Manuscript transcriptions are literatim, and square brackets enclose expansions of contractions and editorial inclusions. Contractions and abbreviations in printed books are expanded silently. The modern use of i/j, u/v, and vv/w is followed. To avoid confusion, the terms "Mariological" and "Marian" are applied respectively to the Virgin Mary and to Queen Mary I.

My wife Pauline has supported the entire project unstintingly, not least in her assistance in verifying quotations and citations. Without her help, I could not have completed it. My father, Luther Waddington King, greatly improved the manuscript with his scholarship and editorial skills. Of course, I am responsible for all errors and faults that remain in this text.

Wiscasset, Maine
July 1986

Abbreviations

UNLESS OTHERWISE specified, London is the place of publication, and reference is to the first edition. The abbreviation *sig.* is omitted from signature references. Except for biblical passages quoted in early printed books, scriptural texts are from *The Geneva Bible*, facsimile of the 1560 edition with introduction by Lloyd E. Berry (Madison, Wis., 1969). Shakespearean references are to *The Riverside Shakespeare*, ed. G. B. Evans et al. (Boston, 1974).

A & M (1563)	John Foxe, *Actes and Monuments of these Latter and Perillous Dayes* (1563). Unless specific reference is made to the first or second edition, this work is designated by the general title of *Acts and Monuments*
A & M (1570)	———, *Actes and Monumentes of Thynges Passed in Every Kynges Tyme in this Realme*. 2nd ed., rev. and enlarged, 2 vols. (1570)
A & M (1877)	———, *Acts and Monuments*, edited by S. R. Cattley, rev. and corrected by J. Pratt, 8 vols. (1877)
Anglo, *Spectacle*	Sydney Anglo, *Spectacle, Pageantry, and Early Tudor Policy* (Oxford, 1969)
B.L.	British Library, Reference Division, Departments of Manuscripts and Printed Books
Bodl.	Bodleian Library, Oxford University
"Book of Martyrs"	The popular title of Foxe's *Acts and Monuments*
Chrimes	S. B. Chrimes, *Henry VII* (1972)
CSP	*Calendar of State Papers*
C.U.L.	University Library, Cambridge University
DNB	*Dictionary of National Biography*, edited by Leslie Stephen and Sidney Lee, 63 vols. (1885–1900)
EETS	Early English Text Society
ERL	John N. King, *English Reformation Literature: The Tudor Origins of the Protestant Tradition* (Princeton, 1982)
Fitz.	Fitzwilliam Museum, Cambridge University
FQ	Edmund Spenser, *The Faerie Queene*, edited by A. C. Hamilton (1977)
Harl. Misc.	*The Harleian Miscellany*, ed. William Oldys and Thomas Park. 10 vols. (1808–13)

Hind	Arthur M. Hind, *Engraving in England in the Sixteenth and Seventeenth Centuries*, 3 vols. (Cambridge, 1953–64)
Hodnett	Edward Hodnett, *English Woodcuts: 1480–1535* (1935)
N.P.G.	National Portrait Gallery, London
Norbrook, *Poetry*	David Norbrook, *Poetry and Politics in the English Renaissance* (1984)
REED	*Records of Early English Drama* (Toronto, 1979–)
Scarisbrick	J. J. Scarisbrick, *Henry VIII* (1968)
Scribner	R. W. Scribner, *For the Sake of Simple Folk: Popular Propaganda for the German Reformation*, Cambridge Studies in Oral and Literate Culture, no. 2 (Cambridge, 1981)
STC	*A Short-Title Catalogue of Books Printed in England, Scotland, and Ireland, and of English Books Printed Abroad, 1475–1640*, first compiled by A. W. Pollard and G. R. Redgrave; 2nd ed., rev. and enlarged, vols. 1–2, begun by W. A. Jackson and F. S. Ferguson, completed by Katharine F. Pantzer (1976–86); vol. 3 is forthcoming
Stow, *Annales*	John Stow, *Annales, or a Generall Chronicle of England* (1631). Continued by Edmund Howe
Strong, *Cult*	Roy C. Strong, *The Cult of Elizabeth: Elizabethan Portraiture and Pageantry* (1977)
Strong, *Elizabeth*	———, *Portraits of Queen Elizabeth I* (Oxford, 1963)
Strong, *Holbein*	———, *Holbein and Henry VIII* (1967)
Strong, *Icon*	———, *The English Icon: Elizabethan and Jacobean Portraiture* (1969)
Strong, *Portraits*	———, *Tudor and Jacobean Portraits*, 2 vols. (1969)
Trapp & Herbrüggen	J. B. Trapp and Hubertus S. Herbrüggen, *"The King's Good Servant": Sir Thomas More, 1477/8–1535* (1977)
Yates, *Astraea*	Frances A. Yates, *Astraea: The Imperial Theme in the Sixteenth Century* (1975)

Tudor Royal Iconography

Introduction

 Although idealized images of just and pious sovereigns abounded during the English Renaissance, scholarship has never adequately acknowledged the glorification of the Tudor monarchs as "godly" rulers in royalist portraiture and art, and in works like Foxe's *Acts and Monuments* (known popularly as the "Book of Martyrs"), the poetic drama of Marlowe and Shakespeare, and Spenser's dynastic epic, *The Faerie Queene.* This lack results in part from the outdated assumption that propaganda and art are antithetical modes, so that insofar as works succeed as "literature" or "art" they rise above political, nationalistic, and religious concerns. Ignorance of the pious role-playing of the Tudors may reflect scholarly stereotypes that posit an apparent contradiction between religious devotion and the "cold pragmatism" of Henry VII and Elizabeth I or the "ruthless brutality" of Henry VIII and Mary Tudor. It can be difficult, if not impossible, however, to draw sharp distinctions among political, pietistic, and aesthetic endeavors during this age.[1] Furthermore, scholars have emphasized the importation of classical and Continental models for Tudor royalism, at the expense of medieval typological formulas familiar from English devotional books and stained-glass windows, and to the neglect of evangelical patterns from the vernacular Bible and "unsophisticated" popular religious writing that supplied a reservoir for the iconography of the Protestant monarchs Henry VIII, Edward VI, and Elizabeth I in particular.

Previous scholarship has emphasized the achievements of the brief 1530s "renascence" under Henry VIII and the "golden age" of Elizabeth that is said to have been heralded by the publication in 1579 of Spenser's *Shepheardes Calender.* Accordingly, any serious examination of Tudor monarchical imagery must build upon the groundbreaking studies of Frances Yates and her student Roy Strong, which tend to view Tudor iconography as an offshoot of the classicism and

[1] See David Bevington, *Tudor Drama and Politics: A Critical Approach to Topical Meaning* (Cambridge, Mass., 1968), pp. 1–26; Stephen Orgel, *The Illusion of Power: Political Theater in the English Renaissance* (Berkeley and Los Angeles, 1975), pp. 88–89; and Norbrook, *Poetry,* pp. 1–17.

Neoplatonism of the Continental Renaissance. Strong offers the definitive examination of Holbein's role in creating the Tudor image through his courtly portraits of Henry VIII.[2] The medieval, biblical, and popular origins of royalist art have been neglected by comparison. Prevailing views tend to assume that the emergence of the Tudor royalist "cult" and veneration of the queen as Astraea are characteristically Elizabethan and to see the Renaissance in contrast to medieval spirituality and all that accompanies it. The association of the idea of Renaissance with classical and Italian ideas and formal language tends to exaggerate the importance of the appearance of these elements during this period. On the contrary, the present study argues not only that continuity of imagery links religious and political expression and the pre- and post-Reformation periods, but also that there is a continuity between "late medieval" England and the period after the influx of Italian concepts. Classical conventions and influences do not *define* the Tudor epoch, but are only one of its themes.

The process of defining and redefining the Tudor image was set in uninterrupted motion soon after the Battle of Bosworth Field (1485), and continued until the extinction of the dynasty that Henry VII founded (1603). The present study aims to recover neglected biblical models for the iconography of the Protestant Tudors in particular. These models underlie the recurrence in Tudor portraits of certain Reformation devices—the Sword and the Book, and the Crown versus the Tiara—that begin to infiltrate coronation pageantry, court drama, political allegory, millennial prophecy, poetry, woodcuts, and court portraits of the early Tudor period prior to their infusion into crowning Elizabethan masterworks like *The Faerie Queene* (see Chapters 2 and 3). Analysis of these and related devices should correct prevailing views that exaggerate the manifest classicism of late Tudor iconography at the expense of its native English, biblical, and Protestant origins. An aura of piety was important to all of the Tudors, not least the notoriously zealous boy whom Foxe terms "this godly King *Edward*" (*A & M* [1570], p. 1566) and his equally zealous Catholic sister, Queen Mary. Previous studies of Tudor monarchism that ignore these two and their grandfather Henry VII tell only part of a very long and complicated story.[3] It is important to recognize that what Roy Strong

[2] Yates, *Astraea*, pp. 29–88, passim; Strong, *Holbein*, p. 14; and Strong, *Cult*, pp. 46–48. Elkin C. Wilson's *England's Eliza* (Cambridge, Mass., 1939) provides a helpful bibliographical summary concerning the "idealization" of Queen Elizabeth in the poetry of her age.

[3] Gordon Kipling carries the study of Tudor iconography back to Henry VII's reign in *The Triumph of Honour: Burgundian Origins of the Elizabethan Renaissance* (Leiden,

terms the "cult of Elizabeth" originated in a carefully orchestrated manipulation of the doctrine of royal supremacy by the circle of courtiers, writers, artists, and preachers who operated under the aegis of Henry VIII and Edward VI; it also evolved from the praise of Mary Tudor as a type of the Blessed Virgin.

The iconography of royal images is the subject of this book. Erwin Panofsky defines iconography as "that branch of the history of art which concerns itself with the subject matter or meaning of works of art, as opposed to their form." He identifies a primary analytical stage (level one) that addresses purely formal or "natural" elements of line, color, and shape, which convey "pre-iconographical" understanding. The goal of this level is the recognition of "motifs," or sign-like units, made up of forms (signifiers) and referents in nature (things signified). The "conventional" elements of "artistic *motifs* and combinations of artistic *motifs*" are expressed through the "natural" elements. A picture or sculpture may, for example, portray as its "primary or natural subject matter" a crowned woman sitting on a throne surrounded by attendants. The inclusion of an infant on her lap could indicate that the "secondary or conventional subject matter" is a queen posing with her heir, although the presence of a nimbus around her head or the moon at her feet would specify that she is the Virgin Mary holding the Christ child. The goal of "iconography" (level two) is description of images—sign-like units of "motifs"—and their referents in ideas. "Images" are conventional and can be read only by knowing (through literature) the culture's arbitrary assumption of meaning to objects (like lilies as symbols of Paradise or purity). The necessity of knowing a conventional system of symbols characterizes level two; it usually involves the same forms as level one, but we see added dimensions of meaning.[4]

An iconographical approach enables one to understand that the added presence of three crowned men at the side of a crowned woman holding an infant further defines the scene as the Adoration of the Magi, a theme that was eventually associated with the dynastic praise of great ruling houses like the Medici and the Tudors. In line with the general necessity of knowing types to understand iconographical

1977), pp. 41–71; and "Henry VII and the Origins of Tudor Patronage," in *Patronage in the Renaissance*, ed. Guy Lytle and Stephen Orgel (Princeton, 1981), pp. 117–64.

[4] Erwin Panofsky, *Studies in Iconology: Humanistic Themes in the Art of the Renaissance* (Oxford, 1939), pp. 3–8. Michael Podro notes that critics have attacked Panofsky for "reducing the interest or nature of works of art to that of vehicles for a programme," in *The Critical Historians of Art* (New Haven, 1982), p. 198. For an opinion that Panofsky's approach constitutes a "semiotics" of art, see Michael Ann Holly, *Panofsky and the Foundations of Art History* (Ithaca, N.Y., 1984), pp. 44, 181–82.

themes, recognition of conventional signs of the Virgin Mary and other traditional symbols enables one to interpret the royalist images of the Tudors. The portrayal of a crowned female with neither nimbus nor child may therefore represent Queen Elizabeth, the virgin queen whose apologists retained formulas used in the veneration of the Blessed Virgin, but stripped them of theological associations. The retention of three men at the right of the queen carries the desanctified iconography of the Adoration of the Magi into portraits of Elizabeth (Figs. 50 and 78). Although such symbols had been emptied of their traditional religious associations, longstanding images and motifs were reapplied in praise of the house of Tudor.

Iconography transcends the realm of purely visual images, because it is necessary to relate texts (books, inscriptions, quotations, mottoes, and epigraphs) to the images that contain or accompany them and, alternatively, to determine how to "read" images that may function like texts. The protestation of undying love by Henry VIII and Anne Boleyn, for example, may seem utterly conventional, but their articulation of that sentiment through annotations in a devotional book places their love relationship in the context of Christ's sacrificial love and the iconography of ideal kingship. Anne Boleyn used Mariological imagery as a means of defining her relationship to Henry VIII in a sixteenth-century Flemish book of hours owned by the royal couple (B.L. MS King's 9, fol. 66ᵛ; inscribed 1533–36). At the beginning of the Hours of the Blessed Virgin and beneath a large miniature of the Annunciation, a figure used to celebrate the advent or coronation of queens, Anne addressed an epigram written in her own hand to her royal husband:

> be daly prove you shalle me fynde
> to be to you bothe lovynge and kynde.

Anne emulated the ideal love of Mary for her son in order to convey the permanence of her affection. Henry VIII reciprocated by adding an inscription beneath an illumination of a scourged figure of Christ wearing the Crown of Thorns—a symbol for Christian kingship—to sanctify his affection for Anne: "Si silon mon affection la sufvena[n]ce sera en vos prieres ne seray gers oblie car v[ost]re suis Henry R[oi]. a jam[m]ays" ("If according to my affection the memory will be in your prayers, I will never be forgotten because I am yours forever, King Henry"). Thus Henry and his queen employed their book of hours as a vehicle for a dialogue in which they modeled their undying love on biblical types for kingship and queenship. The present study considers

the dominant motifs employed in the iconography of the Tudors as pious monarchs, and how they operate and interweave in particular forms, like these affectionate messages that Henry VIII and Queen Anne inscribed into a religious manuscript whose text and images they devoutly "read."

The analysis of four frequently used and influential regal motifs (or *topoi*) furnishes the structure of the present study. Chapter 1 discusses the continuity of imagery shared by Henry VII and Henry VIII as Defenders of the Faith who, in the period before the English Reformation, paid homage to the pope as a spiritual overlord. Chapter 2 demonstrates how the motif of the Sword and the Book was appropriated during the Reformation—and rejected during Queen Mary's effort to enforce an English Counter-Reformation—as a figure for the propagation of evangelical faith. The opposition between the Crown and the Tiara as an enduring figure for the conflict between royal and papal authority is the subject of Chapter 3. The final chapter analyzes the incorporation of religious and scriptural typology into the sovereign images of Mary I and Elizabeth I as queens who were fully capable of governing in their own right and without the intercession of men.

The major paradigms for the iconography of the Tudors as pious rulers were drawn from the imagery of religious orthodoxy that had developed by the late Middle Ages and the alternative Protestant tradition that grew out of Luther's protest against merely formalistic religion. Where Catholic iconography emphasizes the respective primacy of popes over secular rulers and church tradition over scriptural texts, Protestant imagery derives from the Bible as the self-sufficient record of divine revelation and truth in this world. Over the centuries, medieval devotion shifted from powerful images of Christ as Pantocrator ("ruler of the universe") or Judge, which dominated early Christian art, to the more humanized images of Jesus as a vulnerable infant or as a condemned prisoner wracked with suffering on the cross.[5] Veneration of the Virgin Mary, images of saints, and relics occupied an important place in late medieval devotion as embodiments of sanctity and supernatural power in everyday life. Mariological observances and the cult of saints accordingly played important roles in the iconography of Henry VII and Mary Tudor. Frances Yates and Roy Strong have made major contributions in noting how old iconographical formulas sur-

[5] Jaroslav Pelikan, *Jesus through the Centuries: His Place in the History of Culture* (New Haven, 1985), pp. 67–70, 93–94, 107–108, and 139–40.

vived the Reformation through assimilation into or concealment by more ostentatiously Protestant observances.[6]

Although Roman Catholic iconography was also drawn from the Bible, the alternative Protestant tradition was characterized by heavy reliance on the scriptures and reluctance to use extrabiblical and apocryphal subjects. The reformers employed the complete range of narratives, genres, and tropes derived from the Bible as a model for life and art. Barbara K. Lewalski argues that during the Reformation a "specifically biblical poetics" comprised "the most important component of an emerging Protestant aesthetics." In addition to producing verse translations of the metrical parts of the Bible, the reformers mined the lives of great biblical individuals—Moses, David, Solomon, Judith, and Deborah—as subjects for drama, narrative, and epic poetry. This movement carried over into visual images. The Old Testament was an important source in royal iconography for "correlative types" that recalled events in the history of ancient Israel, as publicists searched for parallels that enabled them to praise Henry VIII as a second Moses or David, Edward VI as a new Josiah, or Elizabeth as Judith, Esther, or Deborah. Although such typology is not specifically reformist (after all, Charlemagne was a new David, and Mary Tudor was seen as Deborah), Protestants were especially eager to search the scriptures for political precedents. This tradition lived on into the Stuart age in praise for James I as a second Solomon, Prince Henry Stuart as a new Josiah, and Charles II as David.[7] In contrast to the Old Testament types favored in Protestant royalist iconography, papal names tended to be drawn from great figures in the New Testament or in Christian history, such as the apostles John and Paul, or saints like Stephen and Gregory. (During the Renaissance, popes with "imperial" pretensions emulated classical emperors in choosing names like Alexander and Julius.)

Because Tudor apologists appropriated, transformed, or rejected available cultural codes to create authoritative texts and images that self-consciously examine the dynamics of political and religious authority, the transmission and reception of such imagery are vital areas for study. Like the imperial apologists of the Carolingian and Ottonian ages, for example, Tudor publicists emulated the pose of Constantine the Great as a pious ruler who provided a model for *renovatio* because of his reputation for establishing Christianity as an official religion in the Roman Empire. His image was enhanced by that of his mother,

[6] See Yates, *Astraea*, pp. 78–79; and Strong, *Cult*, pp. 168, 182–85.

[7] Barbara K. Lewalski, *Protestant Poetics and the Seventeenth-Century Religious Lyric* (Princeton, 1979), pp. 8–9, 130–31.

Empress Helena, the reputed discoverer and preserver of the most sacred sites associated with Christ in Jerusalem. Charlemagne had also followed this imperial model when he styled himself as a new Constantine. Modern historians have shown great concern for the Roman emperor's quasi-pagan status,[8] but Tudor apologists, focusing instead on Constantine's British heritage and the central role he played in the establishment of the Christian church, praised Elizabeth I as a second Constantine (Fig. 50). As a model for the legitimacy of the idea of a secular ruler establishing a church, Constantine provided a forceful precedent for Elizabeth's reestablishment of Protestantism with her 1559 settlement in religion.

Early Christian art contained an amalgamation of biblical and Roman symbolism. By the fourth century, Christ had come to be portrayed as an enthroned and crowned emperor presiding over a court composed of angels and saints. When Charlemagne and his successors appropriated Christian-Roman imagery in order to consolidate their authority over the Holy Roman Empire, it represented a culmination of late classical and early Christian iconography. The illuminated frontispiece of the Aachen Gospels (c. 975) thus eulogizes Emperor Otto II by depicting him enthroned as a Christlike intermediary between heaven and earth (Fig. 1). The hierarchical levels of the scene portray, from top to bottom, the Hand of God sanctioning Otto's majesty, the elevation of the emperor toward heaven, and veneration of him by figures symbolic of the ecclesiastical and noble estates.[9] The Donation of Constantine modified this definition of secular rulers as godlike figures by establishing a fraudulent precedent for the belief that the pope shared the authority of the Holy Roman emperors. Before Lorenzo Valla proved this document to be a forgery, it was accepted as proof that Emperor Constantine had delegated Pope Sylvester and his successors as rulers over the papal dominions in Italy and established the primacy of the pope over all other bishops. The crowning of Charlemagne by Pope Leo III on Christmas Day in A.D. 800 helped to strengthen the belief that the bishops of Rome were secular rulers as co-inheritors of the imperial power of ancient Rome. The image of the founder of the Holy Roman Empire is often associated with the acceptance of the church as the *source* of political legitimacy.

[8] See Ramsey MacMullen, *Christianizing the Roman Empire (A.D. 100–400)* (New Haven, 1984), pp. 44–48.
[9] Ernst H. Kantorowicz, *The King's Two Bodies: A Study in Mediaeval Political Theology* (Princeton, 1957), pp. 61–65, and fig. 5; see André Grabar, *Christian Iconography: A Study of Its Origins* (Princeton, 1968), p. 41.

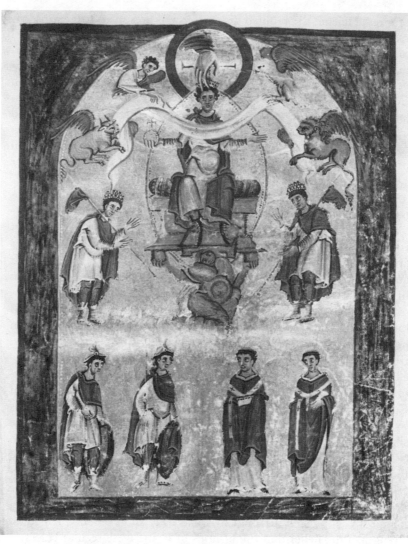

1. Reichenau School. *Otto II-in-Majesty*, c. 975

The Tudor image of the "godly" monarch permitting the free circulation of the scriptures recalls the imperial theme of Charlemagne-in-Majesty (or Otto II-in-Majesty), which is modeled in turn on the early Christian iconography of Christ-in-Majesty. The medieval images function not as sources for Tudor iconography, but as analogous examples of the construction of political images upon biblical and reli-

10

gious themes. Otto III thus envisioned his predecessor Charlemagne as the founder of a " 'universal Roman Empire' " that paralleled the "universal Roman Church" founded by Christ.[10]

Charlemagne was identified further with the theme of *translatio*, which meant that he was seen as successor to David and Solomon, figures who were identified with the unification of heavenly and secular concerns on earth. During medieval conflicts with the papacy, the Old Testament ideal of theocratic government was infused with millennial yearnings for imperial *renovatio* and Davidic kingship. David in particular provided an image of establishing a kingdom *on earth* that mirrors the one in heaven, in this case a prophetic kingdom. He was first anointed as the favorite of God and later crowned. In some images he is crowned twice to denote spiritual and secular authority. The Holy Roman Empire claimed to inherit the status of the kingdom of Israel as God's chosen nation. Depictions of enthroned emperors in both Byzantium and the western Latin world were therefore modeled on David and Solomon in order to express the view that the Hebrew kingdom was created anew in the Eastern Roman and Holy Roman Empires.

Early images of Charlemagne confer upon him the attributes of the scepter and church, which he bears in the manner of a Byzantine emperor, thus symbolizing the "conjoining of the secular and spiritual realms, the *regnum et sacerdotum*, in the king's person and authority."[11] The portrayal of the emperor on the Charlemagne reliquary preserved in the cathedral treasury at Aachen is elevated above and between the likenesses of Pope Leo III and Archbishop Turpin, in an iconographical representation of the independence of secular authority and its supremacy over the ecclesiastical order.[12] In later centuries this imperial prototype for the primacy of Crown over Tiara would be reversed in papal art to portray the "demotion" of emperors beneath the pope as supreme temporal authority.

Carolingian and Ottonian art exerted no direct influence on Tudor iconography, but apologists of both eras drew upon a common reservoir of paradigms, many of which derived from the Bible and traditional court ritual. The First Bible of Charles the Bald (846), known

[10] Stephen G. Nichols, Jr., *Romanesque Signs: Early Medieval Narrative and Iconography* (New Haven, 1983), p. 82.

[11] Ibid., p. 91; see also Norman Cohn, *The Pursuit of the Millennium* (1957), p. 15.

[12] Ibid., pp. 90–93, and figs. 17–19; see also pp. 79, 82, 85–86, 88, and figs. 12, 15–16, and Kantorowicz, *King's Two Bodies*, pls. 5–7. On the cult of Davidic and Solomonic kingship encouraged by Pepin and Charlemagne, see Ernst H. Kantorowicz, *Laudes Regiae: A Study in Liturgical Acclamations and Mediaeval Ruler Worship*, University of California Publications in History, vol. 33, 2nd ed. (Berkeley and Los Angeles, 1958), pp. 56–59, 64.

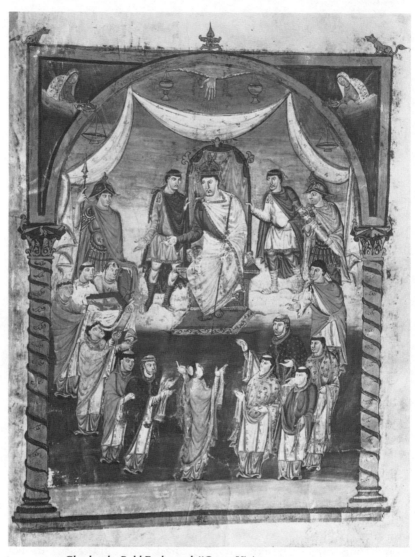

2. *Charles the Bald Enthroned*, "Count Vivian
Bible," 846

also as the "Count Vivian Bible" after the abbot of St. Martin's at
Tours who commissioned the volume, portrays the Frankish king as
an enthroned and crowned ruler whose authority is sanctioned by the
Hand of God above his head as he receives the Bible from flanking
figures of clerics (Fig. 2). Charles's stance here is remarkably similar

not only to that of Otto in the frontispiece of the Aachen Gospels (Fig. 1), but also to that of Henry VIII in the frontispiece of the Great Bible (Fig. 14). The sword and the book held respectively by a soldier and a cleric in attendance upon Charles the Bald constitute a prototype for a major device of the Protestant Tudors.

The portrayal of Protestant Tudor monarchs is more complicated and ambiguous, however, because they are presented as both recipients *and* disseminators of the scriptures, thus uniting secular and religious authority. The illustrations in the "Count Vivian Bible" sharply divide dissemination and reception because Charles the Bald clearly *receives* a Bible manuscript that is *sent upward* by the cleric at his lower right.[13] The frontispiece of the "Count Vivian Bible," on the other hand, portrays St. Jerome distributing his Latin translation of the scriptures to the monks who flank him at the left and right (fol. 3ᵛ). The seated representation of this Father of the Church closely resembles the enthroned images of Henry VIII and his Protestant successors.

From the Carolingian period onward, as the coronation ritual expressed the wish that God would confer on kings the attributes of Old Testament heroes and sovereigns, idealized royal virtues like the faith of Abraham, the mercifulness of Moses, the fortitude of Joshua, the humility of David, and the wisdom of Solomon were commonly attributed to rulers in a manner akin to the praise of Constantine the Great as a new Moses. Charles the Bald was compared, for example, not only to David and Solomon, the great kings of Israel, but also to Hezekiah and Josiah. Similarly, the iconography designed in the twelfth century by Abbot Suger for the reconstructed royal abbey church of Saint-Denis portrayed "good and pious" Hebrew kings like David and Solomon as the spiritual antecedents of French rulers. Images of these kings appeared in royalist iconography at locations other than Saint-Denis. Although the original sculptures are no longer extant, Adolf Katzenellenbogen argues persuasively in reference to Chartres Cathedral that the depiction of prophets like Samuel and Nathan in the company of kings was intended to "prefigure the harmony between *regnum* and *sacerdotum*" during a medieval epoch when little if any conflict existed between regal and clerical authority. Because Carolingian queens were honored by comparison with canonical and apocryphal scriptural types like Sarah, Rebecca, Rachel, Esther, and Judith, it seems likely that the sculptures at Saint-Denis, Chartres, and other

[13] Bibliothèque Nationale, MS lat. 1, fol. 423. See Kantorowicz, *King's Two Bodies*, pl. 16a; Walter Cahn, *Romanesque Bible Illumination* (Ithaca, N.Y., 1982), pl. 24; and Robert G. Calkins, *Illuminated Books of the Middle Ages* (Ithaca, N.Y., 1983), pp. 96–97 and pl. 42.

locations included some of these figures, notably the Queen of Sheba, who sought out Solomon from afar because of his reputation for wisdom.[14]

Literary critics have bypassed some of the artistic objects examined in this study of Tudor iconography (for example, woodcuts) because these materials are considered subliterary or extratextual. Art historians have avoided them partly because they are crafted works said to lack the distinguishing characteristics of "fine" art, but even more because the monumental art of the period is not beloved of art history. When a period's monuments are valued by art historians, woodcuts are often cherished as clues to meanings of larger works. Woodcuts have frequently been overlooked because they are considered secondary, and art historians have little interest in what they are secondary *to*. The dynamics of book illustration have generally been ignored by literary critics whose primary goal is the elucidation of literary texts, although Middle English literature has been well served by studies that address interactions between text and image in illustrated manuscripts.[15] The descriptive and enumerative bibliography of woodcuts has been devoted largely to formal questions relating to the cutting of woodblocks, the identification of cutters, and the place of illustrations in the technical process of book production and publication.[16] When historians of politics or culture have addressed other vehicles of royalist praise, such as drama, civic pageantry, or courtly masques, they have often ignored the aesthetic dynamics of literary genres or iconographical imagery in order to reduce those works to their historical "content" or representation of influential ideas like the legal fiction that the monarch had "two bodies."[17] In so doing, they have often overlooked the sophisticated evolution of materials that are not reducible to relatively static footnotes, but are our best evidence for developments that are important in themselves. The present study applies neglected materials directly to larger political and intellectual themes without the intervention of art history. It treats works like woodcuts

[14] Adolph Katzenellenbogen, *The Sculptural Programs of Chartres Cathedral* (Baltimore, 1959), pp. 27–36.

[15] See Rosemond Tuve, *Allegorical Imagery: Some Mediaeval Books and Their Posterity* (Princeton, 1966); and V. A. Kolve, *Chaucer and the Imagery of Narrative: The First Five Canterbury Tales* (Stanford, Calif., 1984).

[16] See Edward Hodnett, *English Woodcuts: 1480–1535* (1935), and *Image and Text: Studies in the Illustration of English Literature* (1982); and David Bland, *A History of Book Illustration: The Illuminated Manuscript and the Printed Book* (1958).

[17] See Anglo, *Spectacle*; Kantorowicz, *King's Two Bodies*; and Marie Axton, *The Queen's Two Bodies: Drama and the Elizabethan Succession* (1977).

on their own terms as serious subjects for investigation that are neither subordinate to nor dependent upon traditional fields of investigation.

An iconographical approach enables one to relate the different media employed in royalist praise—manuscript illustrations, woodcuts, illustrated books (or those devoid of illustration), pageantry, drama, portraits, and sermons—in terms of an interlocking network of ideas, images, and gestures that convey panegyrical meanings. This dynamic language of praise continually changes as artists define, reinterpret, invert, and parody images that may seem superficially to remain the same. The workings of the presentation scene in which an author, translator, or editor supplicates a prospective patron is a case in point. Generally set in the patron's private apartments or an audience chamber, such scenes characteristically appear in dedication copies of illuminated manuscripts, very often in historiated initial capitals. Thus Thomas Hoccleve kneels, in what appears to be the dedication copy of his *Regement of Princes*, to present his book to the Prince of Wales, who would soon become Henry V.[18] The easy transference of this kind of conventional scene from manuscripts into printed books designed as patronage appeals may be noted in the portrayal of Edward VI's reception of a book from the author John Bale (Fig. 21).

Variations of such scenes appear on the title pages of authorized Bibles and related texts published under the Protestant Tudors: Henry VIII, Edward VI, and Elizabeth I (Figs. 8, 14, 27, and 75). Although kneeling supplicants continue to appear before an enthroned sovereign in these woodcuts, their multiplication into pairs or groups indicates that they are not the generators, but the *recipients* of scriptural translations that may circulate only with the sufferance of the crown. The symbolic book or Bible of evangelical kingship is the focus of these woodcuts. This image recalls the use of the Bible as a political symbol in modeling the *imperium* of Constantine, Justinian, and Charlemagne

[18] B.L. MS Arundel 38, fol. 37; written 1411–12. The presence of the royal arms on fol. 1 suggests that this is a dedication copy. See J.J.G. Alexander, "Painting and Manuscript Illumination for Royal Patrons in the Later Middle Ages," in *English Court Culture in the Later Middle Ages*, ed. V. J. Scattergood and J. W. Sherborne (New York, 1983), p. 148 and pl. 7. Another example is the depiction of Jean de Wavrin presenting his *Premier volume des anchiennes et nouvelles chroniques dangleterre* to Edward IV (B.L. MS Royal 15 E. iv, fol. 14), reproduced in British Library, *William Caxton: An Exhibition to Commemorate the Quincentenary of the Introduction of Printing into England* (1976), no. 6 (p. 25). The conventions of manuscript illustration are carried over into early printed books, as in the specially prepared frontispiece of the Huntington Library copy of William Caxton's first book, his translation of Raoul Le Fèvre's *Recyvell of the Historyes of Troye* (Bruges, c. 1475; STC 15375). Here Margaret of York is portrayed receiving the text from a kneeling author, possibly Caxton himself. Reproduced in Hind, vol. 1, pl. 1.

on the Augustinian ideal of the wise Christian ruler, the "rex iustus et pius" who governs according to Christian principles of justice and mercy (*De civitate dei* 5.24).[19] The monarchs' dissemination of Bibles to both clergymen and magistrates indicates that these high-ranking officials mediate between rulers and subjects, who occupy the opposite ends of the social hierarchy. The presentation scene has transmuted from an upward image of petition by supplicant to patron into a downward symbol of permission—and control.

The ambiguous title page of the Great Bible (Fig. 14) also functions as an encouragement from Thomas Cromwell and Thomas Cranmer, who are portrayed as recipients of the vernacular Bible (*Verbum Dei*) from Henry VIII, in favor of the continuation of Protestant reforms that the king has set in motion. As Henry's vicegerent and vicar-general in spiritual matters, Cromwell patronized the volume on the king's behalf; Cranmer administered the church as Archbishop of Canterbury. These twin figures personify the monarch's traditional control over the state as well as his leadership of the church, which he assumed at the time of the Reformation Parliament in 1534. The scene preserves its medieval function to the extent that the monarch may appear to receive a work translated or published under royal patronage. Although this presentation scene retains a longstanding visual structure, it has been transformed into a rendering of royal approval for the free circulation of the English Bible. Henry's primary role is that of giver, rather than receiver, of the text.

Portrayals of the Protestant Tudors as "liberators" or "permitters" of the open reading of the vernacular Bible are linked to the hierarchy of the king's two roles and suggest that religion exists at the pleasure of the king. Such images abound in evangelical texts, and they are drawn into allied panegyrical forms in civic pageantry and drama. Thus one may relate the symbolic image of Henry VIII on the title page of the 1539 Great Bible to the contemporary courtly production of *King Johan* (c. 1538), composed by Cromwell's protégé John Bale, where Imperial Majesty (a figure modeled on Henry VIII) implements church reform and expels an allegedly corrupt Roman clergy from the realm. It would be altogether appropriate for Bale's idealized version of a Reformation king to adopt a commanding stance similar to the royal pose established in the Great Bible. Richard Grafton, who co-published the Great Bible with Edward Whitchurch, definitely used its

[19] On the tradition of the imagistic book symbolic of the Bible, see Ernst R. Curtius, *European Literature and the Latin Middle Ages*, trans. Willard R. Trask (New York, 1953), pp. 310–11. See also Kantorowicz, *King's Two Bodies*, figs. 5 and 16a–b and related text, on the inclusion of Carolingian and Ottonian portraits in biblical manuscripts.

title page as the model for his 1554 pageant for Queen Mary and her consort Philip of Spain, in which the queen's late father was portrayed carrying a Bible inscribed with the words "Verbum Dei." Lord Chancellor Stephen Gardiner ordered the deletion of the Bible from the tableau because it was "read" as a conventional symbol for Reformation majesty (see below, p. 102). When Elizabeth came to power, one of her earliest public gestures was the kissing and embracing of the Bible during her entry into London on the eve of coronation. The Great Bible title page was then modified to present her in the role of transmitter of the scriptures in the 1569 Bishops' Bible (Fig. 75; see below, pp. 229, 233–35).

Tudor iconography preserved not only alternating versions, but also a unique fusion of Catholic and Protestant images. Panegyrics for Henry VII and his granddaughter Mary centered on the cults of the saints and the Blessed Virgin, and on devotional objects like relics or religious images, just as their symbolic devices incorporated Latin tags from the Vulgate Bible and apocryphal legends of the saints. The Protestant Tudors, on the other hand, associated themselves with the free dissemination and popular reading of the vernacular Bible, which they elevated above "manmade" forms of church tradition. Although Reformation images defined monarchy in evangelical terms, the iconography of the Protestant Tudors preserved ancient "Catholic" symbols associated with the Adoration of the Magi or Coronation of the Virgin, albeit in forms that are varied through imitation, truncation, parody, or inversion. The formation of such "countergenres"[20] was particularly important during the Tudor Reformation, when new literary and artistic forms were established both in reaction to orthodox Catholic iconography and in order to fill the void left by acts of Protestant iconoclasts, who tended during this period to transform and assimilate old iconography rather than destroy it outright.

Royal iconography filled the vacuum left by iconoclastic attacks when images of monarchs and royal heraldry inherited the veneration that statues of the Virgin and Child, saints' images, and other cult objects had acquired by the late Middle Ages. The royal coat of arms replaced religious images and the crucifix on the rood screens of English churches.[21] A woodcut allegory in Foxe's "Book of Martyrs" portrays this iconographical shift by juxtaposing scenes of the pulling

[20] Claudio Guillén uses this term to define new literary genres that result from the combination of imitation and reaction against distinguished predecessors, rather than through invention of forms that did not exist previously. See *Literature as System: Essays Toward the Theory of Literary History* (Princeton, 1971), pp. 8, 109, and 133.

[21] John Phillips, *The Reformation of Images: Destruction of Art in England, 1535–1660* (Berkeley and Los Angeles, 1973), pp. 88, 119, 128–29, and figs. 28, 29a, and 31.

down of a statue from a church wall and the "Burning of images," with the inset at the lower left portraying "King Edward delivering the Bible to the Prelates" (Figs. 26, 27). The stark simplicity of the inset at the lower right symbolizes the evangelical service and readings from the scriptures mandated for the Church of England under Edward VI (Fig. 28). As Edward's regent, Protector Somerset replied to the objection raised by Bishop Stephen Gardiner that images are acceptable as "books" for the ignorant and illiterate laity with the counterargument that only royal devices deserve homage: "The king's majesty's images, arms, and ensigns, should be honoured and worshipped after the decent order and invention of human laws and ceremonies" (A & M [1877], 6: 28). In order to avoid any appearance of idolatry, Somerset offered an iconoclastic interpretation of the royal image as a worldly reflection of truth revealed in the scriptures.

While the glorification of the monarch as the embodiment of "sacred" majesty has long been associated with the reign of Elizabeth I, praise of this kind did not represent a new development. Iconography of Elizabeth as a "godly" queen assimilated formulas associated with both the adulation of Henry VIII and Edward VI as kings committed to the English Reformation and the more traditional religious imagery of Henry VII and Mary I. Like every other Tudor monarch, Elizabeth subscribed to the necessity of disseminating an image of regal piety both inside and outside the royal court. It is essential to remember that while royal action may produce an environment suitable for the creation of particular art forms, it need not control or commission works generated outside the court. Protestant ideologues in particular tended to mold the royal image as part of their campaign for further alterations in religious practices that were resisted not only by Mary Tudor, but often by Henry VIII and Elizabeth. More clearly than the monarchs themselves, religious activists may have recognized that images of dynastic assertion could be exploited or even "subverted," by iconoclasts committed to programs that sometimes ran counter to royal prerogative.

1. The Defenders of the Faith

"Lo, surely this is he, to whom both we and our adversaries levyng the possession of all thinges, shall hereafter geve ro[o]me and place." So thys holy man shewed before, the chaunce that should happen, that this erle Henry [later Henry VII] so ordeyned of God, should in tyme to come (as he did in deede) have and enjoye the kingdome, and the whole rule of the realme. —Henry VI, as quoted in Hall, *Union . . . of Lancaster and York* (1548)

Political pragmatism joined with piety in leading Henry VII to embark upon a conscious strategy of image-making that proclaimed both his own virtue as an orthodox Christian and the legitimacy of the house of Tudor as England's ruling dynasty. Because Henry recognized the political reward of a reputation for godliness, his religious practices were distinctive largely for their extreme conventionality. According to Polydore Vergil, orthodoxy marked his conduct in both public and private worship:

> He was the most ardent supporter of our faith, and daily participated with great piety in religious services. To those whom he considered to be worthy priests, he often secretly gave alms so that they should pray for his salvation. He was particularly fond of those Franciscan friars whom they call Observants, for whom he founded many convents, so that with his help their rule should continually flourish in his kingdom.[1]

After declaring his obedience to the pope following the Battle of Bosworth Field, Henry's dealings with the hierarchy of the church of Rome were unexceptional. He patronized clerics and religious houses, and sponsored the erection of churches. His veneration of saints and relics, endowment of prayers for his eternal soul, and devotion to the cult of the Blessed Virgin were utterly conventional. In every respect Henry's reign is marked by an orthodox acceptance of the suzerainty

[1] Polydore Vergil, *Anglica Historia* (1534), ed. and trans. Denys Hay, Camden Soc., 3rd ser., 74 (1950), pp. 146–47.

of the pope *and* a shrewd awareness of the political value of projecting a public image of regal piety. The common acceptance of this image of "godly" kingship may be noted at the beginning of his reign in the pageantry for his 1486 entry into Hereford, where the king witnessed a nationalistic tableau depicting St. George's defeat of the dragon. Through George, its patron saint, England—and its sovereign—was identified with the conquest of evil by true faith. The victorious saint greeted Henry VII with epithets that were reiterated throughout Henry's reign:

> Moost Cristen Prince, and Frende unto the Feith,
> Supporter of Truth, Confounder of Wikkednesse.[2]

In itself, the conservatism of Henry's piety may seem remarkable, given the violent twists and turns in religious policy that marked the reigns of his descendants. Yet Henry never forgot his position as head of state, and he exploited every opportunity to augment his power and position as king. Despite his ostentatious devotion to relics, religious endowments, devout observances, and formal piety, the king remained very much a political pragmatist.[3] As David Knowles points out, Henry VII "was not personally interested in religion in its theological or devotional aspects, still less in its spiritual depth, but neither was he a critic or a libertine. His actions and policies, as we see them, were earthbound."[4]

Henry VII's image-making strategy involved a formal effort to claim legitimacy and authority on the basis of his fealty to the pope in Rome. According to centuries-old tradition, it was the pope or his delegate as an intermediary between God and humanity who crowned kings and emperors, thus validating secular authority. Saddled by a claim to the English throne of dubious legitimacy, Henry VII followed widespread European precedents for regal piety in publicly acknowledging the titular overlordship of the pope. The king placed himself and his dominions under papal protection. Innocent VIII responded in a bull of 27 March 1486 by declaring Henry King of England "by right of war and also by notorious and undoubted title." As a further mark of legitimation, the pope awarded Henry the honorary title of Defender of the Faith (a favor that Henry VIII later coveted) and bestowed upon him the symbolic sword and crimson velvet cap of maintenance that the

[2] John Leland, *De rebus Britannicis Collectanea*, ed. Thomas Hearne, 3rd ed., 4 vols. (1774), 4: 197.

[3] Chrimes, pp. 4, 240–41, 244, and 304.

[4] David Knowles, *The Religious Orders in England*, 3 vols. (Cambridge, 1948–59), 3: 3.

king wore beneath the crown as a gesture of fealty.⁵ These papal gifts arrived in 1488 during Whitsuntide, when "ther entrid In to this reaulme a cubiculer of the popes whic[h] broght to the kyng a swerde and a cappe which for honnor of the pope was honnourably receipiud [received] by the kings co[m]maundement" (B.L. MS Cotton Julius B. XII, fol. 51ᵛ). John Stow records a second bestowal of these favors at about Midsummer 1505, when "Pope *Julius* the 2. sent to the King a cap of maintenance, and a sword as to defender of the church, the which cap and sword were received with many and great ceremonies" (Stow, *Annales*, p. 484). The cap of maintenance and sword provided important iconographical symbols of the king's fealty to the pope and, in the kind of reciprocal gesture that was essential to the feudal code, the pope's validation and acceptance of Henry's regal authority inside the borders of England.

The cultivation of a legendary view of Richard III as the embodiment of individual and political evil was an adjunct to Henry's strategy of presenting himself in the manner of a pious and orthodox prince; indeed, the positive image of Henry VII *required* the negative image of Richard. The denigration of Richard's moral character and abilities as a ruler following the Yorkist king's defeat in 1485 contributed implicitly to the portrayal of his Tudor successor as a god-fearing monarch who succeeded to the throne through providential intervention. The contemporary account by John Rous therefore describes Richard as an "excessively cruel" tyrant who "like the Antichrist to come . . . was confounded at his moment of greatest pride."⁶ The Antichrist, or the Beast of the Apocalypse, had served for centuries as a fearful example of religious and political error. Other chroniclers record allegations concerning Richard's sleepless premonition of defeat the night before the clash between Yorkist and Lancastrian armies. The failure of chaplains to celebrate the morning mass on his behalf was seen, accordingly, as a mark of divine disfavor. Sir Thomas More's seminal account in *The History of King Richard the Third* offers an unhistorical portrait that is remembered to the present day of a crippled king whose physical deformities mirror his sinful soul:

⁵ J. Wickham Legg, "The Gift of the Papal Cap and Sword to Henry VII," *Archaeological Journal* 57 (1900): 184ff. To the present day the sword is carried at the State Opening of Parliament before the sovereign who continues to wear the red velvet cap, the "significance of which has been forgotten" according to *Baedeker's London* (Norwich, 1984), p. 23. C.U.L. MS Mm. I 49, p. 214, notes "that K: Henry the VII: had the Title formerly of Defender of the Faith."

⁶ John Rous, "Historia Johannis Rossi Warwicensis de Regibus Angli[a]e," trans. Alison Hanham, in *Richard III and His Early Historians, 1483–1535* (Oxford, 1975), p. 123.

Little of stature, ill fetured of limmes, croke backed, his left shoulder
much higher then his right . . . close and secrete, a deepe dissimuler,
lowlye of counteynaunce, arrogant of heart, outwardly coumpinable
[companionable] where he inwardely hated, not letting [hesitating]
to kisse whome hee thoughte to kyll.[7]

Richard III's reputation was carefully blackened by skillful publi-
cists, such as Rous and More, who looked to the Tudor regime for
patronage. Completed in 1513, a full generation after the Battle of
Bosworth Field, More's account presumably drew upon the views of
Cardinal John Morton, who advanced to become Lord Chancellor and
Archbishop of Canterbury through appointments by Henry VII; be-
cause of his loyal service first to Henry VI and then to Edward IV,
Morton had been arrested and imprisoned under Richard III.[8] At a
later date, chroniclers like Hall and Holinshed passed on to posterity
the revisionist image of King Richard. Fully aware that the Tudor
claim to dynastic legitimacy was even shakier than Richard III's—the
Tudor inheritance from Edward III was marked with bastardy in both
the paternal line of Owen Tudor and in the maternal descent through
Margaret Beaufort—Henry VII or his associates encouraged fictions
that portrayed the last Yorkist king as cruel, tyrannical, murderous,
and deformed, in contrast to Henry's own alleged godliness and mag-
nanimity. The myth of Richard's hump is only the most notorious of
these fabrications, one that predates a hostile portrait (c. 1533–43)
made after his death that depicts him as a menacing hunchback pos-
sessing, in place of regalia, only a broken sword.[9] Surely the shattered
weapon in Richard's hand symbolizes the moral failures of a figure
judged unworthy of wielding the regal sword of justice and the military
incapacity of a king defeated in battle by his Tudor challenger.

Evidence surviving from Richard III's reign illustrates how his visual
image was altered to bring it in line with the Tudor myth. It is no ac-
cident, then, that "a late descendant of what is probably the earliest

[7] *The History of King Richard III*, ed. Richard S. Sylvester, in *The Complete Works
of St. Thomas More*, ed. Richard S. Sylvester et al., 10 vols. in 15 (New Haven, 1963–),
2: 7–8. More begins this work with a detailed comparison of Edward IV and Richard
III as "good" and "evil" princes (2: 3–9). See Trapp & Herbrüggen, nos. 109–110.
Edward Hall incorporated the English version of More's *History* into his *Union . . . of
Lancaster and York* (1548), thus setting a precedent for the chronicles of Holinshed and
Stow.
[8] More, *History of Richard III*, pp. lxv–lxvii. Although More's account reflects views
dear to the Tudors, he did not write the work as dynastic propaganda. His version is
flattering to Edward IV, qualifies hearsay reports of Richard's physical deformity, and
ends abruptly prior to Henry VII's accession.
[9] Pamela Tudor-Craig, *Richard III* (1973), no. P40.

surviving likeness of the king," one derived from a lost original drawn during his lifetime, depicts a handsome, vigorous, and fair-featured man who shows no evidence of crippling deformity. It contains "no trace of the hostile image [of the king] . . . , or of the physical and moral deformity attributed to him."[10] Portraits that were presumably modeled upon studies from life depict him with neither the humpback nor the sinister slitlike eyes typical of later versions. Possibly the oldest surviving likeness is one in the royal collection that includes a deformed right shoulder (c. 1518–23). X-ray analysis revealing that the shoulder was originally lower than its present silhouette proves that the original portrait was altered to create the appearance of malformation that recurs incessantly in later versions of the king's image. The eyes were also made to appear more threatening. The firsthand testimony of "Richard III's Book of Hours" further calls into question the Tudor vision of Richard as a man of near limitless depravity; it contains an added prayer designed for Richard's own use (Lambeth Palace MS 474; written c. 1430–50). Possessing the nature of a litany, this insertion "provides an insight into his private life of almost unparalleled intimacy" by recording the beleaguered king's sense that he is surrounded by peril, tribulation, and oppression (fols. 181–83). This petition for deliverance from enemies proclaims his innocence concerning rumors and false reports, the chief of which was the charge of murdering his nephews, Edward V and Prince Richard. Richard claims to have been betrayed by those close to him when he identifies himself with King David, on whose behalf God intervened to bring "to nothing the advice with which Achitofel counselled Absalom."[11]

In pointed contrast to their blackening of Richard III's character, Henry VII and his apologists encouraged the cult of Henry VI as a saintly king. As the last of the Lancastrian line, Henry VI occupied a special place in early Tudor propaganda as a pious monarch from whom Henry VII inherited political and moral authority. Like King Richard, Edward IV was viewed as a pretender whose reign represented an exception to a direct line of succession running from Henry IV through his son and grandson to Henry VII. As a corollary to blaming Richard III, Henry VI was praised as a "saintly" model for the Tudor claim to govern as wise and pious princes. Henry VII declared a special bond to the royal "uncle" who was reputed to have prophesied that the Tudors would succeed him on the throne.[12]

[10] Trapp & Herbrüggen, no. 2 (N.P.G., no. 148; c. 1590–1600). See Tudor-Craig, *Richard III*, no. P18.

[11] Tudor-Craig, *Richard III*, nos. 51 and P44, and pp. 96–97.

[12] Bertram Wolffe, *Henry VI* (1981), p. 4. Wolffe concludes that "there is no evidence

Although Henry VII laid claim to the mantle of the Lancastrian "saint," surely he had no share in the unworldliness of a predecessor who neglected political affairs and suffered from madness. Shrewd political calculation lay behind the Tudor monarch's claim to be the namesake and "nephew (by his uterine brother) of Henry VI,"[13] who was accepted as a saint by the population at large. This assertion and the equally dubious one of legitimate direct descent from John of Gaunt recurred throughout the Tudor age in the badges of the Tudor rose (a combination of the white rose of York with the red rose of Lancaster) and the Tudor rose tree that reunites the dynastic offshoots rising from the ancestral stock of Edward III. These devices portrayed the symbolic unification of the rival houses through the marriage and offspring of Henry VII and Elizabeth of York. The title page of Hall's *Union . . . of Lancaster and York* (2nd ed., 1550), for example, depicts this claim in its portrayal of the Tudor rose tree rising upward to Henry VIII from the recumbent figures of John of Gaunt and Edmund of York.[14]

Henry VI was considered a "saint" prior to the Battle of Bosworth Field because of his reputation as a political martyr who had worked many attested miracles. He "had long been an embarrassment to the Yorkist party, which, soon after his death, had been forced to deal with unpleasant rumours" attributing his death to Richard, Duke of Gloucester (Anglo, *Spectacle*, p. 38). Despite his partisan views, Thomas More did not invent the charge that Richard "slewe with his owne handes king Henry the sixt."[15] After reaching the throne, King Richard evidently intended to neutralize the growing cult of the royal "saint" by providing for his reinterment at St. George's Chapel, an act

dating from Henry's lifetime to support this posthumous early Tudor hagiographic picture of Henry as a saintly, blameless, ascetic royal pauper" (p. 12). He summarizes the evidence concerning the king's "apotheosis" in pp. 351–58.

[13] Rous, "Historia," in Hanham, *Richard III*, p. 123. See also Anglo, *Spectacle*, p. 36.

[14] Reproduced in R. B. McKerrow and F. S. Ferguson, *Title-page Borders Used in England and Scotland: 1485–1640* (1932), fig. 75. The title-page border first used in John Stow's *Chronicles of England* (1580) incorporates a later variation that portrays Queen Elizabeth, flanked by her predecessors Edward and Mary, as the scion of the houses of Lancaster and York (reproduced in McKerrow and Ferguson, *Title-page Borders*, fig. 166). Only the white rose of York was a definitive dynastic badge throughout the fifteenth century. Henry VII assumed the recently invented red rose of Lancaster as a heraldic emblem and adopted the union rose of the Tudors by superimposing the white rose over the red. The plucking of red and white roses by the adherents of Lancaster and York respectively in the Temple Garden scene of Shakespeare's *1 Henry VI* (2.4) therefore dramatizes an anachronistic interpretation of the origin of the so-called Wars of the Roses. Henry VI's wearing of a red rose in the same play (4.1.152) represents a similarly anachronistic imposition of Tudor iconography on earlier dynastic events.

[15] More, *History of Richard III*, p. 8.

that brought the late king's remains within crown control in a ne-
glected tomb located at the site of the cult of British monarchy, the
Order of the Garter. John Stow records that Richard "caused the body
of King *Henry* the sixt to be remooved from Chertsey Abbey in Surrey,
and to be buryed at Windsore" on 12 August 1484 (Stow, *Annales*, p.
466). Actively venerated as a place of pilgrimage, the king's tomb at
Windsor warranted comparison to Edward the Confessor's Chapel at
Westminster as a holy place identified with regal piety.[16] Edward IV
(d. 1483) had conceived of his reconstruction of St. George's Chapel
as a "vast chantry chapel" where perpetual masses might be celebrated
for the sake of his soul;[17] when Henry VI was buried in a tomb south
of the high altar, nearby Edward's tomb on the north side, the chapel
came to rival Westminster Abbey as a royal shrine. It was later chosen
as Henry VIII's burial place.

By launching an official campaign to canonize Henry VI, Henry VII
planned to honor himself as the saint's apprentice. Pope Julius II re-
sponded to this appeal in a letter of 19 June 1504 (C.U.L. MS Mm. I.
45) authorizing the formation of a canonization commission headed
by the Archbishop of Canterbury. An account of miracles attributed to
Henry VI attests to the strenuous effort made at this time to substan-
tiate the claim that he had interceded on behalf of his faithful people.
Originally written in English, it survives in a Latin transcript by an
anonymous monk. This record was evidently prepared for submission
to an ecclesiastical authority, presumably in the Roman curia, as evi-
dence for the proposed canonization, because glosses like "probatum"
and "non probatum" are sometimes added in the margins. This manu-
script documents the pursuit of the canonization effort within circles
associated with the Tudor court, because it was compiled either by or
for John Morgan, a churchman who was closely identified with Henry
VII's succession to the throne.[18] Individual entries illustrate the belief

[16] C. R. Beard, "The Tomb and Achievements of King Henry VI at Windsor," in *Frag-
menta Armentaria*, ed. Francis Henry Cripps-Day, II, Pt. 1 (1936), pp. v–vi, 18–20. See
also Wolffe, *Henry VI*, pp. 352 and 358.

[17] Walter C. Leedy, Jr., *Fan Vaulting: A Study of Form, Technology, and Meaning*
(1980), p. 221.

[18] B.L. MS Royal 13 C. VIII, esp. fols. 86–111. Paul Grosjean, ed., *Henrici VI Angliae
regis miracula postuma*, in *Subsidia Hagiographica*, no. 22 (Brussels, 1935). Ronald
Knox and Shane Leslie's *The Miracles of King Henry VI* (Cambridge, 1923) contains
Latin selections with translations. According to Wolffe, *Henry VI*, p. 6, almost all of the
recorded miracles postdate the translation of Henry's remains to Windsor by Richard
III. Tradition holds that Morgan absolved Sir Rhys ap Thomas of his sworn fealty to
Richard III in order to win him over to the cause of Henry of Richmond, the success of
whose invasion depended upon the Welsh leader's support. In the early weeks of Henry
VII's reign, Morgan received the deanship of St. George's Chapel as a reward for his
services; in that capacity he controlled the site of Henry VI's tomb, which was the des-

that Henry VI was regarded as the patron and protector of the young, infirm, and retarded. Typical of his alleged intercession is the 1487 account of a "little girl, who was taken ill almost to death through swallowing a load of coarse wheat, [who] was set free and cured wonderfully through the invocation of the same blessed man." In 1490 a young man named John Wall, who was run over by a wagon and left for dead, was reportedly restored through invocation of Henry VI. Simonitta Pelton similarly recovered her vision after having lost it for ten years.[19]

Contemporaries blamed Henry VII for the failure of his petition for the canonization of Henry VI, claiming that the Tudor king balked at the high fees demanded by the Vatican. Although Francis Bacon rejects this view, it does accord with his unflattering picture of Henry VII as a "miser-king, happy only in his 'felicity of full coffers.' "[20] At the same time that Bacon gives credit to the pope for blocking the action in order to preserve the dignity of the church and its recognition of sainthood, he assumes that political expediency motivated the entire campaign to verify the sanctity of the Lancastrian king and, by extension, his Tudor heir.[21] Unlike St. Louis, whose canonization rested upon his blameless life and kingship, the case for canonizing Henry rested largely on his posthumous reputation; the evidence from his own life that was cited in his favor could as easily have been proof of feeble-mindedness or insanity.[22] In actual fact, the pope did grant Henry VII's petition for canonization, but the king died before it took effect. The presence of Thomas Cranmer's signature, "Thomas Cantuarien[sis]," on Bishop Morgan's list of Henry VI's alleged miracles suggests that official interest in canonizing Henry VI remained alive at least until 1533. Henry

tination of pilgrims seeking the miraculous intervention of the saintly king. Morgan was eventually elevated to the bishopric of St. David's. See "John Morgan or Yong," *DNB*; and Chrimes, pp. 39–43.

[19] Knox and Leslie, *Miracles of Henry VI*, pp. 39, 65, and 73.

[20] Kipling, *Triumph of Honour*, p. 10.

[21] Bacon states in his *History of the Reign of King Henry the Seventh*: "About this time the king was desirous to bring into the house of Lancaster celestial honour; and became suitor to Pope Julius to canonise King Henry the Sixth for a saint; the rather in respect of that his famous prediction of the King's own assumption to the crown. Julius referred the matter (as the manner is) to certain cardinals to take the verification of his holy acts and miracles: but it died under the reference. The general opinion was, that Pope Julius was too dear, and that the King would not come to his rates. But it is more probable, that the Pope, who was extremely zealous of the dignity of the see of Rome and the acts thereof, knowing that King Henry Sixth was reputed in the world abroad but for a simple man, was afraid it would but diminish the estimation of that kind of honour, if there were not a distance kept between innocents and saints." Quoted from *Works*, ed. James Spedding et al., 14 vols. (1857–74), 6: 233–34.

[22] Wolffe, *Henry VI*, pp. 6–7.

VIII renewed the petition, but the process was stopped by the Reformation, when the effort fell into oblivion.[23]

Henry VII's campaign to make Henry VI a saint evoked an enthusiastic response from aristocrats and courtiers close to both the late king and his Tudor "heir." Evidence that many aristocrats accepted Henry VI as a miracle-worker may be found in the prayers and invocations dedicated to him in manuscript psalters and books of hours that they used in their private devotions. A book of hours commissioned by George Talbot, Fourth Earl of Shrewsbury, exemplifies this movement through the addition of a prayer to "blessed King Henry" ("de beato rege Henrico"); it was inscribed approximately fifteen years after the Tudor succession. Like other suffrages addressed to the "saint," this poem commemorates his piety and aid to those in distress. The pleasantly metrical composition contains mid-line rhyme that is not found in classical Latin:

> Rex henricus sis amicus nobis in angustia.
> Cuius prece nos a nece salvemur perpetua.
> Lampas mor[um] spes [a]egror[um] ferens medicamina.
> Sis tuorum famulorum ductor ad celestia.
> Pax in terra non sit guerra orbis per continia.
> Virtus crescat & ternescat charitas per omnia.
> Non sudore vel dolore moriamur subito.
> Sed viuamus & plaudamus c[a]elis sine termino.[24]

As a loyal adherent of Henry VII, Talbot bore the curtana at Henry VII's coronation; the king created him knight of the Garter in 1488.

The effort to honor Henry VII as the protégé of his "saintly" predecessor had an impact far beyond courtly and aristocratic circles. When Henry VII went on progress in spring 1486 to the northern and western parts of England, York and other cities responded to his im-

[23] Beard, "Tomb and Achievements of King Henry VI," p. vi.

[24] "King Henry be a friend to us in distress, / By whose prayer we are saved from everlasting death, / Light of character, hope of the sick, bearing medication, / Be the leader of your servants to heaven. / Peace on earth, let there not be war through the boundaries of the globe, / Let virtue flourish and charity triple for everyone, / Let us die suddenly without exertion or sorrow / But let us live and praise heaven without end" (quoted from Bodl. MS Gough Liturg. 7, fol. 119). This manuscript was written in Flanders for importation into England. Similar commemorations and prayers were added to other devotional texts, including Bodl. MSS Gough Liturg. 19, fol. 32v; Jones 46, fol. 117^{r-v}; and Fitz. MS 55, fol. 141. The last-named manuscript is decorated with a miniature of Henry VI. Fitz. MS 38–1950 (the Bohun Psalter) contains an added leaf bearing a memoria for St. Henry beginning "Hec vir dispiciens mundum" ("This man despising the world"; fol. iv), which honors the king for his unworldliness and devotion to good works. See "George Talbot, Fourth Earl of Shrewsbury," *DNB*.

age-making campaign by staging pageantry that employed Henry VI as a saintly intercessor on their behalf. These civic performances were analogous to the prayers and invocations to the royal "saint" that were recorded in private devotional manuscripts. Because this region had first sided with Richard III during his ill-fated campaign and then supported the Yorkist rebellions that followed his defeat, Henry VI seemed like an appropriate mouthpiece for lodging appeals for royal clemency. Henry VII's express purpose in making this progress during the first year of his reign was to reinforce his authority in the areas of the country where it was weakest.

The city of York greeted the victorious king's entry with a tableau composed of his six predecessors with the name Henry, who consult and delegate Henry VI to pass the scepter of Wisdom and Justice to King Solomon. From a throne set up at the end of Ouse Bridge, Solomon as the patron of prudent statecraft and possessor of "eternall sapience" confirms Henry VII's wisdom, a traditional attribute of monarchs, by conferring upon him the "septour of sapience" and urging him to govern righteously in accordance with "politike providence." The figure of Solomon here symbolizes both regal wisdom and the political pragmatism that had led civic authorities to capitulate in the early months of the new regime. The city's choice of Henry VI as its intercessor was particularly flattering because it associated York and the other cities with a king who was absorbed into Tudor iconography as a figure for the new monarch's legitimate direct descent from the house of Lancaster.[25] York claimed, in effect, to acknowledge the new dynasty as a continuation of the Lancastrian house.

Worcester responded to Henry VII's image-making campaign with preparations for a tableau similar to the York pageant. Although the king never witnessed the projected performance, civic authorities commissioned the composition of unpretentious verses for an actor playing Henry VI, whose greeting would have begged for mercy and acknowledged the legitimate Lancastrian descent of the new dynasty:

> Welcome Nevew, welcome my Cousyn dere,
> Next of my Blood descended by Alyaunce,
> Chosen by Grace of God bothe fer and ner,
> To be myn Heir in Englande and in Fraunce,
> Ireland, Wales, with al the Apertenaunce
> Of the hole Tytle which I sumtyme had,
> All is thyn owne, wherefor I am right glad.[26]

[25] *REED: York*, ed. Alexandra F. Johnston and Margaret Rogerson, 2 vols. (Toronto, 1979), 1: 141; see Anglo, *Spectacle*, pp. 25–26.
[26] Leland, *Collectanea*, 4: 192. Robert Withington notes that Henry VI appeared as a

Even though civic pageantry was prepared by local rather than royal authority, the iconography of this tableau, like that of the tableau at York, closely approximated political commonplaces that emanated from the royal court at Westminster. The dramatization of Henry VI's recognition of Henry Tudor as heir to his dominions was flattering in the extreme to the new regime. Because Worcester had been a hotbed of support for the recent insurrection of the Stafford brothers, Humphrey and Thomas (Anglo, *Spectacle*, p. 29; Chrimes, pp. 69, 71), this pageant would have functioned as a dramatized apology and request for royal forgiveness. The Christian themes of supplication and mercy were well suited to the actor playing Henry VI, who introduced other British types for piety and forgiveness: Sts. Oswald and Wulfstan. Similarly, the Blessed Virgin prayed on behalf of Henry VII and counseled clemency.

Although the canonization campaign bore no fruit, Henry VII's veneration of Henry VI resulted in the planning or completion of chapels honoring the Lancastrian monarch, and himself as that king's "heir." These construction projects constituted a major pietistic activity of members of the royal family, including the king, his mother, and, eventually, his own heir. In addition to his abortive plans for a chapel at Windsor to the memory of the late king, Henry VII initially thought of the Lady Chapel in the Perpendicular Style, which he added to Westminster Abbey, as a shrine to his saintly predecessor; that intention did not detract from the primary purpose of the Westminster chapel as a memorial to Henry VII and the dynasty he founded.

Because King Henry died before his predecessor's remains could be translated from Windsor to Westminster, King's College Chapel at Cambridge survives as the major architectural monument to the alleged line of inheritance from Henry VI to Henry VII. In 1446, Henry VI laid the cornerstone for the chapel at the college he had founded. Work interrupted by his death was renewed by grants from Edward IV and Richard III, but the original design remained unfinished until Henry VII decided to support the project following a visit to Cambridge on St. George's Day in 1506. His mother, Lady Margaret Beaufort, took a personal interest in completing the project. Construction began anew in 1508, and the splendid vaulting for which the chapel is renowned was completed during the final period of building that lasted

conventional model for sacred kingship as late as the pageantry designed for the 1522 entry of Charles V into London, in *English Pageantry: An Historical Outline*, 2 vols. (Cambridge, Mass., 1918), 1: 178. At a pageant at the Little Conduit in Cheapside representing the sun, moon, and stars, with angels and the twelve apostles, the Lancastrian martyr joined St. George, the English saint-kings, Edmund and Edward the Confessor, and other saints.

3. *Arms of Henry VII*, antechapel, King's College
Chapel, Cambridge, c. 1508–15

until 1515. Though the structure remained unfinished at the time of his own death, Henry VII underwrote the greater part of the surviving building, both through grants made during his lifetime and through benefactions in his will. Although one of his bequests made provision for stained glass windows, glazing work was accomplished wholly at the expense of Henry VIII. In all likelihood, Henry VII decided to support the project in anticipation of his own death and in expectation of the eventual success of his attempts to have Henry VI canonized.[27]

The ostentatious ornamentation of King's College Chapel makes it clear that the structure as we now find it honors Henry VII and the dynasty he founded; praise of the Lancastrian king was subordinated to Tudor propagandistic purposes. Henry VII altered the chapel's original design by introducing grandiose carvings of his own arms, supporters, and badges: the Tudor rose, red dragon of Wales, greyhound of Richmond, and Beaufort portcullis (Fig. 3). A rose in the southwest corner of the interior depicts a woman rising from a cloud against a glory; this decoration combines a device symbolic of the Blessed Virgin with both a badge of Elizabeth of York and the Tudor rose. Such flourishes violated Henry VI's express purpose of producing a plain structure devoid of "entaille and besy moldyng." The new style of decoration overshadowed Henry VI's contribution as founder of King's College Chapel in its proclamation of the glory of the house of Tudor.[28] It may be that the replacement of the simpler design originally intended by Henry VI with the resplendent fan vault completed during Henry VIII's reign was intended to bring the chapel in line with the plan of Henry VII's Lady Chapel at Westminster. The fan vaults are the most striking architectural elements in both structures. If this is the case, even the fan vaulting at King's College Chapel may glorify Henry VII's "inheritance" of the kingdom from Henry VI in an iconographical assertion of the legitimate transition of power from the house of Lancaster to the Tudor dynasty. The date when the ceiling was designed cannot be determined exactly, but it seems likely that its general conception was in line with Henry VII's wishes.[29]

[27] The solitary surviving indications of Henry VI's role as founder are a full-length image that decorates the lectern in the choir and a portrait in stained glass in a side chapel; both items date from the provostship of Robert Hacomblem (1509–28). See Wolffe, *Henry VI*, fig. 23c; and Hilary Wayment, *The Windows of King's College Chapel Cambridge, Corpus Vitrearum Medii Aevi: Great Britain*, supplementary vol. 1 (1972), pp. 1–4, 121 and pl. 45.1. On the role of Margaret Beaufort as a pious benefactor of Cambridge University, see Malcolm G. Underwood, "The Lady Margaret and Her Cambridge Connections," *Sixteenth Century Journal* 13, no. 1 (1982): 67–81.

[28] J. W. Clark and M. R. James, *The Will of King Henry the Sixth* (Cambridge, 1896), p. 7, as quoted in Leedy, *Fan Vaulting*, p. 140.

[29] Leedy, *Fan Vaulting*, pp. 140–41, pls. 49 and 52; Wayment, *Windows*, pp. 1–4.

Henry VI has lacked the esteem of later historians and artists despite his personal reputation for piety and the propagandistic efforts of Henry VII. Subsequent Tudor generations discovered disastrous precedents in the reign of this impotent and ill-fated king, who came to the throne during infancy and ruled incompetently due to either his unworldliness or his feeble-mindedness. The glorified image of Henry VII as a pious king whom divine providence brought to the throne as the true heir of his devout predecessor endures, however, in Shakespeare's sweeping dramatization of fifteenth-century history in *1–3 Henry VI* (c. 1589–91) and *Richard III* (c. 1592–93). Although the playwright did not invent the myth that the advent of the house of Tudor represented a divinely sanctioned resolution to the discord of the Wars of the Roses, he does transmit a received image that reflects glory on the entire dynasty. Shakespeare's version of events hinges upon such staples of early Tudor propaganda as the respective portrayals of Henry VI as a saintly king, Richard of Gloucester as a demonic master of murder and intrigue, and Henry VII as a benevolent monarch elected by God. The playwright dramatizes these stereotypes through a series of highly charged encounters among the two Henries and Richard. Henry VI thus prepares the way for Tudor greatness when he prophesies during an unhistorical encounter at the Tower of London that the eventual succession to the throne of Henry, the youthful Earl of Richmond, will resolve England's suffering:

> Come hither, England's hope. If secret powers
> Suggest but truth to my divining thoughts,
> This pretty lad will prove our country's bliss.
> His looks are full of peaceful majesty,
> His head by nature fram'd to wear a crown,
> His hand to wield a sceptre, and himself
> Likely in time to bless a regal throne. (*3 Henry VI*, 4.6.68–74)

Shakespeare's transformation of Henry VI from a miracle-working saint into a prophet of nationalistic glory may reflect Protestant attitudes against the medieval cult of saints.

Shakespeare transmits to posterity Thomas More's vision of Henry

For a technical account of the completion of King's College Chapel that considers the building contracts, stone masonry, vaulting, and relations with other buildings, see Francis Woodman, *The Architectural History of King's College Chapel and Its Place in the Development of Late Gothic Architecture in England and France* (1986), pp. 153–97. H. M. Colvin notes that only the portion of the chapel erected by Henry VII involves the "elaborate heraldic display" reflecting Tudor taste in "The 'Court Style' in Medieval English Architecture," in *English Court Culture in the Later Middle Ages*, ed. V. J. Scattergood and J. W. Sherborne (New York, 1983), p. 134.

VI as one who was murdered even though he never "stopp'd" his ears to the demands of his people. The king exemplifies the gentle virtues of pity, mildness, and mercy. The emergence of Richard of Gloucester as a counterweight to Henry reaches its climax when the former stabs the saintly "prophet" after the latter curses him as "an indigested and deformed lump.... Teeth hadst thou in thy head when thou wast born, / To signify thou cam'st to bite the world" (*3 Henry VI*, 4.8.39–46, 5.6.37–56). This lurid image of Richard's deformity echoes his own acknowledgment that he is "an unlick'd bear-whelp" (3.2.161) and reflects his later vilification by Henry VI's widow, Margaret of Anjou, as a "poisonous bunch-back'd toad" (*Richard III*, 1.3.245). In one of the great confrontation scenes in *Richard III*, the Duke of Gloucester encounters Lady Anne over the corpse of Henry VI, whose wounds are said to "open their congeal'd mouths and bleed afresh" in testimony against his murderer (1.2.56). As the widow of Edward, Prince of Wales, Lady Anne praises her late father-in-law as "a holy king" (1.2.5) and "that dear saint" (4.1.69).

Richard's feigned reluctance to assume the throne and his prayerful pose between two bishops inverts Henry VI's stage presentation as a "godly" prince. As author of this stratagem, the Duke of Buckingham cynically interprets the scene as a tableau symbolic of devout government and "right Christian zeal":

> Two props of virtue for a Christian prince,
> To stay him from the fall of vanity;
> And see, a book of prayer in his hand—
> True ornaments to know a holy man. (3.7.96–99)

Henry VI had earlier been captured with prayer book in hand after the Yorkist triumph at Towton (*3 Henry VI*, 3.1.12). These prominent displays of devotional texts as dramatic props highlight the opposition of regal injustice and hypocrisy versus benign kingship that is altogether devoid of military strength and prowess. Henry VI's ghost appears on the eve of the Battle of Bosworth Field in another spectacular scene from *Richard III*. After damning Richard with the nightmarish refrain "Despair and die!" the spirit of late king reiterates his prophecy of the Tudor succession to the peacefully dreaming Earl of Richmond:

> Virtuous and holy, be thou conqueror!
> Harry, that prophesied thou shouldst be king,
> Doth comfort thee in thy sleep. Live and flourish! (5.3.126–30)

Shakespeare's mythic image of Richard exaggerates the alleged virtues of his successor Henry Tudor, who self-consciously lauds his own

foundation of a dynasty through healing the rift between the divided houses of York and Lancaster. This prayerful vision praises all of his descendants, not least of whom is the queen during whose reign Shakespeare established his writing career. At the close of *Richard III*, following a victory attributed to providential intervention, the new king announces:

> O now let Richmond and Elizabeth,
> The true succeeders of each royal house,
> By God's fair ordinance conjoin together!
> And let their heirs (God, if thy will be so)
> Enrich the time to come with smooth-fac'd peace,
> With smiling plenty, and fair prosperous days! (5.5.29–34)

Proclamations of this kind are a recurrent element in Tudor royal iconography, because every member of the dynasty laid claim to self-anointed status as a divinely chosen and inspired ruler. Despite the distortions and anachronisms of Shakespeare's politics, Henry VII's strident assertion of his own virtue and godliness is in keeping with claims that were actually made by him, his descendants, and their apologists.

 Henry VII's exploitation of the cult of sainthood and the proceedings for canonizing Henry VI represented one of the more striking aspects of early Tudor iconography. The Lancastrian king was, however, only one of many prototypes for regal piety. Other poses struck by the sovereign and members of the royal family often compared them to Old Testament rulers and saints. Tudor apologists and others wishing to cultivate royal favor exploited the ancient tradition of honoring the monarch as a contemporary manifestation of biblical types for royal wisdom, power, and magnificence, notably David and Solomon. Although those Old Testament kings had been viewed as regal prototypes for many centuries, they were adapted to the particular circumstances of Henry VII's reign. David, like Henry VII, had the task of drawing together a divided kingdom, whereas his son Solomon, who rebuilt the Temple in Jerusalem, offered a model for unparalleled regal wisdom and piety. These virtues were clearly identified with the divine order rather than the temporal world. As types for Christ and the kingdom he established, both David and Solomon offered biblical models for Henry VII's governance as an ideal Christian king. Praise of this kind brought the king's image in line with widespread European iconographical tradition. Other biblical worthies with whom Henry VII was compared were Noah, Abraham, and

Isaac; Jacob and Joseph typified the "triumphing exile" who succeeded by just inheritance. There is nothing distinctively Tudor about such praise, but it does indicate how conventional pietistic formulas were reinterpreted at this time to support Henry VII's claims to govern as Defender of the Faith and the legitimate heir of the Lancastrian kings.[30]

To envisage Henry VII as David was to liken England to a realm with a *double* approval, in contrast to kings preceding David who had merely a *secular* anointing. The Davidic theme was commonplace in celebrations of Henry's triumph over Richard III, where it enhanced the perception of the Yorkist king as an evil usurper. Those cities which had supported Richard III relied on Davidic iconography as they pleaded with his successor for mercy. At the civic pageants staged for the royal entry into York on 20 April 1486, the crowned figure of the Hebrew king paid homage to Henry VII by surrendering the "nakede Swerde in his Hand" to the new David, who had won victory through providential intervention. The scene dramatized the direct transmission of spiritual authority from ancient Israel to Tudor England. A tableau at York and an aborted pageant at Worcester treated David's victory over Goliath as a prefiguration of Henry's victory over the superior forces of Richard III. The mediatory function of these displays was made explicit when, at his entry into Hereford, the pageant figure of Ethelbert Rex interceded with Henry as a ruler who is "not rigorous, but mercifull, as David in his Juggement."[31]

Solomon was pressed into service as a royal patron and type for regal wisdom as early as the York pageant of the Six Henries (see p. 28 above). The Solomonic theme fitted Henry's reputation for calculated political shrewdness by presenting him as a king anointed by God and possessing preternatural wisdom of divine origin. *Solomon redivivus* and the "Second Solomon" gained currency as royalist epithets in works like *The Pastime of Pleasure* by Stephen Hawes, Henry VII's Groom of the Wardrobe, and George Cavendish's *Life and Death of Wolsey.*[32] Cavendish in particular chose the tag because it had special relevance to the reign of "that prudent prynce." A broadside elegy on the death of Henry VII praises "this most crysten kynge" as "the prudent Salomon" and "Salamon in wysdome."[33] Henry VII is revered as

[30] Anglo, *Spectacle*, pp. 30–31.

[31] Leland, *Collectanea*, 4: 190, 197; see also Anglo, *Spectacle*, pp. 31–32.

[32] John Wayland employs this commonplace in the preface to his 1554 edition of Stephen Hawes' allegory. See *The Pastime of Pleasure*, ed. William E. Mead, EETS, o.s., 173 (1928), p. xxxiii; and George Cavendish, *The Life and Death of Wolsey*, ed. Richard S. Sylvester, EETS, o.s., 243 (1959), pp. 10–11, and note.

[33] Published by Wynkyn de Worde in 1509. The Bodleian Library preserves this unique half-sheet folio (*STC* 13075).

"another Solomon, wise, rich, and peaceful" ("alter Salomon sapiens, dives, pacificus") in a prayer appended to a gospel manuscript commissioned by John Colet; the extension of this compliment to Henry VIII in the same prayer converts the Solomon allusion into a figure appropriate for praising a dynasty composed of God-fearing princes.[34] The survival of the royalist epithet of the second Solomon may be noted in works like the genealogy in which Thomas Gardiner praises Henry VIII for possessing "wisdome & Riches equall to kinge Salamon after he had openly in the felde obtained his Right."[35]

Although the Old Testament offered many acceptable models for ideal kingship, the New Testament held only one: Christ. The contrast of the humility of his birth and life with the prideful arrogance of Herod, Pilate, and Caesar makes him an exemplar for very special, almost "antiroyal" kingship. The 1486 pageant of the Assumption at York presented Christ as a universal overlord with whom the Virgin Mary, in her traditional capacity as a mediator, interceded on behalf of Henry VII. Christ's forgiveness furnished a mirror for the royal mercy and magnanimity sought from King Henry by citizens repentant for their recent support of Richard III. Mary is the type of the church, even of the priest, and of the human role in understanding the divine. Her special relationship to Henry VII here strongly suggests that he is an ideal Christian king.[36]

Henry VII and his eldest son Arthur, Prince of Wales, were likened respectively to God the Father and Christ the Son in civic pageantry staged in London to welcome the arrival in 1501 of Catherine of Aragon, who was to marry the Tudor heir. The spectacle had the immediate effect of approximating Tudor England to the kingdom of heaven. According to a contemporary report, Arthur received special recognition in the fourth pageant in the sequence. An image of the prince was set up on a throne in a place of honor on a massive revolving cosmological tableau that represented the "Sphere of the Sun"; this spectacle was conceived as a celestial locale revolving in the manner of a universal sphere. From ancient times the "hierarchy of the heavens, with the sun surrounded by the lesser stars," had been viewed as a symbol for "political hierarchy." Clad with the armor of Justice (2 Cor. 6:7), Prince Arthur appeared in the guise of *Sol Iustitiae* ("Sun of Justice") in a visual pun upon his capacity as Henry's son and heir. With its ancient regal associations, this sun pun identified the Tudor scion with

[34] From a double Latin text of Matthew and Mark in the Vulgate and Erasmian versions (C.U.L. MS Dd. 7. 3, fol. 295ᵛ).

[35] Bodl. MS Eng. hist. e. 193, Pt. 1, Membrane 2.

[36] *REED: York*, 1: 142–43.

Christ both as the Son of God and as the biblical Sun of Righteousness. This conceit found its origin in the messianic expectation of the "Sunne of righteousnes" (Vulg., "Sol justitiae") in the Day of the Lord prophecy of Malachi 4:2. Arthur's allegorical costume was linked to the Pauline Armor of God, which symbolizes the protection of the true Christian by the shield of Faith, the helmet of Salvation, and the sword of the Spirit (Eph. 6:13–17). The related typology of the Bridegroom and the Spouse from both the Old and the New Testament had been a familiar part of royal iconography as early as the civic pageantry welcoming Richard II into London in 1392.[37]

The fifth pageant in the 1501 London sequence praised the Tudor dynasty by likening the court of Henry VII to God's heavenly court in the New Jerusalem. With its portrayal of God the Father surrounded by angelic hierarchies and golden candlesticks, looking down with approval from the heavens above, the tableau implied that England was a new Israel governed by an ideal Christian king whom God had elected. This spectacle centered on the heavenly throne of God, who is surrounded by seven lamps "which are the seven spirits of God" (Rev. 4:5). The ostentatious decoration of the tableau with the Tudor arms and badges of the British lion, red dragon of Wales, and greyhound of Richmond indicated that this scene was designed as dynastic propaganda, but Henry VII's prominent presence as a spectator underscored the identification made between him and God the Father. He was presented as one who had received divine sanction and, in turn, governed over England as a godlike king. As the interpreter of the scene, Boethius explains the analogy between the worldly and celestial kingdoms:

> And right so as oure soveraign lord, the Kyng,
> May be resemblid to the Kyng Celestiall
> As well as any prince erthely now lyvyng,
> Sittyng amonge the vij candilstikkes roiall,
> As he whom hit hath pleasid God to accept and calle,
> Of all honour and dignite unto height,
> Moost Cristen kyng and moost stedfast in the feithe.[38]

[37] Anglo, *Spectacle*, pp. 78–83. Leedy comments on the assimilation of solar symbolism into the royalist iconography of Henry VII's chapel at Westminster, in *Fan Vaulting*, pp. 32–33. The solar pun is an ancient one, according to Ernst H. Kantorowicz, "Dante's 'Two Suns,'" in *Selected Studies* (Locust Valley, N.Y., 1965), pp. 330ff. On the 1392 pageantry, see Richard Maydiston, *Concordia Facta Inter Regem Riccardum II et Civitatem Londinie*, ed. with intro. and notes by Charles R. Smith, Ph.D. Diss., Princeton, 1972.

[38] Quoted from the forthcoming edition of *The Receyt of the Ladie Kateryne* (College of Arms MS I M. 13, ff. 27–67), ed. Gordon Kipling for EETS, ll. 2/571–77.

The conservatism of Henry VII's piety may be noted further in his orthodox devotion to relics and images of the saints, notably St. George. Veneration of St. George was a widespread European phenomenon, but he had a special place as patron of England, its monarchs, and the knights installed as members of its most exclusive institution, the Order of the Garter. The chapter met each year at St. George's Chapel, Windsor. Although the cult of St. George played a prominent role in royal iconography throughout the Tudor age, prior to the Reformation it followed the orthodox lines of traditional saints' observances. On 23 April 1505 (St. George's Day), for example, Henry VII joined in a formal procession at St. Paul's Cathedral that honored the display of the silver reliquary of the thigh bone of St. George.[39] The translation of Prince Arthur's remains from Ludlow Castle for interment at Worcester Cathedral began on St. George's Day, and the reredos of his chantry chapel at Worcester contains a niche decorated with the saint's image.[40]

In commissioning a striking votive image for use as an altarpiece at his favorite monastery at Sheen (Fig. 4), Henry VII exploited the cult of St. George as a means of validating the piety of the Tudor dynasty. The king and his heir apparent, Prince Arthur, are portrayed as participants in orthodox religious devotions. The scene is highly unrealistic, however, because the entire family is present, including Elizabeth of York, who had already died, and Princess Catherine, who died soon after birth. The scene should be viewed as a symbolic image, therefore, rather than as realistic portraiture. King Henry and Elizabeth kneel in prayer before prie-dieux bearing devotional books. The panel provides a record of personal devotion, because it embodies Henry's "visual prayer" to the royal family's patron saint. The variation of traditional iconography in this panel suggests that it may have been designed as a counterpart or even a reply to another painting in the possession of the king, Raphael's *St. George and the Dragon*, in which the Italian painter portrays the mounted saint looming over the impotent and defeated beast, which he has transfixed with his lance. Henry's altarpiece is a departure from this representation in its portrayal of the dragon as a fearsome figure poised in airborne assault above, rather than below, the knight. Although wounded, the beast attacks openly and boldly.

[39] Wilhelm Busch, *England under the Tudors*, trans. Alice M. Todd, 2 vols. (1895), 1: 310.
[40] *The Victoria History of the Counties of England: Worcestershire*, ed. J. W. Willis-Bund, H. Arthur Doubleday et al., 4 vols. (Westminster, 1901–24), 4: 401; see also Nikolaus Pevsner, *The Buildings of England: Worcestershire* (Harmondsworth, Middlesex, 1968), p. 311 and fig. 44.

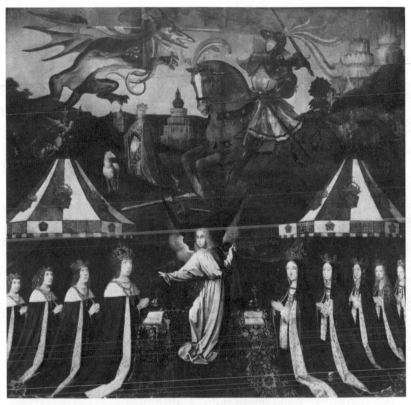

4. Maynard(?), *Henry VII and His Family with St. George and the Dragon*, 1503–9

Gordon Kipling interprets this unusual deviation from traditional iconography to be the result of an effort to associate Henry VII with the Burgundian theme of "facing adversity with equanimity." The saint embodies chivalric virtue and courtly magnificence in attacking his foe "calmly, confidently, without desperation." Through association with the saint, Henry VII provides an example of Christian heroism in his governance of England.[41]

The kneeling pose of Henry VII and Elizabeth of York in the St. George altarpiece furnishes a conventional image of medieval piety, one that repeats a standard scene in the fine transept window at Great Malvern Priory in Worcestershire (c. 1499–1500). The iconography of this panel is notable for its conventionality and the evidence that it

[41] Kipling, *Triumph of Honour*, pp. 62–65 and fig. 13.

provides of the responsiveness of highly placed patrons to Henry VII's strategy of presenting himself as an orthodox and pious prince. The probable donors, Sir Thomas Lovell and Sir Reginald Bray, who are portrayed in the place reserved for patrons, no doubt planned the window to honor the new dynasty. Bray's involvement in building works at St. George's Chapel, Windsor, and Henry VII's Chapel at Westminster may have familiarized him with the use of architectural ornamentation for dynastic praise. At the same time, the panel reflects glory on the donors themselves. Depicted at the bottom of this representation of the "Joys of Mary" is the crowned figure of Henry VII kneeling in prayer before a devotional manual open on a prie-dieu. An image of the Blessed Virgin Mary rises above the king. Prince Arthur appears in an identical pose near Queen Elizabeth. The legend invokes the prayers of onlookers for the welfare of the royal family: "Orate pro bono statu nobillissimi Et: excellentissimi regis Henrici septimi Et: Elisabethe regine ac domini Arturis: principis filii. . . ."[42]

Despite his reputation for miserliness, Henry VII patronized ecclesiastical structures and foundations on a grand scale as an act of devotion that was ever colored with an awareness of the usefulness of such benefactions for dynastic self-advertisement.[43] (King's College Chapel is a case in point.) The crowning architectural achievement of Henry's reign was the magnificent fan-vaulted Lady Chapel at Westminster Abbey that he had planned and erected to house the tombs of himself and his queen; his mother's tomb was to be located nearby in a side chapel. Piety and political pragmatism united in the king's plan to use the chapel to proclaim the legitimacy of the Tudor inheritance of the throne. Henry VII originally intended to arrange for the reinterment of the remains of Henry VI in the Lady Chapel, which would have had the effect of making the Tudor burial place a pilgrimage site renowned for the holiness of the "saintly" king entombed therein along with his pious successors. Various indentures indicate that Henry VII envisaged the structure as a "vast chantry chapel" endowed for the singing of perpetual masses for the sake of his soul and those of his queen and other members of the royal family.

Henry VII's will directed that the structure be emblazoned with Tudor heraldic devices, including "our armes, bagies [badges], cognoisants, and other convenient painteng, as in goodly and riche maner as

[42] "Pray for the good condition of the most noble and excellent King Henry VII, and for Queen Elizabeth, and for his son lord Prince Arthur." See Chrimes, pp. 335–37, figs. 12a and 14a.

[43] Chrimes notes, "That in fact he was a liberal spender of his gains is demonstrated beyond doubt not only by these products but also by the magnificence of his court and expenditure upon a great diversity of interests, pastimes, and causes" (pp. 305 and 333); see also Kipling, "Henry VII and the Origins of Tudor Patronage," pp. 117–18ff.

suche a work requireth, and as to a Kings werk apperteigneth," in an attempt to perpetuate praise of himself and his dynasty. In line with his wishes, the chapel was decorated with the ubiquitous Tudor heraldic ornaments: the Beaufort portcullis, union rose, greyhound of Richmond, and red dragon of Wales. (Related embellishments were added to King's College Chapel [Fig. 3].) Even the fan-vaulting of the Lady Chapel at Westminster, which was probably complete by the time of the king's death in 1509, contributed to the iconographical function of the chapel as a vehicle of dynastic self-praise, because it contains circles and sun-wheels that were elsewhere incorporated into Tudor royalist propaganda. The pageant displaying the image of Prince Arthur on the revolving Sphere of the Sun, which greeted Catherine of Aragon on her 1501 entry into London, provides an outstanding example of this kind of Tudor solar symbolism. Such imagery identified the Lady Chapel as "a celestial place" where, according to the king's will, saints images and statues of the prophets and apostles would flank the royal tombs in testimony "to the singular mediacions and praiers of all the holie companie of heven."[44] Henry VIII completed the chapel by commissioning Pietro Torrigiano to sculpt tomb effigies as a memorial to his parents and grandmother, all of whom are portrayed in pious poses with their hands folded in an attitude of prayer.[45]

The establishment of chantry chapels honoring the souls of the dead had become an important pietistic act by the late Middle Ages, because perpetual masses offered a means of gaining remission of purgatorial punishment.[46] A complicated set of four indentures (B.L. MS Harley 1498) accordingly delegates the monastic chapter at Westminster to administer funds for anniversary celebrations on behalf of the royal family at a total of twenty churches and abbeys throughout England. These documents, dated 16 July 1504, also describe in close detail the collects, obits, masses, prayers, sermons, ringing of bells, burning of candles, and distribution of alms to be conducted in perpetuity in the Tudor shrine at Westminster Abbey itself. The ostentatious decoration of this precious document indicates the importance assigned to it by the king. Its covers are of crimson velvet, with edges and tassels of gold and silk thread; the gilt silver bosses and clasps are made in the shape of the Beaufort portcullis or decorated with the royal arms and red rose of Lancaster. Five royal seals are suspended on tethers of silken thread

44 Thomas Astle, *The Will of King Henry VII* (1775), p. 4, as quoted, discussed, and illustrated in Leedy, *Fan Vaulting*, pp. 32–33, 214–15, and pl. 49.

45 Chrimes, pp. 305, 333–35, and pls. 3b and 16c.

46 Rosalind and Christopher Brooke note in *Popular Religion in the Middle Ages: Western Europe 1000–1300* (1984), p. 110, that the establishment of chantry chapels and endowment of masses to be sung in them by specially appointed clergy "helped to make large churches resemble vast mausolea."

and encased in gilt silver containers decorated with Tudor badges. Several elaborate historiated capitals portray Henry VII conferring the indenture on Abbot John Islip, who bears a crozier, and other members of the chapter of Westminster Abbey (fols. 1, 59, and 98). These initials preserve self-conscious and carefully stylized portrayals of Henry VII as a piously orthodox monarch (Fig. 5).

Three handsomely decorated indentures survive out of the twenty subsidiary documents that originally provided for anniversary masses, obits, and prayers for the royal family at Eastminster Abbey, St. Paul's Cathedral, and the Convent of St. Albans, London; all are dated 20 November 1504. The quadripartite indenture for St. Paul's, for example, directs that the celebration of requiem masses and prayers continue "for euer while the worlde shall endure" (Bodl. MS Barlow 28, fol. 1). The presence of identical brass bosses and clasps in the shape of the Beaufort portcullis on the purple velvet bindings of these indentures indicates that they are companion vehicles for dynastic praise. The first leaf of each document is similarly decorated with the royal arms and supporters, and with the Tudor badges of the portcullis and red rose tree. The waved edge and random lettering at the top of each manuscript *is* the indenture; each document is divided into four copies that must fit together in order to validate their authenticity.[47]

 Prior to his revolutionary break with the Roman church, Henry VIII followed his father's precedent of strict religious orthodoxy and acceptance of the titular supremacy of the pope in religious and ecclesiastical affairs. He did so at least partly to validate the legitimacy of the Tudor claim to govern England. In addition to the sword and cap of maintenance that his father had received before him, he was given the golden rose by the pope. However, the apparent fervency of Henry's beliefs exceeded the cool pragmatism and formal piety of his father, possibly in reaction to the opening of religious schism during his reign. At the same time, he and Cardinal Wolsey, his second Lord Chancellor, followed policies independent of Rome; they subordinated and manipulated the appearance of regal piety for the sake of political expediency.

As a younger son who was apparently destined for a career in the church—it was assumed that Prince Arthur would inherit the throne—Henry developed an interest in religion at an early age. Thus he was able to style himself as a theologian, arguably the chief lay theologian

[47] B.L. MS Harley 28, Bodl. MSS Barlow 28 and Rawlinson 370; see also C.U.L. MS Mm. 2. 24. Lambert Barnard's painting of Henry VII granting the see of Chichester to Robert Sherburne (c. 1508) is analogous to Fig. 5 as an image of collaboration between king and cleric. It is located in the south transept of Chichester Cathedral.

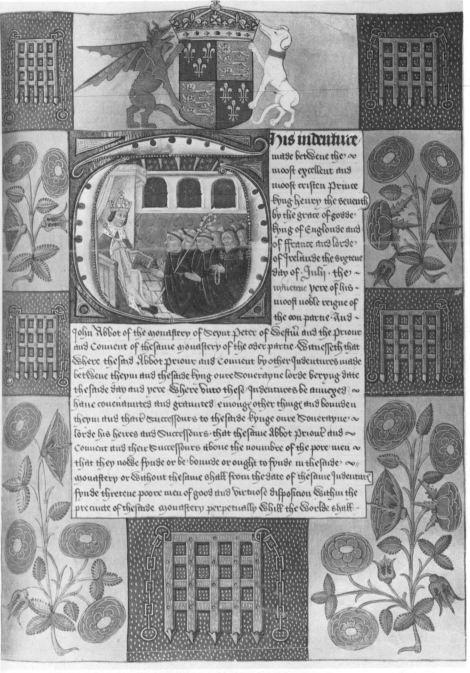

5. *Henry VII and Abbot John Islip*, quadripartite
indenture made by Henry VII, 16 July 1504

in the land, once he became king. This commitment led Henry to defend the traditional sacramental system in his *Assertio septem Sacramentorum* (published on 12 July 1521), a work produced in response to Luther's inflammatory *De captivitate Babylonica ecclesiae praeludium* (Strasbourg, 1520). Even though the king's theology there was routine and sometimes faulty, the book had a great impact as propaganda because its author was a powerful and distinguished European monarch. Few if any contemporary rulers proclaimed their religious beliefs with the fervency and stridency of King Henry.

Despite Thomas More's objection, the king carried religious orthodoxy to the point of arguing for the divine institution of papal supremacy. It is no accident, therefore, that his *Assertio* attracted recognition from the Vatican for the king's piety. The elaborate presentation manuscript for Pope Leo X, to whom the work is dedicated, was written on vellum and bound in cloth of gold (Biblioteca Apostolica Vaticana, MS Vat. Lat. 3731). Elaborately decorated with the royal arms and the Tudor badges of the red and white roses, the incipit bears a holograph inscription in which Henry claims that the document is a "witness of faith and friendship" ("fidei testis et amiciti[a]e"). Soon afterward, Leo conferred on Henry the long-coveted title of Defender of the Faith (*Fidei Defensor*), an award that acknowledged his equality with his father, who had earlier received the same honor from the pope. With this act, Henry VIII finally achieved recognition as a peer to the rival rulers of France and Spain, who had already received the papal titles of "Most Christian King" and "Most Catholic King."[48] Although his quest for papal recognition was orthodox in the extreme, Henry pursued his claims with unusual vigor in order to attain personal and dynastic legitimacy.

Although Henry VIII wrote his *Assertio* as both a pious work and an act of piety, it was Cardinal Wolsey who instigated the project and arranged for its appearance. A contemporary miniature flatteringly records the cardinal's involvement in this episode (Fig. 6); the lost document from which it originates might have been designed under the

[48] Trapp & Herbrüggen, nos. 116–17; see also Scarisbrick, pp. 110–17. and Erwin Doernberg, *Henry VIII and Luther: An Account of Their Personal Relations* (Stanford, 1961), pp. 14–26. Despite scepticism about Henry VIII's authorship of the *Assertio*, which was voiced from the time of publication, the king claimed responsibility for the text. In the published version of a royal attack against Luther, *A Copy of the letters, wherin kyng Henry the eyght made answere unto a certayne letter of Martyn Luther* (2nd ed.; 1528), Henry claims that "although ye fayne your selfe to thynke my boke nat myne owne . . . yet it is well knowen for myn" (B4ʳ). Glyn Redworth demonstrates Henry's active involvement in revising and correcting another major document of his reign in "A Study in the Formulation of Policy: The Genesis and Evolution of the Act of Six Articles," *Journal of Ecclesiastical History* 37 (1986): 65–66.

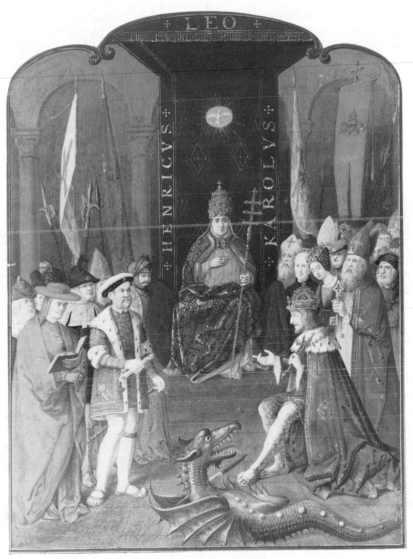

6. *Henry VIII Disputing with Charles V before Pope Leo X*, c. 11 October 1521

auspices of Wolsey or someone close to him.[49] The scene presents Henry as an orthodox ruler submissive to the church in spiritual affairs by placing him under Wolsey's tutelage and subordinating him to Leo X (d. 1 December 1521). The enthroned figure of the pope dominates the heads of state who dispute before him. Regardless of who commissioned this work, the scene clearly predates the iconographical reversal brought about by the Reformation; after the break with Rome, this image would undergo inversion when Henry VIII and the Protestant Tudors insisted on the supremacy of the regal Crown over the papal Tiara (see Chapter 3). The tableau represents the defeat of the rival ruler, Emperor Charles V, by Henry, who plays the role of England's patron, St. George, as the victor over the dying dragon in the foreground. If the scroll in Henry's hand represents the papal bull of 11 October 1521 granting the title of *Fidei Defensor*, the scene depicts the monarch's attainment of superiority over the emperor, who is no more than "Protector of the Holy See." Wolsey's role as Henry's supporter may allude to their collaboration on the *Assertio*, because the book in Wolsey's hand most likely represents that text.

The precise nature of the balance between papal and temporal authority remained a matter of intense concern, as it had for centuries. The miniature portrait of Leo X as adjudicator of disputes between worldly rulers is analogous to civic pageantry for the 6 June 1522 entry into London of Emperor Charles V and Henry VIII, which idealized their achievement as kindred rulers who governed in accordance with Christian principles. Charles visited England to confirm his recently forged alliance with Henry against Francis I of France. Pageants displaying their common lineage from John of Gaunt and Alphonsus, King of Spain, celebrated their "brotherhood" at Leaden Hall and at the Standard in Cheapside. (Genealogical tableaux of this kind were conventional in pageantry celebrating coronations and royal weddings.)

William Lily composed nationalistic verses praising Henry VIII as Defender of the Faith to accompany these spectacles. As High Master of St. Paul's School, he collaborated with the Lord Mayor and aldermen in welcoming these rulers; schoolboys under his charge recited his verses. Lily's pageant proclaimed Henry's equality with Charles as a temporal governor. A placard set at the Southwark gate to London Bridge greeted the rulers as "defenders, that is to say Henry defender

[49] B.L. MS Add. 35,254, fol. S; c. 11 October 1521. The provenance of this leaf is assigned to an Italian manuscript formerly in the possession of John Malcolm of Poltalloch in *The Catalogue of Additions to the Manuscripts in the British Museum in the Years 1894–1899* (1901), pp. 223–24. See also Anglo, *Spectacle*, p. 173; and Scarisbrick, p. 113.

off th[e] feyth, Charlys defender of the churche." Legends placed at every pageant and at the Cross in Cheapside proudly counterbalanced Charles's title of *Defensor Ecclesiae* with Henry's designation as *Defensor Fidei*: "Carolus Henricus uiuant. Defensor uterque. / Henricus Fidei. Carolus Ecclesiae" ("Long live Charles and Henry. Each one a Defender. Henry of the Faith. Charles of the Church").[50] Another placard bore this compliment:

> God save noble Charles / and pu[is]sant kynge Henry
> And gyue to them bothe: good helth / lyfe / and long
> The one of holy church / defender right mighty
> The other of the faithe / as champions moost strong.

A pageant at Gracechurch Street in London greeted Henry, in particular, as a pious ruler by praising his "highe doctryne / wysdome / faythe / and relygion."

Lily's scenario gave Charlemagne a prominent role as a prototype for Christian kingship. At the Conduit in Gracechurch Street, an actor costumed as the founder of the Holy Roman Empire was attended by Roland and Oliver, traditional types for courage and wisdom, as he offered an imperial crown and a sword symbolic of temporal power to both Charles and Henry. Most obviously, Charlemagne was dramatized as the transmitter of temporal authority to pay a compliment to Charles V as his namesake and successor as Holy Roman Emperor. Thus the pageant account notes: "Also ther stode a chylde in a goodly apparell salutyng the emp[e]rowr and shewyng thatt he was descendyd off the seyde Charlemagne." The figure of the Frankish ruler offers a source for the legitimation of secular authority. The medieval alliance between church and state originated when Pope Leo III crowned Charlemagne as Holy Roman Emperor on Christmas Day in 800. The papal claim to primacy over both the ecclesiastical hierarchy and secular governments was inherent in that coronation. Charlemagne was, nevertheless, a powerful leader who exercised great authority over the church. Leo's action in crowning the ruler was motivated by his need to cultivate a strong protector of the Roman church's interests against the Byzantine emperors. Charlemagne's coronation at Rome cemented an alliance between the Frankish king and the church in which the former was the arbiter of military and political power.[51]

Lily dramatizes Charlemagne as the source of the authority of Christian kingship in an imperial line going back seven centuries. Thus the

[50] C. R. Baskervill, "William Lily's Verse for the Entry of Charles V into London," *Huntington Library Bulletin*, no. 9 (April 1936): 9–11.
[51] *The New Encyclopaedia Britannica*, 15th ed., 29 vols. (Chicago, London et al., 1986), 16: 284–85.

Holy Roman Emperor stands at "the ryght syde of the stage . . . setting the Pope in his see." Charlemagne appears again at the other end of the stage, where he is presented with "the crowne off thorne whiche he receyved with grete honour" from "the kynge of Constantinople and the patriarke off Jerusalem." Lily's tableau is difficult to interpret because he alters chronology and incorporates historical inaccuracies. Although kings never ruled over the Eastern Empire, the Fourth Crusade did supplant the Byzantine emperors and establish a Latin Empire of Constantinople (1204–61). It was St. Louis, not Charlemagne, who purchased the reputed Crown of Thorns from John of Brienne, emperor at Constantinople, during the period of the Crusades; Louis erected Saint Chapelle in order to house this and other sacred physical remains of Christ's passion that he had acquired. Lily's Charlemagne looks like a composite type who possesses some of St. Louis's attributes as the ideal Christian king of medieval Europe. By styling the founder of the Holy Roman Empire and his successors as ideal rulers deserving of a Christlike crown, Lily presents Charlemagne and, by extension, Charles V and Henry VIII, as governors in an "apostolic succession" from Christ. He pays special honor to Emperor Charles as "Protector of the Holy See."[52]

The public image of Cardinal Wolsey incorporated an adaption and elaboration of iconographical themes associated with Henry VIII. As Lord Chancellor of England, this worldly prelate emulated his master's role as a defender of religious orthodoxy, thus fusing religious and political functions that the king alone would assume during the English Reformation. Wolsey's adoption of the early Tudor iconography of Christian kingship may have influenced Henry's image-making strategy. By appropriating the existing iconography of sacred kingship, Wolsey may have compromised it with his fall, necessitating a new kind of regal image at the very time that Henry VIII broke England's relationship with the papacy. Until his downfall and loss of office, however, this lowborn man, whom enemies like John Skelton damned as "the butcher's cur," governed as the effective ruler of England and lived on a palatial scale at Hampton Court and York House, where his grand lifestyle outshone that of the monarch. Not until after the suppression of the Roman church would the scarlet hat and vestments of this "king-cardinal" become conventional stage symbols for hypocrisy, dissimulation, and the usurpation of political power.[53]

[52] Quoted from Withington's transcription from Corpus Christi College, Cambridge, MS 298, in *English Pageantry*, 1: 176–78.

[53] Shakespeare, *Henry VIII*, 2.2.19. Also note the handling of Private Wealth (alias

Wolsey gloried in the role of savior of the church when he entered into Amiens with Francis I on 4 August 1527. Long after the breakdown of the earlier accord with Charles V, the cardinal journeyed there to ratify a peace treaty with France. A pageant display representing Wolsey's completion of a temple depicted him in the regal role of a Solomonic architect of the true church. Another pageant portrayed the rescue of the Ship of St. Peter ("Navicula Petri") by sword-bearing figures for France and Britain, thus identifying Wolsey as the rescuer of Holy Church, whose predicament mirrored the political impotence of the papacy. By association with Peter's role as a "fisher of men," the ship served as a traditional symbol for the church and religious orthodoxy. In yet another pageant, an angel costumed in red to symbolize Wolsey took up a position as the supporter of two women personifying Holy Church and Peace, all of whom found shelter beneath the protection of God the Father. Clearly Wolsey assumed the regal posture of defender of the faith, in a manner reminiscent of the pageantry that celebrated Charles V's entry into London in 1522.[54]

The political and religious turmoil that attended the onset of the Reformation provided the conditions under which Wolsey assumed the kingly role of protector of the true church. A revels play staged at the royal palace at Greenwich on 10 November 1527, following Wolsey's return from abroad, paralleled the design of the earlier pageantry at Amiens. The topical drama at Greenwich Palace enacted the current state of religious discord in terms of conflict between Religion, Ecclesia, and Veritas, who were clad as three novices, on the one hand, and Heresy, False Interpretation, and Corruption of the Scriptures, on the other hand. Heretic Luther stood by as the patron of the false women, whereas a cardinal (evidently a figure for Wolsey) was the chief defender of religious orthodoxy. According to Sydney Anglo, the entire scenario articulated "lavish praise of Cardinal Wolsey as mediator and saviour of the Church." In conjunction with the King of France, Wolsey joined Henry VIII as a defender of the pope and Holy Church (then held captive by Emperor Charles V) against attacks from Luther. Although the harmonious masque danced in conclusion by Henry VIII and several attendants complimented him for facilitating the attainment of concord and peace, the king played a minor role in an international political program orchestrated and directed by Wolsey.[55]

Cardinal Pandulphus) in John Bale's *King Johan*, and of the revels characters cited below in Chapter 3, p. 173.

[54] Anglo, *Spectacle*, pp. 228–29; see also Norbrook, *Poetry*, p. 280.

[55] For discussion of these performances with extensive quotations from the original documents, see Anglo, *Spectacle*, pp. 232–34.

Although Wolsey's diplomatic failures and inability to obtain a divorce for Henry VIII from Catherine of Aragon led to the cardinal's disgrace and eventual downfall and contributed to the onset of the English Reformation, a shift in royal iconography did not follow immediately. Henry's remarriage to Anne Boleyn was an important part of the process that led to the complete rupture of relations with the papacy, but pageantry staged prior to her coronation (31 May 1533) continued in the late medieval mode of praising queens for their religious orthodoxy and for serving as conduits for spiritual advent and renewal. The absence of "allusions to the breach with Rome" (Anglo, *Spectacle*, p. 247) accords with the theological conservatism of the king.

The conventional religious themes of the pageantry devised by Nicholas Udall and John Leland for Anne's entry into London praised the queen-to-be for her role in perpetuating the Tudor dynasty. As it had for centuries, queenly iconography represented an extension of kingly praise. The scenario continued the late medieval tradition of praising queens consort as types of female saints and the Blessed Virgin Mary (see p. 196). In accordance with Henry VIII's determination to produce a legitimate male heir, Udall's pageant of "the progenie of Saint Anne" at Leaden Hall in Cornhill was filled with fertility imagery from the Bible that suggested that Anne, who was six months pregnant, would produce a prince. Verses spoken by four children styled the expected Tudor heir in the image of Christ, for Henry's queen-to-be was presented in the image of both St. Anne and the Virgin Mary. These parallels explicitly shaped Tudor royal iconography along the lines of the gospel conception of Christian kingship:

> ffor like as from this devout saint Anne,
> Issued this holy generacion,
> ffirst Christ, to redeme the so[u]ll of man,
> Then James thapostle, and theuangelist Jhon
>
>
>
> Wee the Citizens, by you, in shorte space,
> hope suche issue and descente to purchase,
> Whereby the same faith shalbee defended,
> And this Citie from all daung[er]s preserued.[56]

The spectacle traced the lineage of Christ from the Virgin Mary and her mother, St. Anne. According to Hall's *Union . . . of Lancaster and*

[56] "A copie of diuers and sundry verses as well in latin as in Englishe," B.L. MS Royal 18 A. LXIV, fol. 8ᵛ; a holograph draft by Leland and, perhaps, Udall (c. 1533).

York (1548), "the fruitfulnes of saint Anne and of her generacion" offered a precedent "that like fruite should come of" Anne Boleyn (3N4v).

Perhaps Udall and Leland meant to suggest that in bearing Henry a son, Queen Anne was destined to produce a pious ruler who would govern as an instrument of divine authority. It is an irony of history that the queen bore not the prophesied boy, but the daughter who would eventually attain the throne as Elizabeth I. Following the oration concerning St. Anne, a cloud opened to let down the white falcon of Anne Boleyn, which lighted on a mount covered with the red and white roses of the Tudors. An angel wearing a closed imperial crown then crowned the heraldic bird. This falcon and its scepter and roses represented the personal badge used by Anne as Marchioness of Pembroke, a device that recurred prominently among the decorations and banners for her entry into London.[57] Udall's verse sums up the meaning of the tableau by asserting that providential oversight governed the advent of Anne Boleyn as Henry VIII's queen:

> Wheron to rest,
> And build hir nest,
> God graunte hir moste of might,
> That England maye
> Reioyce alwaye,
> In thissame ffalcon whight.[58]

All of these tableaux symbolized spiritual advent and renewal through the agency of Anne Boleyn as a royal helpmeet who reflects the king's glory. At the end of the pageant sequence, an empty throne was designated for the new queen, beside which three attendant maidens bore silver tablets reading respectively: "Veni amica coronaberis"

[57] The manuscript of "Le pasteur euangelique," a panegyric addressed to Anne Boleyn c. 1533–36, is decorated with a falcon badge that now appears black because the white pigment has oxidized (B.L. MS Royal 16 E. XIII, fols. 1v and 231v). The existence of this presentation copy of the anonymous *Sermon du bon pasteur et du mauvais* suggests that Anne may have had connections to the French evangelical movement; whoever commissioned the manuscript added praise of Henry VIII as both a proponent of religious reform and as a type of Christ as the Good Shepherd. The work concludes with a prayer that Anne might bear the king a son and heir. See Maria Dowling, "Anne Boleyn and Reform," *Journal of Ecclesiastical History* 35 (1984): 43. In "The Meaning of the Corpus Christi Carol," *Medium Aevum* 29 (1960): 10–21, Richard L. Greene demonstrates that the carol's refrain, "The fawcon hath born my mak away," necessarily alludes to Anne Boleyn's displacement of Catherine of Aragon as England's queen. He argues that the poem as a whole was written out of sympathy for Henry VIII's first wife.

[58] B.L. MS Royal 18 a. LXIV, fol. 9v. Udall's association with religous heterodoxy was compatible with Anne's sympathy for evangelical reform and the free circulation of the vernacular Bible. See Dowling, "Anne Boleyn and Reform," pp. 30–46.

("Come my love thou shall be crowned"), "Domine dirige gressus meos" ("Lord direct my ways"), and "Confide in domino" ("Trust in the Lord"). The first tag conflated the iconography of the Coronation of the Virgin and the union of the Bridegroom and the Spouse, which were both interpreted as allegories concerning the honor paid by Christ to the Church. The messianic expectations of the text beneath the attendants' feet held out the promise of government by an ideal Christian king who would inherit the throne: "Regina [Anna] nou[um] Regis de sanguine natum, cum paries populus aurea s[a]ecla tuus" ("Quene Anne whan thou shalte beare a newe sone of the kynges bloude, there shalbe a golden world unto thy people").⁵⁹

The coronation took place on Whitsunday (Pentecost) 1533, a feast day that commemorates the descent of the Holy Spirit and foundation of the primitive church. The lowering of the white falcon provided a device symbolizing celestial inspiration, one akin to the conventional pattern of the Annunciation in which the Holy Spirit descends in the form of a dove. The visitation of the archangel Gabriel to the Blessed Virgin Mary had long been identified with queens in the iconography of royal entries and other celebrations. Despite the harsh reality of Queen Anne's eventual execution on grounds of adultery, her "saint-like" reputation was recalled eighty years later in Shakespeare's *Henry VIII* (c. 1612–13), where a gentleman lauds her coronation:

> At length her Grace rose, and with modest paces
> Came to the altar, where she kneel'd, and saint-like
> Cast her fair eyes to heaven, and pray'd devoutly;
> Then rose again and bow'd her to the people;
> When by the Archbishop of Canterbury
> She had all the royal makings of a queen. . . . (4.1.82–87)

Other testimony in Shakespeare's play follows the historical record, however, in acknowledging that Anne's reputation as a virtuous and pious queen was hardly unambiguous. Because of the controversial nature of this subject, Shakespeare had to wait until after the death of Queen Elizabeth to dramatize the story of her parents' marriage. By concluding the play unrealistically with Henry's joy at the christening of his "royal infant" (5.4.17), Shakespeare tactfully avoids the ensuing execution of Anne Boleyn and bastardization of her daughter.

A convincing argument may be made that Catherine of Aragon rather than Anne Boleyn is the true heroine of *Henry VIII*, because the

⁵⁹ "The Receyuyng, Conueyng and order of the Coronacion of the quene Anne Bullen," B.L. MS Add 6285, fol. 9–9ᵛ; and *The noble tryumphaunt coronacyon of quene Anne, wyfe unto the moost noble kynge Henry the .viii.* (1533; STC 656), A5ʳ.

dying moments of the Spanish consort are presented in the manner of the beatific vision of one who has been awarded a martyr's crown (4.2.81–92). This anachronistic act of dynastic rehabilitation conformed to the policies of James I, who attempted to narrow the yawning gulf opened by Henry VIII's breach with Rome.[60] Henry's own actions had shattered his father's orthodox identification of their regal role of "Defenders of the Faith" with support of the pope's spiritual supremacy as Christ's vicar on earth. That act of royal iconoclasm was not wholly destructive, however, because it led to a reformation of the regal image in accordance with the Protestant principle of *sola scriptura*, whereby the Bible alone provides a model for religious belief. Queenly iconography of the kind that Udall and Leland incorporated into the pageantry celebrating Anne's entry into London contributed, futhermore, to the eventual redefinition of the royal image when Mary and Elizabeth Tudor, who were borne respectively by Catherine and Anne, acceded to the throne as regnant queens. The government of Mary and Elizabeth as unprecedented exceptions to the rule of masculine supremacy and patriarchy created a new iconographical problem that led to an eclectic amalgamation of the traditional symbols of kings as defenders of Catholic orthodoxy or Protestant reform, as well as the images of powerless queens consort, biblical heroines, female saints, and the Blessed Virgin Mary.

[60] See Glynne Wickham, "The Dramatic Structure of Shakespeare's *King Henry the Eighth*: An Essay in Rehabilitation," *Proceedings of the British Academy* 70 (1984): 149–66.

2. The Sword and the Book

And take the helmet of salvation, and the sworde of the Spirit, which is the worde of God.—Ephesians 6:17

 Hans Holbein established the definitive portrayal of Tudor Protestant royalism when he fashioned the title-page border of the 1535 Coverdale Bible as a depiction of tacit royal consent to the publication of the scriptures in translation (Fig. 7). Restoration of the vernacular Bible as the source of spiritual understanding was a fundamental Protestant concern. Holbein's intricately carved compartments clearly present the Henrician Reformation as a return to the New Dispensation brought by Christ. Although the volume was not formally authorized, it was brought to completion under the patronage of Henry VIII's agent in religious affairs, Thomas Cromwell, and circulated with the assent of the crown.[1] Crowded with biblical images and inscriptions, this woodcut personifies the theocratic ideal of evangelical kingship in terms of the transition from Old Law to New. At the very top, the Tetragrammaton made up of the four Hebrew characters for the name of Yahweh symbolizes divine revelation. Flanking it at the right is the antitype of the resurrection of Christ who, as the Logos, brings release from original sin (Matt. 28). The fall of Adam and Eve (Gen. 2) appears on the opposite side as the Old Testament type or figure that foretokens the New Testament event of Christ's triumph over Death. The commanding figure of Henry VIII wields the Sword and the Book at the base of the title page as a worldly manifestation of divine revelation (see Fig. 8). His authority "descends" from the Old and New Testament models for sacred kingship depicted elsewhere on the page: Moses receiving the Ten Commandments, David with his lyre, and Christ preaching.

Holbein's image of Henry VIII bearing the Sword and the Book epitomizes the effort to reinterpret medieval iconography as part of the campaign to unify ecclesiastical and secular authority in the hands of

[1] Trapp and Herbrüggen note that "despite the implications of royal support embodied in its woodcut title-page and its dedication to the king, [the translation] was not authorized by Henry" (no. 144).

54

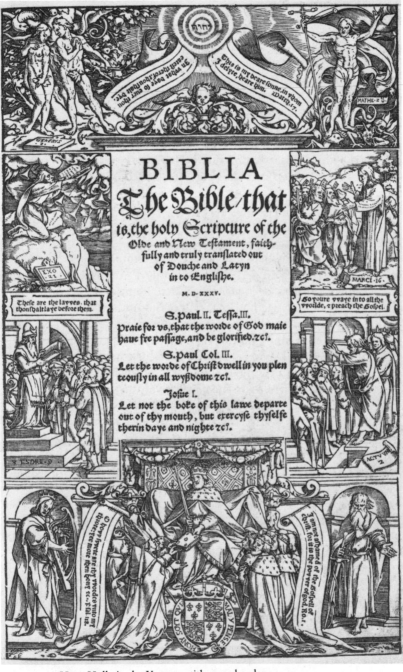

7. Hans Holbein the Younger, title-page border,
Coverdale Bible (1535)

the king. This composite biblical symbol not only played a vital role in an officially sponsored campaign to establish an image of the Tudor monarch as a theocratic ruler, but it recurred in the royal style of Edward VI and Elizabeth I, whose governments attempted to harness the expectations of those who wished for further Protestant reforms. The regal symbol of the Sword and the Book underwent many variations during the reigns of Henry's children: Edward's image was modeled closely on that of his father; Mary rejected Protestant iconography; and Elizabeth's imagery emphasized the priority of the Book over the Sword in an assertion that she dedicated herself to peace rather than war.[2]

Corollary to the formulation of the major image of the Sword and the Book are applications of biblical types for ideal government—Moses, David, Solomon, Josiah, and Deborah—who epitomize different attributes of a divinely sanctioned and scripturally modeled monarch. Moses and David appear prominently as monarchical types in the woodcut borders of Henrician Bibles. It must be acknowledged that to praise a king as another David or Solomon is not distinctively "reformist"; this device appears constantly in medieval christological imagery, where Solomon and David are particularly important regal prototypes because David is the progenitor of Christ's line, and Solomon joins Christ as a "son of David." All medieval kings governed as types of Christ, according to medieval royal theology.[3] Nevertheless, traditional scriptural typology adopts a reformist tone when apologists for the Protestant Tudors emphasize the direct relationship of ideal monarchs to God or Christ, regardless of whether they govern over ancient Israel or Reformation England. Literary and artistic works that emphasize the status of David and Solomon as direct instruments of divine providence offer a powerful iconographical argument in support of the Protestant monarchs' disestablishment of the Roman church, which allowed them to exercise authority over both church and state without the intercession of the pope or any other clerical intermediary.

In the text-centered Protestant kingdom, the Bible or symbolic Book often appeared as an autonomous symbol of royal authority. Real texts of the scriptures could even be employed as symbols of evangelical kingship when they contained pictures of monarchs or bore ornamental covers elaborately embroidered with biblical mottoes. Ernst Curtius charts the iconography of the Bible or Book, when used as a

[2] For other allusions to the motif of the Sword and the Book, see *ERL*, pp. 192–94.
[3] Kantorowicz, *King's Two Bodies*, pp. 42–86 passim.

pictorial device for truth and the revelation of the divine Word in the vernacular, as a ramification of the metaphoric tradition of "book-as-symbol."[4] He shows that books had been used for centuries in illustrated manuscripts and other art forms, either as representations of the Bible or its parts (e.g., the New Testament, the gospels, or individual books), or as metaphors for the Holy Scriptures. Although Christlike images of Charlemagne and his successors had emphasized the harmony of the Sword and the Book and the supremacy of the emperor over ecclesiastical authority (see Figs. 1–2), images of swords and books came into opposition during the later Middle Ages as symbols of the subordination of regal power to that of the church.[5] The Book played a relatively small role in late medieval royal iconography because it was a characteristic attribute of saints and clerics; it could even serve as an antiregal symbol prior to its adoption under Henry VIII.[6] Although Henry VII never laid claim to this symbolic image, it was readily available during his son's reign when royal apologists began constructing a new iconography suitable to the changed circumstances of the Reformation. Almost immediately after Henry VIII's break with the church of Rome, the Book attained a prominent position in Tudor iconography as a symbol for Reformation royalism.

The border of the Coverdale Bible addresses the hierarchy of spiritual versus secular functions, legitimation, and the nature of kingship. As a consequence of his separation from the Roman church, Henry VIII superseded the pope and the clerical establishment to become head of both church and state, and the sole intercessor between tem-

[4] Curtius, *European Literature and the Latin Middle Ages*, pp. 302–347.

[5] See p. 13 above. Among the relatively few medieval images that prepared for Henry VIII's union of the Sword and the Book were crowned figures of Solomon carrying a sword and a book or scroll that represented his reputation for wise judgment and authorship of canonical scriptures, including the Song of Songs and Proverbs. These symbols appear in an initial capital for 2 Chronicles and a miniature at the beginning of the Wisdom of Solomon in a thirteenth-century English Bible (Emmanuel College, Cambridge, MS I. 3. 15), and in a historiated capital D at the beginning of the same apocryphal text in a thirteenth-century French Bible (Bodl. MS Can. Bibl. Lat. 41, fol. 247ᵛ). Walter Cahn notes that "the conjunction of the book with the sword" that symbolized the "contrasting virtues of wisdom and power" was identified during the high Middle Ages with the "pairing of king and bishop." See "The Tympanum of the Portal of Saint-Anne at Notre Dame de Paris and the Iconography of the Division of the Powers in the Early Middle Ages," *Journal of the Warburg and Courtauld Institutes* 32 (1969): 63–66.

[6] Although a tentative movement to absorb the symbol into royalist iconography may be noted in an early Tudor woodcut portraying Henry VI bearing a scepter and a book, this image symbolizes Henry's "saintly" virtues of humility and piety rather than regal power. It appears in John Blakman, *Collectarium mansuetudinum et bonorum morum regis Henrici.vi.* (n.d.; *STC* 3123), title page and B4ᵛ. See Hodnett, no. 2017; and Wolffe, *Henry VI*, p. 6.

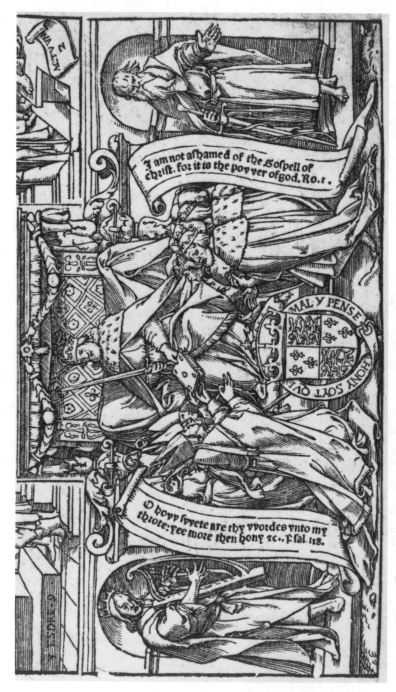

8. Hans Holbein the Younger, *Henry VIII with the Sword and the Book*, detail from title-page border, Coverdale Bible (Fig. 7)

poral society and the divine order. Cromwell, as the effective patron of the Bible translation, presumably intended the Holbein image to validate, by a universally available means, Henry's claim to govern as an English "pope." Miles Coverdale's preface comments on the symbolism of this scene as a call for obedience to royal authority as the final arbiter in spiritual affairs. He explains that the Bible

> declareth most abountdauntly that the office, auctorite and power geven of God unto kynges, is in earth above all other powers: let them call themselves Popes, Cardynalles, or what so ever they will, the worde of god declareth them (yee and commaundeth them under payne of dampnacion) to be obedient unto the temporall swerde: As in the olde Testament all the Prophetes, Pr[i]estes, and Levites were (✠2ᵛ).

The figures of David and Paul flanking Henry VIII represent sources of spiritual authority that are drawn from the scriptures rather than from church tradition. As major authors of the Old and New Testaments, David and Paul respectively symbolize divine revelation before and after the advent of the New Dispensation brought by Christ. They carry iconographical attributes that identified them in medieval art. The image of David and his lyre is usually placed at the beginning of the Psalms in manuscript books. During the Reformation, songs of divine praise attributed to David epitomized the Protestant recognition of the poetic texture of the scriptures,[7] but in the Coverdale Bible scene he serves primarily as a type for Henry VIII's claim to combine priestly with regal functions. David's image is particularly useful in portraying Henry as the intermediary between heaven and earth, because the Hebrew king was regarded by Christians as a prototype of the Messiah and thus a salvatory symbol of the link between God and humanity.

In accordance with Holbein's portrayal of king rather than pope as the apostolic successor to Christ, St. Paul's dominant presence denies Petrine supremacy. His chief attribute, a sword, was employed throughout the Middle Ages as a martyr's device commemorating the saint's decollation in Rome. From the time of Luther onward, however, Paul was revered as the paramount saint in Protestant tradition, not for his martyrdom, but for his authorship of New Testament epistles and promulgation of the crucial distinction between faith and works. Thus Paul's assertion "that a man is justified by faith without the workes of the Law" (Rom. 3:28) provided the basis for Luther's doctrine of justification by faith alone as the fundamental religious

[7] Lewalski, *Protestant Poetics*, pp. 39–41ff.

tenet. No longer a simple martyr's symbol, the sword in Paul's hands came to be identified during the Reformation as an evangelical symbol for the Bible or "the sworde of the Spirit, which is the worde of God" (Eph. 6:17).

Roy Strong rightly notes that Holbein's portrayal of Henry VIII initiated "the use of royal portraiture in England as propaganda in the modern sense of the word." Even though Strong asserts that the Coverdale title page is "overtly reformist," he stresses classical iconography by identifying this "definitive" portrayal of the Tudor monarch as a variant of the Renaissance device of the "Emperor bearing the book and sword" that allude to his power in peace and war. Strong's ground-breaking interpretation emphasizes the image of Julius Caesar in the impresa "Ex utroque Caesar" as a model for the scene; that woodcut portrays Caesar armed with the Sword and the Book and standing on a globe representing the world.[8] The proximity of sword-bearing Paul on the Coverdale Bible title page should compel us, however, to identify royal power with the evangelical "sword of the Spirit."

The Holbein border resolves the longstanding iconographical conflict between ecclesiastical and secular power by conferring upon Henry VIII the Davidic and Christlike majesty associated with emperors during the Middle Ages. Illustrations in Carolingian and Ottonian scriptural manuscripts anticipated Holbein's portrayal of the Reformation king not only in the subordination of ecclesiastical and secular estates to an all-powerful ruler, but also in their common return to the Bible as an artistic model (Figs. 1–2). The kneeling hierarchies of Henrician prelates and princes at the base of the Coverdale Bible border represent powers whose subordination to an omnicompetent king has replaced the one-time rivalry of church and state (Fig. 8). The woodcut inverts the conventional pattern of the dedication portrait, in which an author or translator kneels before a patron to present a copy of a work. The "upward" movement found in standard portraits (see Figs. 2, 21) is reversed in the Coverdale Bible to show Henry VIII, like a little god, handing the Bible down to the prelates and lords who kneel before him at the base of the scene. These recipients personify the clerical and magisterial estates who are delegated to disseminate the scriptures to the population at large.

The side compartments of Holbein's border portray royal permission for the Coverdale Bible as a recapitulation of pivotal biblical events (Fig. 7). Cromwell's role as patron of the volume suggests that

[8] Strong, *Holbein*, pp. 14–16, 44, pl. 9. Strong refers to a moralized tetrastich on "Immortal fama" that Gabriel Symeoni supplied for Paulo Giovio's *Le Sententiose Imprese* (Lyons, 1561), b1ᵛ.

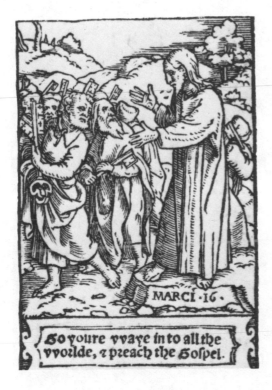

MARCI ·16·

Go youre vvaye in to all the
vvorlde, z preach the Gospel.

9. Hans Holbein the Younger,
*Christ's Delegation of the
Apostles*, detail from title-page
border, Coverdale Bible (Fig. 7)

he may have chosen the scenes to include in the artist's design as a compliment to King Henry. Moses' reception of the Ten Commandments on the left side furnishes a type for a divinely inspired leader capable of delivering God's chosen people out of bondage to the tyrannical Pharaoh, whom the reformers interpreted as a figure for the pope. Beneath this scene, Esdras preaches the Old Law. In the balanced New Testament scenes at the right, Christ first commissions the apostles with the words "Go youre waye into all the worlde, and preach the Gospel" (Mark 16:15). Christ's delegation of the apostles as his successors establishes a direct line of spiritual authority that descends to Henry VIII without any intervention from the ecclesiastical hierarchy (Fig. 9). With tongues of flame upon their heads, Peter and his companions then preach to the Jews after Pentecost (Acts 2:3). As the occasion of the birth of the Christian church, Pentecost supplies a type for the rebirth of the church during the Reformation.

The prominent quotation of Mark 16:15 suggests that the Coverdale Bible is connected to the courtly iconography of Henry VIII as a Reformation king. According to Strong, at about the time that Holbein

61

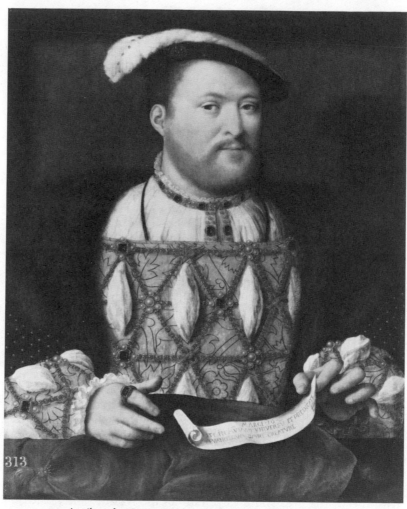

10. Attributed to Joos van Cleve, *Henry VIII as an Evangelical King*, c. 1535

designed the blocks for the title page, a portrait attributed to Joos van Cleve depicted the monarch holding a scroll bearing the Vulgate version of that scriptural text (Fig. 10). This courtly image is an iconoclastic work in the sense that it appropriates a Latin text that the church of Rome had used as a precedent for the papal claim of apostolic succession from Christ.[9] The painting presumably refers to Hen-

[9] Strong, *Portraits*, 1: 158; vol. 2, pl. 299. Strong argues that this portrait provides

ry's chosen role as a latter-day "apostle" engaged in the evangelical task of propagating the scriptures; in all likelihood it alludes directly to the publication of the Coverdale Bible. The private self-definition of the monarchical image is therefore reflected in Henry's woodcut portrait, which embodies his permission and control of Bible publication.

Holbein's woodcut amalgamates the portrait of Henry VIII and the scriptural images above it, with their accompanying texts, into a complex portrayal of the liberating power of the vernacular Bible. The evangelical images in the New Testament panels are compatible with the Reformation emphasis on gospel preaching, in contrast to the legalism of Old Testamental worship, which the reformers interpreted as a type for the formalistic religion of the late Middle Ages. The proliferation of keys in the inset portrait of Christ and the apostles at the right-hand side undermines the papal claim to primacy as the inheritor of the keys of St. Peter (Fig. 9). By appropriating a symbol that had been identified with the primacy of the church of Rome, Holbein suggests that the "keyes of the kingdome of heaven" (Matt. 16:19) function as a symbol for Reformation kingship rather than the papal power to loose and to bind.

The sword in King Henry's hand is an ancient symbol for royal authority and the administration of justice. Proximity to the sword borne by St. Paul identifies it, moreover, with the "sword of the spirit" portrayed at the lower right. The regal sword was reinterpreted as an evangelical device for the exercise of royal justice in line with scriptural precepts when Henry denied the pope's claim of divine authority to delegate temporal power to emperors and kings. Thus Archbishop Cranmer proclaimed that

> contrary to [the pope's] clayme, the emperial crowne and jurisdicion temporal of this realme is taken immediatly from God, to be used under him only, and is subjecte unto non[e], but to God alone. . . . As the pope taketh upon him to geve the temporall sworde, or royall and Imperiall power to kynges and princes, so dothe he likewise take upon hym to depose them from their Imperiall states, yf they be disobedient to him.[10]

Henry's symbolic armament is the sole offensive weapon cited among the shield of faith, helmet of salvation, and breastplate of righteousness that make up St. Paul's Armor of God in Ephesians 6:10–17.

evidence concerning the "immediate impact of the Reformation on the arts," in Strong, *Holbein*, p. 8. See also Trapp and Herbrüggen, no. 202.

[10] *The copy of certain lettres sent to the Quene . . . from prison in Oxeforde* (c. 1556), A3ᵛ, B2ᵛ.

In Reformation iconography, the complex symbol of the Sword and the Book played a special role in the displacement of St. Peter as the ultimate source of spiritual authority. For example, the composite image appears in a German woodcut that portrays Luther wearing armor and wielding a sword as St. John the Evangelist, who went into exile on the island of Patmos. Luther here adopts the role of Junker Jörg (Squire George), the identity that he assumed when he went underground in 1521.[11] Symbolic of the sharp-edged "worde of God" (Heb. 4:12) uttered by "true" preachers, the sword entered into Protestant pictorial tradition through the formulations of Albrecht Dürer and the more stridently Lutheran images of his disciple, Lucas Cranach the Elder. Whereas Dürer's Lutheranism is notoriously indefinite, Cranach worked at the avowedly reformist court of the Elector of Saxony.

The works of Holbein, Dürer, and Cranach incorporate a Protestant redefinition of the iconographical triad of the Sword, the Book, and the Key. Medieval practice may be noted in a fine miniature by the Fastolf Master, which pairs Peter and Paul in an allusion to the universality of the Christian message (Fig. 11). Key-bearing Peter clearly equals sword-bearing Paul in age and stature.[12] In this image, Peter is able to read the scriptures without assistance while Paul looks on with book in hand. The Lutheran reinterpretation of this symbolic triad may be noted in Dürer's *The Four Apostles* (1526). The scene reverses standard medieval images of the primacy of St. Peter or the equality of the two saints. Although the characterizations are subtle, even ambiguous—not the stuff of emblems—Dürer's diptych identifies Paul as the favorite saint of Protestant tradition (Fig. 12). The Sword and the Key had long served as symbols of the intrinsic authority of regal and papal power, respectively, but Dürer's presentation emphasizes the superiority of scriptural books over the Petrine key. The portrait reflects Reformation ideology by depicting St. Paul's primacy over St. Peter, who retreats into the background with the key borne by the popes as the reputed inheritors of Petrine authority.

The Dürer tableau represents not a rejection, but a redefinition of ecclesiastical tradition by reference to the Bible as the fundamental source of spiritual authority. Dürer revises iconographical formulas found in the Fastolf Hours and elsewhere by presenting Peter as an aged and phlegmatic figure who takes instruction from the book in John's hands. By sharing the foreground with John, the other New

[11] Heinrich Göding, "Dr. Martin Luther in Pathmo" (1598); etching in copper. For German woodcuts containing idealized images of Luther inspired by the dove of the Holy Spirit and carrying a book as a latter-day apostle, see Scribner, nos. 8–9, 11–12.

[12] Book of Hours (Sarum use), in French, c. 1450. Bodl. MS Auct. D. infra. 2. II, fol. 41ᵛ.

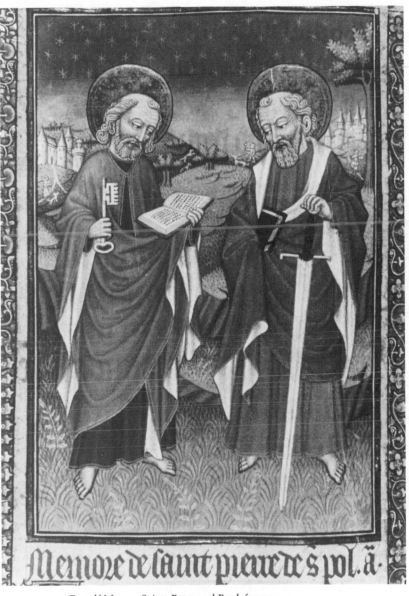

11. Fastolf Master, *Saints Peter and Paul*, from a
Book of Hours in a Norman hand, c. 1450

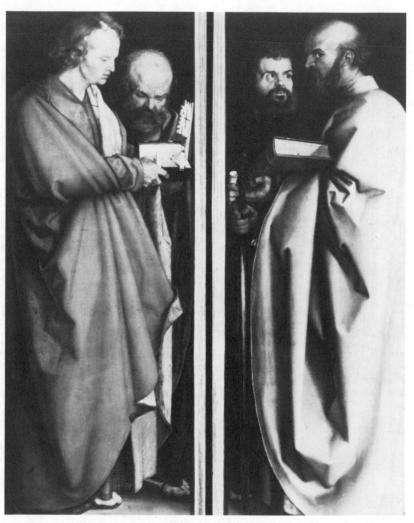

12. Albrecht Dürer, *The Four Apostles*, 1526

Testament author whose writings exerted profound influence on reformist thought, Paul dominates the painting. The scriptural books in their hands are the foremost iconographical elements in sight. Paul's stature confers upon him a quasi-evangelical status equivalent to that of John as the author of one of the four gospels. If the shadowy implement in Paul's right hand is a sword rather than a staff, its proximity to the Bible in his left hand suggests that the saint bears the "sword of the spirit" that symbolizes the divine Word. The sword would here stand for the truth disseminated by Paul's evangelical missions.

By combining evangelical iconography with the symbolism of the four humors or temperaments,[13] Dürer portrays both the militant and the pietistic sides of the Reformation. The melancholic temperament of bluish-robed Paul accords with the intellectuality of Protestant faith as he directs a stern gaze directly into the eyes of onlookers. Choleric Mark seems to guard his companion against attack from behind. John, the sanguine visionary, shares the foreground with Paul as he peaceably reads a book, evidently the New Testament. Although St. Peter's key lacks the authority of the scriptures venerated in the text-centered Protestant tradition, it does augment them. Even though Peter is the eldest member of this group, he must take instruction from the youngest. In Protestant iconography, age is often identified with both the Old Dispensation of the Mosaic Law and the Roman church. By contrast, youth represents the Reformation renewal of the New Dispensation brought by Christ.

Although royal apologists sometimes presented the Sword as an antithesis to the Keys of St. Peter, the Keys never disappeared from Protestant iconography. They were, in fact, appropriated as an evangelical adjunct to the Pauline "sword of the spirit." The reformers revised traditional iconography by treating the papal keys as a parody of "the keyes of the kingdome of heaven" (Matt. 16:19), which were granted by Christ to Peter (and by extension to all true pastors) as a sign of evangelical ministry. The "keye of the house of David" (Isa. 22:22; Rev. 3:7) provided an alternative biblical symbol for the spiritual authority of kings. On the title page of the Coverdale Bible, keys appear near sword-bearing Henry VIII in the image of Christ commissioning the apostles to evangelize the world (Fig. 9). The Geneva Bible glosses the correct use of the keys as a reference to the "preachers of the Gospel [who] open the gates of heaven with the worde of God, which is the right keye: so that where this worde is not purely taught, there is nether key, nor autoritie." According to this view both the Keys and the Sword function as evangelical symbols for the practice of "true" gospel preaching during the Reformation.

By associating Henry VIII or his Protestant successors with the recapture of the power of the keys from the papacy, English apologists praised the monarch as a priestlike leader and as a temporal intermediary between God and humanity. The application of the "keyes of the kingdome of heaven" as a royalist symbol constituted an adaptation

[13] Erwin Panofsky, *Albrecht Dürer*, 2 vols., rev. ed. (Princeton, 1945), 1: 234–35; vol. 2, no. 43, figs. 294–95. Panofsky notes that the inscriptions for these panels include scriptures from the writings of the four apostles that were applied as antipapal texts in Luther's "September Testament." An admonition that secular rulers ought to obey the divine Word was also included (1: 233–34).

Whose sinnes soeuer ye remptte/they are
r mi ted vnto them / ande whose synnes
soeuer ye retayne/they are retained.

13. *The Regeneration of the "True" Church*, from
Luther, *Sermon . . . [on] the True Use of the Keyes*
(1548)

of Lutheran iconography, where the image served as an attribute of the
Protestant clergy. Lucas Cranach the Elder chose, for example, to
praise the reformist ministry by portraying Luther's close associate,
Johann Bugenhagen, grasping a pair of keys.[14]

The title-page woodcut of an English translation of Luther's *Sermon
. . . [on] the true use of the keyes* (Ipswich, 1548; *STC* 16992) accord-
ingly applies the German motif of the recapture of the keys of St. Peter
to the time of Edward VI, when Protestant "mynysters of the Church"
employed the keys to mark the elect (Fig. 13). The text's epigraph,

[14] Oskar Thulin, *Cranach-Altäre der Reformation* (Berlin, 1955), figs. 6 and 23. In the
initial capital C of Foxe's *Actes and Monuments*, the pope holds broken keys as a sign
of his defeat by Queen Elizabeth as a reformist monarch (Fig. 50). On the use of the keys
in antipapal images, see Figs. 41–42, 44 and 47–49.

from John 20:23, associates the keys with the forgiveness of sins. The woodblock for this millennial scene had to be imported from the Low Countries because the short-lived book trade in Ipswich had too small an output to maintain an atelier of woodcutters; the city did serve, on the other hand, as an entrepôt for books printed on the Continent.[15] The translator's note that the papal keys symbolize idolatrous "tradicions ande not Cryst onelye" (A2ᵛ) validates the scriptures rather than church tradition as the highest spiritual authority. By praising Edward VI for permitting the free circulation of the vernacular Bible, the translator makes a distinctively English connection between the true use of the keys and the evangelical sword symbolic of Protestant royalism. Only the king's command can make it possible for God's

> holy woorde frelie to be geven unto all his lovinge subjectes, and Christ onelie truelie and syncerelye to be taught ande redde every where, the which is the very true keye, wherby to enter into the Kingdome of heaven, ande the nexte waye, to obteyne the mightie ande strange swearde, for ever to beate downe the devell and his derelie beloved antechriste. (A2ᵛ)

Because the portal in the woodcut symbolizes the entry from the temporal to the spiritual realm, the Roman clergy, saints, and martyrs who lack shelter from the shower of fire and brimstone are denied entry into the celestial kingdom. The scene operates on a horizontal plane; the reader "looks outward" from the inside as one of the saved, an angle of vision that must have reflected the assurance of salvation that Protestant readers sought through Bible study and intense self-examination.

When Edmund Spenser came to write the Reformation allegory in Book One of *The Faerie Queene* ("The Legend of Holiness"), he maintained the royalist bias of this Protestant reinterpretation of the keys by having Prince Arthur, the embodiment of regal magnificence, demonstrate the proper function of the unused and rusted "bonch of keyes" belonging to Ignaro (Ignorance). This gatekeeper's inability to open the doors of Orgoglio's castle (*FQ* 1.8.30–34) demonstrates the alleged failure of the Roman church to provide effective spiritual instruction; Ignaro lacks knowledge sufficient to unlock the "doors" of

[15] Anthony Scoloker, the printer and publisher, reprinted this woodcut from a Dutch block that had been used in Cornelis van der Heyden's *Corte instruccye ende onderwijs hoe een ieghelic mensche met God ende zynen even naesten schuldigh es ende behoord te leven* (Ghent: Joos Lambrecht, 1545). Scoloker also included the series of Dutch illustrations from which this cut comes in his translation of the van der Heyden text, *A bryefe summe of the whole Byble* (c. 1549; *STC* 3017), and his translation "out of Doutche" of *The ordenarye for all faythfull chrystians* (1548; *STC* 5199.7). On the relationship of Ipswich printing to the book trade in the Low Countries, see *ERL*, pp. 101–102.

understanding. Arthur's appropriation of the keys functions in the historical allegory as an allusion to the royal denial of the authority of the popes as the self-proclaimed heirs of St. Peter. The Reformation monarchy, it implies, provides adequate religious instruction through its policies of permitting the populace to read the Bible in vernacular translation and using the same version of the scriptures as the basis for public preaching and worship. Spenser's appropriation of the symbol of the papal keys is analogous to Dürer's reordering of Catholic iconography in *The Four Apostles*. Arthur's correct operation of the gatekeeper's keys therefore demonstrates a Protestant commitment to adapt old images rather than simply to destroy traditional religious imagery. The iconoclastic principle of use and abuse underlies Ignaro's failure, for it is not the keys but their disuse that is rejected. In a later episode, the reverend figure of Contemplation carries the same symbolic keys, which are conferred upon him by Fidelia; in a reflexive doubling of images, Fidelia personifies the scriptural faith and knowledge that are represented by the keys (1.10.50). Contemplation's blindness to this world counterbalances his spiritual "foresight" in a representation of "true" church tradition and the prophetic vision that is denied to Ignaro.[16]

In the iconography of its title page and its propagandistic impact, the Great Bible (1539) was the direct successor of the Coverdale Bible. The publication of the Great Bible under royal patronage as the first authorized English scriptural translation represented a revolutionary victory for Protestant ideology, one that had a direct effect on the transformation of the Book, symbolic of the scriptures, into a distinctive new device for Tudor Protestant royalism. The Great Bible's title page symbolizes complex relations among concepts of authorship, authority, and authorization, for it represents not only official sanction of the Bible translation, but also the royal control over church and state from which it stems (Fig. 14). Carved by a member of the school of Holbein, the illustration reflects the title page of the Coverdale Bible in its inversion of the conventional "movement" of the dedication portrait, in which a patron characteristically receives a presentation copy of a manuscript or book from its author, translator, or donor (see Figs. 2 and 21). Henry VIII's posture in the Great Bible woodcut therefore

[16] James Nohrnberg terms Ignaro "a 'blind guide' who has lost the meaning of the apostleship given to Peter (Matt. 23:13, 24; 16:19)," in *The Analogy of "The Faerie Queene"* (Princeton, 1976), p. 152. See also Michael O'Connell, who finds that this "image of senility" suggests "an icon of the papacy," in *Mirror and Veil: The Historical Dimension of Spenser's "Faerie Queene"* (Chapel Hill, 1977), p. 58. In the ensuing discussion, texts from the Geneva version are supplied in place of the Vulgate passages inscribed on the title-page border of the Great Bible.

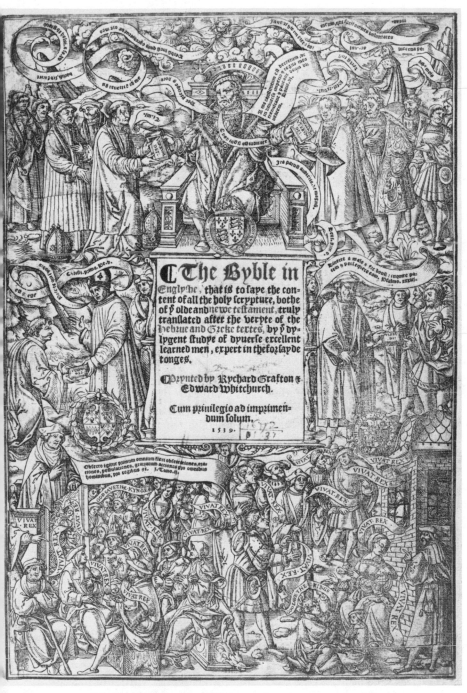

14. School of Holbein, *Henry VIII as a Reformation King*, Great Bible (1539)

combines that of both artist and patron as he assumes the quasi-authorial role of transmitting *Verbum Dei* to the flanking figures of Thomas Cromwell and Thomas Cranmer, who served respectively as the king's chief minister and as the Archbishop of Canterbury. As the king's vicegerent for religious affairs, Cromwell patronized publication of the Bible translation.

Holbein's original design for the Coverdale Bible (Fig. 7) was loosely adapted by his anonymous follower for the Great Bible title page, which symbolizes the royal supremacy over church and state by depicting a graded hierarchy in which the king replaces the pope as the temporal intermediary between heaven and earth. Henry's reception of the divine Word directly from God embodies the reformers' belief that the vertical process of reform is a royal prerogative, because the king alone can transmit the Bible to the bishops and magistrates in the second level. The rigid stratification of the scene parallels medieval images of the Emperor-in-Majesty (Figs. 1–2). The title page enacts a tense balance between freedom and control, because its orderly ranks reflect Henry's cautious retention of traditional doctrine and ritual during the early stages of the English Reformation. It ambivalently endorses the Protestant commitment to the priesthood of all believers in a realm where the monarch maintained tight control over religion. Accordingly, the women and men in the congregation hear the English Bible from the lectern rather than read it for themselves, because they are still passive recipients of scriptures that are transmitted by a priestly elite operating under political instructions from the crown. The ability of aristocrats to call out "Vivat Rex" distinguishes them from the tiny, almost childlike figures of commoners, who shout out "God Save the King."

The complicated typology of this woodcut border applies different scriptural guises of Henry VIII in a heavily layered and overlapping fashion. The most prominent visual allusion is to his instrumental role in the transmission of *Verbum Dei* ("the Word of God"), an apostolic image for the dissemination of the Bible in the post-Pentecostal world of the early church; it offered Protestants a figure for the renewal of the "true" church during the Reformation. The image of the sacred book, as it descends through various levels of the political and social hierarchy, objectifies the utterance emanating from God in the banderole at the top of the border: "So shal my worde be, that goeth out of my mouth: it shal not returne unto me voyde, but it shal accomplish that which I wil" (Isa. 55:11). In the New Testament, *Verbum Dei* refers specifically to the preaching of the divine Word and missionary activity of the apostles (Acts 8:14). Inspired by the Holy Spirit, St. Paul

15. School of Holbein, *Henry VIII as David*, detail from *Henry VIII as a Reformation King* (Fig. 14)

spread the "Word of God" among the Gentiles at Salamis, Thessalonica, and Ephesus (Acts 13:5, 17:13, 19:20). The tag-phrase *Verbum Dei* offers a visual analogue to the inset scenes in the Coverdale Bible showing Christ's delegation of the disciples and the inspiration of the apostles at Pentecost.

Key scriptural texts inscribed in sinuous banderoles present the iconographical program of the woodcut border. Although Henry VIII's preeminent role is that of David, he also voices King Darius's acknowledgment of the power of Yahweh and speaks to Cromwell in the voice of Moses and to Cranmer through words uttered by St. Paul. With the exception of Darius, all of these regal prototypes also appear in the border of the Coverdale Bible. The praying figure of the king in the upper right corner (Fig. 15) utters words attributed to David in celebrating the power of the divine Word as a guide for royal conduct: "Thy worde is a lanterne unto my fete" (Ps. 119:105; Vulg. Ps. 118:105). God reciprocates in his selection of Henry as David to govern over England as a new Israel: "I have founde David the sonne of Jesse, a man after mine owne heart, which wil do all things that I wil" (Acts 13:22). The largest banderole attributes to Henry's enthroned figure the response of Darius the Mede to the miraculous survival of Daniel in the lion's den, whereby he proclaimed: "I make a decre[e] that in all the dominion of my kingdome, men tremble and feare before the God of Daniel: for he is the living God" (Dan. 6:26). The Bible's

presentation of the unhistorical figure of Darius as the conqueror of Babylon may be interpreted as a prefiguration of the English king's rejection of the authority of papal Rome.

Henry VIII's balanced actions at the right and left sides of the border present him as a figure who unifies the roles of Moses, who imparts law to judges, and St. Paul, a clerical authority who offers counsel to an apostle on the conduct of Christian missions to the Gentiles. In the border's second register, Cranmer is empowered to "commande and teache" religious doctrine (1 Tim. 4:11), casting him in the role of a new Timothy who is entrusted with converting the English to an evangelical religious program. Cromwell in turn receives a Mosaic charge to "judge righteously" and to "heare the small aswel as the great" (Deut. 1:16–17). In the third register, these servants of the crown transmit *Verbum Dei* to figures representative of the clergy and magistracy, respectively. Cranmer instructs the cleric at the left by repeating St. Peter's injunction that pastors fulfil their obligation to "Fede the flocke of God" (1 Pet. 5:2); according to Protestant teaching, the Bible is the worldly source of spiritual "feeding." Cromwell outlines the responsibility of civil authorities by quoting from Psalm 34:14 (Vulg. Ps. 33:15): "Eschew evil and do good: seke peace and followe after it." At the base of the title page, a congregation representative of the English people hears a biblical text that was interpreted as a foundation of the political doctrine that subjects must obey royal authority: The cleric enjoins them to pray for "Kings, and for all that are in aut[h]oritie" (1 Tim. 2:1–2).

 The image-making strategies of the Coverdale Bible and the Great Bible exemplified the modification of Henrician style following the onset of the Reformation. Members of the royal court who had reformist sympathies could now flatter the king for delivering the English people as a new Moses or for establishing control over church and state as a new David. His apologists and those who sought royal patronage created courtly works of art and literature that contained flattering portrayals of the king that imitated his published images. In some cases, these compliments were doubtless designed to encourage the monarch to satisfy expectations for an evangelical government.

Medieval and Renaissance rulers had frequently been envisioned in the image of Moses, but Tudor iconography reinterpreted the Israelite leader as a personal figure for Henry VIII as the initiator of the English Reformation. The association of Henry VIII with Moses on the title pages of both Bibles suggests that his government is akin to Moses's

leading of the Israelites out of the land of Egypt. These borders may incorporate a modification of German iconography that presents the Reformation as an Exodus. The distinctively Protestant attack on the pope as a tyrannical Pharaoh appears in the writings of Martin Luther and in the antipapal art of Lucas Cranach the Elder that Luther inspired.[17] This may be noted in a 1524 broadsheet, *Luther Leads the Faithful from Egyptian Darkness*, in which the German reformer appears as Moses and the pope as Pharaoh.[18] Moses' combined role as leader of the Chosen People and recipient of the Ten Commandments furnishes a precedent for Henry VIII's reputed deliverance of England out of bondage to the papal Pharaoh and for his authorization of the vernacular Bible. The vignette in the Coverdale Bible that portrays Moses receiving the divine Word from its transcendent author identifies worldly sovereignty with an external and universal source of spiritual power, thus validating its temporal authority.[19]

In line with this view, Catherine Parr, the king's last wife, praises him as a new Moses in *The Lamentacion of a Sinner* (1547), a set of pietistic meditations drawn from the scriptures. Her complex figure compares the tyrannical pope to Pharaoh and the English nation to the Israelites fleeing from papal Egypt:

> But our Moyses, a moste godly, wise governer and kyng hath delivered us oute of the captivitie and bondage of Pharao. I mene by this Moyses Kyng Henry the eight, my most soverayne favourable lorde and husband. One (If Moyses had figured any mo[re] then Christ) through the excellent grace of god, mete to be an other expressed veritie of Moses conqueste over Pharao. And I mene by this Pharao the bishop of Rome, who hath bene and is a greater persecutor of all true christians, then ever was Pharao, of the children of Israel. (E1r-v)

Catherine Parr's compliment suggests that praise of Henry as a Mosaic king was fashionable at the royal court during the English Reformation, because her works first circulated in manuscript within royal circles before they appeared in print. That comparison to Moses continued to be current may be noted in Miles Coverdale's praise of Edward

[17] See the commentary on Genesis 41:37–38 and 47:22 in Luther's *Works*, ed. Jaroslav Pelikan et al., 55 vols. (St. Louis, 1958–76), 7: 162; 8: 125.

[18] Scribner, pp. 27–30, ill. 21.

[19] See Michel Foucault, *Power/Knowledge*, ed. Colin Gordon (New York, 1980), pp. 93–94. On the manipulation of traditional dedication images by royal apologists, see Elizabeth Hageman, "John Foxe's Henry VIII as *Justitia*," *Sixteenth Century Journal* 10, no. 1 (1979): 35–44. Additional information concerning the iconography of Figs. 7, 12, and 14 may be found in *ERL*, pp. 52–54, 189–92.

VI as a new Moses in his dedication to the "second tome" of Erasmus's *Paraphrases on the New Testament* (1549). Coverdale served his patroness, Catherine Parr, as a household chaplain prior to editing this volume of the *Paraphrases* under the patronage of Anne Seymour, Duchess of Somerset and aunt of King Edward.²⁰

A different inside view of the royal court during this period of religious crisis is provided by miniatures portraying the king as a new David in "Henry VIII's Psalter" (B.L. MS Royal 2 A. XVI), a Latin manuscript written for presentation to the king by Jean Mallard, who served as French orator in the royal household c. 1540–41.²¹ Although David had been regarded as a regal prototype throughout the Middle Ages in royal psalters and other works, Mallard adapted traditional iconography to suit contemporary circumstances. Both donor and recipient share the prevailing assumption of their time, that the Book of Psalms represents an autobiographical collection of sacred songs composed by King David. Mallard's portrayal of Henry VIII playing his lyre in the guise of King David (Fig. 16; fol. 63ᵛ) provides a close analogue to the vignette at the lower left of the Coverdale Bible title page (Fig. 8). Holbein's inclusion of David as an Old Testament type for Reformation kingship is likely to have derived from Henrician court circles, because Cromwell was the effective patron of that volume.

Mallard's miniature fuses type and antitype within a single monarchical image. (Holbein's woodcut border depicts David as a separate figure, on the other hand, albeit one that flanks the central figure of the Tudor king.) The specific image of David with his lyre is associated by convention with either Saul's madness or David's reputed authorship of the Psalms, and it appears in widespread images of the Tree of Jesse that artists derived from the messianic prophecy that "there shal come a rod forthe" from the stock of Jesse (Isa. 11:1; see Fig. 31). Mallard's portrait of Henry seated at a table while playing the lyre in a private chamber of a royal palace may also allude to the king's well-known reputation as a composer and musician. Although he is remembered for composing tunes for secular songs like "Pastime with good Company" and "Helas, Madam," his work also includes masses and a sacred motet (Scarisbrick, pp. 15–16). Like his son Edward VI, the king had a special fondness for hearing English versifications of the Psalms

²⁰ See my "Patronage and Piety: The Influence of Catherine Parr," in *Silent But for the Word: Tudor Women as Patrons, Translators, and Writers of Religious Works*, ed. Margaret P. Hannay (Kent, Ohio, 1985), p. 50.

²¹ This manuscript was presumably written prior to the opening of the Reformation Parliament in 1534, because a miniature for Psalm 82 (Vulg. Ps. 81) portrays God wearing a papal tiara, a symbolic headpiece that would have constituted an insult to the king following his break with Rome (fol. 98ᵛ). Henry might have inscribed his marginalia at any point after he received this gift.

16. *Henry VIII as David with Lyre,* from "Henry
VIII's Psalter," c. 1530–33

sung in his private apartments, and he rewarded Thomas Sternhold,
Groom of the Robes, for turning out ballad versions of the biblical
poems (*ERL*, pp. 178, 217–18, and 224). Scriptural metaphrases of
this kind were popular in Protestant circles. Portrayal of the royal fool,
Will Somer, at the left of the lyre-playing king is an appropriate illus-
tration for Psalm 53 (Vulg. Ps. 52; "The foole hathe said in his heart,
There is no God").

Henry appears both as David and as one of his lyric subjects in illus-
trations for two other Psalms, whose appeals for deliverance from ex-
ternal enemies and false accusers are altogether appropriate to the self-
image of the Reformation king and his court. The manuscript thus
identifies the English king as both the subject and the object of a col-
lection of lyrics that was traditionally taken to be an autobiographical
work by King David. Henry plays the learned and pious role of "the
man that doeth not walke in the counsel of the wicked" in the minia-
ture for Psalm 1, which portrays him reading a book in his bedcham-

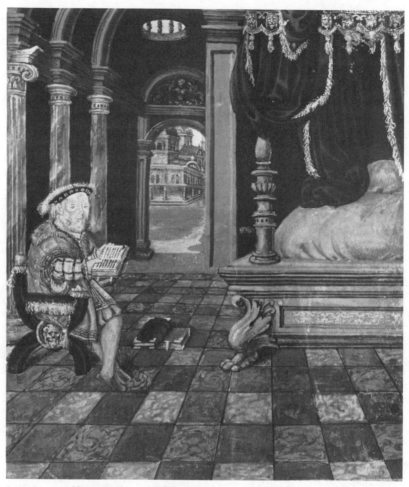

17. *Henry VIII as David Reading Books*, from
"Henry VIII's Psalter," c. 1530–33

ber, with two books on the floor beside him (Fig. 17; fol. 3). Henry has
withdrawn from the active world, shown beyond the portal of the el-
egantly furnished room, into introspective contemplation. A miniature
for Psalm 69 (Vulg. Ps. 68) portrays the king praying for deliverance
from enemies; with his crown at his feet in a setting of classical ruins,
he kneels beneath an angel who has a sword, a skull, and a rod (fol.
79). His plight recapitulates an outcry attributed to David: "They that
hate me without a cause, are mo[re] then the heeres of mine head: thei

that wolde destroye me, and are mine enemies falsely, are mightie, so that I restored that which I toke not" (Ps. 69:4). This verse took on a special resonance during the 1530s, when England experienced a sense of encirclement by foreign Catholic powers: the Hapsburg emperor, the French king, and the pope.

Henry received Mallard's psalter with approval, because he annotated the gift, kept it among his private books, and presumably accepted Mallard's view that the Psalms constitute a *speculum principis* concerning ideal kingship. In reading this collection of divine poems as a royal text, both men ignore David's flaws as an adulterer and his reputation during the Middle Ages and the Renaissance as a type for the repentant sinner in the Seven Penitential Psalms (Pss. 6, 32, 38, 51, 102, 130, and 143; Vulg. Pss. 6, 31, 37, 50, 101, 129, and 142). Henry clearly sees David as a model for regal strength rather than personal weakness. Annotations that appear throughout the text in the king's heavy swashing handwriting therefore designate particular Psalms as advice on government and religion. By noting "officiu[m] regi[s]" ("the king's office") beside Psalm 72:4 (Vulg. Ps. 71:4), Henry styles himself as an evangelical king in response to Mallard's view that the hymn was written "De regno christi et gentium vocatione" ("concerning the kingdom of Christ and the calling of the people"). The king indicates his concern with matters of faith by drawing attention to a passage "de idolatria" ("concerning idolatry") in Psalm 44:20 (Vulg. Ps. 43:20). Henry's note "de rege" ("concerning the king") accords with the donor's reading of Psalm 63:11 (Vulg. Ps. 62:11) as an utterance concerning regal piety. The note "de regib[us]" ("about kings") endorses Mallard's view that Psalm 21 (Vulg. Ps. 20) concerns the triumph of Christ through the agency of Christian kings. Henry VIII similarly read Psalm 20:9 (Vulg. Ps. 19:9) as "pro rege oratorio" ("a prayer for the king").

Jottings independent of Mallard's commentary provide even greater insight into Henry VIII's private interpretation of the Psalms by showing how he applied specific passages to his own conduct as king. Sometimes he merely bracketed verses or indicated passages of particular importance with the designations "n[ota] bene" or "bene n[ota]." Many notations indicate that Henry assumed the Davidic role of a righteous man who sings praise to the Lord for delivering him from the hands of his enemies. The 1530s context of the psalter suggests that these perceived threats may have come both from foreign enemies of Henry's policy of religious reform and from domestic opponents, whose hostility to the Cromwellian regime led to the outbreak of the 1536 Pilgrimage of Grace. Henry's annotations furnish a written ana-

logue to the miniature that portrays the king pleading for divine assistance against enemies (Ps. 69). Thus his "n[ota] bene" beside Psalms 11:6 and 41:11 (Vulg. Ps. 10:6 and 40:11) exults that God will uphold him and direct "fyer, and brimstone, and stormie tempest" against the wicked. His annotations on Psalms 18:20–24 and 62:12 (Vulg. Ps. 17:20–24 and 61:12) claim that God will reward him and punish his enemies. Exclamation marks alongside Psalm 34:7, 9 (Vulg. Ps. 33:7, 9) call attention to promises that those who fear the Lord will receive divine protection. Notes on passages in Psalm 37:28, 38, and 39 (Vulg. Ps. 36:28, 38, and 39) that refer to damnation and salvation comment on the meting out of divine penalties "de iniustis et impiis" ("concerning the unjust and impious") and rewards "de iustis" ("concerning the just").

In contrast to the private record of Henry VIII's envisagement of himself as David in his manuscript psalter, *The Exposition and declaration of the Psalme, Deus ultionum Dominus* (1539) by Henry Parker, eighth Baron Morley, embodies a courtly view of the king that was eventually published for popular consumption. The translator originally prepared his manuscript and dedicated it to the king in 1534, at the time of the Reformation Parliament. Its publication by the King's Printer, Thomas Berthelet, suggests that Henry VIII patronized its publication. The patriotic fervor of Parker's interpretation of Psalm 94 (Vulg. Ps. 93) as a Reformation hymn displays the unconditional royalism that enabled him to survive so many twists and changes in religious policy during the reigns of three Tudor monarchs. Parker's commentary may even allude to the portrayal of Henry VIII as David on the title page of the Great Bible, which was published in the same year as this text, when it praises Henry as a modern version of "the royall kyng David" (A7) or "the excellente kynge and prophete David" (B8); such praise is closely aligned with the contemporary campaign to revolutionize the church. By emphasizing the role of David not as the psalmist, but as the youthful victor over Goliath, Parker cries out against the violence and arrogance of tyrants and treats Psalm 94 as a prayer to God, the Lord of Vengeance, and as a prophecy of Henry VIII's liberation of England from the pope, the "gre[a]t Golyas [Goliath]" (A7r-v). The Davidic victory is a type not only for Henry VIII's defeat of the papacy, but also for the earlier successful defense of England by Henry VII against "the tyrant kynge Rycharde" (A5v). Parker additionally compliments the king as a second Moses leading Israel out of bondage to the papal Pharaoh (A5v), and the text as a whole is filled with commonplaces calling for vengeance "ageynst this serpent," the

pope, and the liberation of England from its "captivite Babylonical" (A3ᵛ, A5).

Solomon was second only to David as the most enduring biblical type for Tudor kingship, one that is rooted in the princely iconography of western Europe and Byzantium. The family relationship of the Hebrew kings could readily be adapted to support the legitimacy of Tudor dynastic descent by tracing out the lineage from Davidic father to Solomonic son. Like his father, Henry VIII was praised as a second Solomon[22] in a doubling-up of regal prototypes that produced comparisons to both the father and the son who were regarded as paramount among the rulers of ancient Israel. These comparisons were adapted to different purposes, however: David was remembered largely for authoring of the Psalms, slaying Goliath, establishing the united kingdom of Israel and Judah, and governing as the ideal king, who was viewed by Christians as a prototype of the Messiah; Solomon, on the other hand, consolidated his father's achievements. By tradition, Solomon was the greatest of the Hebrew kings, one whose stature as a sacred ruler was marked by the erection of the Temple in Jerusalem; for Christians the construction of the Temple was a prototype for the foundation of the "true" church during the early Christian period, or for its renewal during the Reformation. Solomon's reputation for unparalleled wisdom and prudence was associated with the period of Israel's greatest material wealth and well-being. It is important to remember that pre-existing iconography of this kind was applied to the particular claims of all the Tudors to govern as Christian monarchs, regardless of whether they embraced orthodox or reformist religious positions.

At about the same time that Holbein portrayed Davidic Henry as the transmitter of the scriptures and agent of the English Reformation in the title-page border of the Coverdale Bible, he composed a miniature portrait on vellum showing the king as Solomon receiving the gifts of the Queen of Sheba, who kneels at the head of her retinue (Fig. 18). The composition of this portrait in the same period as the break with Rome suggests an allusion to the Reformation. After all, the Queen of Sheba is a traditional type for the church, and her kneeling homage and submission to an omnicompetent monarch carry every suggestion that the miniature is designed to commemorate the recent submission of the Church of England to Henry as the head of the church. The opulent attire of the crowded courtiers and the rich offerings borne by the queen's attendants enhance the glory of the king. This scene func-

[22] See above, pp. 35–36.

18. Hans Holbein the Younger, *Solomon and the
Queen of Sheba*, c. 1535

tions as an epiphany of sacred majesty, in response to which the queen averts her head as a mark of homage. Because Holbein came to England under crown patronage as portraitist of the Henrician court, the miniature was presumably created, either directly or indirectly, under the king's auspices. The artist, who was known for his Lutheran sympathies, reinterprets the queen's visitation (1 Kings 10:1–13, 2 Chron. 9:1–13) according to the understanding of Solomon's wisdom as a type of divine revelation through scripture: "Muche more happie are they, which heare the wisdome of God reveiled in his worde" (Geneva Bible, gloss on 1 Kings 10:8).

Solomon's stance loosely resembles that of King Henry on the Coverdale Bible title page (Fig. 8). The full frontal view of the Hebrew king, who sits enthroned, wearing a crown and holding a scepter beneath an arch at the top of a high dais, dominates the scene, in which the Queen of Sheba meets him and exclaims: "Happie are thy men, and happie are these thy servants, which stande before thee all way, and heare thy wisdome. Blessed be thy Lord thy God, which loved thee, to set thee on his throne as King" (2 Chron. 9:7–8). Inscribed on the wall and canopy behind Solomon, the Latin version of the queen's salutation alludes to the Reformation Parliament's recent replacement of the pope with Henry as Supreme Head of the Church of England; this text suggests that both Henry and Solomon are responsible to God alone and to no other worldly power. The inscription on the base of the throne articulates the queen's response to their meeting: "VICISTI FAMAM VIRTVTIBVS TVIS" ("By your virtues you have won fame").[23]

Toward the end of Henry VIII's reign, it was fashionable for high-ranking ladies of the royal court to wear diminutive prayer books, with elegantly decorated covers, dangling at the ends of long ornamental chains. An elaborate Girdle Prayer Book made out of enameled gold demonstrates the vogue for biblical portraits associated with Henry's role as a Reformation king (Fig. 19). The incorporation of iconographical themes dear to the reformers contributes to the presumption that these golden covers were commissioned by or for a Protestant lady

[23] Michael Levey, *Painting at Court* (New York, 1971), p. 95 and fig. 77. The Latin text from 2 Chronicles 9:7–8 reads: "Beati viri tui et beati servi hi tui qui assistant coram te omni t[em]p[or]e et avdivnti sapientiam tuam. Sit dominus deus benedictvs, cui complacit in te, ut poneret te super thronvm, vt esses rex constitutvs domino deo tvo." See Queen's Gallery, Buckingham Palace, *Holbein and the Court of Henry VIII* (1978), no. 88. This exhibition catalogue overlooks the portrayal of Henry as Solomon in a stained-glass window at King's College Chapel (Fig. 20; see below, pp. 86–88) in claiming that this miniature is "the first known example of Solomon being given a contemporary likeness in such a representation." The woodcut of the "Royal Throne of Salomon" in the 1560 Geneva Bible (1 Kings 10) depicts the posture and elevation of the king in a manner that resembles Holbein's miniature.

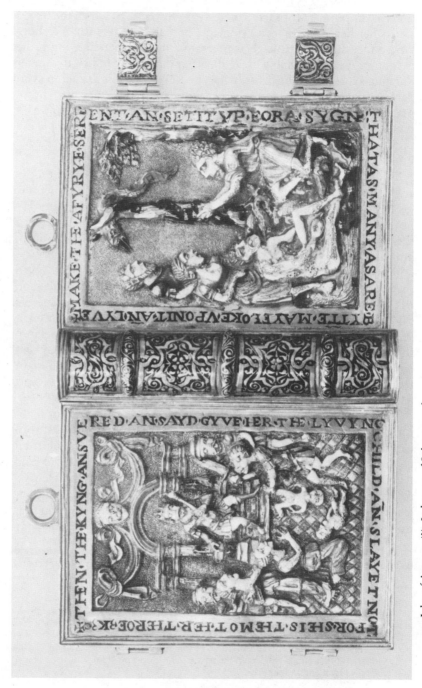

19. John of Antwerp (?), *Judgment of Solomon and Moses with the Brazen Serpent*, c. 1540

related to the royal family, like Mary Fitzroy, Duchess of Richmond and widow of Henry VIII's natural son, or Anne Seymour, Prince Edward's aunt and wife of the Earl of Hertford. The front cover portrays Moses and the Brazen Serpent, while the back shows the Judgment of Solomon. In all likelihood, these covers were crafted by John of Antwerp soon after the 1539 publication of the Great Bible, which supplies the wording for the engraved texts from Numbers 21:8 and 1 Kings 3:27. This Flemish goldsmith obtained patronage at the royal court through the offices of his friend Hans Holbein, whose definitive portrayals of the king (Figs. 8 and 18) furnished the models for the posture of Solomon on the golden book cover. While Moses and Solomon were interpreted at this time as Henry's precursors as religious reformers, one must grant that they could be applied as "conservative" types as well. (They were employed in such "Catholic" contexts as the pageantry for Charles V and Philip II on the Continent.) The Lifting of the Brazen Serpent is closely identified with the Reformation, however, because Protestant commentators interpreted that event as a figure for justification by faith; any person who gazed faithfully at the sculpted serpent was considered invulnerable to the bites of poisonous vipers.[24]

The most impressive portrait of Henry VIII as Solomon provides a focal point among the stained-glass windows of King's College Chapel, a structure whose embellishment was designed as a work of homage to the Tudor dynasty (see above, pp. 30–31). The repetition of the heraldic badges of the red, white, and combined Tudor rose, portcullis, and fleur-de-lis, as well as the royal arms and royal monograms, in the tracery lights at the top of all the windows, serves as a constant reminder of the intimate association of the Tudors with the monument. The climactic royalist image occurs in the two lights (windows contained within stonework) in which the Queen of Sheba kneels before King Solomon, whose image is recognizable as an idealized portrait of Henry VIII (Fig. 20). Except for the looming tableau of the Crucifixion, this image of Christlike majesty is the most important one in the chapel. The Arabian queen's bearing of gifts to Solomon functions, in effect, as a donor panel, because the entire sequence of windows was commissioned and completed during Henry VIII's reign (1515–47) under the supervision of the King's Glazier, Bernard Flower, and his suc-

[24] A. G. Somers Cocks, ed., *Princely Magnificence: Court Jewels of the Renaissance, 1500–1630* (1980), no. 11; and Hugh Tait, "Historiated Tudor Jewellery," *The Antiquaries Journal* 42 (1962): 232–35, pl. 41a-b. I am grateful to Mr. Tait of the Department of Mediaeval and Later Antiquities at the British Museum for permitting me to examine these covers (Inv. no. M&LA, 94, 7–29 1). On the Brazen Serpent, see Gertrud Schiller, *Iconography of Christian Art*, trans. Janet Seligman, 2 vols. (New York, 1971–72), 2: 125.

cessor, Galyon Hone. Although Henry VII was responsible for the completion of the chapel's fabric, the bequest that he left for its furnishing was insufficient to supply the woodwork and stained glass.[25] The choir screen or rood loft was completed during Henry VIII's marriage to Anne Boleyn (c. 1533–36), because it prominently bears her white falcon badge and the H-A monogram.[26] Its decoration was designed as a heraldic compliment to the king during the period when Henry actively patronized the creation of the chapel windows.

The stained-glass portrait of the Queen of Sheba bringing gifts to Solomon was presumably created (c. 1535) by Galyon Hone (Fig. 20). Solomon wears rich robes and a crown as he sits beneath a cloth of estate on a gilded throne. The king reaches forth with his right hand to accept the queen's offering of a massive golden vessel; he holds a scepter with his left. She is clad as richly as he. The heads of the lights of Window 4 were rearranged during restoration, but if they were restored to their original order, the cloth of estate would be supported by a putto bearing the king's HR monogram. This detail indisputably identifies the Hebrew king with Henry VIII. Wayment argues that it was appropriate for the King's Glazier, as "chief contractor" of the entire project, to "seize the opportunity of showing his sovereign in the guise of Solomon."[27]

Typological relations among different scenes in Window 4 amplify the function of the Visitation of the Queen of Sheba as a general compliment to royal power. Henry VIII in the semblance of Solomon is positioned directly above the Star of David and the Adoration of the Magi in the lower register. This is a standard connection in medieval iconography. By the later Middle Ages, the journey of the Three Kings to deliver gifts to the Christ Child at the stable in Bethlehem had been drawn into the iconography of secular rulers, because the Magi were viewed as prototypes for "true" kingship as kings who recognized Christ's higher authority as the omnipotent ruler of the universe (see pp. 123–26). The visit of the Queen of Sheba appears conventionally in the *Biblia Pauperum* as a type for the Adoration of the Magi, a comparison that also appears in the stained glass at Canterbury Cathedral.

The execution of this window at about the time of Henry VIII's assumption of the title of Supreme Head of the Church, and its general

[25] Wayment, *Windows*, pp. 1–4, 24, and pl. 61. See also the detailed view of Henry VIII in pl. 20.7.

[26] John Summerson, *Architecture in Britain: 1530 to 1830* (Harmondsworth, Middlesex, 1953), pl. 3; and Strong, *Holbein*, pl. 42.

[27] Wayment, *Windows*, pp. 55–56.

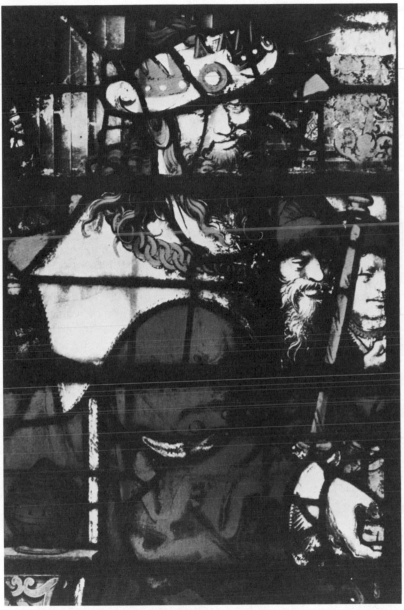

20. Galyon Hone(?), *Henry VIII as Solomon*, King's
College Chapel, Cambridge, c. 1535

resemblance to Holbein's miniature of the reception of the Queen of Sheba, suggest that the portrait in stained glass may have been designed to praise Henry as a Reformation king. Sheba's homage to Solomon may symbolize the submission of the church to Henry VIII. The symmetrical balance of the upper and lower scenes results in a complex typological image that associates Henry VIII with biblical kingship. Solomon's reception of offerings from the Queen of Sheba in the upper register anticipates the delivery of gifts to Christ by the Magi in the lower register. The historical Solomon therefore prefigures both Christ and Henry VIII. The proximity of the Solomonic scene to the Adoration of the Magi may suggest that Christ, too, prefigures Henry VIII in his capacity as head of the Church of England. As Christ receives gifts from worldly kings, Henry VIII as Solomon receives homage from Sheba as the embodiment of the church. It must be granted that the typology of this window incorporates medieval commonplaces; Solomon and Sheba as well as the Adoration of the Magi appeared widely during the Middle Ages as types of the Epiphany. Nevertheless, Solomon's priestly capacity may be adapted readily to Henry VIII's claim to govern as a Reformation king whose authority derives directly from God, without priestly intercession. The intercession of women in the cause of spiritually right action is a recurrent theme in the window. The Queen of Sheba is a type of the Blessed Virgin, especially of her coronation as Queen of Heaven. Mary herself appears in the lower register with the infant Jesus on her lap. Both the Queen of Sheba and Mary are frequently regarded as types for the Church, even when Mary is depicted as the Mother of God.[28]

Regal iconography abounds elsewhere in the stained glass of King's College Chapel.[29] Bathsheba's crowning of Solomon in Window 12

[28] Ibid., pp. 7, 27, and pls. 61–63. Additionally, the Circumcision of Isaac in the upper register at the left side of Window 4 serves as a testimonial of God's covenant with Abraham and as a prefiguration of the Circumcision of Christ and advent of the New Covenant depicted below.

[29] Monarchical imagery is central in two other sets of windows that were presumably patronized by Tudor monarchs. Henry VII is the likely donor of the windows of the Church of St. Mary, which were created by the royal glaziers who worked at King's College Chapel. These windows place very strong emphasis on kingship and regal typology. See Hilary Wayment, *The Stained Glass of the Church of St. Mary, Fairford, Gloucestershire* (1984), pp. 95–96. The stained-glass windows at the Vyne were probably removed from a cycle portraying the lives of Christ and the Blessed Virgin Mary in the apse of the Chapel of the Holy Ghost, Basingstoke. Donor panels that were created c. 1516–24 portray Henry VIII, his sister Queen Mary of Scotland, and Catherine of Aragon at prayer before a late Gothic altar. They are supported respectively by their name saints: St. Henry the Emperor, St. Margaret of Antioch, and St. Catherine of Alexandria. An image of the crucified Christ wearing the Crown of Thorns appears on the altar above the central figure of King Henry. See Hilary Wayment, "The Stained Glass

recognizes the important role that she performed in bringing her son to power, because the scene acknowledges her "king-making" function in persuading David to name their offspring as his successor. It also constitutes a typological introduction to the Passion sequence in the adjacent window. The placement of Christ's reception of his Crown of Thorns directly beneath the coronation of Solomon connects the two as "sons of David"; this pairing may, once again, link true kingship with recognition of Christ's spiritual authority. The use of a crown, albeit a parodic one, as a symbol of Christ's temporal authority represents a shift from the earlier use of the orb and cross. Pilate's fruitless effort to cleanse his hands of guilt in the Passion sequence at the east end (Window 13) offers a contrasting figure of "false" kingship, because he sits like a turbaned oriental potentate on a grandiosely regal throne beneath a cloth of estate. The onlookers' eyes are drawn upward on a vertical axis, however, to the towering figure of Christ crucified, whose Crown of Thorns and mockery as King of the Jews overshadow Pilate's palatial grandeur. Christ's suffering dominates the entire chapel in a recognition of "true" kingship that is predicated on revelation of Christ's spiritual majesty.

Work on the climactic Judgment scene planned for the west window of King's College Chapel was ready to begin when Edward VI ascended the throne at the death of his father on 28 January 1547. The English Reformation then entered its most radical phase, and Cranmer's stringent equation of religious imagery with idolatry prevailed. Within a very brief period of time, according to Hilary Wayment, "the glazing of that great span with what might have been the finest of all the subjects, a *Doom* embracing the whole area of 800 square feet, must have become unthinkable." Sensational as this view may be, it is possible that the "brutal void of white glass" in the unfinished window and its mute contrast with the rest of the stained glass in the chapel stands as a fitting tribute to Edward's reign.[30] During the iconoclastic

in the Chapel of the Vyne," in *National Trust Studies 1980*, ed. Gervase Jackson-Stopes (1979), pp. 35–47.

[30] Wayment, *Windows*, pp. 29, 99, and pls. 69, 93, 95, 99, 105, and 131. In a debate with Bishop Stephen Gardiner concerning a statue of the Virgin Mary, Cranmer argued that " '*ydolum* and *imago* in Greek was one.' Then said Gard[i]ner 'Pleaseth your Grace I think nay; for an idol is that thing which hath given unto him such honor as is due unto God or unto some Saint.' Then said my lord [Cranmer] 'You know not the Greek; *ydolum* and *imago* are all one.' 'My lord,' said Gard[i]ner, 'although I know not the Greek, yet I trust I know the truth, and that by St. Paul, rehearsing Rom. i.' " Transcribed in *Letters and Papers, Foreign and Domestic, of the Reign of Henry VIII*, ed. John S. Brewer, rev. by J. Gairdner and R. H. Brodie, 21 vols. in 37 pts., reprinted (Vaduz, 1965), vol. 18, pt. 2, no. 546 (p. 348).

outbursts of his rule, stained-glass windows were smashed in many churches, wall paintings were whitewashed and covered over with inscriptions of evangelical texts, and the crucifix was often replaced by the king's coat of arms on the rood screens of churches.[31]

Edward VI's accession to the throne as a minor created an unusual problem for his public presentation. Unlike the commanding figure of Henry VIII, who so often dominated portraits as a divine right monarch wielding absolute power, Edward often shared his portraits with his father, his uncle Protector Somerset, or some other authoritative figure like Hugh Latimer. Regardless of whether the boy-king exercised real power, the inclusion of powerful adults in his portraits served to validate his claim to govern, in at least an implied response to the widespread quotation of a verse from the Bible (Eccles. 10:16) that had not been applied to England since the disastrous minority of Henry VI: "Wo[e] unto thee, o land, when thy King is a childe." Basing Edward's official image on his father's portraits represented another response to this iconographical problem. When the King's Painter, William Scrots, portrayed Edward, he modeled the figure and its powerful legs-astride posture on the well-known Holbein painting of Henry VIII at Whitehall.[32]

Adaptation of the Henrician device of the Sword and the Book provided a striking means of styling Edward as a Reformation king and sanctioning his ability to embark on a program of religious reform despite his status as a minor. Portrayal of sword-bearing Edward distributing the Bible to the prelates (Fig. 27) functioned as an implied image of dynastic continuity, because the evangelical stance of the young king alludes to the well-known image of his father in the Coverdale Bible (Fig. 8). In this portrait and others, the government of Edward as a zealous ruler was identified with a book symbolic of the Bible, one that "supported" his ability to govern in conventional imitation of the same Holbein woodcut (see Figs. 22, 52). Books appear prominently in other portraits of the boy-king as a monarch who was said to possess wisdom beyond his years (Fig. 21).

Although Edwardian iconography exploited Henry VIII as one who established precedents that "validated" more radical policies executed under his son, it implicitly criticized the late king for delaying the implementation of Protestant reforms in worship and theology. Comparisons with David were appropriate to this critique of King Henry be-

[31] Phillips, *The Reformation of Images*, pp. 89–90, 95–96, and fig. 16.
[32] Strong, *Portraits*, 1: 93.

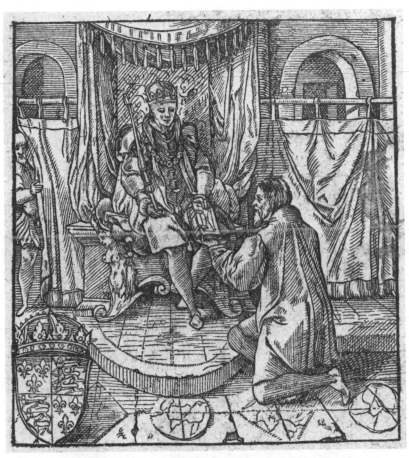

21. *Edward VI Receiving the Author's Book*, from
John Bale, *Illustrium maioris Britanniae scriptorum
summarium* (Wesel, 1548)

cause the late monarch clearly shared the inadequacies and failures of
the Hebrew king, as well as his status as an adulterer and penitent
sinner. Although few if any bishops or divines would confront Henry
in the manner of the prophet Nathan, Hugh Latimer did assume that
role in his sermons before Edward VI, at whose court he blamed the
late king, as a "polygamous" David, for setting a bad example for the
Tudor Solomon who inherited the kingdom "by the advice and will of
his father" (*ERL*, pp. 175–77).

Comparisons with David are virtually absent from Edward's pane-

22. Unknown artist, *Edward VI and the Pope*, c. 1548–49

gyrics; indeed, they would have been quite inappropriate to the praise of a boy-king with a legendary reputation for flawless piety and uncompromising zeal. Apologists did portray him as a new Solomon who, wise in his youth, succeeded a flawed father. Because they found it convenient to blame Henry's failure to follow a policy of thoroughgoing church reform on his Davidic contamination with sin, warfare, and international intrigue, the apologists rigidly segregated the David and Solomon types following Edward's accession. King David's choice of Solomon as his heir despite his youth was well suited to the peculiar problem of panegyric and royal presentation during Edward's minority, when the legitimacy of the young king and his advisors was questioned by those who argued that any further alterations in religion must await the ruler's attainment of his majority. By according Solomonic status to the youth, royal apologists were able to claim divine sanction for decisions that were actually made by the Protestant lords who ruled in Edward's name. Indeed, a mythic image was fashioned of a child ruler who was not only thoroughly involved in the activities of his government, but who initiated policies and issued effective commands. Edward's reputation for both chastity and religious zeal led to the suppression of references to Solomon's record as a penitent sinner and an adulterer who acquired a large harem of foreign princesses.

Pageantry preceding Edward's coronation added a distinctively reformist cast to the transfer of power from father to son, when the personification of ancient Truth articulated the conviction that the young Solomon was divinely ordained to suppress "hethen rites and detestable idolatrye" left intact by "God's servant my defender king Henry": "Then shall England, committed to your gard, / rejoyce in God, which hath geven her nation, / after old David, a yonge kynge Salomon."[33] Reformist ideology led to the portrayal of England under Edward VI as a New Israel whose "godly" king, the young Josiah, was in the process of purging the land of idolatrous images and ritual (2 Kings 22–23). Josiah had implemented religious reforms after a period of backsliding. An apologist therefore saw Edward as

> that true Josias, that earnest destroyer of false religion, that fervent setter up of Gods true honor, that mooste bounteous Patrone of the godly learned, that moste worthy mayntayner of good letters and vertue, and that perfecte & livelye myrrour of true nobilite and syncere godlines.[34]

[33] John Gough Nichols, ed., *Literary Remains of King Edward the Sixth*, Roxburghe Club, 2 vols. (1857), 1: ccxci. See also *ERL*, pp. 161–67.
[34] Thomas Becon, *A confortable* [sic] *Epistle, too Goddes faythfull people in Englande* (1554), A3ᵛ. On Edward VI as the new Josiah, see *ERL*, pp. 161, 177, 185–86, 426, and 439.

23. *Edwardian Iconoclasm*, detail from *Edward VI and the Pope* (Fig. 22)

Josiah's cleansing of the Temple provided an outstanding example for the validation of a policy of church reform during a royal minority.

The anonymous courtly portrait of *Edward VI and the Pope* (c. 1548–49) epitomizes the iconographical shift that followed Henry's death (Fig. 22). An open Bible is at the center of this allegorical portrayal of the English Reformation, which transposes the conventional royal stance from the Coverdale Bible to King Edward (compare Fig. 8). The scene depicts the transfer of power from the dying monarch to his more radically Protestant son. At Edward's left stands Protector Somerset, who held power during the early years of the king's reign. Commentators elsewhere compared this regent to Nehemiah, the governor of Judah during the reign of Artaxerxes, who introduced a program of religious and social reform and rebuilt the walls of Jerusalem (Nehemiah 1–6). Although Edward exercised no genuine authority during his brief reign as a minor, this painting does idealize the king as one who governed under the guidance of members of the privy council, who surround the table. The inset panel in the upper right-hand corner depicts an outburst of the kind of iconoclasm that accompanied the thorough program of Protestant reform implemented following Henry's death; an iconoclast is toppling a statue, probably of the Madonna and Child, from the top of a column (Fig. 23). The smoldering ruins

94

presumably contrast the Fall of Babylon—a common figure for the defeated papacy—with the New Jerusalem of Edward's court.

The Bible at the focus of this portrait is the fundamental and most often repeated pictorial symbol for Edward's government as a zealous ruler. Evangelical kingship could be represented not only by images of books but also by the actual books that those images symbolized: Bibles, devotional manuals, and pious treatises. Woodcuts of Edward VI thus appeared on the title pages of New Testaments published during his reign in apparent emulation of Henry VIII's portrayal in the Coverdale Bible and the Great Bible. The epigraph of a crude portrait in John Oswen's edition (Worcester, 1550; STC 2862, reused in STC 13759) presents Edward as a pious king by means of an allusion to Christ's missionary command to the apostles: "Go unto the wholl worlde and preche the Gospell to all creaturs: he that beleveth and is baptised, shalbe saved: he that beleveth not, shalbee banned [i.e., damned]" (Mark 16: 15–16). The same text had been linked to Henry VIII's image as a Reformation monarch in the court portrait painted by Joos van Cleve at about the time that the Coverdale Bible appeared (see above, p. 62). An artistically superior woodcut portrays King Edward on the title page of Richard Jugge's 1552 quarto edition of Tyndale's New Testament, which had been specifically authorized and licensed by the privy council (Fig. 24; STC 2867). The traditional words of homage, "Vivat Rex," and an epigraph referring to Christ's parable of the Pearl of Great Price (Matthew 13:45–46) idealize Edward's authority as a Christlike king. This allusion likens the realm of England to "the kingdome of heaven."

A Bible commands attention in the foreground of a woodcut in Foxe's "Book of Martyrs" that epitomizes the "godly" reign of Edward VI as a time when the preacher Hugh Latimer held sway at the royal court (Fig. 52). As if to prove that true faith inheres in no physical edifice, a woman reads the scriptures at the foot of a pulpit set up in the privy gardens at Whitehall Palace to accommodate the overflow congregation for Latimer's sermons.[35] Two adult men share the viewer's attention with Edward in what constitutes a symbolic dilution of his authority. The royal uncle, Protector Somerset, occupies the same

[35] The extraordinary popularity of Latimer's sermons led to the erection of a wooden outdoor pulpit to accommodate the throng of courtiers, retainers, and hangers-on. See Foxe, A & M (1563), p. 1353. Although this woodcut first appears as a fold-out illustration tipped into The Seven Sermons of M. Hugh Latimer (at D7), the publisher, John Day, incorporated it as an integral part of the "Book of Martyrs." The scene portrays Latimer delivering the 1549 Lenten sermons "whiche he preached before our late soverayne Lorde of famous memory king Edward the .vi. within the Preaching place, in the Palace at Westminster" (D1). Seven Sermons is the second part of 27 Sermons Preached by Maister Hugh Latimer (published by John Day, 1562; STC 15276).

The newe Testament

ofour Sauiour Iesu Christe. Faythfully tran-
slated out of the Greke.

Wyth the Notes and expositions of the darke pla-
ces therein.

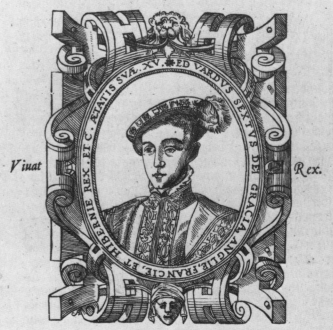

Viuat *Rex.*

Mathew.xiij f.
Vnio,quem præcepit emi seruator Iesus,
Hic situs est,debet non aliunde peti.

**The pearle, which Christ cōmaunded to be bought
Is here to be founde, not elles to be sought.**

24. *Edward VI as an Evangelical King,* Tyndale
New Testament (1552)

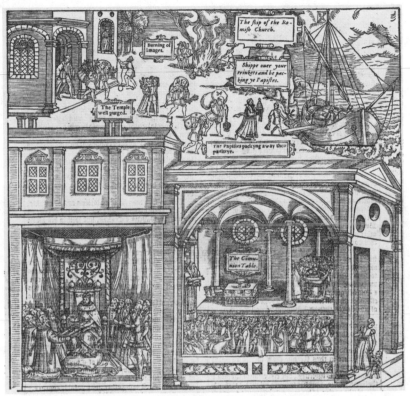

The labels within the image read:
- The ship of the Romish Church.
- Burning of images.
- Shippe ouer your trinkets and be packing ye Papistes.
- The Temple well purged.
- The Papistes packyng away their paultrye.
- The Communion Table.

25. *The Reign of Edward VI*, from John Foxe, *Actes and Monumentes* ("Book of Martyrs"), 2nd ed. (1570)

position at the king's side that he has in the allegorical portrait of Edward VI toppling the pope. Edward himself appears as a monarch receiving religious instruction under the guidance of his powerful regent and an influential cleric. The scene represents the special political circumstances of government during the royal minority, when the king's power was circumscribed by a preeminent lord and a prominent cleric.

Royal iconography filled the artistic vacuum left by outbursts of Edwardian iconoclasm, because images of the king and royal heraldry inherited the veneration that statues of the Virgin and Child, saints' images, and other cult objects had acquired by the late Middle Ages. The woodcut allegory of Edward's reign that John Day inserted into Foxe's "Book of Martyrs" portrays this iconographical shift (Fig. 25). The top panel juxtaposes the pulling down of a statue from the wall of a church (Fig. 26) with the scene at the lower left showing King Ed-

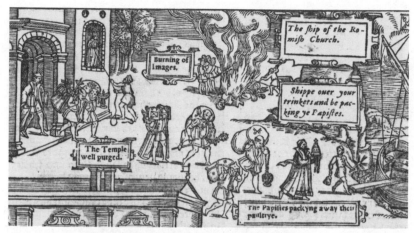

26. *The Temple well Purged*, detail from *The Reign of Edward VI* (Fig. 25)

ward delivering the Bible to the prelates (Fig. 27). The stark simplicity of the new Protestant church service at the lower right portrays the reduction of the seven Catholic sacraments to the two associated with the "Communion Table" and baptismal font (Fig. 28). The Edwardian religious settlement denied sacramental status to confirmation, penance, ordination, marriage, and extreme unction. Clearly, the preaching of the gospel to a Bible-reading congregation supplants the allegedly idolatrous images depicted in the top panel. In an allusion to Josiah's cleansing of the Temple and, possibly, to Christ's expulsion of the money-changers, captions at the top contrast "The Temple well purged" with the packing away of Roman "trinkets" (Fig. 26).[36]

We know that this published image of religious purification coincided with Edward VI's private view of his reign. Extirpation of "idolatry" was a matter of such intense personal concern to the king that he gathered together a collection of scriptural texts concerning false images and translated them into French as a gift for Protector Somerset. Edward's admission that he prepared this text concerning "la reformation de L'ydolatrie" as an exercise in language study does not lessen "le fervent zele" that the king invested in the project (Trinity College, Cambridge, MS R. 7. 31, fols. 1ᵛ, 3). The king's ideas accorded with the Old Testament definition of idols as graven images that were intended to represent or serve as substitutes for God (Exod. 32:4, 24). He perceived devotion to Catholic images of saints and the

[36] See below, p. 164. See also *ERL*, pp. 184–85.

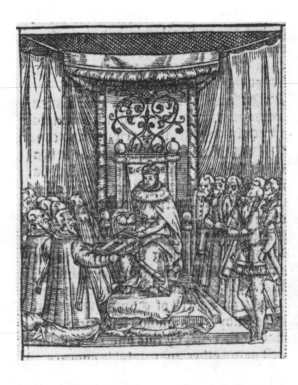

27. *King Edward delivering the Bible to the Prelates*, detail from *The Reign of Edward VI* (Fig. 25)

Virgin Mary, such as the cult objects portrayed at the top of the Foxe woodcut (Fig. 26), to be little more than the worship of idols. Edward therefore felt it was his role to help lead the struggle to observe the second commandment and to return to pure worship in a world where pagan practices flourish.

The iconoclastic fervor of the Edwardian attack against "idolatry" extended to an attempt to eradicate the royalist cult of St. George, whose apocryphal legend and observances radical Protestants attributed to Antichrist. The *Golden Legend* was the most readily available source for the saint's life. King Edward, led by zealotry, considered replacing the image of St. George with scriptural symbols in the insignia of the Order of the Garter. Proposals that received his initial approval would have supplanted St. George with Protestant iconography symbolic of or drawn from the Bible. Although they never received final approval, draft revisions of the Garter statutes would have substituted for the patron saint of the order a king holding the composite image of the Sword and the Book, the respective elements of which would have borne the labels *Ivstitia* and *Verbum Dei*. This badge

99

28. *The Edwardian Worship Service*, detail from
The Reign of Edward VI (Fig. 25)

would have alluded directly to Henry VIII's dissemination of the divine Word on the title page of the Coverdale Bible and the Great Bible. An alternative proposal would have substituted for St. George a horseman holding a sword in one hand and a shield in the other. The sword was to support a book inscribed *Verbum Dei*, and *Fides* was to be inscribed on the shield. Yet another proposed symbol was the Shield of Faith (*Scutum Fidei*) with a red cross on the reverse side; it would have combined a Protestant image for justifying faith with the shield of St. George whose cross also served as the Tudor battle flag. Alterations in the hands of Edward VI and William Cecil provide some indication of how seriously these proposals were considered.[37] The use of the sword and shield as symbols for Christian governance derives from St. Paul's Armor of God, an association that Spenser preserves when he explains to Raleigh that the Redcrosse Knight (or Saint George) wears "the armour of a Christian man specified by Saint Paul v. Ephes." (*FQ*, Appendix I: "A Letter of the Authors").

[37] Edward M. Thompson analyzes the proposals preserved in a manuscript at Windsor Castle in "The Revision of the Statutes of the Order of the Garter by King Edward the Sixth," *Archaeologia*, 2nd ser., 4 (1895): 179–80. See also Michael Leslie, *Spenser's "Fierce Warres and Faithfull Loves": Martial and Chivalric Symbolism in "The Faerie Queene"* (Cambridge, 1983), pp. 151–52.

The revised statutes of the Order of the Garter that went into effect on 17 March 1553, shortly before Edward's death, deleted all references to St. George and stipulated that the cult "shalbe cauled the order of the Garter and nat [*sic*] of sainte George leste the honor which is dew to god the Creator of all things might seme to be geuen to any creature." The desire to replace "obscure sup[er]sticions and repugnante opinions" with Protestant evangelical observances accounted for the shift of the annual Garter feast from St. George's Day to Whitsunday (Pentecost), the holy day commemorating the descent of the Holy Spirit at the time of the foundation of the primitive church. Parliament had already abolished the saint's day, and Cranmer had chosen Whitsunday for the institution in 1549 of the newly reformed church service in the vernacular. Although St. George's silver shield with its emblazoned red cross was sufficiently noncontroversial to be retained as the coat of arms, the statutes excluded essential heraldic elements that defined the St. George motif. The crucial change was the deletion of the dragon as the embodiment of evil. The presence of a mounted knight trampling upon a dragon and slaying it by driving his spear through its mouth or neck had been the conventional representation of the saint's victory. The new Garter pendant was to bear instead a "Massy [solid] golden Image of an armed knight sytting on horseback with a drawne sworde in his right hande all compassed within the garter." Although this knight differed in no material respect from the standard visualization of St. George, the absence of the dragon-slaying incident eradicated all reference to the old saint's cult. The replacement of St. George's spear with the drawn sword in the knight's right hand was a vestige of the purely evangelical iconography under consideration in the earlier draft proposals. Edward's death on 6 July 1553 prevented the full implementation of these revised statutes, which were abrogated under Mary Tudor in the following September. The St. George's Day celebration was thus one of the few forms of pre-Reformation pageantry to survive without modification into Elizabethan England.[38]

During Mary Tudor's regime, all aspects of Protestant royalist iconography were rejected as the new queen tried to return England to the state of Catholic orthodoxy that prevailed in the time of her mother, Catherine of Aragon. Because a government that banned the vernacular Bible could not praise the Tudor sovereigns as "liberators" of the scriptures, a tableau of Henry VIII

[38] B.L. MSS Royal 18 A. I, fols. 9ᵛ, 10ᵛ–11; 18 A. II, fols. 2ᵛ–3. On the refounding of the order, see Strong, *Cult*, pp. 166, 182; and *ERL*, pp. 149–51. For an illustration of the Garter collar, see Richard Marks and Ann Payne, *British Heraldry: From Its Origins to c. 1800* (1978), no. 238.

and the Nine Worthies for the London entry of Mary and Philip (18 August 1554) had to be altered to bring it in line with traditional orthodoxy. Its designer, Richard Grafton, .had evidently planned to praise Henry VIII as a Reformation monarch bearing *Verbum Dei*, the evangelical symbol familiar from the title page of the Great Bible (Fig. 14). Grafton had published that text in partnership with Edward Whitchurch, another well-known Protestant partisan. Grafton lost his position as Royal Printer soon after the death of Edward VI because he issued the proclamation of Lady Jane Grey as queen. The designation of Grafton as a designer of pageantry suggests that the City of London authorities who were responsible for this royal entry had residual Protestant sympathies. Bishop Stephen Gardiner intervened as Lord Chancellor, however, to order the censorship of a decorated niche in a cross at the Conduit in Gracechurch Street, because it violated "the quenes catholicke proceedinges":

> This yeare the ix worthies, at graces church was paynted, and the king henry the eight emongst them w[i]th a bible in his hand, written uppon it Verbu[m] dei. but com[m]andement was geven ym[m]ediatlye that [it] should be put out, and so it was, and a paier of gloves put in the place.[39]

The Marian regime thus redefined its iconographical inheritance from Henry VIII and Edward VI, who was also present in that mural, to efface all reference to alterations in religion. The revised pageant provided a noncontroversial image of dynastic succession from Henry VIII to his Catholic daughter.

Of course, the queen had no intrinsic objection to portrayal of the Bible so long as it was subject to the traditional controls of the church of Rome. This explains why Philip and Mary did not object to a different tableau that greeted them at St. Paul's Cathedral. In a pageant where Misericordia and Sapientia paid homage to the royal couple, the arming of Veritas with *Verbum Dei* subordinated the scriptures to church tradition; Truth alone bore the Bible, without any form of royal intercession. Actors representing the king and queen appeared at the center of this tableau. They were honored on one side by personifications of "*Iusticia* with a swerd in her hande, and *Equitas* wyth a payre of ballaunce. And of theyr left side *Veritas* wyth a boke in her

[39] B.L. MS Harley 419 (John Foxe Collections, vol. 4), fol. 131; mistakenly dated 1555. See also John Gough Nichols, ed., *The Chronicle of Queen Jane, and of Two Years of Queen Mary, and Especially of the Rebellion of Sir Thomas Wyatt*, Camden Soc., 1st ser., vol. 48 (1850), pp. 78–79; Anglo, *Spectacle*, pp. 329–30, 350–54; and *ERL*, pp. 53–54.

hande, wheron was written, *Verbum Dei.*"⁴⁰ The personification of *Veritas* was related to Queen Mary's motto—*Veritas Temporis Filia* ("Truth is the Daughter of Time"), a phrase that crystallized her hostility to religious innovation (Fig. 61). Because of the notoriety of *Verbum Dei* as a symbol for the free circulation of the Bible under Protestant Tudor monarchs, it is possible that the tableau referred obliquely to the restoration of the Vulgate Bible as the only acceptable version of the scriptures in England; in that case, the scene would have represented an inversion of a well-known Reformation slogan.

Cardinal Pole reversed biblical iconography dear to the Protestants when he reinterpreted the Sword and the Book in his inaugural speech to Parliament as papal legate on 27 November 1554. His return to England in itself epitomized the progress of the Counter-Reformation. Just as the exile of this descendant of royalty had demonstrated the existence of highly placed resistance to the Reformation, his return from Rome and assumption of the office of Archbishop of Canterbury typified England's renewed submission to the papacy and Mary's refusal to assume the title of Supreme Head of the Church. Applauding the separation of the ecclesiastical and temporal powers that Henry VIII had united in the person of the monarch, Pole distinguished between "the Temporall swerde" of Philip and Mary and the power inherent in papal control of the holy scriptures and ecclesiastical tradition. Pole's imagery squared with the pageantry for the royal entry of Philip and Mary in that he identifies ancient church tradition with Truth, regardless of whether that virtue is considered an abstract personification, the queen, or the pope. The cardinal's definition of ecclesiastical authority assumed that the pope is the rightful custodian of both the Bible and the keys of St. Peter:

> The other power is of ministracyon whyche is the power of the keies, and order in the Ecclesiastical state, which is by the authoritie of gods word and examples of the Apostles, and of all olde holy fathers from Christ hitherto attributed and geven to the Apostolike Sea of Rome, by speciall prerogative.

A crucial element here is Pole's Catholic definition of the ministry. In place of the Henrician and Edwardian conception of a caesaropapal monarch who unites secular and ecclesiastical authority, Pole returned

⁴⁰ John Elder, *The Copie of a letter sent in to Scotlande, of the arrivall and landynge, and moste noble marryage of the moste Illustre Prynce Philippe, Prynce of Spaine, to the moste excellente Princes[s] Marye Quene of England* (1555), C3ᵛ-4. Nichols transcribed this document in its entirety in *Chronicle of Queen Jane, and of Two Years of Queen Mary*, pp. 136–66. See also Anglo, *Spectacle*, pp. 329, 337–38; and pp. 192–94.

to the medieval separation of the two powers. He demoted monarchs because they altogether lack spiritual authority and receive divine sanction through the intercession of the pope and clerical hierarchy. Unlike the Protestants, who brought the "keys of the kingdom of heaven" in line with the royal supremacy, Pole restored the keys of St. Peter as a symbol of the pope's exclusive power in spiritual affairs (see above, pp. 67–70).

Pole's speech revised other symbols that were fashionable under the Protestant Tudors. In addition to separating the compound symbol of the Sword and the Book into its constituent parts, he modified the application of David and Solomon as types for the succession of power from a devout king to his faithful heir. The dynastic succession of pious monarchs accordingly extended not from Henry to Edward, but from Emperor Charles V to his son Prince Philip. Although Davidic Charles was a monarch elected by God, Pole stated, like Henry VIII he was "contaminate[d] with bloode and war." Completion of the Temple of Jerusalem, a type for the settlement of religious controversies and the reunification of Holy Church, must be left to a Solomonic son. It was therefore the Hapsburg heir Philip, according to Pole, "who shal perfourme the buildyng that his father hath begun." The cardinal's iconographical scheme replaced Edward VI with the Spanish consort who was hated and vilified by English Protestants.[41]

The final reversal of the iconography of the Sword and the Book came with Queen Elizabeth's accession at the death of Mary I in 1558. Images of Elizabeth that display that composite symbol are relatively rare, but there does exist an elaborate memorial portrait in which her sword of justice rests upon *Verbum Dei* (Fig. 87). An important variation of this regal device occurs in a woodcut from the early part of her reign that depicts "Elizabeth Regina" at her prayers (Fig. 30). Much more common than presentations of the queen with the Sword and the Book are her portrayals as the Protestant heroine and savior of England who reads or carries a Bible or evangelical book. Elizabeth's histrionic gesture of kissing and embracing an English Bible or "*Verbum veritatis*, the woorde of trueth" when she entered London at the time of her coronation thus constituted a spectacular public announcement of England's return to Protestant ecclesiastical practices. She restored the Bible to the place it had enjoyed as a means of spiritual instruction and as a device symbolic of

[41] Elder, *Copie of a letter sent in to Scotlande*, D7v–E1.

royal authority under her late father and brother (see below, pp. 229–30).

The prominence of actual texts of the English Bible at the Elizabethan court conformed to evangelical ideals and practices in place during the time of Edward VI. Texts commissioned by or designed for the queen therefore stood as testimonials to her convictions as a ruler who had reestablished the Protestant religious settlement of her late brother's reign. Like Edward, Elizabeth possessed a prized fifteenth-century manuscript of the Wyclifite version of the New Testament. Her chaplain, John Bridges, dedicated this volume as a gift to the queen because it provided "an auncient president [precedent], for warrantise of your Ma[jestie]s doing, that it is not new and neuer h[e]ard of before this age (as some dare auouche) that [the] woord of God shoulde be translated into our mother tongue." The donor articulated the familiar defense that Protestant reforms represent a return to age-old religious practices, rather than religious innovations. The volume should be valued more highly than secular literature, according to Bridges, who argued that the Lollard translation should be read with greater "reuerence and pleasure" than medieval poems that retain their popularity despite the antiquity of "Gowers or Chawcers olde Inglish."[42] His effort to unearth medieval prototypes for Reformation beliefs had its origin in the antiquarian endeavors of Protestant scholars like Leland, Bale, and Foxe, who were particularly active under Henry VIII and Edward VI.

The Bishops' Bible (1568) occupied an important place in Elizabethan iconography as the queen's officially authorized Bible translation. Produced under the patronage of Matthew Parker, her appointee as Archbishop of Canterbury, this revision of the Great Bible was conceived partly in response to the extremely popular Geneva Bible; it expressly omits the polemical notes that made the latter version a particular favorite of the Puritans. The inclusion of the queen's portrait (Fig. 29) on the title page establishes the Bishops' Bible as the direct successor to the Great Bible, with its well-known portrait of Henry VIII (Fig. 14). Elizabeth's image is positioned between flanking female personifications of Faith and Charity, making it clear that the queen completes St. Paul's triad of theological virtues (1 Cor. 13:13) by personifying the Hope brought by gospel faith.[43] Although the image of

[42] B.L. MS Royal 1 A. XII, fols. 2ᵛ–3. On the "providential" discovery of a different manuscript of the Wyclifite Bible in Edward VI's library, see ERL, pp. 98–100, 185.

[43] The title-page border of a 1566 edition of the Great Bible (published in Rouen by Richard Carmarden) portrays Elizabeth, alternatively, as the embodiment of Charity. Flanking her in this instance are the figures of Faith and Hope.

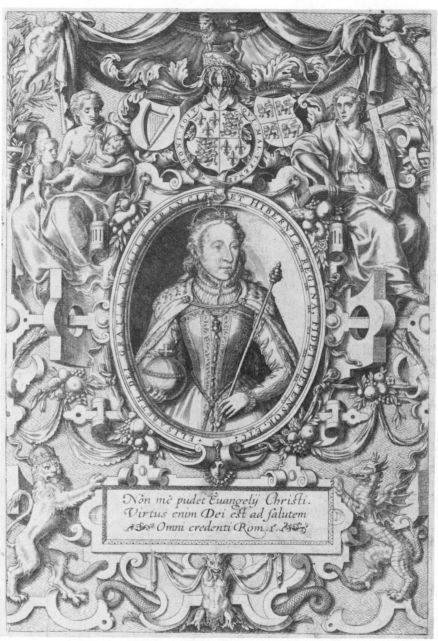

29. *Elizabeth I as Hope*, Bishops' Bible (1568)

Charity suckling her two babes is conventional in late medieval art, the portrayal of Faith holding a Bible and a cross represents a variation of her traditional presentation with a cross and a chalice; that she bears an open copy of the scriptures constitutes an endorsement of the Protestant insistence on the free circulation of the vernacular Bible. (The cross rests upon an open Bible in Counter-Reformation representations of Faith.) The epigraph offers the text of Romans 1:16 as a gloss: "Non me pudet Evangelii Christi. Virtus enim Dei est ad salutem Omni credenti" ("I am not ashamed of the Gospel of Christe, because it is the power of God unto salvation to all that beleve"). This verse supplies a textual link to the Coverdale Bible border, where it appears in the banderole to the left of Henry VIII (Fig. 8). Depiction of the queen as England's only "Hope" for resolution of religious discord clearly praises her as the embodiment of peaceful and godly government; the scene evidently refers to the Elizabethan religious settlement of 1559. A medal designed only a few years earlier supplies a variation of this allegory of the theological virtues by portraying Elizabeth on the obverse as the "holy fountain of the realm" (ZÁΘΕΑ ΒΑΣΙΛΊΑΣ ΛΙ-ΒΆΣ). The reverse portrays *Fides* as a woman holding a cross at the base of a fountain. The medal compliments the queen, who incorporated Protestant theology into her settlement in religion, by identifying Faith as one who drinks pure waters that find their source in Elizabeth herself.[44]

A grandiose volume of the first issue of the 1568 Bishops' Bible (Folger Shakespeare Library, *STC* 2099, copy 3) occupied a prominent place in Queen Elizabeth's library. This handsome folio is bound in the crimson velvet that she favored for her books; the covers are embossed with silver studs and clasps bearing her monogram, the royal arms, and Tudor roses. The inclusion of a woodcut of a peer, Robert Dudley, Earl of Leicester, on the title leaf of the second part of this official Bible translation is without known precedent. His depiction at the beginning of Joshua may suggest that Leicester is a new Joshua, a compliment that was paid to him at this time as the leading advocate of English intervention on behalf of the international Protestant cause. The delicate hand-coloring of Leicester's image evidently reflects his high standing with the queen. When the Bishops' Bible was published, he was still the leading English claimant for the queen's hand in marriage.

The obvious care taken in the preparation of this volume suggests that it was expressly designed for Elizabeth's use. Its embellishment

[44] Jan van Dorsten, "Steven van Herwyck's *Elizabeth* (1565)—A Franco-Flemish Political Medal," *Burlington Magazine* 111 (1969): 143–47. On the iconography of Faith, see James Hall, *Dictionary of Subjects and Symbols in Art*, rev. ed. (1979), pp. 118–19.

might have been commissioned on her own behalf, or it might have been ordered to decorate a presentation copy from Richard Jugge, who issued the text as the Queen's Printer; Bible publication was a royal privilege. This volume could have provided a "prop" for the queen's private "dramatization" of her public role as an evangelical monarch, one who had physically embraced the Bible as a devotional example to her subjects during her coronation entry into London. Should she have opened the volume to read its contents for herself, the title page would have taken on special meaning. The queen would have seen her own portrait, reflected as it were in a mirror image. To Elizabeth alone, the title page would portray the queen, not in her public capacity as a permitter and advocate of the free circulation of the divine Word, but as a private individual who takes it upon herself to read and understand the scriptures. Only in this private royal copy of the Bishop's Bible could the queen's portrait have functioned as an image of personal religious conviction and piety.[45]

Small format editions of the scriptures and biblical prayers occupied a place in Elizabeth's private devotions similar to that filled by books of hours and psalters in the religious observances of pious men and women during the time of her father and grandfather. The bare and unadorned appearance of many of Elizabeth's private books may be attributed, however, to the iconoclastic Protestant effort to subordinate religious images to scriptural texts. Where her ancestors might have employed heavily illustrated prayer books and devotional manuals, Elizabeth owned a tiny set of prayers and meditations in many languages, including Italian, Spanish, German, French, Dutch, Hebrew, and English (B.L. MS Stowe 30). Bound in red velvet for presentation to the queen, whose monogram is embroidered on the cover, this text was designed to provide a Protestant alternative to traditional

[45] For discussion of the queen's portrayal in the second edition of the Bishops' Bible, see pp. 233–36 below. On Leicester as a new Joshua, see Eleanor Rosenberg, *Leicester, Patron of Letters* (New York, 1955), pp. 105–106. The queen also possessed an elaborately decorated copy of the 1583 Geneva Bible published by Christopher Barker, the Royal Printer (Bodl. Douce Bibl. Eng. 1583 b. 1). Apparently he presented it to her as a New Year's gift in appreciation of her patronage. The woodcuts, borders, and capitals are delicately hand-colored or gilded, and the fine embroidery on the covers portrays Tudor roses in an arbor embroidered in gold, silver, and colored silk threads; the edges are gilt and tooled. The text has been described as "one of the most decorative and in many ways the finest of all the remaining embroidered books of the time"; see Giles Barber, *Textile and Embroidered Bindings*, Bodleian Picture Books, Spec. Ser., no. 2 (Oxford, 1971), p. 5 and pl. 8. A parchment roll of New Year's gifts given and received by the queen (B.L. MS Egerton 3052; 1 January 1584) records that the embroidery originally contained seed pearls and that Barker's gift was entrusted to the care of Blanche Parry, Gentlewoman of the Privy Chamber. The printer received a gift of gilt plate as a reward.

manuals of courtly devotion. Although the title page is decorated with the queen's arms and royalist mottoes, the text itself is decorated not with pictures, but with titles and capitals in inks of different colors; because it is a presentation copy, it is not absolutely certain that the queen used it herself. This elegant volume is appropriate to a royal or aristocratic lady broadly learned in languages.

Protestant assumptions concerning justification by faith and the necessity and efficacy of Bible-reading underlie additions that Elizabeth made in her own hand to a tiny sextodecimo New Testament (c. 1579; Bodl. MS e. Mus. 242). The queen commented on the spiritual nourishment provided by the scriptures when she used colored silk and silver thread to embroider the black cloth covers with her monogram and a variety of pious mottos. She chose aphoristic texts like "[CO]ELUM PATRIA" ("Heaven [is my] Fatherland"), "SCOPUS VITAE X[RIST]VS" ("Christ the Guardian of life"), and "CHRISTVS VIA" ("Christ is the Way") to indicate that the Bible is an appropriate guide to queenly conduct.[46] These private sentiments are very much in keeping with her public presentation as an evangelical monarch in her precoronation pageantry and the title-page woodcut of the Bishops' Bible. She inscribed the flyleaf with a pietistic conceit attributed to St. Augustine:

> I walke many times into the pleasant fieldes of the holye scriptures, Where I plucke vp the goodlie greene herbes of sentences by pruning: Eate the[m] by reading: Chawe the[m] by musing: And laie them vp at length in the hie seate of memorie by gathering them together: that so hauing tasted thy sweetenes I may the lesse perceaue the bitternes of this miserable life.

We know with certainty that the queen owned and used other courtly copies of devotional texts. Sometimes they contain her personal marginalia or alterations that tailor a given text to a queenly reader. The Protestant subordination of image to text may be noted in a tiny sextodecimo volume containing copies of both *The Leteny, wyth certayne other devoute and godlye meditations* (1562) and an edition of fifteen Psalms or prayers taken out of the scriptures; the book is bound in the standard red velvet covers of the queen's library. The text's small size was a fashionable format for pietistic works intended for female aristocrats. Although the volume would have performed a function analogous to that of a book of hours, in either manuscript or print, it lacks the illustrations that filled Catholic devotional texts.

[46] The printed text is foliated as an octavo and contains part of Laurence Tomson's New Testament (Barker, 1578).

Even though the two combined texts are printed books, the use of vellum instead of paper and the addition of delicately colored capitals, borders, and flourishes give the volume the artificial appearance of a single tiny manuscript. The volume also includes three sets of inserted manuscript leaves that add a sacred calendar and nine additional prayers for mercy and forgiveness.[47]

Because Queen Elizabeth was the only individual to whom this modified text could make sense, the book as we now find it was evidently commissioned by or for her. The first set of manuscript insertions follows the printed text of the *Leteny* that includes public prayers for the bishops, magistrates, members of various estates, and "the quenes Maiestie"; the last-named prayer addresses God as "the onely ruler of all princes" ($*$v). The inserted manuscript prayers continue to address God through Christ as Elizabeth's special "aduocate and mediator." The added prayers appeal to the Holy Spirit to inspire the bishops, curates, and congregation of the Church of England, and they invoke divine assistance on the queen's own behalf for the satisfactory discharge of her unique responsibilities as Governor of the Church of England. The special place that this volume had in the queen's devotions is suggested by Elizabeth's fragmentary inscription on the flyleaf, which concerns her trust in divine aid during times of adversity:

> . . . vnto me and I will heare the[e]. I will alwayes be with the[e] in all thy tribulac[i]on. Behold I call vpon the[e] oftner with myne hart then with my lippes. Lo how neare Tribulation cometh vnto me, and no bodie to deliuer me fro[m] it but thou o swete IESU. In this sure hoope & co[n]fidence I rest[,] deale with me fauorably o Christ accordinge to thy will.

This volume shows a little-known side of the queen's personality as a piously orthodox woman. Its validity is confirmed by the preservation at the British Library of a facsimile of her *Book of Devotions*, a collection of private prayers in Greek, Latin, French, Italian, and English that dated from the early part of her reign; this tiny manuscript is

[47] Bodl. Arch A. g. 17. *The Leteny* (*STC* 16455) carries the non-inked colophon, "Printed at / London. / 1562" (E8v). The second text, which lacks a title page, might have been printed c. 1545 by Thomas Berthelet, Printer to Henry VIII. Because the illuminated capitals of the previously unrecorded manuscript leaves are identical to those in the set of fifteen Psalms, it seems likely that its title page was removed and one gathering of ten leaves added as a preface. After the *Leteny* was printed at a later date, possibly by the Royal Printer, the manuscript leaves were evidently incorporated into that text in their present configuration. Two leaves bearing the manuscript calendar are interpolated between A1 and A2. Four manuscript leaves are inserted between $*$7 and $*$8. The remaining four leaves follow $*$8.

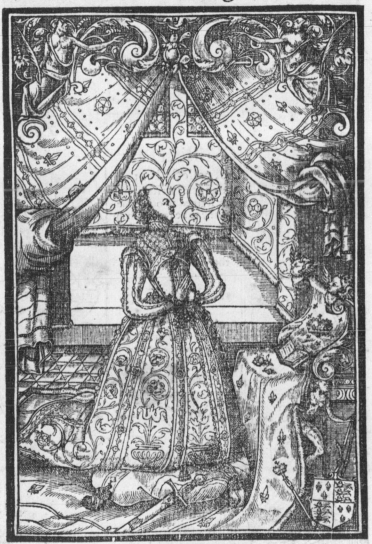

Elizabeth Regina.

2. PARALIPOM. 6.

Domine Deus Iſrael, non eſt ſimilis tui Deus in cœlo & in terra, qui pacta cuſtodis & miſericordiam cum ſeruis tuis, qui ambulant coram te in toto corde ſuo.

30. *Elizabeth Regina*, from Richard Day, *A Booke of Christian Prayers* (1578)

no longer extant. Its contents shared in the Christocentric piety of the additions to *The Leteny*. Time and again, prayers that Elizabeth composed reflect upon divine sovereignty and the corollary responsibility of subjects to believe and to obey. William P. Haugaard concludes that "it is hardly surprising that the image of God as king should be prominent in Elizabeth's devotions since she, after all, judged that good order in English society depended on her own subjects' obedience to her own royal authority."[48]

The queen's name is associated with two collections of prayers attributed to Richard Day and printed by his zealous father, the eminent publisher John Day. Also known as "Queen Elizabeth's Prayer Book," *Christian Prayers and Meditations* (1569) contains a frontispiece portrait of "Elizabeth Regina" kneeling devoutly in prayer (Fig. 30). This image of queenly piety supplements the royal arms at the beginning and end of the book, and the title-page border portraying the Tree of Jesse, which traces the descent of Mary and Christ from David, Solomon, and related Old Testament kings (Fig. 31); the Madonna and Child are superimposed upon the flower that blossoms forth as a symbol of Christ. Nearly a decade later, the Days transferred the title page, frontispiece, and woodcut borders to *A Booke of Christian Prayers* (1578).[49]

Elizabethan iconography receives a prominent place in both of these collections through the interweaving of the royal badges of the Tudor rose and Beaufort portcullis into the lower borders (Figs. 31–33); sometimes the fleur-de-lis appears in recognition of the queen's claim to France as well. The random appearance of the staked bear and staff of the Earl of Leicester functions as a compliment to the queen's confidant.[50] The Elizabethan connection is personal and explicit in a copy of *Christian Prayers and Meditations* that the queen once owned, which is now preserved in Lambeth Palace Library (MS 1049). The printed alteration of prayers that refer to her in the Litany, from the third to the first person (G3 and I1), indicates that this copy was tailor-made for the queen's own use. A manuscript note on the flyleaf states:

[48] William P. Haugaard, "Elizabeth Tudor's *Book of Devotions*: A Neglected Clue to the Queen's Life and Character," *Sixteenth Century Journal* 12, no. 2 (1981): 84.

[49] Richard Day, *A Booke of Christian Prayers* (1578), facsimile ed., The English Experience, no. 866 (Amsterdam, 1977). See Samuel C. Chew, "The Iconography of *A Book of Christen Prayers* (1578) Illustrated," *Huntington Library Quarterly* 8 (1945): 293–305. Chew notes that the use of the first person in the prayers in foreign languages indicates that *Christian Prayers and Meditations* (1569) was expressly designed for the queen (p. 293).

[50] Neither of the Days is known to have received support from this munificent patron of Protestant authors and publishers, according to Rosenberg, *Leicester, Patron of Letters*.

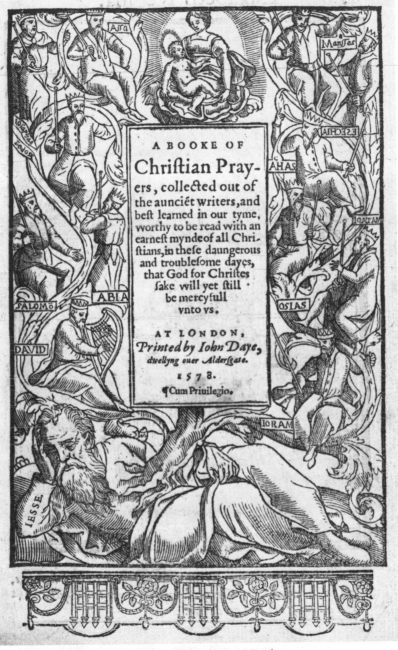

A BOOKE OF
Chriſtian Pray-
ers, collected out of
the ancient writers, and
beſt learned in our tyme,
worthy to be read with an
earneſt mynde of all Chri-
ſtians, in theſe daungerous
and troubleſome dayes,
that God for Chriſtes
ſake will yet ſtill
be mercyfull
vnto vs.

AT LONDON,
Printed by Iohn Daye,
dwellyng ouer Alderſgate.
1578.
¶ Cum Priuilegio.

31. *The Tree of Jesse*, from Richard Day, *A Booke
of Christian Prayers* (1578)

"This book had from Queene Elizabeth's dayes remained in the Wardrope att Whitehall till the time of Cromwell." This hand-decorated book may be a presentation copy from either the elder or the younger Day.[51]

Richard and John Day collaborated in the production of what are, in effect, Protestant books of hours that pay tribute throughout to Elizabeth as a Reformation queen. In an outstanding example of literary iconoclasm, Elizabeth receives the place of honor in collections of prayers comparable to the *Horae*, in which the Blessed Virgin Mary once reigned supreme as Mother of God and Queen of Heaven. This iconoclastic theme may be noted in the border that features the banned ritual objects of Catholic "idolatry"—for example, the small chalice intended only for priestly use and the mass wafer, which contrast with the broad-mouthed cup and loaves of bread that the minister shares with the entire congregation in the Protestant communion service (Fig. 32).

The incorporation of royalist devices in the frontispiece portrait of "Elizabeth Regina" (Fig. 30) provides a suitable accompaniment to the prayers contained in both books. The epigraph offers the Vulgate text of 2 Chronicles 6:14 as a caption for this woodcut image of the queen: "O Lord God of Israel, there is no God like thee in heaven nor in earth, which kepest covenant, and mercie unto thy servants, that walke before thee with all their heart." Solomon uttered this prayer after his completion of the Temple, when he knelt as a priestly king before the congregation of Israel to dedicate the structure. This epigraph suggests that Elizabeth, like Solomon, is an ideally religious ruler. The great Hebrew king prefigures Christ in the Tree of Jesse depicted in the title-page border, and he offers a biblical model for the queen's capacity as a wise governor who has reestablished the Lord's Temple by imposing a Protestant settlement in religion and bringing peace to England. A prayer in *Christian Prayers and Meditations* that is tailor-made for Elizabeth puts into the queen's mouth words that relate directly to her frontispiece image:

> wheras the wisest king Salomon plainly confesseth him self unable to governe his kingdome without thy helpe and assistance: how much lesse shall I thy handmaide, being by kynde a weake woman, have sufficient abilitie to rule these thy kingdomes of England and Ireland. (p2ᵛ–3)

[51] S. W. Kershaw, *Art Treasures of the Lambeth Library* (1873), pp. 87–89. See below, pp. 200–201.

The subtle variation of the motif of the Sword and the Book in the woodcut of "Elizabeth Regina" transforms Holbein's definitive image of monarchical power in the Coverdale Bible (Fig. 8) into a portrayal of the queen as a Christlike Prince of Peace. In contrast to the prayer book that is displayed clearly on the prie-dieu, the sword in front of the cushion upon which the queen kneels is cut short by the lower edge of the picture. A book of divine invocation receives clear priority over a weapon symbolic of Elizabeth's punitive capacity as an instrument of retributive justice. The truncation of the sword may be intended to suggest an optimistic belief that her Protestant settlement of religion has brought an end to the discord that wracked the reigns of her father and siblings. This weapon is analogous to the unused and rusted sword that Elizabeth was known to have kept in her private apartments as a reminder that her desire for peace was ever tempered by the corrective power that she kept in reserve. The subordination of the sword recurs in other portraits of the queen (see Fig. 74).[52] Unlike her father, Henry VIII, who rarely hesitated before applying harsh measures, Elizabeth styled herself as a Solomonic ruler who was slow to anger, but always capable of stern action. This woodcut accords with the image of a cautious queen who in her own life adopted the pose of a ruler who prefers reading the book symbolic of divine wisdom and mercy to wielding the sword of military and judicial power.

[52] William Nelson cites a recurrence of this motif in *FQ* 5.9.30 in "Queen Elizabeth, Spenser's Mercilla, and a Rusty Sword," *Renaissance News* 18 (1965): 113–17. In addition to noting Sir John Harington's comment that Elizabeth kept at hand a rusty sword of justice during the aftermath of Essex's rebellion, Nelson cites an original poem in which the queen reminds herself: "My rusty sword through rest shall first his edge employ / To poll their tops that seek such change or gape for future joy." See also the painting of the queen standing above a sword and holding the olive branch of peace, attributed to Marcus Gheeraerts the Elder, cited in Strong, *Elizabeth*, Paintings, no. 85; and Yates, *Astraea*, pp. 71–72.

3. The Crown versus the Tiara

Finally, the crowne of Christ was of sharpe thorne: the Pope hath three crownes of gold upon hys head, so far excedyng Christ the sonne of God in glory of this world, as Christ excedeth hym in the glory of heaven. — John Foxe, *Actes and Monumentes* (1570)

When the hero's fortunes have ebbed completely in the first book of Edmund Spenser's *Faerie Queene*, the Redcrosse Knight has fallen "full low" in defeat before the giant Orgoglio and his paramour Duessa. The "triple crowne" or tiara upon her head and her garment of "gold and purple pall" link Duessa explicitly with the papacy and the Whore of Babylon, whom Protestant commentators identified with the church of Rome (1.7.12 and 16).[1] Because of the knight's identity as England's patron, St. George, his conquest at the feet of Duessa evokes England's history of papal domination, during either the later Middle Ages or the recent reign of Mary Tudor. Thus Spenser is historically accurate in noting that the harlot's Roman tiara "her endowd with royall maiestye" (1.7.16). When in turn she and Orgoglio meet their downfall before Prince Arthur, an embodiment of British royalty, the crown's symbolic defeat by the tiara is reversed when the "crowned mitre [she] rudely threw aside" (1.8.25).[2]

[1] See Rev. 13:11 and 17:4, and Geneva Bible glosses; and Fig. 66. John Bale's *Image of Both Churches* (Antwerp, c. 1545), Heinrich Bullinger's commentary, and the glosses of the 1560 Geneva Bible establish the standard Tudor Protestant interpretation. See also Josephine W. Bennett, *The Evolution of "The Faerie Queene"* (Chicago, 1942), ch. 9; John E. Hankins, "Spenser and the Revelation of St. John," *PMLA* 60 (1945): 364–81; and Frank Kermode, *Shakespeare, Spenser, Donne: Renaissance Essays* (1971), ch. 1.

[2] Frances Yates notes in *Astraea*, p. 43, that "the royal crown triumphs over the papal tiara" in the initial capital C for Foxe's "Book of Martyrs." See Fig. 50. Roy Strong similarly observes that during the Henrician Reformation of the 1530s, royal patronage emphasized the "never-ending theme of the triumph of the . . . crown over the tiara" (Strong, *Holbein*, p. 9). Spenser contrasts these symbols when Una's rightful inheritance of the Kingdom of Eden is contested by the claim of the pretender Duessa to imperial ancestry as ". . . the sole daughter of an Emperour, / He that the wide West under his rule has, / And high hath set his throne, where *Tiberis* doth pas" (*FQ* 1.2.22). The elevation of an imperial throne in Rome, on the banks of the Tiber, alludes to papal usur-

The triumph of the regal crown over the papal tiara is a widespread iconographical device for the establishment of royal authority over both church and state by the Protestant Tudor monarchs. Time and again the closed imperial crown of the Tudors confronts the triple crown that symbolizes the papal claim to both spiritual and secular power. Arthur's victory recalls the conventional movement of antipapal scenes that were commonplace in Tudor royal portraits and woodcuts, as well as the literary formulations of Protestant satire and allegory. Such polemical works function not as specific sources or models for Spenser's *Faerie Queene* and the works of Christopher Marlowe and others, but rather as *schemata* or frames for understanding how many early readers would have interpreted the defeat of Orgoglio and Duessa historically as an allegory of the triumph of the Protestant Tudor monarchs over the pope and "popery."[3] Through the Welsh genealogy of their forebear Owen Tudor, these monarchs looked back to King Arthur as the progenitor of their dynasty, a claim acknowledged when Spenser calls Arthur's genealogy an account of "the famous auncestries / Of my most dreaded Soveraigne" (*FQ* 2.10.1), evidently Queen Elizabeth. Merlin's prophecy likewise traces the succession of the crown from the end of the Arthurian age until the time of Elizabeth, whose advent is celebrated in a prophetic vision of "sacred Peace . . . [under] a royall virgin" (3.3.49). Henry VII had every intention that government by the house of Tudor be conceived of as a return to Camelot when he gave the name Arthur to his first son and heir apparent, for had the Prince of Wales lived to maturity, England would have been governed by a new King Arthur rather than Henry VIII.[4]

Arthur's victory tableau in "The Legend of Holiness" is related to the Roman imperial triumphal procession, with its parade of the con-

pation of the secular authority of the Holy Roman Emperors and other rulers. Yates notes that Una and Duessa "are emperors' daughters; both make a universal claim. Duessa wears a 'Persian mitre'; Una a royal crown. Duessa and Una symbolize the story of impure papal religion and pure imperial religion. Una is the royal virgin of the golden age of pure religion and imperial reform; she is the One Virgin whose crown reverses the tiara" (Yates, *Astraea*, pp. 72–73). See also O'Connell, *Mirror and Veil*, pp. 54–55.

[3] For a 1597 reading of "The Legend of Holiness" as Reformation allegory, see John Dixon, *The First Commentary on "The Faerie Queene,"* ed. Graham Hough (Stansted, 1964). Dixon glosses Duessa, for example, as the "Romish harlot" and "whor[e] of babylon" (1.7.1 and 17).

[4] Michael O'Connell notes in *Mirror and Veil*, p. 80, that Spenser idealizes Arthur Tudor as Elferon when Guyon reads the "*Antiquitie of Faerie* lond" (*FQ* 2.9.60, 2.10.75). Arthur Kelton's *A Chronycle with a Genealogie* (1547) is one of many works that kept alive Geoffrey of Monmouth's legendary lineage of the British kings, which is summarized in *Briton moniments*, the book read by Prince Arthur in *The Faerie Queene*. Kelton follows Geoffrey in tracing the Welsh lineage of Edward VI, who received the author's dedication, back to Priam's son Brutus through Cadwallader and Arthur.

quering *triumphator* preceded by the chained figures of defeated ene-
mies. As a zealous Protestant, Spenser reinterprets triumphal imagery
by personifying idolatry and falsehood with Roman Catholic type
characters who eventually fall victim to iconoclastic attack. The prev-
alence of such scenes in Renaissance art was fueled by their ancient
literary formulation in Prudentius's *Psychomachia*, with its battles be-
tween allegorized virtues and vices, and Petrarch's revival of such
scenes in *I Trionfi*. As the prototype for allegorizing spiritual life as a
combat between personified Christian virtues and pagan vices, Pruden-
tius's fourth-century Christian adaptation of Virgilian epic features
successive encounters, in the manner of "tableaux in a Roman proces-
sion,"[5] between virtues such as Chastity, Patience, Humility, Temper-
ance, and Reason and their alternatives: Perverse Desire ("Sodomita
Libido"), Wrath, Pride, Extravagance, and Avarice. Faith is particu-
larly important because she fights twice, at the beginning and the end,
thus framing the action and making explicit the Christian content of
all the battles. She fights against Devotion to the Pagan Gods ("Cultura
Deorum Veterum") and Heresy ("Discordia cognomento Hereses").
Spenser similarly emphasizes Faith as the chief attribute of godliness in
his "Legend of Holiness" (1.10.13, 18–19).

Throughout the Elizabethan age, Protestant authors and artists pop-
ularized the metaphors of *psychomachia* warfare as a means of en-
dorsing the Elizabethan settlement in religion. During Spenser's adult-
hood, allegorized combats between virtues and vices appeared in
illustrated books issued by the prominent Protestant publisher John
Day. The woodcut borders of *A Booke of Christian Prayers* by Day's
son Richard, for example, incorporate the Prudentian metaphor of
Christian warfare epitomized by "the whole armour of God" (Eph.
6:11–17) and other Pauline texts. A crowned personification of Love
of God as a godly woman accordingly bears a heart symbolic of St.
Paul's concept that "Love of God is in spirite, and truth" (M1ᵛ; Fig.
32). Spenser's identification of pure religion or Truth with Una, the
heroine opposed by Duessa, parallels this iconoclastic triumph of an
idealized woman who rises in victory over "Idolatry" or "Spirituall
adultery" and the symbolic cult objects of Roman ritual: a pax,
scourge, chalice, bishop's crosier, rosary, crucifix, and candle. Another
woodcut personifies the triumph of Una's other attribute, Faith, as a
woman carrying St. Paul's "shield of fayth," which bears the hand-
shake of constancy (M2). This shield is only one part of St. Paul's

⁵ Macklin Smith, *Prudentius' "Psychomachia": A Reexamination* (Princeton, 1976),
pp. 117–18.

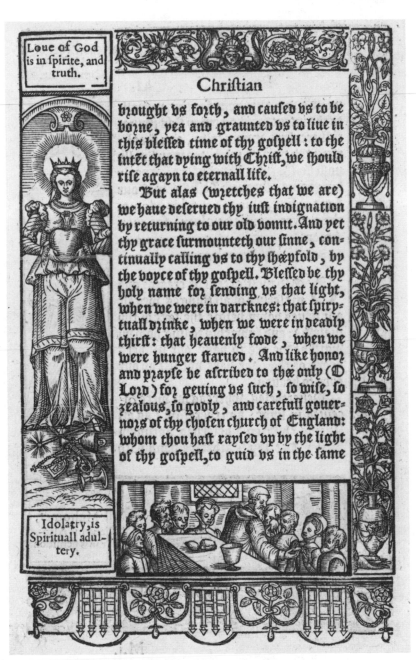

Loue of God
is in spirite, and
truth.

bꝛought vs foꝛth, and caused vs to be
boꝛne, yea and graunted vs to liue in
this blessed time of thy gospell: to the
intēt that dying with Chꝛist, we should
rise agayn to eternall life.

But alas (wꝛetches that we are)
we haue deserued thy iust indignation
by returning to our old vomit. And yet
thy grace surmounteth our sinne, con-
tinually calling vs to thy shæpfold, by
the voyce of thy gospell. Blessed be thy
holy name foꝛ sending vs that light,
when we were in darcknes: that spiry-
tuall dꝛinke, when we were in deadly
thirst: that heauenly fœde, when we
were hunger starued. And like honoꝛ
and pꝛayse be ascribed to thæ only (O
Loꝛd) foꝛ geuing vs such, so wise, so
zealous, so godly, and carefull gouer-
noꝛs of thy chosen church of England:
whom thou hast raysed vp by the light
of thy gospell, to guid vs in the same

Idolatry, is
Spirituall adul-
tery.

32. *Love of God*, from Richard Day, *A Booke
of Christian Prayers* (1578)

"whole armour of God" in a woodcut of the Christian soldier rising in victory above the beast personifying "Hell Temptation" (N1ᵛ; Fig. 33). Redcrosse's discarding of the same symbolic armor makes possible his defeat by Orgoglio and Duessa. A related woodcut appears in another publication by John Day, Stephen Bateman's *A Christall Glasse of Christian Reformation* (1569), where the Christian knight's triumph over the Devil illustrates the operation of Faith "and stedfast beliefe of the fathers in olde tyme."[6] Bateman's gloss indicates how the Pauline Armor of God is commonly applied in defense of the Protestant Reformation:

> The man in armour signifieth all stedfast belevers of the veritie, being armed with constant zeale of Christianitie, and weaponed with the shielde of lively faith, the spere of continuance, and the sworde of the word of God: the Divil under him is temptation, being overcome by faith in Christ Jesus. (M4)

Petrarch's widely imitated *Trionfi* is the chief literary model for the triumphal scenes that occur with great regularity throughout *The Faerie Queene* and others works of Renaissance literature and art.[7] His original poetic tableaux allegorize six consecutive states of the human soul: Love, Chastity, Death, Fame, Time, and Eternity. Tudor Petrarchism takes on a Protestant edge, however, on analogy to Petrarch's association of the pope with the Whore of Babylon in *Bucolicum Carmen*, which led English reformers such as Bale and John Foxe to treat the Italian poet as a proto-Protestant author.[8] Two clearly de-

[6] Even though the poems found in true emblem books are absent from the *Christall Glasse*, the "signification" beneath each of its thirty-seven allegorical woodcuts of virtues and vices is essential to understanding its pictorial companion. In contrast to Edward Hodnett's attribution of the designs to Gheeraerts in *Marcus Gheeraerts the Elder of Bruges, London, and Antwerp* (Utrecht, 1971), pp. 46–48, Betty Ingram's headnote in *English Books with Woodcuts: 1536–1603* (forthcoming) contends that they look like English copies of Dutch originals. John Day may have commissioned Bateman to provide an extended didactic text to accompany a set of blocks already in existence; unlike the short "significations," this work bears no relation to the illustrations. On the importance of emblems and the Pauline Armor of the Christian Man in English Protestant literature, see Lewalski, *Protestant Poetics*, pp. 92, 179, 185–96.

[7] Petrarch models his first pageant in particular on Ovid's "Triumph of Love" (*Amores* 1.2). D. D. Carnicelli indicates the *Trionfi*'s "far-reaching impact . . . [on] an enormous number of paintings, frescoes, miniatures, tapestries, faïences, enamels, and medals" in the introduction to his edition of Lord Morley's *"Tryumphes of Frraunces Petrarcke": The First English Translation of the "Trionfi"* (Cambridge, Mass., 1971), pp. 38–46.

[8] See "Pastorum pathos" and "Grex infectus et suffectus." Joachim de Fiore, Dante, and Savonarola joined the many medieval Catholics who were similarly reinterpreted by Bale, Foxe, and other reformers (Yates, *Astraea*, pp. 41, 44, 113). On the analogous "kidnapping" of the *Piers Plowman* poet for the Tudor Protestant cause, see *ERL*, pp. 322-39.

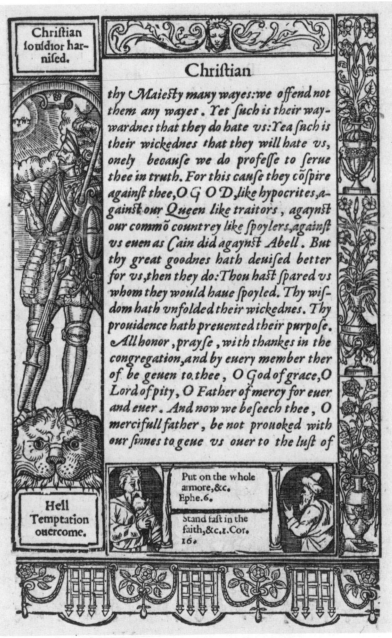

Christian souldior harnised.

Christian

thy *Maiesty many wayes: we offend not them any wayes. Yet such is their waywardnes that they do hate vs: Yea such is their wickednes that they will hate vs, onely because we do professe to serue thee in truth. For this cause they conspire against thee, O G O D, like hypocrites, against our Queen like traitors, agaynst our commō countrey like spoylers, against vs euen as Cain did agaynst Abell. But thy great goodnes hath deuised better for vs, then they do: Thou hast spared vs whom they would haue spoyled. Thy wisdom hath vnfolded their wickednes. Thy prouidence hath preuented their purpose. All honor, prayse, with thankes in the congregation, and by euery member ther of be geuen to thee, O God of grace, O Lord of pity, O Father of mercy for euer and euer. And now we beseech thee, O mercifull father, be not prouoked with our sinnes to geue vs ouer to the lust of*

Hell Temptation ouercome.

Put on the whole armore, &c. Ephe. 6.

Stand fast in the faith, &c. 1.Cor. 16.

33. *The Armor of God*, from Richard Day, *A Booke of Christian Prayers* (1578)

fined symbols of Roman victory, the chariot and the throne, tend to fuse in illustrations for the *Trionfi* that treat the chariot as a kind of throne. Characteristically, the victor looms above the vanquished. The imperial dais in a fifteenth-century Italian version of the Triumph of Love accordingly displays not the tamed and blindfolded God of Love, but the conquering Cupid, who reappears at Spenser's House of Busirane; Love's victims crowd around the chariot. The succeeding Triumph of Chastity over Love, which is depicted in a painting by Jacopo del Sellaio, is a prototype for the victory of Britomart, the personification of Chastity, over Busirane. The portrait positions Chastity rising triumphant above Cupid, who is bound by the virgin maidens in attendance.

The entire sequence of Petrarchan triumphs was associated closely with Queen Elizabeth, who, despite her virginity, was taken to personify Love that was ever triumphant over the courtiers who paid suit to her in the stylized chivalric roles of Petrarchan lovers. Frances Yates argues that Spenser used the Triumph of Chastity as a symbol for governmental reform under the queen, the "just, imperial virgin" descended from Britomart and Artegall.[9] In the *Ermine Portrait* of Elizabeth, the golden circlet around the neck of the ermine (a symbol for virginity) links the beast to the ermine banner in Petrarch's *Trionfo della Castità*, which Strong identifies as "a source widely used by those who wished to compliment the chaste Queen." The eyes and ears portrayed on her attire in the *Rainbow Portrait* may identify the queen with Fame, whose triumph is conventionally symbolized by those organs and mouths (Fig. 76). Eventually Elizabeth "triumphs" over personifications of Time and Death in a posthumous portrait in which the aged and world-weary queen rests her head on her right hand as two putti confer upon her diadems, which may represent earthly and heavenly crowns.[10]

The prototypes for the Protestant triumph of the Crown over the Tiara are not only literary; visual models abound in late medieval and early Renaissance art. One cannot deny that the suppression of the iconography and liturgy of the medieval church by the Protestant Tudors led to the widespread destruction of images of saints, portrayals of the Virgin Mary, and other cult objects. Nevertheless, Protestant imagery not only draws upon, but pointedly redefines traditional Catholic images that remained fixed in people's minds. These images

[9] "*Tryumphes of Fraunces Petrarcke,*" ed. Carnicelli, pl. 2; Yates, *Astraea*, p. 70 and pl. 15. I am also indebted to an unpublished paper by Gordon Kipling.

[10] Strong, *Elizabeth*, Paintings, nos. 86 and 100; Woodcuts, no. 4; Some Posthumous Portraits, no. 8; and pl. XXIa–b.

are not simply sources but constituent elements of a religious attitude that demanded "reformation." Tudor royal iconography continually varies and reconstitutes traditional types, notably the figures of Christ the King, the Coronation of the Virgin, and Mary as Queen of Heaven, which had been used in undiluted form to praise late medieval kings and queens. The Tudors invert recognizable visual patterns by retaining formulas that convey familiar points while replacing key elements with Protestant variations or substitutions.

The widespread imagery of the Procession and Adoration of the Magi in late medieval and early Renaissance art offers a case in point, because it contains many motifs that reappear as a function of the Tudor conflict between the Crown and the Tiara, such as kneeling kings, kissing feet, and removing crowns. Although the abasement of kings before Christ might seem to provide a simple parallel for papal authority over temporal government, many medieval motifs associated with the Adoration of the Magi reappear during the Reformation in Protestant woodcuts that attack the pope for humiliating worldly rulers. These visual satires hinge upon the allegation that the princely pontiffs of the late Middle Ages and Renaissance are *inverted* parodies of the humble infant Jesus receiving homage at the stable in Bethlehem (see Figs. 41–47). When images of the Protestant Tudors portray them rising in victory over the popes whom they have "toppled," this satirical motif is *re-inverted* to praise monarchs as Christlike kings who have taken control of a corrupt church establishment (see Figs. 22, 50–51). Any reference to the Adoration of the Magi in the Tudor portraits is indirect, of course, because these portraits correct images of "perverse" papal triumph.

Because the entire point of Epiphany is the Three Kings' recognition of Christ's divinity although it is not outwardly manifested, overlapping images of secular and divine kingship, humility, triumph, and homage characterize the Adoration scene in late medieval and early Renaissance art. In the Strozzi Altarpiece of S. Trinita Sacristy, Florence (Fig. 34; completed 1423), for example, Gentile da Fabriano portrays the Magi as sacred kings whose nimbi associate their crowns with the haloed heads of the Holy Family. A complicated conventional maneuver brings the foremost Magus into a kneeling position even lower than Christ as he kisses the child's feet. Gentile's infant Jesus, on the other hand, rises in triumph over the crown set on the ground on a profound vertical axis leading to the Star of Bethlehem above Joseph's head, a pattern that emphasizes Christ's supremacy over worldly kingship and suggests a continuing movement upward toward heaven. The lunette set into the apex of the altarpiece portrays divine overlordship

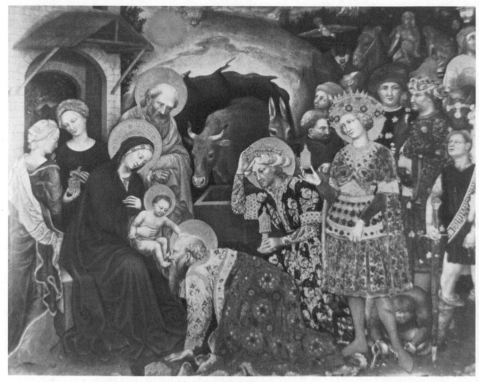

34. Gentile da Fabriano, *The Adoration of the Magi*, Strozzi Altarpiece, completed 1423

through the figure of Christ the King, whose right hand displays the action of benediction in a survival of imperial courtly gesture. Only those participants in the Adoration scene who possess special spiritual insight are linked iconographically to the lunette image, which is invisible to those in the main panel below. The presence of the star emphasizes the scriptural and liturgical connection of Epiphany with divine revelation by means of the radiation of light into a world filled with darkness. The presence in this and other altarpieces of predella panels that are thematically related to the main panel above suggests that it was conventional to submit such works to a vertical "reading."

The Strozzi Altarpiece incorporates a political program that associates "true" kingship with recognition and loyalty to Christ's spiritual authority.[11] Kings who are defined as good are shown recognizing

[11] Darrell Davisson argues that Gentile's painting "could be viewed as . . . [one] manifestation of the renewed identity of the Church refounded after the Great Schism," in

124

what was not clear to all. The validity of temporal power, figured by the Magi, is equated with the wisdom to see divine authority even when it is not openly proclaimed; the kings offer their crowns to Christ when he is humble, that is, when he is most unrecognizable. Although the naked infant Jesus altogether lacks the symbols of imperial power—crowns, robes, retinue, and wealth—a lengthy procession makes its way to him to confer gifts normally considered inappropriate to a stable scene. The kneeling homage and static gaze of the Magi portray Christian government and obedience in terms of feudal loyalty and overlordship. The Magi offer a further contrast to Herod, who sees Christ as a rival, not as a spiritual overlord. In association with the iconography of Epiphany, the interrogation of the Magi by Herod offers a visual opposition between "true" and "false" kingship. Elsewhere, artistic juxtapositions of the Adoration of the Magi with the Massacre of the Innocents portray Herod's spiritual "blindness" and separation from ideal kingship.[12] *The Offering of the Magi* in the Wakefield cycle, for example, consistently dramatizes a ranting Herod as a vainglorious tyrant whose ostentatious throne contrasts with Christ's humility and the simplicity of the manger in which he lies.[13]

The visual imagery of the Nativity and the Adoration of the Magi flows into the iconography of secular rulers. In both northern Europe and Italy, "honor portraits" celebrate the accomplishments of contemporary members of great ruling houses by depicting them in the guise of Magi. The Adoration of the Kings in Rogier van der Weyden's Columba Altarpiece (before 1464), for example, introduces the young heir of the Burgundy dukedom, the future Charles the Bold, as the third Magus (Fig. 35). Although he stands erect while the eldest Magus kneels before the infant Jesus, Charles joins his companions in removing his crown in an act of homage. The paradoxical humility of royal iconography is enhanced not only by the figure of Christ, but also by the portrayal of the Virgin Mary as "one of the gentlest yet queenliest ever painted."[14]

The iconography of the Adoration underwent modification during the Tudor age. Royalist imagery assimilated and redefined the precise

"The Iconology of the S. Trinita Sacristy, 1418–1435: A Study of the Private and Public Functions of Religious Art in the Early Quattrocento," *Art Bulletin* 57 (1975): 331.

[12] Schiller, *Iconography*, 1: 97.

[13] See the introduction and text in David Bevington, ed., *Medieval Drama* (Boston, 1975), pp. 409–428.

[14] Erwin Panofsky, *Early Netherlandish Painting: Its Origins and Character*, 2 vols. (Cambridge, Mass., 1953), 1: 286, and ill. 353 (pl. 213). Compare van der Weyden's portrait of Charles the Bold in ill. 379 (pl. 233). Janet Cox-Rearick observes that an idealized figure of Lorenzo il Magnifico appears at the left-hand side of Botticelli's *Adoration of the Magi*, in *Dynasty and Destiny in Medici Art: Pontormo, Leo X, and the Two Cosimos* (Princeton, 1984), p. 22, and pl. 5.

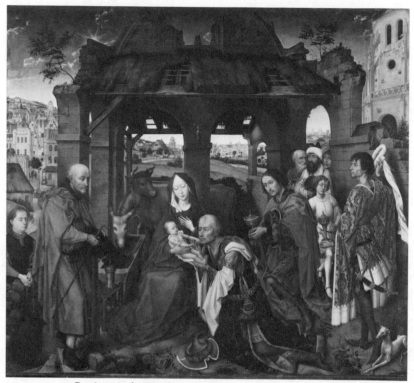

35. Rogier van der Weyden, *The Adoration of the Magi*, Columba Altarpiece, before 1464

point made in this frequent contrast, that the true king is the one who recognizes Christ. Imagery of ecclesiastical "advent" or "epiphany" took on a new resonance when the Protestant Tudors supplanted the pope as the head of the church of England. Their iconography inverted the imagery of Continental portrayals of an "alliance" of Roman and divine authority in opposition to the secular crown. The iconography of Mary Tudor reversed many of these associations, on the other hand. Because of her religious orthodoxy and because she was the namesake of the Blessed Virgin, she could be seen appropriately as a type for the Madonna in an Adoration scene contained in a defense of clerical celibacy published during her reign.[15] Similarly, a topical poem inverts the Adoration theme by treating her reign as a recollection of the Vir-

[15] Historiated initial H in Thomas Martin, *A Traictise declaryng and plainly provyng, that the pretensed marriage of Priestes, and professed persones, is no mariage* (1554), A2.

126

gin Mary's deliverance of Christ through her flight into Egypt. The Flight into Egypt could readily serve as a type for the duress of the "true" church and its eventual restoration. The Marian apologist applied the escape of the Holy Family from the "false" King Herod following the departure of the Magi as a figure for the religious persecution of Catholics under Edward VI:

> Herod by his, greate Crueltie
> Compelled mary, with Christe hir sonne
> Into Egypte, full faste to flee
> till god his will, for hir had done
> his will so wroughte, hir wil she wonne
> this Tyraunte soone, hym self had slayne
> Then Marie Broughte home, Christe agayne.[16]

The most important set of prototypes for the Tudor conflict between Crown and Tiara may be found in contemporary German woodcuts that portray the obsessive Lutheran effort to restore both the purity of the church and the independence of regal or imperial authority from papal overlordship. One may trace the direct and immediate impact of German visual polemics on Foxe's "Book of Martyrs" and other works of Tudor Protestant propaganda. The Continental campaign originated in a reinterpretation of the New Testament, notably the gospels and Revelation, as both an account and a prophecy of the stark opposition between "true" faith as it is epitomized in Christ's ministry and the alleged falsifications of the pope as Antichrist. Lucas Cranach the Elder, the official painter of the Saxon court, transmitted this revisionist view of history in "the most successful work of visual propaganda produced by the Reformation" (Scribner, p. 149), the vastly influential sequence of twenty-six woodcuts that circulated under the title *Passional Christi und Antichristi*. Initially published in Wittenberg in May 1521, it went into nine editions in the last half of that year alone.

The Cranach atelier supplied the illustrations for this work, which Martin Luther designed as a popular guide to Protestant doctrine. The text transforms the medieval "passional," a devotional manual for pri-

[16] Miles Hogarde, "Mary hath brought home, christe agayne," B.L. MS Harley 3444, fols. 2ᵛ–3, 6. Pieter Breughel the Elder, on the other hand, portrays the Duke of Alva at the head of Herod's troops in the *Massacre of the Innocents* (1567–68). The outrage inherent in this painting represents a step beyond the hope for regeneration implied in Breughel's *The Conversion of St. Paul* (1567), where he portrays the Spanish Catholic duke as one who may yet draw back from punitive policies in the Netherlands. See Jan van Dorsten, *The Radical Arts: First Decade of an Elizabethan Renaissance* (Leiden and London, 1970), p. 38 and pl. II.

vate meditation on events in Christ's life, into powerful visual instruction for the illiterate or barely literate laity. By abstracting texts out of the Bible or the *Decretals* by Melanchthon and Schwedtfeger, Luther organized a skeletal framework for a series of contrasting images of the allegedly "true" religious practices of Christ's gospel ministry and the "false" doctrines and ritual of the church of Rome. Broad visual antitheses simplify and virtually replace textual argument, ensuring that the spread of official theology took place "on a primitive level."[17] Thirteen facing pairs of woodcuts portray on the verso side of each opening an event in the life of Christ with an illustrative scriptural quotation; on the recto side is its parody in the career of the pope with an interpretative comment or a quotation from a papal document. With the exception of the triumphal image of Christ in the final pair, these scenes reverse the imagery of birth and renewal in the Adoration of the Magi to portray Jesus suffering humiliation, abasement, and ultimately death.

The overarching purpose of the *Passional Christi und Antichristi* is to attack the church of Rome for worldliness and the abandonment of the simple spirituality preached by Christ. It does so by proclaiming the ubiquitous Protestant accusation that the pope is the Antichrist. Cranach's initial set of woodcuts contrasts Christ's rejection of an imperial crown with the pope's declaration of war to defend a claim to temporal power that was based upon the Donation of Constantine. This satirical antithesis extends to the second pair, where the pope's coronation with the Tiara mocks the Crown of Thorns on the head of the scourged figure of Jesus. In the third pair, Christ's humble washing and kissing of his disciples' feet is reversed when emperors and kings kneel to kiss the feet of the pope, who is enthroned in state. Succeeding woodcuts render in visual form Christ's admonition to "Give therefore to C[a]esar, the things which are C[a]esars, and give unto God, those which are God's" (Matt. 22:21), and its evasion by the proud and avaricious pope, who variously showers an emperor with coins and attends a festive tournament. Where Christ walks barefoot on the ground with his disciples in the sixth pair, Melanchthon sardonically praises the pope for bearing "the cross of adversity" when actually he rides in an ostentatious litter. Protestants viewed the "feeding" of the people with Christ's preaching in the next set as a prototype for the evangelical ministry of devout preachers, but the pope neglects his vocation for feasting and revelry. In the ninth pair, the entry of Jesus into

[17] According to David Paisey, Assistant Keeper of Printed Books at the British Library, Reference Division, London.

Jerusalem on a donkey is juxtaposed with the pope's riding of a richly caparisoned horse, furnishing a scriptural paradigm for the confrontation between the "true" and "false" churches during the Reformation; the papal steed recurs in visual satire as a symbol of vanity (see Figs. 47–48, 51, 53). In this instance the pope sets out toward Hell instead of Jerusalem. The twelfth set was similarly applied to dramatize Luther's initial confrontation with the papacy, for Christ here expels the moneychangers from the Temple in Jerusalem; the pope, on the other hand, acts as their successor by trading indulgences for gold. The closing pair epitomizes Luther's broad interpretation of providential history by bracketing the ascension of Christ with the fall of Antichrist, an ancient theme of Christian art. Cranach's major innovation here is the placement of the papal tiara on the latter's head.

Despite its brevity, the *Passional* is an unexpectedly complicated work with overlapping themes. It should come as no surprise that Luther and Cranach the Elder employ rigid dichotomy and antithesis as basic satirical devices. Lucas Cranach the Younger employs them elsewhere to distinguish between evangelical and Catholic preaching in his notorious portraits of Martin Luther and Johann Tetzel in the complex woodcut, *Unterscheid zwischender waren Religion Christi und falschen Abgottischen lehr des Antichrists in den fürnemsten stücken.*[18] Scribner observes that the *Passional* may be read, as the title suggests, as "an illustrated morality play" containing "scenes" familiar from contemporary cycles of religious plays in the vernacular.[19] It also assimilates the Protestant discovery in Revelation of a vision of history as a conflict between "true" and "false" churches. A third issue it addresses is the sacerdotalism of the late Middle Ages that elevated the ecclesiastical hierarchy into the position of a privileged elite with mysterious and quasi-supernatural powers.

Foxe and other English propagandists take up many charges that had appeared in the *Passional*, and they employ Cranach's characteristic devices of antithesis and dichotomy. The greatest importance of the German text as a context for the Tudor monarchs' harnessing of anticlericalism in their propaganda battle with the church of Rome lay in the potent accusation that the papacy, by claiming to inherit the authority not only of St. Peter but also of the Roman emperors, usurped secular power rightly accorded to kings and emperors. This argument had proved attractive in Germany, where Lutherans successfully appealed to popular prejudice against Rome as an enemy of the

[18] See Scribner, nos. 165–66.
[19] Ibid., pp. 149–56, and nos. 115–26.

Holy Roman Emperors who traced their inheritance back to Charle-
magne.[20]

One emperor in particular—Frederick Barbarossa—possessed spe-
cial appeal at the Tudor court during the Reformation, because his
excommunication and alleged betrayal by the pope could be inter-
preted as precursors to Henry VIII's conflicts with Clement VII and
Paul III. This affair was a germ for antipapal attacks culminating in
Foxe's "Book of Martyrs." The courtier Henry Parker, eighth Baron
Morley, accordingly translated as a gift for Henry VIII a novella about
the betrayal to the Sultan of Babylon of "the most chrysten and moste
noble ffrederyke barbarouse Emperour of Rome" by "that false An-
tec[hri]ste Alexander the .iiij.th [i.e., Pope Alexander III]." Anticlerical
satire permeates this account of the pope's sacrilegious timing of his
action during Frederick's return from a pilgrimage to the Holy Land,
which led to the emperor's pledge of the Host as ransom. Although a
nonbeliever, the sultan exceeded the pope in fidelity and gentility in
that he returned his hostage's ransom. Parker's account of the emperor
pondering in captivity on "the awfull and lecherouse lyues of the
Bysshops of Rome and hys Cardynalls"—allegations that were com-
monplace in Protestant polemics—would have appealed to Henry VIII,
just as the king might have looked for an optimistic precedent in the
account of Frederick later chasing "the bysshoppe of Rome oute of
Rome." Parker's dedication of his translation to Henry VIII as a "most
christen king" makes explicit the parallel between his reign as a time
of religious reform and the turbulence of Frederick's time.[21]

Memory of Emperor Frederick's humiliation was revived at this time
as a cause célèbre in Protestant Germany when an account of his sub-
jugation by popes Adrian IV and Alexander III was published in sev-
eral editions in 1545; the account contains a foreword written by Lu-
ther. The work bears the title *Bapsttrew* [i.e., Papststreu] *Hadriani iiij.
und Alexanders iij. gegen Keyser Friderichen Barbarossa geübt. Aus
der Historia zusamen gezogen nützlich zulesen. Mit einer Vorrhede D.
Mar. Luthers* (Strasbourg, 1545). This document actually has its origin
in Tudor antipapal polemics, because the German translator drew his
account from *Vitae Romanorum pontificum, quos papas vocamus*
(1536; X6–Z6ᵛ), a work dedicated to Henry VIII from Wittenberg by
its compiler, Robert Barnes, at the height of Thomas Cromwell's pro-
paganda campaign against the papacy. Cromwell had sent Barnes to
Germany to seek support from Lutheran theologians for the royal di-

[20] Ibid.
[21] B.L. MS Royal 18 A. LXII, fols. 1ᵛ, 2ᵛ–4, and 9ᵛ, dedicated to Henry VIII, c. 1540–
47; from the *Novellino* (no. 49) of Masuccio de Salerno (1476).

vorce. In a contemporary tract that vilifies the pope for deposing Frederick Barbarossa, *A supplicacion unto the most gracyous prynce H[enry]. the .viii.* (2nd ed., 1534), Barnes duplicates imagery from the *Passional Christi und Antichristi* in his bitterly hostile charge that the popes attempt to "be lorde over the worlde, and cause Emperours, and kynges, to fetche theyr confirmacyon of hym, and to knele downe, and kysse his feete" (D2).

Woodcuts portraying the pope rising in triumph over Emperor Frederick complement the verbal assaults contained in *Bapsttrew* [i.e., *Papststreu*] *Hadriani und Alexanders.* The first edition appeared in Strasbourg with a title-page woodcut of an enthroned pope crowned with the tiara while Frederick, with the imperial crown on his head, kneels to kiss the pope's feet; the emperor prostrates himself beneath an open book symbolic of the Bible. A scroll in this woodcut reads "NIT DIR SONDER[N] PETRO" ("Not to you, but to Peter") in an ironic denial of the papal claim to apostolic succession from Christ. The title page of the third edition, which was published in Wittenberg, a hotbed of the Lutheran movement, displays a conflict in which the pope simply points to the crown on the emperor's head. Far more inflammatory is the woodcut in the same edition that portrays Frederick lying prostrate in defeat, with the crown still on his head, as Alexander III steps on his neck (Fig. 36). The legend explains: "Ist ein fein Exempel der nachvolger S. Petri" ("This is a fine example of the successors of St. Peter"). The editor also lodges an ironic attack against Adrian IV's role in humiliating the emperor: "Darin nu auch ein gut Exempel des Bapsts trew [i.e., Papsts treu] gegen den keysern" ("This also is a good example of the faithfulness of the pope against the emperor").[22] This Lutheran woodcut is of great importance not only because of the violence of its image of imperial defeat and submission, but also because it is the exemplar for the single woodcut in Foxe's *Acts and Monuments* that can be traced directly to a foreign model.

The Lutheran defense of Frederick Barbarossa furnished a model for the designer of an illustration of the conflict between the emperor and the pope for the 1563 edition of *Actes and Monuments* (or the "Book of Martyrs"). An adaptation of the German original that was designed for Foxe's account of Frederick's rift with the papacy (Fig. 37; *A & M* [1563], p. 41) portrays

²² *Bapst trew* [i.e., *Papsts treu*] *Hadriani iiij. und Alexanders III. gegen Keyser Friderichen Barbarossa geübt. Aus der Historia zusamen gezogen nützlich zulesen. Mit einer Vorrede D. M. Luthers*, A4ᵛ–B1. See Josef Benzing, *Lutherbibliographie*, 3 pts. (Baden-Baden, 1965–66), pt. 2, p. 418.

36. *Pope Alexander III Treading on the Neck of Emperor Frederick Barbarossa*, from Robert Barnes, *Bapsttrew* [i.e., Papststreu] *Hadriani iiii. und Alexanders iii. gegen keyser Friderichen Barbarossa geübt* (Wittenberg, 1545)

Pope Alexander "treading on the neck" of the emperor in an influential English account of the hostility between the Crown and the Tiara. The close coincidence between the posture of the figures and the event portrayed indicates that the designer of the English woodcut worked directly from the German original or an intermediary. He could easily have designed the illustration with the German woodcut before him even though he transposes the direction of the emperor's body, adds a bishop and a cardinal, and shifts an outdoor scene indoors. The crucial detail—the pope stepping on Emperor Frederick's neck—is identical in the German and English illustrations. Foxe and possibly the designer of the cut or the publisher, John Day, were aware of the German

model, but their audience would have been virtually ignorant of the reference.

The "Book of Martyrs," in which this scene appears, places the martyrdoms of the Christian faithful from earliest times in the context of the shifting relationship between ecclesiastical and secular power. Thus Constantine's designation of Christianity as an official religion of the Roman Empire was, for Foxe, the central event in reversing the imperial policy of persecuting Christians. He believed that through the popes' later claim to secular authority, on the other hand, the church of Rome came to occupy the role of persecutor once played by tyrannical emperors. Foxe's history focuses on the present age of the Tudor monarchs, whom he glorifies, with the major exception of Mary Tudor, for restoring evangelical government following centuries of usurpation by the "papal Antichrist."

Foxe collaborated with his publisher, John Day, and the illustrators employed by the latter, whose woodcuts represent some of the "best new work seen in English books in the period." Although some of the cuts appeared previously in other books printed by Day, the entire series was first printed in *Acts and Monuments*. These illustrations differ from most prior English work in the attention devoted to detail, but they retain the tendency toward verticality that is a traditional hallmark of native design.[23] During the sixteenth century, publishers organized, controlled, and financed publications and decided whether and how they should be illustrated. When Day commissioned woodblocks for the books he published, he played the central role of artistic

[23] Ruth Luborsky, headnote to *STC* 11222, in *English Books with Woodcuts: 1536–1603*, forthcoming. She points out that the "designs are unusually sophisticated for English work and suggest, particularly in the poses of the figures, the precedent of continental Mannerism." She notes further that 53 separate cuts appear in the 1563 "Book of Martyrs," all but 4 of which are reused in the second edition. There are 54 cuts added to the total of 103 separate illustrations in the 1570 text. While only a few repetitions of woodcuts appear in the 1563 text, the second edition contains many repetitions. Very few woodcuts are added to the series in the third and later editions. Day lavished care and expense on the woodblocks used in the "Book of Martyrs," according to Hodnett, *Image and Text*, pp. 27–31. Although Hodnett contends that the illustrations "are in the Holbein tradition of clean outlines, simplified shapes, and restrained parallel-line shading," stylistic analysis indicates that they are in the English tradition. Hodnett ignores iconography in favor of identifying the cutters from whom Day commissioned his woodblocks and discussing technical and stylistic features like outline, cross-hatching, and shading. On verticality as a trait of native design, see Nikolaus Pevsner, *The Englishness of English Art* (Harmondsworth, 1978), pp. 94–95, 115–19. Warren Wooden notes in *John Foxe* (Boston, 1983), p. 49, that Foxe "often coordinated his text with the engravings," but evidence is lacking for his claim that "he had commissioned" the woodblocks himself. See also William Haller, *Foxe's "Book of Martyrs" and the Elect Nation* (1963), pp. 122–23. On the mid-century origins of Day's career as a publisher of illustrated books, see *ERL*, pp. 128–29, 187–88, 193–94, 462–64.

"middleman" so successfully that he gained a reputation as the publisher of the finest illustrated books of sixteenth-century England.[24] The reprinting in the "Book of Martyrs" of two woodcuts from old blocks that were cut for him during the reign of Edward VI—the execution of Anne Askew and an initial E portraying King Edward's acceptance of a Bible translation—exemplifies the centrality of the publisher's role, because Day retained the blocks during the period under Queen Mary when he ceased open activity as a publisher (see *ERL*, figs. 8, 15, and p. 464). In general, woodcut images are subordinate to the texts in which they appear. For this reason, and because the author's extensive printed commentary offers a detailed program containing many allusions to imagistic details and cross-references to the body of his history, Foxe must have joined Day in planning the woodcut series. He might have designed some of the sketches for the illustrations. When chained copies of the "Book of Martyrs" were placed in English cathedrals under a 1571 order from the Convocation in Canterbury, this text and its illustrations became universally familiar in Elizabethan England.[25]

The woodcuts in the "Book of Martyrs" tend to be of three kinds. Small figures of martyrs recur randomly throughout the collection. Larger and more realistic scenes may have been designed from eyewitness accounts as illustrations for specific martyrdoms; these narrative woodcuts function as direct illustrations for the text because they carefully incorporate details mentioned by Foxe and their banderoles quote words that he attributes to the martyrs. A small number of large illustrations, like the pictures of Henry VIII or Elizabeth triumphing over the pope (Figs. 51 and 50), introduce real persons into allegorical scenes. Most of the woodcuts portray martyrdoms of Protestant saints, filling an artistic void left by the Reformation prohibition against books of hours and collections of saints' lives like the *Golden Legend*, whose illustrations would depict saints and the implements of their martyrdom (swords, arrows, racks, braziers, grids, etc.). In the popular imagination, Foxe's *Acts and Monuments* is remembered for the lurid images of the "roasting" of Sir John Oldcastle; hangings of Lollards; Bilney's expulsion from his pulpit by friars; the seemingly countless burnings of Protestant martyrs, such as Rogers, Latimer, Ridley, Hooper, Cranmer, and others; and even the exhumation and posthu-

[24] Aside from the "Book of Martyrs," Day's major illustrated publications include Stephen Bateman's *Christall Glasse of Christian Reformation* (1569), William Cuningham's *Cosmograpical Glasse* (1559), Richard Day's *Christian Prayers and Meditations* (1569) and *Booke of Christian Prayers* (1578), and Jan van der Noot's *Theatre for Voluptuous Worldlings* (1569).
[25] J. F. Mozley, *John Foxe and His Book* (1940), p. 147.

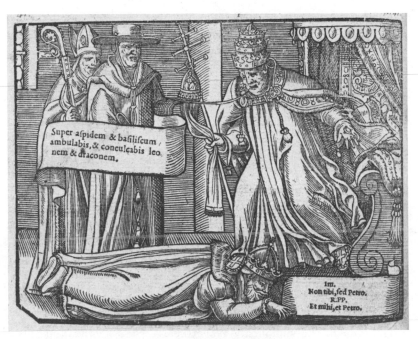

Super aſpidem & baſiliſcum,
ambulabis, & conculcabis leo,
nem & draconem.

Im,
Non tibi, ſed Petro,
R.PP.
Et mihi, et Petro,

37. *Pope Alexander III Treading on the Neck of*
Emperor Frederick Barbarossa, from John Foxe,
Actes and Monuments, 1st ed. (1563)

mous burning of the bones of Fagius and Bucer. The portrayal of
Bishop Bonner, one of the persecutors, was so realistic that he is said
to have complained over the accuracy of his likeness. These pictures
evidently served as visual arguments that could be understood even by
the illiterate.[26]

Most of the nonmartyrological scenes of political controversy pro-
claim powerful visual propaganda on behalf of the Protestant Tudor
monarchs. The *topos* of the Crown versus the Tiara recurs in many of
these scenes, notably in three woodcuts that were introduced in the
1563 "Book of Martyrs": Alexander III "treading on the neck" of
Frederick Barbarossa, Emperor Henry IV's submission to Gregory VII
at Canossa, and the initial capital C portraying Queen Elizabeth's

[26] Ruth Luborsky differentiates between "narrative scenes and isolated martyrs" in
the headnote cited above (n. 23). She points out that the former are "presented dramat-
ically, showing the interactions between the participants. The depictions of the main
characters reveal a careful translation of details described in the text—such as the kind
of expression on a person's face or the special kind of hat he wears." See also Wooden,
John Foxe, p. 49; Mozley, *Foxe and His Book,* pp. 130–31, 140; and *Foxe's Book of
Martyrs,* ed. G. A. Williamson (1965), p. xx.

triumph over the pope (Figs. 37, 43, 50). Aside from images showing Edward VI piously receiving a Bible and attending a sermon by Hugh Latimer (*ERL*, fig. 15; Fig. 52, below), no other portraits of Tudor monarchs or popes appear in the first edition. The only other English ruler to appear is King John in the fold-out illustration of his alleged poisoning by a monk of Swineshead Abbey (Fig. 57).[27]

The absence of a woodcut depicting Mary Tudor in the "Book of Martyrs" reflects the general rarity of extant portraits of her. Despite the similar duration of Edward VI's reign, many of his images survive because of the return to Protestantism that followed the death of his Catholic sister. His likeness was in demand following the religious settlement in 1559 because it was politically useful under Elizabeth I for validation of a line of Protestant succession.[28] The failure to portray Queen Mary may be explained further by the fact that it was difficult to attack a member of the royal family directly, even if she were detested for ordering the executions of hundreds of Protestants—artisans and merchants for the most part—whose persecutions were commemorated by Foxe's text and more than half of the woodcuts in all of its editions. All of the woodcuts of suffering that occurred during Mary's reign blame her only implicitly. Nevertheless, Foxe's vilification of the "bloody persecution" of this reign prepared the way for the queen's later reputation as "Bloody Mary," even if he did not coin the phrase.[29] Historical allusions and woodcut illustrations of martyrdoms associate her reign with government by Antichrist and the tyranny of corrupt emperors like Nero and Diocletian (*A & M* [1877], 8:670).

Foxe carefully qualifies his attacks upon the late queen in the "Book of Martyrs," even though he cites many instances of "God's great wrath and displeasure" against her regime. Although he censures Mary for provoking divine retribution "against her, in plaguing both her and her realm, and in subverting all her counsels and attempts, whatsoever she took in hand," he offers no "detraction to her place and state royal, whereunto she was called of the Lord." Foxe couches even one of his most direct attacks in an ironic mode:

[27] *A & M* (1563), B1 and pp. 25, 41, 68, 675, and 1353. The woodcuts that were pasted onto the page or tipped into the volume are missing in some copies.

[28] Strong, *Portraits*, 1: 93. The production of royal portraits increased substantially during the Reformation, when their possession "became a symbol of loyalty to the crown in troubled times." Most portraits are posthumous tokens of dynastic loyalty, according to Strong, *Portraits*, 1: 157–58.

[29] *A & M* (1877), 8: 624. *OED*, "Bloody," 6, cites Charles Dicken's *Child's History of England* (1853), p. xxx: "As Bloody Queen Mary, this woman has become famous, and as Bloody Queen Mary, she will ever be remembered with horror and detestation." Foxe's verbal assaults against Mary lack the stridency of some contemporary attacks against her as an English Jezebel (see pp. 220, 225).

So may it be said of queen Mary and her Romish religion; that if it were so perfect and catholic as they pretend, and the contrary faith of the gospellers were so detestable and heretical as they make it, how cometh it then, that this so catholic a queen, such a necessary pillar of his spouse the church, continued no longer, till she had utterly rooted out of the land this heretical generation?

This tendency to avoid explicit criticism of the monarch typifies an age lacking in freedom of speech and thought. The Catholic loyalist George Cavendish followed a similar strategy in his "metrical visions" by detaching Henry VIII and Edward VI from the Protestant cause and blaming John Dudley, Duke of Northumberland, for excesses during Edward's reign.[30] Because reluctance to lodge specific attacks against members of the royal house disappeared very slowly, even John Ponet's *A Shorte Treatise of Politike Power* (Strasbourg, 1556), one of the earliest avowals of open resistance to tyrants, displaces considerable blame from Queen Mary onto "savage Bon[n]er" as "a bare whippe Jacke" (D7v–8, E2^{r-v}). Appointed Bishop of Winchester in the days of Edward VI, Ponet was a zealous Protestant who went into Continental exile at the accession of Mary Tudor.

Because Foxe tends to avoid direct criticism of the Catholic queen, whose claim to govern was almost universally accepted as legitimate, he follows a strategy of displacing direct hostility onto two bishops whom he vilifies for executing her orders: Edmund Bonner and Stephen Gardiner. Despite his otherwise careful effort to substantiate polemical attacks and to offer exact transcriptions of documents that he received,[31] uncorroborated attacks on those prelates abound in the text. Although two woodcuts attack "cruel Bon[n]er" for torturing a victim who was later burned alive and for scourging "Goddes Saynctes in his Orcharde" (*A & M* [1563], pp. 1101, 1689), Gardiner is never depicted visually. Foxe does transfer blame from Mary to the latter bishop, whom he characterizes as an Achitophel for "perverting his princes[s]" (*A & M* [1877], 7:591–92, 8:670). The queen is thus made to play the role of a Tudor Absalom in a variation of her father's iconography, for, regardless of gender, she is seen as a "son" who has rebelled against the religious policies of Davidic Henry. The clear implication of Henry VIII in Gardiner's alleged deceptions and some of the martyrologies in the "Book of Martyrs" may help to account for the omission of the king's portrait from the first edition. Zealous Prot-

[30] *A & M* (1877), 8: 625–26, 628. See George Cavendish, *Metrical Visions*, ed. A.S.G. Edwards, Renaissance English Text Society, vol. 9 (Columbia, S.C., 1980).

[31] A. G. Dickens, *The English Reformation*, rev. ed. (1967), pp. 46–47; see also *ERL*, pp. 437–38, 442–43.

estants like Foxe experienced profound ambivalence over Henry's role in the English Reformation. They had every reason to resent the king's papal title of *Fidei Defensor*, for although he ruptured relations with the Church of Rome, he did so only after a long career as a persecutor of Protestants. The latter part of his reign was similarly marked by religious repression and executions of Protestant radicals like Anne Askew (Fig. 67; see also *A & M* [1563], p. 666, and *ERL*, fig. 8).

Stephen Gardiner was even more valuable to Foxe as a scapegoat for King Henry than he was for Mary, because vilification of the bishop as a demonic *éminence grise* helped to exculpate the king whom the reformers blamed for tracking down and burning heroes like John Frith, Robert Barnes, and William Tyndale. This legendary view of Gardiner survived into the next century, when Shakespeare similarly treated Wolsey as a scapegoat in *Henry VIII*, a play heavily indebted to *Acts and Monuments*, where the "cunning Cardinal" repeatedly tricks an unrealistically naive king (e.g., 1.1.168, 2.2.19–36). After the downfall of Wolsey as a "king-cardinal" and "blind priest," however, Shakespeare's Henry easily outwits Gardiner, who first found favor as the cardinal's protégé (5.2.20–189). The adulation of the Tudors as "godly" monarchs could survive intact only through the displacement of blame onto the prelates Gardiner and Bonner (or Wolsey) as unwitting agents of divine wrath against a backsliding nation.

John Day assimilated iconography associated with the Roman triumphal procession and the Adoration of the Magi into the woodcut sequence that he inserted as an appendix to the second edition of the "Book of Martyrs," published in 1570. The illustrations in this appendix, which appears at the end of Volume One, bear the title of "The proud primacie of Popes paynted out in Tables [i.e., woodcuts], in order of their rising up by litle and litle, from faithfull Byshops and Martyrs, to become Lordes and governours over kynges and kyngdomes, exaltyng them selves in the Temple of God, above all that is called God. &c." Foxe's commentary makes it clear that these pictures depict transitory victories of the papacy that will lead eventually to a grand reversal—the Protestant Reformation, an event that prefigures the Second Coming of Christ mentioned in the Day of the Lord prophecy in 2 Thessalonians 2. Foxe mirrors the apocalyptic enthusiasm of St. Paul in his belief that although the end of the world has not yet arrived, the defeat of the pope as Antichrist (the "man of sinne" of 2 Thess. 2:3) is one of the necessary preconditions for Christ's return.

The twelve woodcuts entitled "The Proud Primacy of Popes" trace the relationship between Christian bishops and secular rulers from the time of the "martyrdome of good Bishops under wicked Emperors in

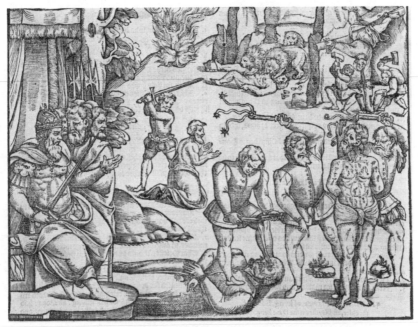

38. *Martyrdom of the Bishops*, from John Foxe,
Actes and Monumentes, 2nd ed. (1570)

the primitive Church."[32] In the manner of Luther's commentary for the *Passional Christi und Antichristi*, Foxe extracted his detailed commentary from papal bulls and decrees. The Foxe cycle has its immediate origin in the 1563 woodcuts of Henry IV at Canossa and Frederick Barbarossa's defeat by Pope Alexander III, which are carried over intact from the first edition (Figs. 43, 37). The Canossa scene is included twice in the second edition, because it is used to illustrate Foxe's narrative account of Pope Gregory's humiliation of the emperor prior to its appearance in the appendix. The eleven other illustrations in "The Proud Primacy of Popes" were designed and cut as a self-contained sequence.

The initial woodcut portraying the torture of a bishop at the feet of an enthroned and crowned emperor, along with other scenes of martyrdom, evokes the waning of the pagan empire associated with the persecutions of Diocletian (Figure 38). At this point the idealized bishop is still no more than the spiritual "overseer" or "supervisor"

[32] The conflict between Christian emperors and the papacy is a major structural principle of the *Acts and Monuments*, according to Yates, *Astraea*, pp. 43–44. Unless otherwise noted, references are to *A & M* (1570).

indicated by the Greek title ἐπίσκοπος, epitomizing the "Image of the true Catholike Church of Christ." The succeeding scene reverses the hostile relationship of church and state by portraying "Constantinus the Emperour embrasing Christen Byshops . . . who at the first were poore, creepyng low upon the ground" (Fig. 39; 2N1^{r-v}), in a scene demonstrating the proper subordination of ecclesiastical authority to the theocratic power of the model Christian ruler. One may question why Foxe idealizes Constantine as the archetype for ideal Christian government rather than Justinian the Great, who was, after all, a true believer who governed the Eastern Roman Empire as a Christian theocracy and showed a genuine interest in theology and the codification of laws. Constantine, on the other hand, was a semi-pagan who continued to build temples to the Roman gods. Foxe overlooks the realities of his reign, however, because of the central role that he played in the establishment of Christianity as an official religion of the Roman Empire.

Succeeding woodcuts portray the steady deterioration of the perceived relationship between the ecclesiastical and temporal powers. The third woodcut thus depicts the Bishop of Rome as a peer who shares the same throne as the emperor; in its first appearance in these woodcuts, the episcopal miter is now opposed to the imperial crown (Fig. 40). Foxe joined other reformers in claiming that the advent of the "false" church of Antichrist came about when a successor to Constantine, the Eastern Roman Emperor Phocas, acknowledged the primacy of the Bishop of Rome by elevating Boniface III to the position of "universall Byshop." Protestants like Foxe were particularly eager to use arguments of this kind to discredit the Donation of Constantine or "S. Peters patrimonie," which supported the papal claim to legitimacy as a temporal authority in the secular world. That forgery granted control of western Christendom to the pope and acknowledged his superiority over the patriarchs of Antioch, Jerusalem, Alexandria, and Constantinople. Not only did the Donation of Constantine confer imperial badges upon Pope Sylvester I and his successors, but it indicated that the emperor should show homage by holding the bridle of the papal steed. Protestants eagerly cited Lorenzo Valla's demolition of this fraudulent document in their identification of the pope as Antichrist. As Foxe states: "Christ never practised but onely the spirituall sword [i.e., divine authority revealed in the scriptures] . . . [but the pope] claymeth both spirituall and temporall" (2N2).

Although thirteenth-century frescoes portraying the Donation of Constantine and other events in the lives of the emperor and Pope Sylvester located in the Oratory of St. Sylvester in the convent adjacent

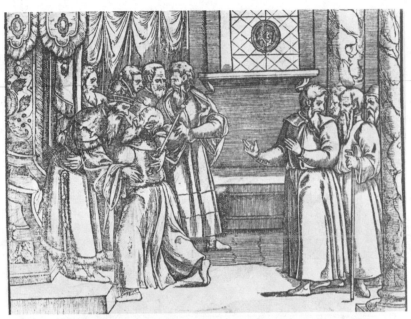

39. *Emperor Constantine Embracing Christian Bishops*, from John Foxe, *Actes and Monumentes*, 2nd ed. (1570)

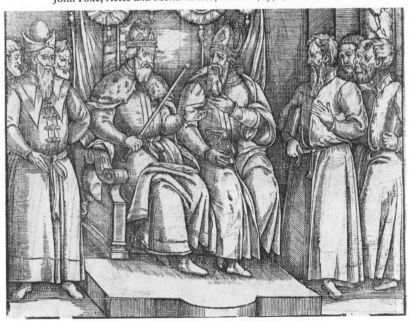

40. *The Bishops of Rome Advanced*, from John Foxe, *Actes and Monumentes*, 2nd ed. (1570)

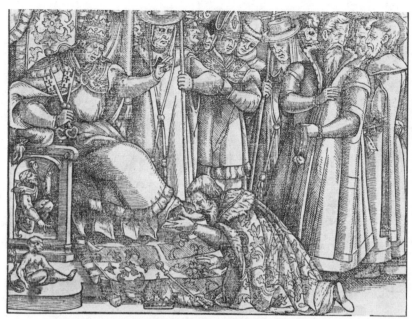

41. *Emperor Frederick Kissing the Pope's Feet*, from John Foxe,
Actes and Monumentes, 2nd ed. (1570)

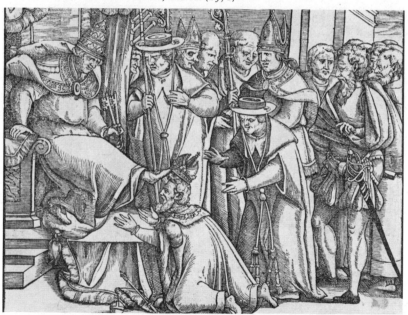

42. *Celestine III Crowning Henry VI with His Feet*, from John Foxe,
Actes and Monumentes, 2nd ed. (1570)

to the Church of Santi Quattro Coronati in Rome are not sources, they
do furnish a series of prototypes for the subordination of the Crown
to the Tiara and for the triumphal processions of the popes in the Foxe
woodcuts. Central to the series is the obeisance that the emperor pays
on bended knee as he confers a diadem on the enthroned pope (this
crown had not yet acquired the second and third circlets added to the
papal tiara in later centuries). A succeeding scene shows the pope on
horseback, shaded by attendants with an umbrella, while the crowned
emperor humbly proceeds on foot holding the horse's bridle like a ser-
vant. The pope then stands above Constantine, who curtseys in a scene
where Sylvester displays an icon of Sts. Peter and Paul. The portrait of
Constantine's baptism starkly contrasts the emperor's nakedness with
the clerical vestments and robes of the pope and others standing up-
right over him.[33]

Foxe manifests the nationalistic motive of these tableaux in the mid-
dle section of six woodcuts, which specifically portray the imposition
of papal authority over the Holy Roman Empire or the Kingdom of
England. It is important to remember that the closed crown of the em-
peror seen in these woodcuts had been adopted by Henry VII as a Tu-
dor dynastic device. In every case, Foxe satirizes papal claims as a cor-
rupt mockery of the humility of Christ and the primitive church, for
the increasing power and wealth of the papacy represent an inversion
of Christ's admonition in Matthew 22:21 about paying taxes to Cae-
sar. Foxe comments that "Christ payed tribute to *Caesar*," whereas the
pope "maketh *Caesar* pay tribute unto hym" (2N2). Christ's differen-
tiation between the temporal and spiritual realms is incompatible with
the papal claim to authority over both church and state. Inversions and
variations of visual imagery associated with the Adoration of the
Magi—images of kings surrendering crowns, kneeling, and kissing the
feet of popes or their representatives—supplement Foxe's documented
scriptural sources. The dominant motif is the humiliation of emperors
before the popes who rise above them in a debasement of the Roman
triumph and overlordship of Christ; the popes usurp the princely claim
to resemble Roman emperors.

Plutarch, who insists in his *Parallel Lives* on close resemblances be-
tween illustrious Greeks and Romans, furnishes major literary models
for the rival claims of emperors and popes to resemble ancient fore-
bears. Woodcuts commissioned by Emperor Maximilian I thus portray

[33] Otto Demus, *Romanesque Mural Painting* (1970), pls. 72–74; see also Roloff Beny
and Peter Gunn, *The Churches of Rome* (New York, 1981), pp. 70, 73, and 80. On the
Donation of Constantine, see Nicolas Cheetham, *Keepers of the Keys: A History of the
Popes from St. Peter to John Paul II* (New York, 1983), p. 18.

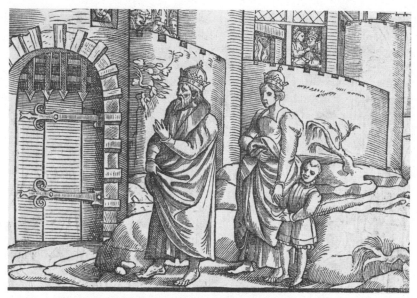

43. *Henry IV at Canossa*, from John Foxe, *Actes and Monuments*, 1st ed. (1563)

him as Caesar *redivivus* riding in triumph. Flavio Biondo's *Roma Triumphans* (1459; published in Brescia in 1482) established the claim that papal Rome represents a second Empire ruled over by Renaissance princes who are the heirs not only of St. Peter but also of the Caesars. In assuming the name Alexander VI, Roderigo Borgia styled his pontificate on the reign of Alexander the Great, just as he named his son Cesare (Caesar). Cesare Borgia then adopted the style of a new Caesar by riding as *triumphator* in ceremonial procession. Pope Julius II distinguished himself not only by his patronage of Raphael and Michelangelo, but also by adopting a pontifical name modeled on the great general and statesman whose dictatorship prepared the way for the Roman empire.[34]

Many woodcut variations of the motif of the popes treading "upon the neckes even of Emperours" and bringing "the heades of Kyngs and Princes under their gyrdle" (2N1ᵛ) dramatize the alleged usurpation of imperial majesty and tyranny by the Bishops of Rome in the "Book of Martyrs." Popes now play the role of persecutor originally held by pagan emperors such as Diocletian. Foxe contrasts the papal tiara or triple "crownes of gold" not only with the crowns of deposed emperors,

[34] I am indebted to an unpublished paper by Gordon Kipling.

144

but also with that of Christ, whose "crowne . . . was of sharpe thorne" (2N2v). Thus he presents Christian kings rather than popes as the "true" imitators of Christ. The heavy use of balance and antithesis in his commentary provides a textual equivalent of the visual dichotomies of Cranach's *Passional Christi und Antichristi* (see above, pp. 127–29).

These antitheses had a timely appeal at the Reformation court. Allegations portrayed by these woodcuts were live concerns when Henry Parker declared, in the context of praising King Henry for liberating England "from the captivitie Babylonicall," that the pope had elevated himself from the status of a humble cleric into "an ymage for pryncis to kisse his shoes."[35] The reformer John Philpot felt that it was appropriate to attack the "papal" Antichrist for hypocrisy in dedicating his translation "Of the trew difference of the powre of a kynge and the powre of the Churche" as a gift to Henry VIII:

> Christe did humble himselffe to washe thei feete of his disciples. But he [the pope] will[s] Emperors and kyngs to submitte the[m]selfes to kysse his f[ee]te. . . . Christe refused the crowne of golde, and receued one of thorns, but he [the pope] fleith from the crowne of thornes, and sekith the crowne of the worlde, and not beynge content w[i]t[h] one crowne, will haue upon hi[s] heade a triple crowne.[36]

John Bale dramatizes one of the most inflammatory charges among these in his courtly production of *King Johan* when the personification of Nobility claims that the pope oppresses "Christen princes by frawde, crafte and dissayte, / Tyll he compell them to kysse hys pestylent fete" (ll. 2408–09).[37]

The related image of the Crown of Thorns offers a figure for spiritual humility, one that is similar to the crowns of the Magi; in both cases, very similar images allude to a moment when Christ's divinity seemed denied. The Crown of Thorns was interpreted not only as an antipapal device, but also as a symbol of ideal kingship under the Protestant Tudors. Thus Edward VI dedicated a holograph copy of an an-

[35] *The Exposition and declaration of the Psalme, Deus ultionum Dominus* (1539), C2v–3. Originally dedicated in manuscript as a New Year's gift to Henry VIII, the text was published by the King's Printer, Thomas Berthelet.

[36] Bodl. MS Jones 3, fols. 3v–4. Matthew Parker endorsed this text on fol. 72v for publication during his tenure as Archbishop of Canterbury (1559–75), but the edition is no longer extant (if it ever appeared). Walter Deleen, a Brabantine emigré attached to the royal household who later headed the Dutch Church in London, similarly dedicated to Henry VIII his dialogue on the Royal Supremacy, "Libellus de tribus Hierarchijs, ecclesiastica, Politica, & oeconomica" (B.L. MS Royal 12 B. XIII, c. 1539–47).

[37] John Bale, *King Johan*, ed. Barry B. Adams (San Marino, Calif., 1969).

tipapal treatise in French, "Petit Traité a l'encontre de la primauté du pape," to Protector Somerset on 31 August 1549. Although his tutors guided such exercises, Edward doubtless cooperated in weaving scriptural commonplaces into a coherent tract:

> Jesus had a crown of thorns, and a robe of purple, and he was mocked by everybody: but the pope has three crowns and is honored by kings, princes, emperors, and all estates. Jesus washes the feet of his apostles: but kings kiss the feet of the pope. Jesus paid tribute: but the pope receives and has paid no tribute. Jesus preaches and the pope relaxes in his Castel Sant' Angelo. . . . Christ carries his cross: but the pope is carried. Christ came in peace like a poor man to the world: but pope takes great pleasure in creating war between the kings and princes of the earth.[38]

James I is the first British monarch whose crown is known to have been interpreted explicitly as a variation of the Crown of Thorns, but the association might have predated his reign.[39]

In the first of Foxe's scenes portraying the submission of an emperor or a king, the reader sees Frederick Barbarossa kneelng to kiss the feet of the pope, whose regalia include, in addition to the tiara, "the keyes of the kingdome of heaven" that were delegated to St. Peter by Christ according to Matthew 16:19 (Fig. 41). Protestants contested the papal claim to bear these heraldic keys in an apostolic succession going back to St. Peter, the first Bishop of Rome, arguing instead that true apostleship is a spiritual state that accords with preaching the gospel message of the New Testament (see above, pp. 67–70). The monkey tethered to the right of the throne symbolizes papal vanity. In the next scene, Pope Celestine III mockingly crowns Emperor Henry VI with his foot, and "with his foote spurneth the crowne from his head againe" (Fig. 42).

Two succeeding woodcuts depict the medieval cause célèbre that occurred when Henry IV went to Canossa to surrender his crown to the

[38] "Iesus auoit vne couronne d'espines, et vne robe de pourpre, et estoit moqué de tout chacun: mais le pape à trois couronnes et es honoré des rois de princes, des empereurs, et de tous estatz. Iesus laue les piedz de ses apostres: mais les rois baisent les piedz du pape. Iesus paié tribut: mais le pape reçoit et ne paié nul tribut. Iesus preche et le pape se repose en son chasteau de saint Ange. . . . Christ porte sa croix: mais le pape est porté. Christ venoit en paix comme vn pauure homme au monde: mais le pape prend grand plaisir à mettre guerre entre les rois et princes de la terre." Transcribed from C.U.L. MS Dd. 12. 59, fols. 13ᵛ–14. Dedicated to Protector Somerset, "De mon palais de Ouestmester sez Londres ce pénultime iour d'Aoust 1549." Edward's inconsistent use of the historical present confuses the distinction he wishes to make between Jesus's actions in the past and the pope's present practices.

[39] Allan H. Gilbert and Edgar Wind, "The Monarch's Crown of Thorns," *Journal of the Warburg and Courtauld Institutes* 3 (1939–40): 156–61.

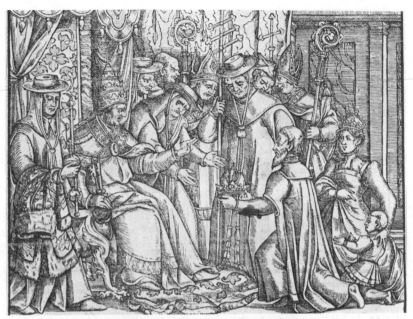

44. *Henry IV Surrendering His Crown*, from John Foxe, *Actes and Monumentes*, 2nd ed. (1570)

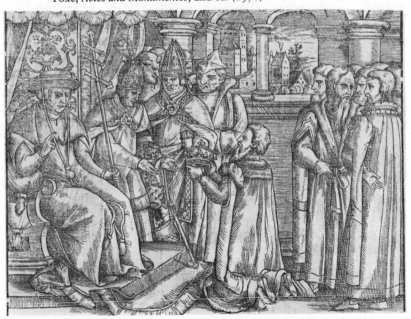

45. *King John Surrendering His Crown*, from John Foxe, *Actes and Monumentes*, 2nd ed. (1570)

147

pope. First we see the emperor and his family, whose unshod feet contrast with the crowns on their heads, debased to the status of lowly subjects as they are forced to wait "iii. daies upon Pope Gregory .7.," who is visible with his concubine through the window above (Fig. 43). The cardinals and clerics in the papal retinue look down from the battlements. Here it is the emperor rather than the pope who is the image of Christian humility, for he resembles "Christ [who] went barefoote uppon the bare ground" (2N2v).[40] The next woodcut portrays Henry IV's arrival in Gregory's throne room, where he "surrenderd his crowne to the Pope," who sits enthroned beneath a cloth of state appropriate to an emperor or king. With his queen and heir still at his side, Henry is forced to kneel and pay homage (Fig. 44).

Two woodcuts then shift the scene to England, where initially King John adopts the by-now-conventional kneeling posture of submission when he surrenders his crown to the papal legate, Pandulphus (Fig. 45). The next scene depicts John's successor Henry III paying homage and acknowledging fealty by "kissing the knee of the Popes Legate comming into England" (Fig. 46). Tudor reformers like Foxe remembered John's reign not for the revolt of the barons and the Magna Charta, but for the advent of the English struggle between Crown and Tiara.[41] Henrician typology also explains the intense concentration on emperors and kings named Henry in the entire woodcut sequence, because Foxe sees Henry VIII's break with Rome as the iconographical reversal of the medieval struggle between emperor and pope. This pattern of "kinship" among rulers named Henry parallels the pageant welcoming Henry VII's entry into York, where Solomon's Scepter of Wisdom was passed on to the founder of the Tudor monarchy by his six English predecessors of the same name (see p. 28).

The woodcut series concludes with three scenes of triumphal pageantry demonstrating the supremacy of the Tiara over the Crown as popes ride in state bearing the keys of St. Peter. These tableaux assimilate the imagery of imperial processions of ancient Rome, which survived in artistic renderings of the Procession of the Magi and Cranach's *Passional* as well as the literary formulations of the *Psychomachia* and Petrarch's *Trionfi*. As symbols of spiritual pride, these tableaux contrast sharply with Protestant advocacy of a return to a simple ministry based upon the New Testament model of Christ and the primitive church. The illustrations present in visual form the

[40] See above, pp. 135, 139.

[41] John's humiliation received visual formulation as early as the pen drawing of the crown falling from the king's head in the margin of *Flores Historiarum*, a historical collection written in Italy in the first half of the fourteenth century (Bodl. MS Latin hist. d. 4, fol. 159).

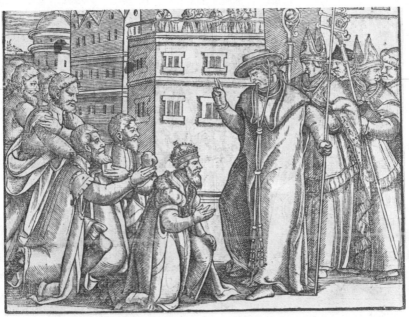

46. *Henry III Kissing the Knee of the Papal Legate*, from
John Foxe, *Actes and Monumentes*, 2nd ed. (1570)

antithesis that underlies Foxe's entire commentary on the woodcut se-
ries, for he satirizes abandonment of the humility of Christ who "went
barefoote uppon the bare ground" in contrast to the pope who "with
hys golden shoes is caryed on mens shoulders" (2N2).

First the crouching figure of Emperor Frederick Barbarossa is dis-
graced "for holding Pope Adrians styrrup on the wrong side" (Fig. 47).
The succeeding scene portrays the complete victory of the pope, who
rides in procession with "the Emperour holding his bridle, and kings
going before him" (Fig. 48). The walking figures of rulers who bear
their coronation regalia typify the papal claim to supremacy over tem-
poral power. The concluding woodcut repeats that image, with the en-
throned pope now carried in triumph on men's shoulders with the em-
peror and kings "going before him" (Fig. 49). These two final scenes
allude to the "Babylonian Captivity" of the church initially attributed
to the migration of the papal court to Avignon in the fourteenth cen-
tury.

Taken as a whole, "The Proud Primacy of Popes" portrays an inter-
national papal conspiracy against the secular rulers of the Holy Roman
Empire and England, who are presented as the inheritors of both Con-

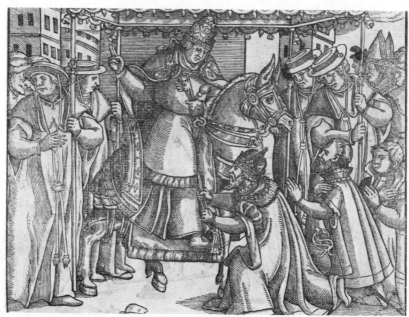

47. *Pope Adrian IV Chiding Frederick I*, from John
Foxe, *Actes and Monumentes*, 2nd ed. (1570)

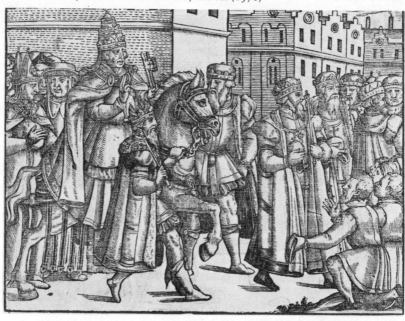

48. *Emperors Preceding the Pope*, from John Foxe,
Actes and Monumentes, 2nd ed. (1570)

stantine (Figs. 39, 40) and the bishops who are martyred in the opening scene (Fig. 38). The princely pontiffs of the later Middle Ages are viewed, on the other hand, as usurpers who govern the church and claim temporal power as the self-proclaimed heirs of the corrupt Roman emperors. The abasement of the crowned "kings of the earth" in the concluding tableaux (Figs. 47–49) evokes the apocalyptic vision of Babylonian (i.e., Roman) triumph (see Rev. 17–18); Protestant commentators interpreted the identification of Antichrist with the empire of the ancient Romans in the Book of Revelation as a prophecy of papal tyranny. Because the victories of Antichrist are transitory, this woodcut sequence provides a preamble to the reconstruction of church and state during the Reformation. It anticipates the downfall of the papacy as the fulfillment of the scriptural prophecy of the Fall of Babylon (Rev. 18).

 The ideological germ for "The Proud Primacy of Popes" is the fundamental Protestant doctrine of *sola scriptura*, which claims to reverse excessive reliance on the "man-made" decrees and traditions of the popes and church councils with a return to the reforms in religion established by Christ and described in the New Testament. Protestants like Foxe regarded "scripture alone" as the unchallengeable worldly authority concerning the church and human life. Iconographically antecedent to the woodcut triumphs of popes over secular rulers is the image of the deposition of the "ungodly" pope that found favor at the Reformation court of Henry VIII during the 1530s. Under royal patronage, Girolamo da Treviso designed a polemical allegory entitled *The Four Evangelists Stoning the Pope* for the king's collection (c. 1536–42). New Testament revelation, symbolized by the New Jerusalem and the light of the candle in the background, triumphs over the toppled pope, whose fallen retinue includes the figures of Avarice and Hypocrisy. Roy Strong observes that the scene imitates a woodcut of the "stoning of the Blasphemous Man" in the Coverdale Bible.[42] It also includes a punning rejection of the Roman doctrine of apostolic succession based upon Christ's deputation of St. Peter as founder of the true church: "Thou art Peter, and upon this rocke I wil buylde my Church: and the gates of hel shal not overcome it" (Matt. 16:18). The manner in which Matthew, the source of this text, joins the other Evangelists in stoning the self-proclaimed heir of St. Peter typifies the Protestant reinterpretation of this verse as

[42] Strong, *Holbein*, p. 9 and fig. 4. He also notes that Henry VIII's collection contained two other variations of this motif, "Truth the Daughter of Time, bringing to light the iniquities of the Pope" and "the King vanquishing the Pope identified as the beast of the Apocalypse." Only the da Treviso work is extant.

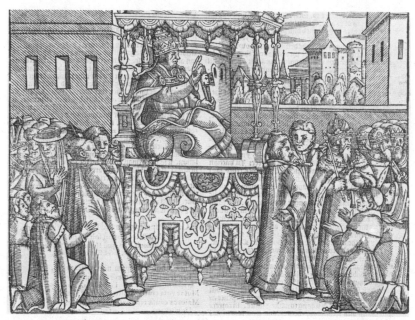

49. *The Pope in Triumph*, from John Foxe, *Actes and Monumentes*, 2nd ed. (1570)

a reference not to ecclesiastical hierarchy, but to the inward faith possessed by any true Christian. The Geneva Bible gloss on this verse accordingly ignores the Roman interpretation: "Upon that faith whereby thou hast confessed and acknowledged me: for it is grounded upon an infallible trueth."

This debasement of the pope by the four Evangelists clarifies the inversion and parody of familiar Catholic imagery in the woodcut sequence in the "Book of Martyrs." The victory of the Crown and Gospel over the Tiara in Tudor Protestant iconography presents the doctrine of papal supremacy as an anomaly that departs from the short-lived ideal of collaboration between the "true" Christian bishop and the emperor, which was perceived to have existed under Constantine. Historical precedents provided the Tudor monarchs with models for self-definition that substantiate Kai Erikson's theory that evangelical Protestants saw themselves in terms of their negations or opposites.[43] Stephen Greenblatt qualifies this view, however, with his insight that this mode of negative definition underlies the self-perception of both Catholic and Protestant authors during the Renaissance, for

[43] Kai Erikson, *Wayward Puritans: A Study of the Sociology of Deviance* (New York, 1966), p. 64.

"self-fashioning is achieved in relation to something perceived as alien, strange, or hostile. This threatening Other—heretic, savage, witch, adulteress, traitor, Antichrist—must be discovered or invented in order to be attacked and destroyed." It follows as a corollary, therefore, that the

> alien is perceived by the authority either as that which is unformed or chaotic (the absence of order) or that which is false or negative (the demonic parody of order). Since accounts of the former tend inevitably to organize and thematize it, the chaotic constantly slides into the demonic, and consequently the alien is always constructed as a distorted image of the authority.[44]

The Tudor Protestant monarchs (and their apologists) accordingly defined royal authority not only as a return to the gospel model, but also as a corrective reversal of the papal usurpation of secular power that destroyed kings and emperors even as it appropriated their icon-ographical symbols: crowns, daises, thrones, robes, palaces, and processions. The Protestant Tudors reenacted the role of the Magi—monarchs who recognize the true emperor, Christ, as opposed to an authority who claims to be Christ's vicar. It is no accident, then, that Henry VIII and his son Edward VI came closer than any European Protestant rulers to wielding the theocratic power claimed by Constantine the Great and the Byzantine emperors. No inherent evil was attached to the imagery of Roman triumph used in the "Book of Martyrs," because Foxe employed it to praise both Henry and Elizabeth. In fact, he interpreted Henry's claim to imperial status for the Kingdom of England as a millennial event reestablishing the "true" Church of England after its domination by the papal Antichrist during the later Middle Ages.[45] It is important to note that Henry VIII never lodged a claim to genuine status as an emperor, nor did the reference to "the imperial crown" in the 1533 Act in Restraint of Appeals have any real significance, except as a sign that Henry claimed within the borders of his own realm the kind of absolute sovereignty exercised by the later Roman emperors.[46]

Because Henry and Edward objected to the papal claim of supremacy and collapsed distinctions between secular and ecclesiastical government, however, it seems difficult to reconcile their absorption of the

[44] Stephen Greenblatt, *Renaissance Self-Fashioning: From More to Shakespeare* (Chicago, 1980), p. 9.

[45] See Strong, *Holbein*, p. 6.

[46] Walter Ullman, " 'This Realm of England Is an Empire,' " *Journal of Ecclesiastical History* 30 (1979): 176, 180–81. See also G. R. Elton's *Studies in Tudor and Stuart Politics and Government*, 3 vols. (Cambridge, 1974–83), 1: 183–84; and his *Tudor Constitution: Documents and Commentary*, 2nd ed. (Cambridge, 1984), pp. 341–43.

church and their molding it into an arm of the state with Christ's admonition concerning the separation of worldly and heavenly realms (Matt. 22:21). The kingship of these English "popes" paradoxically emulated the power of the pope as much as it did that of their model emperor, Constantine. Thus the enthroned king on the title page of the Great Bible (Fig. 14) unifies the ecclesiastical and secular hierarchies that flank him in a redefinition of the motif of the division of the powers in late medieval art. As a Protestant monarch confers copies of the Bible that formerly symbolized clerical authority or supremacy, he assumes the role once reserved for the pope, Ecclesia, or Christ.[47] Even Elizabeth I rejected the claims of her father and brother to spiritual authority as *caput* ("head") of the church, when she styled herself instead as no more than its *gubernator* ("governor" or "director").

The historiated initial C of the dedication of the first edition of *Actes and Monuments* (1563) accordingly praises Queen Elizabeth as a second Constantine governing a Christian empire (Fig. 50), just as Foxe himself plays the role of a new Eusebius chronicling the martyrdoms of the faithful during the recent reign of Queen Mary. According to Frances Yates, this initial capital is "the climax of the whole book" (Yates, *Astraea*, p. 44). Although the Constantine invoked by Foxe in defense of the Tudor *imperium* is closer to myth than reality, the emperor did provide a useful precedent during the Reformation, because he conferred legitimacy upon the Christian church at the same time that he brought it under the authority of the imperial government by convoking the great councils of the church at Arles and Nicaea.[48] When he was Queen Elizabeth's chaplain, John Bridges commented on "howe in all ages, since Christendome began to flourishe under the Great Constantine, that christian Emperors, Kings and Princes, have dealt as doth your Majestie in the oversight of Ecclesiastical Matters, till the Pope by little and little" encroached on them.[49] Frances Yates notes that the Tudor claim to divine right "to rule over both church and state was a derivation from the claims of Roman Emperors to be represented in the councils of the church," just as the "imperial" sovereignty that they claimed over such councils legitimized "the national council under royal authority by which the Church of England was reformed" (Yates, *Astraea*, p. 41).

[47] See Cahn, "Tympanum of Saint-Anne," pp. 70–71.

[48] Patrick Collinson, "If Constantine, Then Also Theodosius: St. Ambrose and the Integrity of the Elizabethan *Ecclesia Anglicana*," *Journal of Ecclesiastical History* 30 (1979): 208–209. For further discussion of the role of Constantine in the "Book of Martyrs," see above, pp. 133, 140.

[49] *The Supremacie of Christian Princes* (1573), ¶4ᵛ.

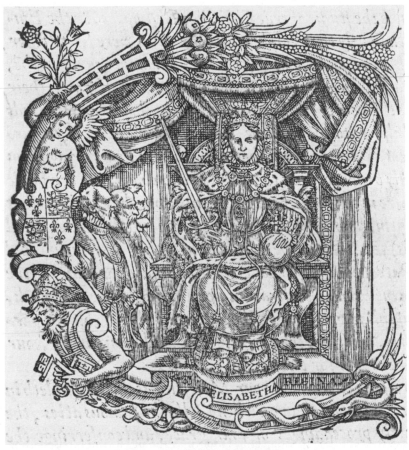

50. *Elizabeth I as Emperor Constantine*, from John
Foxe, *Actes and Monuments* (1563)

The iconoclastic scene in the initial capital C from the "Book of
Martyrs" reverses the triumph of pope over emperor by portraying
Elizabeth, seated on her throne and carrying the sword of justice, as
she surmounts the toppled pope, who is entwined with demonic ser-
pents beneath her feet (Fig. 50). When Yates suggests that Tudor im-
ages of this kind are influenced by "the Catholic imperial symbolism
of Charles V" through "a well-known set of twelve engravings" cele-
brating his imperial triumphs (Yates, *Astraea*, pp. 56–57), she over-
looks the satiric overlay that triumphal scenes receive in Lutheran po-
lemics like the *Passional Christi und Antichristi*. The heaviness of the
queen's dais bears down the pontiff, whose tiara and broken keys are

"outweighed" spiritually by her regalia, the royal arms, and Tudor roses. The cornucopia integrated with the head of the C symbolizes her reign as a time of peaceful "harvest" following spiritual discord; the horn of plenty had long been used as an attribute of fruitfulness and concord. Although the scene lacks the true vertical axis of other triumphal scenes (Figs. 22, 51) because the curvature of the C necessitates the displacement of the pope to the lower left, a strict dichotomy exists between "true" and "false" religion. The figure of the queen assimilates overlapping images of the Coronation of the Virgin and the Blessed Virgin's trampling of symbols of evil. Woodcuts of the Woman Clothed with the Sun, from Revelation 12, characteristically portray her in queenlike opposition to the Seven-headed Beast as the antithesis of the Whore of Babylon (Figs. 64 and 65). These associations coalesce in a powerful portrait in which Queen Elizabeth carries the regal sword symbolic of the Tudor unification of ecclesiastical and secular authority.

All of this is explicit, but the woodcut may also redefine long-established imagery of the Adoration of the Magi by placing three men who reenact the homage of the Three Kings in the favored position at the queen's right-hand side.[50] This association would link her to both the Christ Child and the Virgin Empress on whose lap he sits enthroned (see Figs. 34, 35). Because the woodcut occupies the typographical position of a dedication scene, it is probable that the three men represent John Foxe, John Day, and their likely sponsor at court, Thomas Norton. The man nearest the queen resembles the 1562 portrait of Day in the printer's device printed above the book's colophon. The central figure of the aged man with the bifurcated beard is similar to known portraits of Foxe.[51] Conjectural identification of Norton is based upon the closeness of his association with Foxe, his access to the royal court, and his advanced Protestant views.[52]

[50] Grabar indicates the ancient imperial associations of the Adoration of the Magi in *Christian Iconography*, pp. 81, 99, and ills. 209, 252.

[51] For an engraving of Foxe by Willem and Magdalena van de Passe for Henry Holland, *Herwologia* (Arnheim, 1620), p. 201, see Hind, vol. 2, pl. 83a; and Strong, *Portraits*, vol. 2, pl. 246, The close relationship between author and publisher is manifest in the Foxe autograph within Day's portrait-device (see Hind, vol. 1, pl. 13a) in a first edition of the "Book of Martyrs" presented to Laurence Humphrey, which is preserved at Magdalen College, Oxford. For this information I am grateful to Dr. David Norbrook, Fellow and Librarian of the College. Frances Yates offers no evidence to support her conjecture that the three men in the historiated initial C represent the three estates (Yates, *Astraea*, p. 43). See Hodnett, who suggests in *Image and Text*, p. 32, that the men are "perhaps Foxe, Day, and a court official."

[52] I am indebted to Patrick Collinson for the suggestion that Norton is the third man. Norton's association with Elizabeth's chief minister William Cecil may go back to their service to Protector Somerset during Edward VI's reign. On Norton's role as "a conscientious labourer on behalf of Council and Queen," see G. R. Elton, "Parliament," in

Although Elizabeth receives great praise in this initial capital, Foxe's dedication, and the text itself, the queen had serious reservations about implementing further reforms in church worship that were supported by Foxe, Norton, and their political allies. While Foxe's vision of Tudor history was clearly stimulated by royal actions and used in official support of the 1559 settlement in religion, it was neither directed from nor commissioned by the royal court.

Foxe revised his dedication in the 1570 edition of the "Book of Martyrs" to begin with the name of "Christ the Prince of all Princes" rather than Constantine, and to compare Elizabeth not with the Roman emperor, but with the Salome present at Christ's crucifixion. This change accommodates the division of the text into two separate volumes and the inclusion of the woodcut sequence entitled "The Proud Primacy of Popes" as an appendix to Volume One. Gordon Kipling suggests that these changes were due to political disturbances, including the 1569 Catholic rebellion in the North and, in the year of publication, Pius V's promulgation of a bull, "Regnans in Excelsis," that excommunicated the queen and urged her subjects to depose her. The alterations contribute, furthermore, to Foxe's praise of Henry VIII rather than Elizabeth, which serves to honor all of the Protestant Tudors rather than the queen alone. The account of the Tudor period thus begins roughly halfway through the text, when the pace of narration slows and Foxe begins to include many full-length biographies of important figures.

The second volume of the 1570 edition of *Actes and Monumentes* begins with Henry's reign and a woodcut portrayal of the enthroned king sitting in council beneath the cloth of estate.[53] The initiation of

The Reign of Elizabeth I, ed. Christopher Haigh (1984), p. 83. In the years leading up to the publication of the "Book of Martyrs," Norton translated Calvin's *Institution of Christian Religion* (1561), contributed twenty-five versifications to Sternhold and Hopkins's *The Whole Booke of Psalmes* (a favorite Puritan text), and collaborated with Thomas Sackville in the composition of *Gorboduc*, a play performed at court on 18 January 1562. Norton contributed Latin verses to *Joannis Juelli Angli . . . vita et mors* (1573) by Laurence Humphrey, a member of Foxe's circle and a fellow exile under Queen Mary. He also gave Cranmer's proposals concerning more radical Protestant changes in ecclesiastical laws (B.L. MS Harley 426), which came to him because he had married Cranmer's daughter, to Foxe, at the time when Norton supported the unsuccessful effort in Elizabeth's Third Parliament (2 April–29 May 1571) to implement the proposals as law. John Day, who printed most of Norton's publications, issued Foxe's edition of the manuscript with Archbishop Parker's assent under the title of *Reformatio legum ecclesiasticarum* (April 1571). Norton contributed to the "Book of Martyrs," according to "Thomas Norton," *DNB*.

[53] Hind, vol. 1, pl. 8. See Haller, *Foxe's "Book of Martyrs,"* pp. 128–29. Yates assumes that the council scene originates in *A & M* (1570) (see Yates, *Astraea*, pl. 5b), but Elizabeth Hageman notes, in "Henry VIII as *Justitia*," p. 36, that Jacob Faber's council scene comes from Edward Hall's *Union . . . of Lancaster and York* (1548); Foxe used this chronicle as a source. Day replaced this picture with the one of Henry's defeat of

the Reformation with the imposition of royal authority over the church then prefigures the renewal of reform under Elizabeth that Foxe praises at the end of the same volume. Foxe therefore implies in the revised edition that the construction *and reconstruction* of the reformed Church of England define the formal limits of contemporary English history, while the persecutions of Mary's reign represent an aberration from the Tudor tradition of "godly" government. The original woodcuts remained in use until the eighth edition in 1641, when they were replaced with new illustrations crudely copied from John Day's worn-out woodblocks. Because the later editions of the "Book of Martyrs" are either altered or abridged, they obliterate the original design of the 1570 text as a two-volume work, thus making it impossible to note how "The Proud Primacy of Popes" and the Henry VIII woodcut function as a textual hinge. These late editions similarly obscure the use of the illustrations as part of a coherent book design.

A variation of the depiction of Henry VIII in council was made expressly for the second edition of the "Book of Martyrs" to celebrate the suppression of papal authority by the Reformation Parliament in 1534 (*A & M* [1570], p. 1201; Fig. 51). The king treads upon the back of Pope Clement VII, who is "unhorsed" from the exalted position enjoyed by his predecessors, reversing the imagery of the mounted pontiff riding in triumph in "The Proud Primacy of Popes" (Figs. 47–48). Although the papal steed stands riderless at the lower left corner, Clement's chaplains are "ready to hold the stir[r]up for him to get up agayne." The king bears the Sword and the Book, and his reception of the latter from (or his delegation of it to) his chief assistants, Archbishop Thomas Cranmer and Thomas Cromwell, symbolizes regal control of both church and state. No mention is made, however, of the martyrdom in the following year of Bishop John Fisher, the Catholic prelate who joins Reginald Pole in attendance upon the pope. The cardinal's hat worn by the latter is an anachronistic detail, because he received his cardinalate in 1536.

This woodcut symbolizes the Reformation victory of the Crown over the Tiara, which has fallen uselessly from the head of the toppled pontiff. The epigraph juxtaposes praise of Henry as a new Caesar with mockery of the pope's death, which fortuitously followed the close of the Reformation Parliament by about half a year: "Papa cito moritur, Caesar regnabit ubique, / Et subito vani cessabunt gaudia cleri" ("The pope quickly dies, Caesar will reign everywhere, / And suddenly the joys of the vain cleric will end"). Although the Caesar analogy was

Pope Clement (Fig. 51) in the fourth edition of the "Book of Martyrs" (1583), where it remained in later reprints.

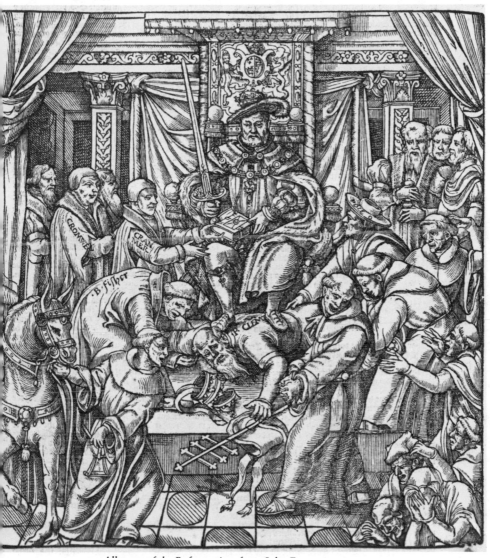

51. *Allegory of the Reformation*, from John Foxe,
Actes and Monumentes, 2nd ed. (1570)

used seriously in royal iconography elsewhere, the comparison may here contain some irony, because Christ contrasts Roman temporal power with his own spiritual authority in Matthew 22:21 and other texts. The envisagement of Henry as Caesar (or David) implies some degree of failure or deficiency relative to the reformers' more forthright praise of Edward VI as Josiah or Solomon, or of Elizabeth as Constantine. Foxe never conceals the ambivalence toward Henry that he shared with his fellow reformers. All editions of the "Book of Martyrs" recount the survival of Catholic practices during the old king's reign.

The iconoclastic tableau in Figure 51 symbolizes the primacy of the English Bible in the ordering of ecclesiastical and political affairs. The direction in which the book travels is actually ambiguous, because the pattern of book dedications and presentation scenes dictates that the king *receive* this gift, but he functions at the same time as a Christlike instrument of divine revelation by disseminating the Bible translation. Figures kneeling at his right symbolize the clerical and secular powers that Henry's reign united. The scene embodies a conventional compliment to Reformation kingship, because it is modeled upon the stance in the Coverdale Bible that Roy Strong terms a "definitive" image of Tudor majesty (Fig. 8).[54]

The pope is the "alien" or the "threatening Other" who, according to Stephen Greenblatt, offered Renaissance minds an opportunity for self-fashioning by means of negative definition. Reformation Protestants grappled with a confusing world where competing churches made apparently equal claims to spiritual authority, a world in which even concerned members of the laity and theologians could easily fall into error. A tradition of religious warfare and conflict between "truth" and "falsehood" is a corollary to this epistemological problem, one manifest in the pervasive iconography of the Pauline Armor of God (Eph. 6:10–17) and the martial imagery of Revelation.[55] Tudor Protestants found themselves surrounded by alien outsiders, notably

[54] Strong, *Holbein*, p. 14. In "Henry VIII as *Justitia*," p. 38, Elizabeth Hageman argues correctly that the strict symbolism of the book held by the king is that of the 1534 "Proclamation for the abolishing of the usurped power of the Pope." Foxe transcribes this document after this woodcut. Although the date printed beside the portrayal of Clement's downfall precedes the publication of the Coverdale Bible by one year, the appearance of this picture in the "Book of Martyrs" three decades later makes it iconographically posterior to Holbein's title page for the Coverdale Bible. The similar modeling of the two scenes causes the widespread and conventional image of the Bible to overlap that of the 1534 proclamation. Furthermore, no Tudor broadside proclamation had the visual appearance of the thick book that the king hands to Cranmer, whereas Holbein designed his title page for the folio volume of the Coverdale Bible. The *visual* allusion is to the well-known scene in the Coverdale Bible of Henry VIII conferring the English scriptures upon his subordinates.

[55] Greenblatt, *Renaissance Self-Fashioning*, p. 9. See *ERL*, pp. 154–60.

English recusants who rejected the authority of the national church, the pope in Rome, and the Spanish Hapsburgs, all of whom appeared to be "ungodly" members of the false church of Antichrist. Martha Rozett notes that this

> self-other paradigm can be perceived vertically (i.e., Man-God or Man-Devil), [but] it is more frequently perceived horizontally within the human realm (saved-damned). For the Elizabethans, the "me" or self was always ultimately a member of the elect, while the "other" represented the damned and what it meant to be damned. The "other" is thus a negation or opposite of the self, and not simply an alien. Moreover it is a negation in a clearly moral sense.[56]

In Henry VIII's triumph over Pope Clement (Fig. 51), we find for the first time in the "Book of Martyrs" a true vertical axis that positions the king, with his symbols of the Sword and the Book, on the back of the fallen pontiff. It reverses the movement of the woodcut of Pope Alexander III "treading on the neck" of Frederick Barbarossa in a recovery of the axis characteristic of illustrations for Petrarch's *Trionfi* and the Adoration of the Magi as it appears in the Strozzi Altarpiece (Figs. 37, 34). The papal triumphs in "The Proud Primacy of Popes" operate on a horizontal plane, on the other hand, because even though kings and emperors kneel before or precede the pope, they are never actually stepped on (Figs. 41, 42, 44, 47–49). The axis of the Henrician triumph descends symbolically from heaven above through the royal arms and the Bible, the vehicle of divine revelation on earth. Held by its royal bearer, the Bible possesses symbolic "weight" as it crushes the pope and his fallen tiara on an axis that seems to continue downward to hell. This portrait of the king as a divine instrument stresses the higher value of spiritual knowing, and the relative insignificance of mere worldly power epitomized by kingship.[57] The king and the book in his hands are seen as the worldly embodiments of a spiritual power that remains invisible. The scene divides into an upper compartment depicting the royal court of "godly" King Henry, and a lower half showing the consternation of the pope and his retinue—the alien "other"—and their expulsion from the kingdom. The initial C portraying Elizabeth's victory over the pope is a variation of the same formulaic triumph (Fig. 50). Like Henry's victory, the Elizabethan scene is divided into upper and lower compartments symbolizing "spiritual" and "demonic" realms.

All but one of the illustrations for "The Proud Primacy of Popes"

[56] Martha Rozett, *The Doctrine of Election and the Emergence of Elizabethan Tragedy* (Princeton, 1984), p. 29.

[57] I am indebted to an unpublished paper by Christine Hasenmueller.

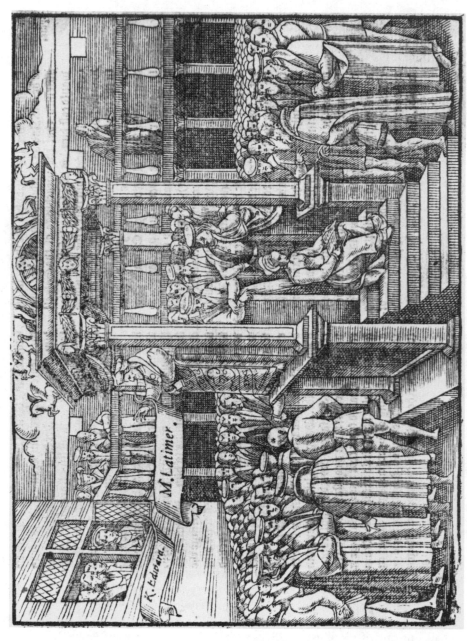

52. *Hugh Latimer Preaching before Edward VI*, from John Foxe, *Actes and Monuments*, 1st ed. (1563)

invert the ideological structure of these woodcuts of King Henry and Queen Elizabeth. The initial persecution of Christian bishops by the Roman emperor is followed by a single portrayal of collaboration and parity between balanced figures of the Emperor Constantine and "true" Christian bishops. In the ensuing sequence of ten woodcuts, the pope again and again deposes right-minded kings and emperors. Only the Protestant Tudor monarchs renew the Constantinian collaboration between the "true" emperor and the ideal bishop, who is exemplified in the Tudor age by Archbishop Cranmer. Imperial typology therefore lodges a claim to legitimacy for a dynasty whose ambiguous origins go back to the insurrection that brought Henry VII to power. Frances Yates notes that Foxe asserts that "the English reform is no new development but represents a pure Catholic church which had always existed." According to this view, the "true church" triumphs once again "in the present happy dispensation in England."[58]

Iconographically antecedent to the conventional image of King Henry deposing Clement VII is a courtly portrait, *Edward VI and the Pope* (c. 1548–49), that shows the transfer of power from the dying Henry VIII to his son Edward (Fig. 22; see above, pp. 94, 95). This Edwardian allegory may provide a model for the likenesses of Elizabeth as Constantine and Henry VIII in triumph over the pope (Figs. 50–51). The iconoclastic outburst shown in the upper right-hand corner of the portrait (Fig. 23) contrasts newly forbidden religious images with the open Bible that seems to support the royal throne at the same time that it crushes the pope and topples the tiara from his head. The vertical axis running from the royal arms above the throne through the fallen pope once again attributes symbolic "weight" to the scriptures. The Bible reflexively supplies its own inscription, "THE WORDE OF THE LORD ENDURETH FOR EVER," as well as a sarcastic motto on the pope's alb: "ALL FLESHE IS GRASSE" (Isa. 40:6). The fillets on the pontifical tiara indicate that "SUPERSTICION" and "IDOLATRY" are papal attributes. The picture is divided into two compartments depicting the victorious Protestant faction above and the defeated Roman Catholics below, as the monarch unites the clerical and temporal powers that were divided in the late Middle Ages. The flight of the tonsured monks who are identified with "FEYNED HOLYNES" at the lower left symbolizes the expulsion from England of the church of Rome as the alien "other." The empty spaces may provide room for moralisms that the artist had not yet made up.

Edward VI reappears in the stereotyped posture of the Tudor mon-

[58] Yates, *Astraea*, p. 43. See also her survey of the imperial typology of the Foxe woodcuts, pp. 42–50.

arch who unifies secular and ecclesiastical authority in the woodcut allegory that introduces Foxe's account of Edwardian England in the second edition of the "Book of Martyrs" (Fig. 27).[59] As a companion to the images of Henry VIII and Elizabeth I in the same edition, the woodcut demonstrates Protestant iconoclasm as a positive rather than a negative force by juxtaposing "King Edward delivering the Bible to the Prelates" with the presentation of "The Temple well purged" in the top panel (Fig. 26). Protestant iconoclasts pull down a statue from the wall of a church and burn images while a procession of old believers carries the Roman tiara and packs of "trinkets" bearing the papal keys to the waiting "ship of the Romish Church."[60] The absence of the pope suggests that Edward's reign may represent a more advanced stage of church reform following his father's expulsion of the "alien" outsider.

Edward, like his father Henry VIII, received praise as an ideal Christian ruler who renewed the collaboration between religious and secular authority that characterized the fourth-century church. A second illustration for Foxe's account of his reign portrays the king at a casement window listening to Hugh Latimer, who preaches an evangelical sermon in the privy gardens at Whitehall Palace (Fig. 52). As in the earlier stage of Constantinian reform depicted in "The Proud Primacy of Popes" (Fig. 40), the figures of the idealized king and cleric seem to be on very nearly the same level plane. The Edwardian image of the proper ordering of church and state inverts the depiction of triumphant Pope Gregory VII, crowned with his tiara, looking down through a window at the barefoot Emperor Henry IV before the gates at Canossa (Fig. 43).[61]

[59] This illustration for p. 1483 of *A & M* (1570) replaces the small historiated capital E in *A & M* (1563), p. 675, which was originally designed to portray Edmund Becke presenting his version of the English Bible to Edward VI in John Day's 1551 edition. See *ERL*, fig. 15.

[60] This polemical scene inverts the longstanding use of the ship as an orthodox symbol for the Roman church in Continental woodcuts (Scribner, nos. 80 and 86). The image appears in pageantry for the 1527 entry at Amiens that praises Wolsey as the rescuer of the Ship of St. Peter, or "Navicula Petri" (see above, p. 49). This figure could undergo elaboration in portrayals of either Catholic or Protestant clergy as "fishers of men" (Mark 1:17; see Scribner, nos. 83 and 87). Although the ship metaphor is theologically neutral, the potential for anticlerical satire is present in the envisagement of attack on the church from either heretics or false churchmen. The orthodox Catholic warning that the church is in danger may be noted in Alexander Barclay's 1509 translation of Sebastian Brant's *The Ship of Fools* (P1ᵛ): "For the shyp of Peter in stormes and tempest / Is throwen and cast clene destytute of rest." A polemical Lutheran woodcut of the Shipwreck of the Roman Church could readily reapply this metaphor (see Scribner, nos. 81 and 84). On the anticlerical element in such satire, see Noel L. Brann, "Pre-Reformation Humanism in Germany and the Papal Monarchy: A Study in Ambivalence," *Journal of Medieval and Renaissance Studies* 14 (1984): 161.

[61] John Day incorporated Figs. 43 and 52 as integral parts of the 1563 edition of the

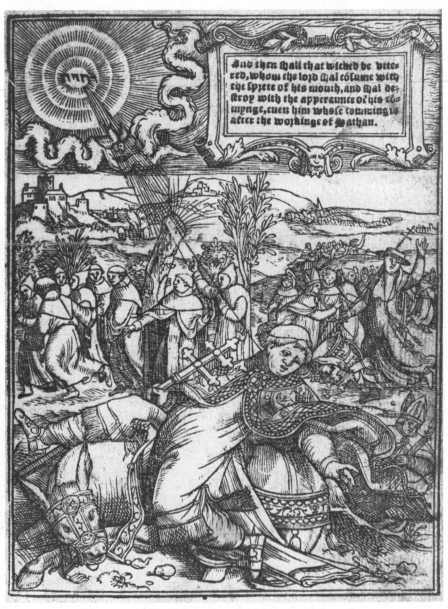

And then shall that wicked be vttered, whom the lord shal cōsume with the spirite of his mouth, and shal destroy with the apperaunce of his cōmynge, euen him whose cominge is after the workinge of Sathan.

53. *The Day of the Lord*, from Walter Lynne, *The Beginning and Endynge of All Popery, or Popishe Kyngedome* (c. 1548)

The importance of the toppling and mockery of the pope in the iconography of Edwardian England may be noted in the title-page woodcut of Walter Lynne's *The Beginning and Endynge of All Popery, or Popishe Kyngedome* (Fig. 53; c. 1548). The flight of a dove down a solitary sunbeam symbolizes the descent of the Holy Spirit and the divine inspiration associated with it. Enlargement emphasizes the figure of the pope, who loses his tiara and falls from his richly decorated mule beneath the power of the dove. The ecclesiastical procession of bishops, friars, and other palm-bearing clerics parodies the simplicity of the donkey ride of Christ into Jerusalem on Palm Sunday. Because the worldly clerics in this procession are "blind" to divine truth, they fail to recognize the Tetragrammaton at the upper left as a sun-bright symbol for divinity. The cities in the background presumably represent opposed spiritual "destinations," the Heavenly Jerusalem and the Fallen Babylon of papal Rome. The woodcut dramatizes an apocalyptic prophecy by St. Paul (2 Thess. 2:8–9) that Lynne's dedication applies to the current reign of Edward VI, who will "use the sword to . . . [him] committed" in order to clear England of vestigial Catholic practices (A3ᵛ). More than two decades later, Foxe cited the same biblical text as the basis for "The Proud Primacy of Popes."

Like the images in *Passional Christi und Antichristi*, the Lynne woodcut draws a sharp distinction between the papal mule and Christ's donkey. The same point is implicit in the panoply of papal steeds in Foxe's "Book of Martyrs" (Figs. 47–48). The mule is a larger animal than a donkey, and it thus offers a gentle ride suitable for an aristocratic rider. It is a more costly animal to purchase and maintain because it is sterile and nonproductive. A contemporary German woodcut, "Christ on an Ass Confronts Pope on Mule," therefore contrasts spiritual humility with papal vanity through the opposition of Christ's simple garment and bare feet to the pope's rich vestments, slippers, and finely outfitted steed. Christ's Crown of Thorns is the antithesis of the tiara worn by the pope.[62]

Lynne used this illustrated title page in his translation of *Practica der Pfaffen* (Strasbourg, 1535?), a German adaptation of a pseudepigraphic prophecy attributed to Joachim de Fiore (c. 1135–1202). Lynne's woodcut is a more intricate and artistically sophisticated variation of the title page of the original German text, where a pope

"Book of Martyrs." For further discussion of the Latimer woodcut and its prior appearance in Day's edition of a collection of the preacher's sermons, see above, Chapter 2, n. 35, and related text.

[62] Scribner, no. 128. Compare Solomon riding on the Mule of David in 1 Kings 1:33 and the Bodleian Library portrait of William Cecil, Lord Burleigh, astride a mule.

riding on a mule is toppled by a manifestation of Christ bearing the cross in a sunburst; the earlier scene lacks the complicated background found in Lynne's picture. The legend for the German woodcut, "Saul, warum verfolgest mich" ("Saul, why do you persecute me?"), makes it clear that the epiphany it portrays is associated with the blinding of St. Paul on the road to Damascus by a light from heaven (Acts 9:1–9); the voice of God had administered this reproof. The theme of the blinding light of divine revelation receives strong emphasis in the English woodcut. The German scene represents papal hostility to the Lutheran reformers as a recapitulation of Saul's persecution of early Christians. Because tradition held that Saul rode to Damascus on horseback, it may also draw upon the medieval representation of Pride as a toppled horseman.[63]

Lynne's woodcutter reproduced the conventional series of fifteen antipapal illustrations in *Practica der Pfaffen*, which were in turn modeled on the set of crude woodcuts in the Latin version of the Joachimist prophecy.[64] All of these woodcuts derive from the series of anticlerical illustrations in late medieval manuscripts of the Joachimist "Vaticinia de Pontificibus Romanis." Lynne's illustrations contain many images of the pope suppressing or trampling imperial and royal symbols. The pope variously thrusts down and throttles a crowned eagle who holds a scepter topped by a fleur-de-lis, for example, in scenes that contain several symbols of imperial Rome and the French monarchy. In one woodcut that portrays the victory of the papal Tiara over the royal Crown, a tyrannical wolf accompanies the pope, who usurps of the royal sword of justice "which is the word of God"; the wolf's rampant posture may parody heraldic beasts like the dragon and greyhound that support royal arms (Fig. 54; see also Fig. 3). The text relates this

[63] On the iconography of the conversion of St. Paul, see Hall, *Dictionary of Subjects and Symbols in Art*, pp. 235–36.

[64] This Latin text is entitled *Vaticinia circa Apostolicos viros & Eccle[siam] Roman[or]um* (Bologna, 1515). On the basis of such stylistic details as figural type and facial expression in the title page of Lynne's *Beginning and Endynge* (Fig. 53), Ruth Luborsky has suggested in private conversation that it is of German derivation. The much coarser work in the remaining illustrations (e.g., Fig. 54) indicates that they are English copies of the German originals. Both the title-page woodcut and the fifteen-cut series were reused in the second edition of the text, which appeared in 1588. (Lynne also used the title-page woodcut in his publication of Bernardino Ochino's *A Tragoedie or Dialoge of the Unjuste Usurped Primacie of the Bishop of Rome* [1549].) A precursor of *Practica der Pfaffen* entitled *Eyn Wunderliche Weyssagung von dem Babstumb* [i.e., Papsttum] *wie es yhm biss an das endt der welt* (Nuremberg, 1527) contains a more elaborate set of images for the same sequence of images; Andreas Osiander, the Lutheran reformer, adapted the printed text of the Latin *Vaticinia* and added his own antipapal commentary. The reproductions from *Eyn Wunderliche Weyssagung* in Scribner, nos. 108–114, exclude the woodcuts containing royalist imagery.

T D be a fotestole, is ouer all ꝑ wozld a vyle and abiecte thinge ‧ Neither myghte themperoure come to a lo= wer degree, then that he and all o= ther wozldly rulers, muste lye vn= der the popes fete. Dauid coulde

Psal. 109.
Math. 22. d
Marc. 12. d
Actu 2. d
1. Cor. 15. c.
Heb. 1. b. 10.

wzite no greater honour vnto Chzist in the Psalter, thē that his enemies shuld become a fotestole vnto hym. And so was it the most paine and spite to the ennempes to ly vnder the fete of him that ouercaine them. Those that be ouercome muste do vnto the conquerer, what soeuer he wyll. And so ruleth nowe the pope themperialle crowne euin as he will, and hath laid it vnder his fete that is, vnder his power. And hathe so vtterly subdued the same , that it is moze

54. *The Pope Standing on the Royal Crown*, from
Walter Lynne, *The Beginning and Endynge of All
Popery, or Popishe Kyngedome* (c. 1548)

picture to Christ's warnings against wolves in sheeps' clothing: "For a wolfe is a tiranne beast, specially amonge shepe. . . . Concerninge these raveninge wolves hath Christ and his apostles left many warninges behind them to teach us to beware of them" (F1).

Recognition of biblical parody aids in the explication of scenes that Lynne's *Beginning and Endynge* shares in common with late medieval manuscripts of the "Vaticinia." The illustrations of Pope Innocent VI standing on a crown while holding a razor and keys (Fig. 54–55) hinge, for example, upon the Latin prophecy that the wolf will devour the *agnus dei* ("lamb of God"); these pictures refer to the previous portrayal of Pope John XXII attacking Christ as the sacrificial lamb. The sword issuing from Pope John's mouth inverts the Revelation image for the Holy Scriptures as a sword issuing from the mouth of Christ (Rev. 1:16, 19:15).[65] Lynne's woodcut portraying the pope standing on the crown satirizes the papal claim to unify the two powers of church and state, as Lynne explains in a comment alluding to triumphal imagery later popularized in Foxe's *Acts and Monuments*:

> To be a fo[o]testo[o]le, is over all the world a vyle and abjecte thinge. Neither myghte themperoure come to a lower degree, then that he and all other worldly rulers, muste lye under the popes fete. . . . And so ruleth nowe the pope themperialle crowne evin as he will, and hath laid it under his fete that is, under his power. . . . It was not ynoughe that the pope hadde spoiled thempire both of landes and goodes. But he muste also have the sworde withall. To thend that even as the sworde appertaineth to the highe powers havinge landes and people, for the wealth of the good, and punishment of the evill. (E4ᵛ–F1)

Comparison with Lynne's title-page cut of the apocalyptic victory of the Holy Spirit over the pope as Antichrist makes it clear, however, that the supremacy of Tiara over Crown represents only a temporary setback for secular rulers (Fig. 53).

The Protestant Tudors and their apologists claimed that the Reformation was a spiritual reconquest, in which the triumph of the Crown over the Tiara effected a return to the biblical faith of the primitive gospel church. An iconoclastic scene added to the 1576 edition of the "Book of Martyrs" as a conclusion to "The Proud Primacy of Popes" therefore symbolizes the monarchical claim to govern as pious rulers (Fig. 56).[66] This illustration, a "lively picture describyng the weight

[65] B.L. MS Harley 1340, fols. 5 and 6ᵛ. See also *ERL*, pp. 196–201.
[66] The first appearance of this woodcut is in *The Whole Workes of W. Tyndall, John Frith, and Doct. Barnes* (1572), edited by Foxe and published by John Day.

169

55. *The Pope Standing on the Royal Crown,*
pseudo-Joachim de Fiore, "Vaticinia de Pontificibus
Romanis," fifteenth century

and substaunce of Gods most blessed word, agaynst the doctrines and vanities of mans traditions," depicts the blindfolded figure of Justice holding her scales as well as the scriptural sword symbolic of both royal power and the biblical Word of God. The scales indicate the spiritual "weight" of the Bible, which is employed elsewhere to crush the pope and topple his tiara (compare Figs. 22, 51). The single volume in the scale at the left symbolizes the "heavy" authority of scriptural truth, which triumphantly outweighs the heaped pile of decrees, decretals, rosaries, images, and wealth of the crowned pope and clerics, who represent the worldly hierarchy of the "false" Roman church. Even the attendant demon cannot tip the balance in their favor. The book's title, *Verbum Dei*, may allude to the woodcut portrayal of Henry VIII as a disseminator of the English Bible on the title page of the Great Bible (Fig. 14).

This judgment scene represents yet another Tudor variation of traditional iconography. The figure of Justice incorporates both classical and Christian notions of spiritual evaluation, because it inherits the antique image of the scales associated with the weighing of souls by Hermes or Zeus, as well as the pattern of medieval Judgment scenes where St. Michael, who is commonly depicted in the act of weighing souls, holds the scales.[67] The central panel in Rogier van der Weyden's *Last Judgment Altarpiece* (Hôtel-Dieu, Beaune, c. 1445–48) suggests the presence of at least one inversion in the Foxe woodcut. The Flemish work bears some relationship to regal iconography because the figure of Christ the Judge, who is enthroned in heaven above the angel's head, carries the sword of justice claimed by secular monarchs. In order to preserve the respective eschatological associations of "rising" and "falling" with salvation and damnation, van der Weyden violates spiritual "gravity" by having the anguished sinner "outweigh" the righteous soul who ascends toward heaven. Artists commonly disagree on whether the "heavier" soul is saved or damned.

In place of this pessimistic "scholastic rationalization," in which the gross weight of evil outbalances that of good,[68] the Tudor woodcut (Fig. 56) shows the victorious side going down. This image also has medieval precedents, for the satirical figure of the devil clinging to the papal scale appears in pictures that reverse the movement of van der Weyden's scales; the intervention of a demon is a recurrent theme. A Lutheran variation of this formula portrays Christ outweighing the pope and prelates, who are swung aloft and out of the reach of the

[67] Christ holds the Scales of Judgment in some illuminated manuscripts of the Apocalypse (see Gulbenkian Museum, Lisbon, MS L. A. 139, fol. 10).
[68] Panofsky, *Early Netherlandish Painting*, 1: 268–72, and ills. 326–27 (pls. 188–89).

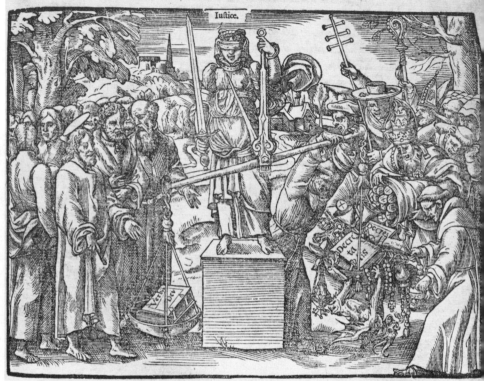

¶ A liuely picture defcribyng the weight and fubftaunce of
Gods moft bleffed word, agaynft the doctrines and
vanities of mans traditions.

56. *The Scales of Justice*, from John Foxe, *Acts and
Monuments*, 3rd ed. (1576)

devils and demonic beasts beneath them.[69] At the left-hand side of the
Tudor scene, the simple figures of Christ and the apostles are associ-
ated, as preachers of the gospel message, with the New Jerusalem vis-
ible in the background. If one interprets this scene in light of the adja-
cent portraits of Henry VIII at the beginning of the second volume of
the "Book of Martyrs," the steeple seen in the background may be
identified with the newly reconstructed Church of England.

[69] Scribner, no. 88. In the title-page woodcut of *The Convercyon of Swerers* (1509) by
the Tudor courtier Stephen Hawes (Hodnett, no. 790), the saved go downward as St.
Michael wards off a devil. This illustration appeared originally in A. Chertsey's trans-
lation of *The crafte to lyve well and to dye well* (1505).

172

 Allegorical tableaux portraying regal victories over the pope lend themselves to dramatic enactment, just as the Foxe woodcuts are analogous to civic pageantry depicting "triumphant ceremonies involving some human icon or idol."[70] For many years, British royalty identified itself with the triumph of the "true" church, be it Catholic or Protestant, either in the annual commemoration of the victory of St. George over the Dragon or in the eventual celebration of Queen Elizabeth's coronation as a Reformation triumph over Roman clerics personifying "false" religion. Related iconoclastic scenes appeared in courtly revels and entertainments that were fashionable under all of the Protestant Tudors as early as the enactment of Henry VIII's triumph over the pope on royal barges in the Thames in June 1539 (Anglo, *Spectacle* pp. 269–70).

The inclusion of ecclesiastical vestments, papal insignia, and British regalia among the properties for court revels suggests that the conflict of the Crown versus the Tiara was especially popular in allegorical masques at Edward VI's court, where the king often participated in performances. Parodic reversals of roles symbolized the suspension of social order and degree during Christmas entertainments, where the young king played the role of a priest in an entertainment that featured a variety of Roman clerics, including cardinals and the pope. A Shrovetide performance that required costumes for Roman clerics and the Seven-headed Beast of Revelation presumably reenacted the apocalyptic conflict between the "true" and "false" churches. The contemporary record even indicates that Edward wrote an antipapal script entitled "De meretrice Babylonica" ("The Whore of Babylon").[71] The tradition of Edwardian satire lived on during the early part of Elizabeth's reign. Soon after her coronation, a harsh attack on the Marian regime was lodged in court revels that satirized cardinals, bishops, and abbots respectively as crows, asses, and wolves. The costumes of the last group of prelates symbolized anticlerical attacks against wolves within the church sheepfold.[72]

[70] Muriel C. Bradbrook, *English Dramatic Form: A History of Its Development* (1965), p. 41.

[71] Albert W. Feuillerat, ed., *Documents Relating to the Revels at Court in the Time of King Edward VI and Queen Mary. Materialen zur Kunde des älteren Englischen Dramas*, vol. 44 (Louvain, 1914), pp. 5–6, 256. See Bale's *Scriptorum Illustrium maioris Brytanniae . . . Catalogus*, 2 vols. (Basle, 1557–59), 1: 674.

[72] Bevington, *Tudor Drama and Politics*, p. 127. See Albert W. Feuillerat, ed., *Documents Relating to the Office of the Revels in the Time of Queen Elizabeth. Materialen zur Kunde des älteren Englischen Dramas*, vol. 21 (Louvain, 1908), pp. 24–29, 80–81. Such attacks allude to Christ's warning: "Beware of false prophetes, which come to you

Popular celebrations of the overthrow of papal power emanated from the royal government. Sir Richard Morison's "A Discourse Touching the Reformation of the Lawes of England," a manuscript proposal drafted in connection with the Cromwellian propaganda campaign, called for an annual commemoration of England's liberation from Rome with feasting, processions, worship, and the burning of bonfires. By the late 1530s, many of the practices recommended by Morison were standard features of both the organized attack against idolatry and antipapal disguisings at rural festivals. The effort at popularization underlying this scheme may be inferred from Morison's intention to replace the Robin Hood plays with antipapal triumphs. His proposals for a special Reformation feast day commemorating England's deliverance "out of the bondage of the most wicked pharao[h] of all pharao[h]s, the bysshop of Rome"[73] read, according to Roy Strong, "like a blueprint" for the annual Accession Day observances that coincided with the festival day of St. Hugh of Lincoln. A medieval Catholic cult was thus adapted into the service of Protestant nationalism (Strong, *Cult*, p. 118). Antipapal plays were performed in London soon after Queen Elizabeth's coronation, including one in which actors playing Philip and Mary joined Cardinal Pole in a discussion of religion. Even though Elizabeth eventually honored a diplomatic request that she block plays mocking Philip II, among other productions, it is clear that William Cecil, a prominent member of her privy council, had encouraged them and even supplied an argument for a production.[74]

In place of the ironic inversions of Edward's dramatic role-playing, pageantry celebrating Elizabeth's coronation personified the unambiguous defeat of Catholic vices by regal virtues. A tableau staged at Cornhill reenacted the restoration of "worthie governance" in which Pure Religion joined Love of Subjects, Wisdom, and Justice, "which did treade their contrarie vices under their feete." With Superstition and Ignorance in the lead, the Catholic vices of Rebellion and Insolence, Folly and Vain Glory, and Adulation and Bribery went down to defeat. According to the pageant's designer, Richard Mulcaster, the spectacle depicted the triumph of Protestantism as the foundation of Elizabeth's government:

in shepes clothing, but inwardely they are ravening wolves" (Matt. 7:15). On the portrayal of the pope and cardinals as wolves in a Lutheran woodcut, see Scribner, no. 20.

[73] Sydney Anglo, "An Early Tudor Programme for Plays and Other Demonstrations against the Pope," *Journal of the Warburg and Courtauld Institutes* 20 (1957): 176–79.

[74] *CSP Venetian*, IX (1558–80), no. 69 (pp. 80–81). See Bevington, *Tudor Drama and Politics*, pp. 127–28; and David Norbrook, "Panegyric of the Monarch and Its Social Context under Elizabeth I and James I," D. Phil. Diss., Oxford University, 1978, p. 26.

> While that religion true, shall ignorance suppresse
> And with her weightie foote, breake superstitions heade
> While love of subjectes, shall rebellion distresse
> And with zeale to the prince, insolencie down treade.

Surely the sight of Pure Religion trampling upon Superstition and Ignorance inflamed the minds of English reformers, who once again saw a dramatization of the triumph of the Reformation under the Protestant Tudors. When the Venetian ambassador interpreted the scene as a reaction against religious turmoil during the reign of Elizabeth's predecessor, Mary Tudor, he made note of these personifications of the church of Rome: Hypocrisy, Vain Glory, Simulation, and Idolatry. The enthronement of a crowned child representing the queen at the top of a gate implicitly styled the scene as yet another victory of Crown over Tiara, one that led to the establishment of Elizabeth in the "seate of worthie governance." Praise for the new queen as a reform-minded Protestant monarch came to a climax in a tableau where Truth conferred the Bible upon Elizabeth. That book had been identified during the reigns of her father and brother as a device for evangelical monarchy.[75]

The appearance in Elizabeth's precoronation pageantry of personifications of Hypocrisy, Superstition, and Simulation imitated Reformation moral interludes, where such characters embody allegations concerning Catholic irreligion. According to convention, they wear the vestments of Roman clergy. Bale's *King Johan* represents a case in point, for not only is Treason a priest, but Usurped Power, Sedition, Dissimulation, and Private Wealth are disguised as the historical individuals Pope Innocent III, the monks Stephen Langton and Simon of Swynsett (Swineshead), and Cardinal Pandulphus.[76] Bale wrote the play under the patronage of Thomas Cromwell when Henry VIII's vicegerent for religious affairs sponsored a broadly based propaganda campaign on behalf of the king's changes in religion. In all likelihood, this play is the antipapal " 'enterlude concernyng King John' " that was performed for Cranmer as part of the Christmas revels on 2 January 1539. Even though the archbishop viewed Bale's king as " 'the

[75] Richard Mulcaster, *The Quenes Majesties Passage*, facs. ed. James M. Osborn (New Haven, 1960), B3–4ᵛ (pp. 37–40). See also David Bergeron, *English Civic Pageantry 1558–1642* (Columbia, S.C., 1971), pp. 17–20; and below, pp. 229–30.

[76] Although this play includes the sole extant dramatization of the pope in English morality tradition, a cardinal appears in Nathaniel Woodes's antipapal play, *A Conflict of Conscience* (composed c. 1575–81). The satirical convention of disguising Vices in the vestments of Catholic clergy in Protestant interludes may be observed in the anonymous *New Custom* and Bale's *Three Laws*.

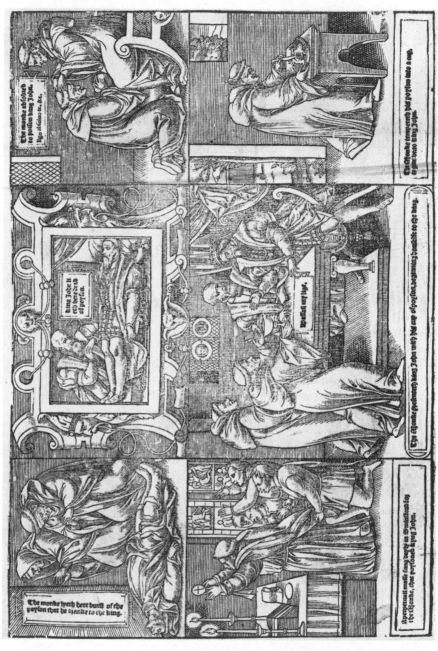

57. *The Poisoning of King John,* from John Foxe,

begynner of the puttyng down of the Bisshop of Rome,' "[77] the play's central scene dramatizes the deposition where John is forced to "delevyr þe crowne to þe cardynall" (l. 1728). This spectacle anticipates the woodcut portrayal of John's surrender in the "Book of Martyrs" (Fig. 45). The pope's regalia of the "crosse keyes, with a tryple crowne and a cope," represent a clear alternative to the regal crown (l. 2560).

The remainder of *King Johan* closely parallels Foxe's "tragical" history of John's reign and its oversize woodcut illustrating "the poysoning of King John, by a Monke of Swine[s]head Abbeye in Lincolnshire" (Fig. 57; *A & M* [1563], p. 68). The six compartments of this fold-out illustration portray the assassin concocting his poison, receiving absolution, and presenting the poison cup to the king with the salutation "Wassa[i]ll my li[e]ge"; the king's death; the monk lying dead "of the poyson that he dranke to the king"; and a perpetual mass sung daily at the Abbey of Swineshead for the murderer. The highlighted central image of the crowned king receiving the monk's cup parodies transubstantiation and the administration of the cup in the Roman-rite mass. The image of an "enchanted cup" had a longstanding association with idolatry (Norbrook, *Poetry*, p. 252). In Bale's play, the king likewise accepted "a marvelouse good pocyon" from Dissimulation disguised as Simon of Swynsett (l. 2104). The cup brandished by the Whore of Babylon in Protestant illustrated Bibles and commentaries (Figs. 65 and 66) incorporates the same Eucharistic parody; as Spenser notes of the "golden cup . . . replete with magick artes" that Duessa bears into battle with Arthur's Squire, "Death and despeyre did many thereof sup, / And secret poyson through their inner parts" (*FQ* 1.8.14).

Protestant apologists saw in King John's unsuccessful resistance to papal usurpation a prefiguration of the full-blown conflict of the Reformation, when Henry VIII resisted Roman domination as a reforming monarch. Although Bale never explicitly identifies his character Imperial Majesty as the Tudor monarch, he parallels the iconography of the Great Bible title page when Imperial Majesty strides on stage to execute Sedition, expel Dissimulation, and play the role of "true defendar" of "the auctoryte of Gods holy worde" and "the Christen faythe" (ll. 2397 and 2427). It would be altogether appropriate if Bale's idealized version of a Reformation king adopted a commanding stance similar to the royal pose established in the Great Bible. Bale readily adapted the play at the beginning of Elizabeth's reign by adding an epilogue spoken by representatives of the estates who praise her as

[77] As quoted in Bale's *King Johan*, edited by Barry B. Adams, p. 20.

an evangelical queen for glorifying the gospel and reversing the Marian Counter-Reformation:

> In Danyels sprete she hath subdued the Papistes,
> With all the ofsprynge of Antichristes generacyon;
>
>
>
> She vanquysheth also the great abhomynacyon
> Of supersticyons, witchecraftes and hydolatrye,
> Restorynge Gods honoure to hys first force and bewtye.
>
> (ll. 2678–79, 2682–84)

Muriel Bradbrook observes that the "first great poetic drama of the English stage is a pageant of iconoclasm, and of iconoclastic ruthlessness," which reflects the "general destruction of sacred images" during the Tudor Reformation. The grandiose rhetoric of Marlowe's *Tamburlaine* is therefore rooted in the "street processions of the sixteenth century."[78] The Tudor audience would doubtless have recognized an inversion of the visual image of Henry VIII planting his feet on the back of Pope Clement (Fig. 51) in Tamburlaine's deposition of "king's kneeling at his feet," his "spurning their crowns from off their captive heads," and his use of Bajazet as a "footstool" for the "royal throne." Tamburlaine's actions mimic the woodcut portraits of popes treading on the necks of emperors and kings or receiving their crowns. In the long account of Turkish history that Foxe interpolates into his account of Henry VIII's reign in the second edition of the "Book of Martyrs," the pope and the Great Turk are interpreted as two metamorphoses of Antichrist during his assault on Christendom, an association that recurs in the undercurrent of antipapal satire in Tamburlaine's fantasy that the accomplishment of universal conquest would be "as if the Turk, the Pope, Afric and Greece / Came creeping to us with their crowns apace." More deeply imbedded in the fabric of the play is the imitation of the Coronation of the Virgin in Tamburlaine's crowning of Zenocrate as if she "wert the empress of the world." His joining with two companions in a parody of the Trinity parallels the iconography of the Blessed Virgin, as does his insistence upon her lack of "all blot of foul inchastity" and her "heavenly" status as the "divine Zenocrate."[79] Bradbrook notes that "only the old familiar images of the coronation of another Virgin will bring home" the power of this scene,

[78] Bradbrook, *English Dramatic Form*, pp. 47–48.

[79] Christopher Marlowe, *Tamburlaine the Great*, ed. J. S. Cunningham (Manchester and Baltimore, 1981), pt. 1, 1.2.55–57, 2.5.85–86, 3.3.125, 4.2.14–15, 5.1.487–88 and 507. See William J. Brown, "Marlowe's Debasement of Bajazet: Foxe's *Actes and Monuments* and *Tamburlaine, Part I*," *Renaissance Quarterly* 24 (1971): 38–48; and Roy W. Battenhouse, "Protestant Apologetics and the Subplot of 2 *Tamburlaine*," *English Literary Renaissance* 3 (1973): 30–43.

"but the visual pattern is unmistakable once it has been seen."[80] This kind of inversion is familiar in Elizabethan iconography.

Marlowe dramatizes antipapal imagery familiar from the "Book of Martyrs" in the Vatican scene in *Doctor Faustus* that celebrates "the Pope's triumphant victory" over Bruno, the rival pope. After being led in chains in a procession of cardinals, bishops, monks, and friars, the antipope is made to kneel down as the "footstool" for Pope Adrian to ascend "Saint Peter's chair and state pontifical." The papal threat to "depose" the Holy Roman Emperor, "as Pope Alexander, our progenitor, / Trod on the neck of German Frederick," alludes to the cause célèbre portrayed in the Foxe woodcut of that event (Fig. 37). This satirical scene provides an occasion for Faustus to join Mephistophilis in devising means

> . . . to cross the Pope
> Or dash the pride of this solemnity,
> To make his monks and abbots stand like apes
> And point like antics at his triple crown.

This crudely antipapal slur looks like the work of Marlowe's collaborator, but it seems reasonable to assume that the coauthors had agreed on an overall scenario for the play.[81] Anticlerical satire recurs in other works by Marlowe, like *The Jew of Malta*, with its attack on worldly and abusive friars. It may be that Barabas's plan to blow up Turkish leaders by igniting gunpowder parallels an account of a Hungarian siege in *Acts and Monuments*.[82] The Bishop of Coventry defies temporal authority in a recollection of the conflict between the two powers in Act 1, Scene 1 of *Edward II*. Marlowe wrote *The Massacre at Paris* in response to the general circumstances of the Huguenots and the St. Bartholomew's Day massacre.

The pervasiveness of the Tudor ideal of the reunion of ecclesiastical and secular authority may be noted, too, in Shakespeare's works. In a play in which he rejects lurid accounts of King John's poisoning to focus on misrule and dynastic chaos, Shakespeare dramatizes the monarch's submission of the crown—"the circle of my glory"—to Cardinal Pandulph prior to the legate's imposition of the feudal overlordship of the Bishop of Rome:

[80] Bradbrook, *English Dramatic Form*, p. 50.

[81] Christopher Marlowe, *Doctor Faustus*, ed. John D. Jump (Cambridge, Mass., 1962), p. lv and scene 8, ll. 57, 81–84, 90–92, 127, and 136–37. For discussion of the alterations in Foxe's historical account, see Leslie M. Oliver's "Rowley, Foxe, and the *Faustus* Additions," *Modern Language Notes* 60 (1945): 391–94.

[82] N. W. Bawcutt, "Marlowe's *Jew of Malta* and Foxe's *Acts and Monuments*," *Notes and Queries* 213 [n.s. 15] (1968): 250.

> Take again
> From this my hand, as holding of the Pope,
> Your sovereign greatness and authority.　　　*(King John 5.1.2–4)*

Henry V dramatizes the reversal of this defeat by a protagonist styled as "a true lover of the holy Church," a possessor of a "sacred throne" who is well versed in "divinity" (1.1.23, 38; 1.2.7) In Act 1, Scenes 1–2, Henry V looks like a prototype for Henry VIII when the Archbishop of Canterbury and Bishop of Ely submit to royal authority at a time when the Plantagenet ruler, as an ideal Christian king, plans a holy war against France. The primate of England acknowledges a threat of royal appropriation of ecclesiastical foundations very much like the monastic dissolutions of the 1530s:

> For all the temporal lands, which men devout
> By testament have given to the Church,
> Would they strip from us.　　　　　　　　　*(1.1.9–11)*

According to *1 Henry VI*, it is the death of Henry V that permits a renewal of the ancient conflict between church and state. Exeter accordingly cites a prophecy attributed to Henry V concerning Cardinal Beauford's hunger for political power: " 'If once he come to be a cardinal, / He'll make his cap co-equal with the crown' " (5.1.32–33). The conventional Machiavellianism of this stage cardinal provides a sharp contrast to the statesmanship of his rival, Humphrey of Gloucester, the "good duke" and protector of the realm during the minority of his nephew Henry VI.

The collaboration of church and state undergoes a temporary reversal in *Henry VIII*, however, where the intrigues of Shakespeare's Wolsey are implicated in the adjournment of the trial concerning the validity of the king's marriage to Catherine of Aragon. The monarch, whose initial "leaning" on Wolsey's shoulder symbolizes his reliance on the prelate's counsel (1.2.1), sits enthroned above Wolsey and the papal legate, Cardinal Campeius, during Catherine's "appeal unto the Pope" (2.4.119). Henry eventually outwits the "king-cardinal" (2.2.19) by assuming royal control over the church and undertaking a program of ecclesiastical reform:

> I abhor
> This dilatory sloth and tricks of Rome.
> My learn'd and well-beloved servant Cranmer,
> Prithee return; with thy approach, I know,
> My comfort comes along.　　　　　*(Henry VIII 2.4.237–41)*

During the latter part of the play, Cranmer receives the king's backing despite Bishop Gardiner's attacks on the Protestant views of the Archbishop of Canterbury:

> The whole realm by your teaching and your chaplains
> (For so we are inform'd) with new opinions,
> Divers and dangerous; which are heresies,
> And, not reform'd, may prove pernicious. (5.2.51–54)

That Shakespeare joined his contemporaries in restaging many theatrical encounters between kings and satirical embodiments of papal power demonstrates that memories of the conflict between ecclesiastical and secular authority long outlived the generations who came of age during the many religious crises that occurred between the 1534 Reformation Parliament and the Elizabethan settlement of religion in 1559. The apocalyptic fervor associated with the 1613 staging of *Henry VIII* helps to explain why it, for example, provides a throwback to iconography associated with the glorification of both Henry and Elizabeth as Reformation monarchs. Performance of this play was clouded by mourning for the early death of Prince Henry Stuart, whom Protestant progressives idealized as the heroic namesake of the eighth king bearing that name. Weary of James I's reluctance to enter into an international alliance against Continental Catholicism, religious activists had cast the Stuart prince in a role very similar to that of the last Prince of Wales, who had aligned himself with the forward-looking Protestant faction after he came to the throne as Edward VI. Like Edward, Prince Henry had served as a magnet for the millennial hopes of radical reformers (Norbrook, *Poetry*, pp. 204–205). Nevertheless, *Henry VIII* closes with the "prophetic" speech that Cranmer delivers at the christening of Princess Elizabeth, whose reign he anticipates as a time of peace when "God shall be truly known" (5.4.36). The primate's insistence that "Truth shall nurse her, / Holy and heavenly thoughts still counsel her" evokes hindsight memories of Elizabeth as a saintly virgin and a "godly" queen (5.4.28–29, 60). In like fashion, Protestant progressives of the Jacobean period looked back to her reign as a time when the Crown had made great advances against the power of the Tiara.

4. The "Godly" Queens

To promote a woman to beare rule, superioritie, dominion or empire above any realme, nation, or citie, is repugnant to nature, contumelie to God, a thing most contrarious to his reveled will and approved ordinance, and finallie it is the subversion of good order, of all equitie and justice. — John Knox, *First Blast of the Trumpet* (1558)

Because Mary I and Elizabeth I were the first regnant queens of England, their apologists faced the unprecedented problem of defending the authority of women to govern.[1] Tudor artists addressed this political issue by rehabilitating the iconography of late medieval queens, who until this time had fulfilled no more than an ancillary role as the wives and mothers of kings. Fused into the composite ideal of a godly Woman of Faith, scriptual prototypes like the Virtuous Woman of Proverbs, the Five Wise Virgins, and the Woman Clothed with the Sun were appropriate vehicles for honoring both Mary and Elizabeth because they had been applied conventionally in praise of prior queens.

Mary and Elizabeth each received praise as types of the Virgin Mary, many female saints, and notable biblical women. In the manner of Elizabeth of York, Catherine of Aragon, and Anne Boleyn, they were compared to such saints as Elizabeth, Catherine, and Anne, or to scriptural heroines like Martha, Sarah, and Rachel. Nevertheless, the revolution-

[1] Prior to the Tudor age, with the possible exceptions of the British queen Boadicea and the Saxon queen Seaxburh, the disastrous attempt by Empress Matilda to supplant King Stephen (c. 1139–48) provides the single precedent for government by a woman. The powerful lords who controlled England at the death of Edward VI failed in their attempt to establish a Protestant succession during the brief reign of recently wed Lady Jane Grey (6–19 July 1553). Mary Tudor, whose marriage negotiations with Philip of Spain began soon after her accession, reigned as a virgin queen for barely more than one year (19 July 1553–24 July 1554). J. E. Neale comments in *Queen Elizabeth* (1934) that, prior to Mary's death, government by a virgin queen was "unthinkable" (p. 40). Marie Axton observes further in *The Queen's Two Bodies*, p. 11, that the "situation throughout Elizabeth's reign was unprecedented: a virgin queen and no immediate heir to the throne." Although Mary does furnish a precedent for Elizabeth as a regnant queen, widespread discontent with that Catholic sovereign's Spanish consort and her executions of Protestants may have strengthened Elizabeth's claim to govern as an unmarried woman (see Neale, *Queen Elizabeth*, pp. 51–52, 66).

ary changes effected by the English Reformation resulted in a cleavage between the Tudor sisters. Although Elizabeth received compliments couched in language reminiscent of Mary's treatment as an unambiguous type of the Blessed Virgin, apologists for the later queen parodied, inverted, or otherwise reinterpreted Mariological formulas in order to accommodate reformist ideology. Many themes and conventions of Marian panegyrics survived until the end of Elizabeth's reign, albeit in forms that were transposed and disguised. Because scriptural images of godly and faithful women are opposed by corresponding figures of seductresses, harlots, and tyrannesses, some Protestant vilified Queen Mary as a new Jezebel or a latter-day Whore of Babylon (slanders that were also directed against Mary, Queen of Scots). Not all praise of Elizabeth as a faithful woman emanated from the royal court or government. For example, Protestant ideologues with views more radical than those held by the queen praised her as a new Judith or Deborah to promote religious and political policies that she often frowned upon.[2] Mary Tudor's apologists had likewise compared the Catholic queen to many of the same biblical types in order to construct a powerful image of an autonomous woman capable of government.

Because Elizabeth's failure to marry further complicated an already difficult political question, her apologists inverted iconography that had once hailed queens consort as intercessors with imperious husband-kings, offering instead symbolic variations that praised Elizabeth as a powerful monarch who could govern in the absence of any consort. As a consequence, Elizabethan iconography incorporates a complex structure of symbols once associated with the Virgin Mary, medieval queens, Mary Tudor, *and* British kings. The political appeal of the image of Elizabeth as restorer of true religion possessed extraordinary force during an age in which ecclesiastical and secular power were inseparable. Scriptural figures for "godly" women furnished her with a means of self-dramatization that legitimized queenly authority as a

[2] Elizabeth's cautious aversion to innovation is well documented. She believed that Parliament's implementation of an uneasy balance among Protestant theological doctrine, episcopal polity, and certain forms of traditional "Catholic" ritual and church ornamentation at the outset of her reign (the Elizabethan Compromise of 1559) represented an unalterable program for the Church of England. She therefore insisted upon conformity and rejected efforts to introduce "lower" Protestant practices like presbyterian church government and the wearing of simple clerical vestments. Although individuals like Foxe, Walsingham, and Norton favored continuing reforms in the Church of England and intervention on behalf of militant international Protestantism, the queen favored an ambiguous settlement of domestic religious issues and a policy of noninvolvement in foreign affairs. See Norman L. Jones, "Elizabeth's First Year: The Conception and Birth of the Elizabethan Political World," in *Reign of Elizabeth I*, ed. Christopher Haigh (1984), pp. 46–52, and below, n. 69.

worldly manifestation and extension of the overlordship of God. Her apologists continued to associate the royal supremacy with the Protestant commitment to an ideal of universal literacy, which encouraged Bible reading on the part of the entire laity, including both men and women.

The nature of Mary I's image has been misunderstood because scholars have tended to view Elizabethan art and literature with hindsight as the high point of the Renaissance in England. Foxe's "Book of Martyrs" has had a profound impact on the retrospective rewriting of Marian history from a vantage point that assumes the failure of her effort to further the Counter-Reformation in England. During Queen Mary's own lifetime, however, it was by no means assumed that she would die childless, thus leaving the way clear for Elizabeth to inherit the throne. Because many aspects of what has come to be known as the "cult of Elizabeth" owe their origin to her sister's reign, it is essential to differentiate between imagery that the Tudor queens shared in common and new departures in Elizabethan iconography, like the introduction of the classicized figures of Diana, Venus-Virgo, or Astraea as regal prototypes.[3]

 Queen Mary devoted her energy to overturning the Protestant religious settlement imposed by her late father and brother. Her policy of undoing the religious revolution that they had accomplished may even have led to the ultimate act of dynastic erasure. Some contemporary accounts claim that she ordered the exhumation of her father's corpse from what was to have been its temporary burial place in Jane Seymour's tomb at St. George's Chapel. Reports emanating from the privy council claimed that Cardinal Pole, at Mary's command, presided over Henry VIII's posthumous "execution" as a Protestant schismatic when his remains were consumed on a heretic's pyre. Such an act of symbolic revenge against a father hated on personal and religious grounds would have been appropriate to a reign marked by hundreds of heresy trials and burnings.[4]

The Marian regime turned back the Edwardian ban on Catholic devotional books and observances and endorsed a return to orthodox Catholic piety. The pope celebrated this dynastic turnabout by once again honoring a Tudor sovereign with the golden rose; he conferred

[3] On late Elizabethan iconography, see Yates, *Astraea*, pp. 29–87, passim; and Strong, *Cult*, pp. 46–52.

[4] Foxe notes the hearsay report that Cardinal Pole intended "to have taken up king Henry's body at Windsor, and to have burned it" (*A & M* [1877], 8: 637). See also Scarisbrick, p. 497.

upon Mary's consort, Philip of Spain, the cap of maintenance and sword previously given to Henry VII and Henry VIII. The court poet Henry Parker praised Mary's reign as a return to "all the plentye that was in your wyse graundfathers daies king henry the seventh, and my godly maistres the lady Margaret [Beaufort] your great grandame, and in your worthy fathers dayes king henry the eight" (B.L. MS Add. 12,060, fols. 9ᵛ–10ᵛ). He did so in a collection of miracles and narratives giving proof for the dogma of transubstantiation, a work that would have been banned under the late King Edward.

Queen Mary's commitment to the Counter-Reformation had a profound impact on the iconography of her reign. Her encouragement of recently discarded forms of popular devotion accords with a miniature that depicts her as an orthodox Catholic queen kneeling at a prie-dieu before an open book and altar (Fig. 58). The telltale iconographical element that differentiates this image from likenesses of her Protestant sister is the statue of the Madonna and Child on the wall (compare Fig. 30). The royalist device of St. George slaying the dragon, which appears in the lower border, is a traditional Christian figure for the defeat of paganism or error. This picture of the queen kneeling piously in prayer illustrates a contemporary manuscript that was evidently prepared as a vehicle for implementing her policy of "Catholic revival." The text provides the ritual to be followed in preparation for the monarchical healing of two illnesses: epilepsy (or other spasmodic disorders) and the scrofula (the King's Evil). In each case it was believed that the monarch's supernatural standing as a divine instrument imparted an ability to heal when the royal touch was administered either directly to the ulcers of victims of scrofula or indirectly by rubbing cramp-rings to be given to epileptics and sufferers from some other diseases.⁵ Such rings await the royal blessing in the dish before Queen Mary. Although Elizabeth I ended the practice of blessing cramp-rings, touching for the King's Evil endured until the reign of Queen Anne (d. 1714).

Mary's resurrection of the badge of her late mother, Catherine of Aragon, conferred a Spanish Catholic flavor on Tudor royal iconography. She adopted the pomegranate of Aragon as her personal device.⁶ Among the applications of the device is the binding of a fine

⁵ Westminster Cathedral MS, "Certain prayers to be used by the quenes heignes in the consecration of the crampe rynges" (1553–58); miniature attributed to Levina Teerling. See Roy Strong and V. J. Murrell, *Artists of the Tudor Court: The Portrait Miniature Rediscovered, 1520–1620* (1983), no. 39; and Keith Thomas, *Religion and the Decline of Magic: Studies in Popular Beliefs in Sixteenth- and Seventeenth-Century England* (Harmondsworth, 1973), pp. 235–36.

⁶ Beatrice White, *Mary Tudor* (1935), p. 334; see Hodnett, no. 883, fig. 115.

fourteenth-century illuminated manuscript ("Queen Mary's Psalter") that the queen apparently kept as a private possession rather than as part of the royal library (B.L. MS Royal 2 B. VII). The queen's reverence for this Latin Vulgate text epitomizes her ban on the central texts of the recent Protestant regime: the English Bible, *Book of Common Prayer*, and *Book of Homilies*. She also valued a fifteenth-century Latin-rite book of hours that contains intact Catholic images, including a martyrdom of St. Thomas à Becket that presumably escaped Henry VIII's orders for its obliteration because the volume was a private possession of "Marye Princesse." She inscribed the text with a pious meditation in favor of the Catholic doctrine of good works in which she argues:

> Geate you such ryches as when the shype is broken, may swyme away wythe the master. for dyverse chances take away the goods of fortune: but the goods of the soule whyche bee only the trewe goods nother [i.e., neither] fyer nor water can take away. yff you take labour and payne to doo a vertuous thynge the labour goeth away and the vertue remaynethe: yf throughe pleasure you doe a vicious thynge the pleasure goeth away and the vice remaynethe.[7]

The virtual oblivion into which Marian literature and iconography have fallen results, in part, from scholarly emphasis on the Elizabethan period as a "golden age" of rebirth and renewal springing from the arrival in England of humanistic classicism from the Continent.[8] Another reason is the uninspired quality of so much literature of the time. The prevailing literary taste of Mary's reign was decidedly old-fashioned, and the huge outpouring of modishly radical Protestant literature that marked her late brother's reign dried up as printers abandoned the Protestant favorites—Chaucer and Langland—to turn to publishing safely noncontroversial medieval "classics" like *Le Morte d'Arthur* and Gower's *Confessio Amantis*. One of the landmark publications of the time, William Rastell's 1557 edition of Thomas More's *Workes Wrytten in the Englysh Tonge*, is a throwback to an earlier

[7] Bodl. MS Auct. D. inf. 2. 13, fol. 199ᵛ. According to the inscription by Richard Connock, the Bodleian Library received this manuscript in 1615 "as a Monument worthie to be kept, not for the Religion it containes, but for the Pictures & former Royall Owners sake. And in regard of a note written expecially heerin by Q. Mary with her owne hand." See William D. Macray, *Annals of the Bodleian Library, Oxford*, 2nd ed. (Oxford, 1890), p. 53.

[8] Scholars like C. S. Lewis, in *English Literature in the Sixteenth Century Excluding Drama* (Oxford, 1954), pp. 64–65, dismiss as "drab" and "medieval" the literature of the reigns of Edward VI and Mary I. For an alternative view, see *ERL*, pp. 9–11. Mary Tudor receives passing comment in Yates, *Astraea*, pp. 42 and 108, but no mention is made in Strong, *Cult*.

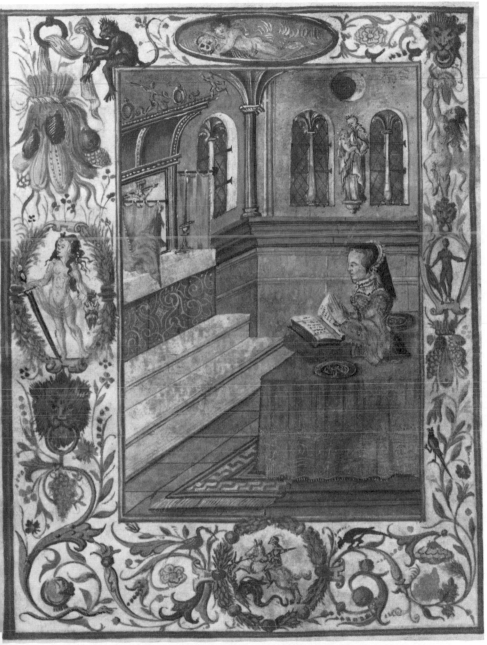

58. *Mary I as a Catholic Queen*, from "Certain Prayers to be Used by the
Quenes Heignes in the Consecration of the Crampe Rynges," 1553–58

era. The publication of two editions of Stephen Hawes's *Pastime of Pleasure* (1554–55) similarly reverted to court taste during the reign of Henry VII.

The interest in Hawes accords with a fashion for elaborate allegorical romance in the mode of the late medieval dream vision, which was satisfied by the most prolific popular poet of the time, Miles Hogarde, an artisan who had remained loyal to Princess Mary when she staunchly resisted the Edwardian changes in religion.[9] He praises Mary as a "godly" queen in his *Assault of the Sacrament of the Altar* (1554), a revision of a manuscript work originally dedicated to the princess in 1549; it could not appear in print until after Mary's accession to the throne. Hogarde subordinates evangelical iconography that once buttressed the Protestant regime to the female personification of *Fides Catholica* ("Catholic Faith"), who holds aloft the consecrated Host while standing on a stone that symbolizes *Christus*, the firm foundation upon which faith rests. He thus accords higher spiritual authority to the Catholic doctrine of transubstantiation than to the text of the New Testament revered by the reformers, which is personified by the four evangelists and St. Paul. Those figures wield swords bearing the widely known slogan of the Protestant Tudors—*Verbum Dei*—in defense of *Fides Catholica*. In the course of her defense against seven heretical assaults by enemies that include Luther and Wyclif (probably an inversion of the seven Roman Catholic sacraments), Faith turns the Protestant device of the Sword and the Book ("the Sworde of the word of God") against some of its major proponents, including Thomas Cranmer, John Hooper, and Robert Crowley. Preceded by a green and white standard bearing heraldic roses, Mary rushes to the rescue as "a crowned quene and vyrgin" who kneels before "Lady faieth style [i.e., still] holding the sacrament" (C2r–v, E1v–2v). Hogarde's *Treatise entitled the Path waye to the towre of perfection* (1554) similarly praises transubstantiation and the mass when a holy priest bears the sacrament out of a tower to honor the presence of Christ the King (E2–4). The design of this allegorical structure subordinates Protestant Faith to Catholic Charity in a reorientation of the three theological virtues, which also include Hope.

Mary Tudor reappears as a faithful woman in *The Spider and the Flie* (1556), John Heywood's allegorical analysis of the Reformation in the form of seemingly interminable debate and conflict between Protestant spiders and their prey, the Catholic flies. Heywood worked

[9] See Joseph W. Martin, "Miles Hogarde: Artisan and Aspiring Author in Sixteenth-Century England," *Renaissance Quarterly* 34 (1981): 359–83; and *ERL*, pp. 412–14.

on the text intermittently, by his own account, from the time of the dissolution of the monasteries, but only after the death of Edward VI was it safe to drop his allegorical veil and identify Queen Mary as the Maid who ends the protracted conflict by destroying the spider when "wyth her foote [she] presseth hym to death" (Fig. 59; 2Q2ᵛ). This "parable" constitutes an important adaptation of royalist panegyric, because Heywood bases his satire of "domestic" politics on the parables of the Kingdom, in which Christ analyzed true obedience in terms of the relationship between servant and master (e.g., Matt. 18:23–35, Luke 12:42–48). Conceiving of Mary's pious restoration of "auncient order" in a faction-ridden nation in terms of servitude to "her master Christ, the head master principall" and to her "maistres, mother hollie church catholicall," Heywood modifies the evangelical symbol of the sword of justice into a "bro[o]me not sword of rigor, (do[u]ble edgid blade) / But the branche of Mercie." He praises Mary for wielding her "sworde like a bro[o]me" (2R1, 2S1ᵛ–4).

Heywood's portrayal of a pious, clement, and mild queen clashes with her later reputation as "Bloody Mary," but it accords with contemporary Marian iconography. His transformation of a partisan epithet into the language of proverb—"the grene new bro[o]me swepith cleene"[10]—constitutes an implicit defense of the Marian heretical prosecutions as actions of political necessity and mercy in defense of domestic tranquillity.[11] The use of a quarto format and introduction of costly full-page woodcuts into every chapter of *The Spider and the Flie* suggests that Heywood designed this expensive work for an elite audience as part of a campaign for royal patronage. The author appears in all of the illustrations in the guise of a disinterested observer capable of perceiving the good intentions of the new regime.

Female personifications could be applied in defense of different creeds during the mid-Tudor period, when warring believers identified Truth with both Catholic orthodoxy and the newly reformed church. Protestants adopted the well-known classical epigram *Veritas Temporis Filia* ("Truth is the Daughter of Time") as a partisan political slogan with the publication of William Marshall's reform-minded primer, a text whose issuance coincided with the breach with Rome. This saying identified Father Time as the revealer of Truth that has remained hidden. Although the representation of the ungarnished sim-

[10] John Heywood, *A Dialogue of Proverbs*, ed. Rudolph Habenicht, University of California English Studies, vol. 25 (Berkeley and Los Angeles, 1963), l. 1394.

[11] Hogarde similarly approves of the burning of heretics as a divinely inspired penalty in *The displaying of the Protestants, and sundry their practises, with a description of divers their abuses of late frequented* (1556).

¶The mayde (appeering as woe to diſtroye the ſpider as he
is to be dyſtroyde) wyth her foote preſſeth hym to death.
Cap. 94.

59. *Mary I as God's Handmaid,* from John
Heywood, *The Spider and the Flie* (1556)

plicity of Truth as a naked woman found expression during the classical period, not until the late Middle Ages did it enter into Christian art. An antiprelatical preface and prayer that Marshall added to this Lutheran manual praise Henry VIII as a Reformation king who champions the cause of the people against the ecclesiastical hierarchy. When John Byddell published Marshall's *Goodly Prymer* in 1535, he inserted a frontispiece woodcut depicting "Tyme [who] reveleth all thynges" welcoming "Truthe, the doughter of tyme" as she emerges out of the cave of envy and calumny (Fig. 60; Hodnett, no. 2013). The hovering figure of "Hipocrisy" personifies the Roman church, from whose concealments and disguisings Protestants believed they were unveiling true belief. Fritz Saxl notes that the structure of the picture constitutes a revision of Christ's descent into Limbo, a well-established theme in religious iconography.[12] The epigraph makes clear the polemical context of this scene:

> Nothyng is covered, that shall not be discovered.
> And nothyng is hydde, that shall not be reveled.

This scriptural tag, drawn from Matthew 10:26, assimilates the classical image of Father Time revealing his daughter Truth with the Reformation argument that Protestantism represents old belief newly rescued from the nonscriptural elements added by Roman Catholic tradition. This woodcut is an ideal adjunct to an iconoclastic text in which the preface attacks Roman-rite prayer books and the cult observances involving devotional images.

Because Truth is conceived as a female personification, it was easy to convert the iconography of *Veritas Temporis Filia* to the personal praise of Queen Mary and the Counter-Reformation. Cardinal Pole therefore greeted the queen's accession as the victory of Truth as "a virgin, helpless, naked, and unarmed."[13] When Mary adopted the phrase as her motto, she converted it into an argument for the validity of Catholic tradition, rescued by Time from oppression. The slogan thus symbolized Mary's religious policy on her Great Seal (1553) and

[12] The proverb is grounded on Ps. 85:11, "Trueth shal bud out of the earth," which was generally interpreted as a prophecy of the coming of Christ. See Charles C. Butterworth, *The English Primers (1529–1545): Their Publication and Connection with the English Bible and the Reformation in England* (Philadelphia, 1953), pp. 60–65. On the polemical interpretations of this phrase during the reigns of Henry VIII and his daughters, see Fritz Saxl, "Veritas Filia Temporis," in *Philosophy and History: Essays Presented to Ernst Cassirer*, ed. Raymond Klibansky and H. J. Paton (Oxford, 1936), pp. 203–210; and Norbrook, *Poetry*, p. 38. See also above, Chapter 2, p. 103; Chapter 3, n. 42; and Donald Gordon, " 'Veritas Filia Temporis': Hadrianus Junius and Geoffrey Whitney," *Journal of the Warburg and Courtauld Institutes* 3 (1939–40): 228–40. On the figure of Time the Revealer, see Erwin Panofsky, *Studies in Iconology*, p. 83.

[13] As quoted in Saxl, "Veritas Filia Temporis," p. 207.

on a 1555 engraved portrait of the stern-looking queen (Fig. 61).[14] As the embodiment of the traditions of the Roman church, Veritas joined Misericordia and Sapientia in a pageant that greeted Mary and Philip upon their 1554 entry into London (see Chapter 2, n. 40). Mary's loyalists brought the royal motto to life in a *tableau vivant* designed for the June 1556 Lord Mayor's Show in Norwich, where Augustine Steward's public adherence to Catholic Truth personified the advent of Peace in the second city of the realm. The " 'auncyente personnage whoo represennted Tyme' " revealed his daughter to Mayor Steward with this statement: " 'My Dawghter trewth apperethe playne in every course of age.' "[15]

At the outset of Mary's reign, a more personal application of the motto was incorporated into *Respublica*, a moral interlude composed for production at court during the 1553 Christmas revels. The play's full-length analysis of the political problems of Edward VI's reign rejects Henry VIII's reputation as a Protestant "saint" as it looks back nostalgically to the pre-Reformation phase of the Tudor dynasty under the stable and orthodox government of Henry VII. Direct blame of Henry VIII and Edward VI is displaced, however, in the manner of Foxe's later treatment of Mary herself, because they never appear among the allegorical Vices. Although the conventional type characters who represent the failures of the Reformation—Avarice, Insolence, Oppression, and Adulation—are modeled very generally on the Protestant counselors who governed during Edward's minority, the play dramatizes their corruption not in personal terms (one cannot identify Protector Somerset, for example), but as a resurgence of the age-old problems of avarice and selfishness, the very same abuses that Robert Crowley singled out in his Protestant analysis of the Reformation in *Philargyrie of Greate Britayne* (1551).[16]

In *Respublica*, Veritas springs "owte of the earth" to be announced by the chief Vice, Avarice, as "the dawghter of Tyme" in a fulfillment of the messianic prophecy in Psalm 85:11 (Vulg. 84:12): "the booke saieth, *Veritas de terra orta est.*" Along with her sister personifications among the Four Daughters of God—Misericordia, Iustitia, and Pax—the figure of Veritas joins in a prayerful welcome to Nemesis, her alter ego and a figure for Queen Mary, as a "godly" ruler possessing absolute power to "reforme thabuses which hithertoo hath been."[17] The

[14] Strong and Murrell, *Artists of the Tudor Court*, no. 43; and Hind, vol. 1, pl. 40b.

[15] Carole A. Janssen, "A Waytes of Norwich and an Early Lord Mayor's Show," *Research Opportunities in Renaissance Drama* 22 (1979): 57–64.

[16] Robert Crowley, *Philargyrie of Greate Britayne*, ed. John N. King, *English Literary Renaissance* 10 (1980): 46–75.

[17] Nicholas Udall, *Respublica*, ed. W. W. Greg, EETS, o.s., 226 (1952), ll. 50, 1699–1706, 1930–37. *Somebody and Others* (c. 1550), an anonymous Protestant play, incor-

60. *Truth, the Daughter of Time*, from William Marshall,
A Goodly Prymer in Englyshe, newly corrected (1535)

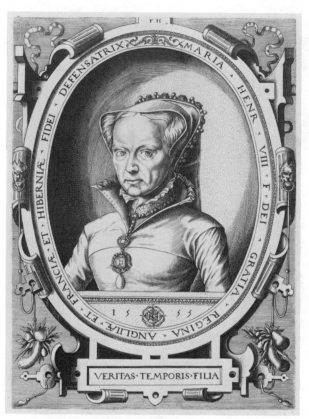

61. Frans Huys, *Mary I as the Daughter of Time*, 1555

work is attributed to Nicholas Udall, but it is inaccurate to assume that his continued participation in court entertainments after the death of Edward VI labels him a time server; even his zealous Protestant colleague Richard Grafton devised pageants for the London entry of Philip and Mary. The Erastian loyalism of such servants of the crown

porates an opposed allegory in which the burial of Verity is sought by the Catholic Vice characters, Avarice and Minister. Verity's prophecy that "tyme" will deliver her out of her "pyt" beneath the ground corresponds to millennial expectations that greeted the implementation of Protestant policies under Edward VI. (The date of this translation from a French original is uncertain, however, because it might have appeared under either Henry VIII or Elizabeth I.) Indeed, the figure of Ancient Truth stepped forward to welcome the young king in pageantry designed to celebrate Edward's coronation. See Peter Houle, "A Reconstruction of the English Morality Fragment *Somebody and Others*," *Papers of the Bibliographical Society of America* 71 (1977): 259–77; and *ERL*, pp. 166, 310–11. See also Bevington, *Tudor Drama and Politics*, pp. 107, 115–18.

194

makes them the norm for this time; those who accepted martyrdom at the heretics' pyres because they refused to recant were exceptional individuals.[18] Protestant zealots who went into exile adopted a more radical stance, one typified by the sarcastic placement of the queen's motto—*Veritas Temporis Filia*—as the epigraph on the title page of John Knox's violent attack on the Marian regime and the principle of female government, *The First Blast of the Trumpet against the Monstruous Regiment of Women* (Geneva, 1558).

 A complicated network of scriptural examples was readymade to praise both Mary and Elizabeth Tudor, whose iconography assimilates two major biblical types: the Bride of Canticles and the Woman Clothed with the Sun (Rev. 12). These figures had a longstanding connection with royalist panegyrics, because they recur commonly both in praise of the Virgin Mary and in civic pageantry celebrating late medieval queens as types of the Blessed Virgin. The ancient tradition that Mary, upon her Dormition (death) and Assumption into heaven, was crowned by Christ, with whom she rules as *Regina Caeli*, also lies behind the praise of many English queens. Crucial texts in the Mass in Remembrance of the Feast of the Blessed Virgin and in the liturgy for the Feast of the Assumption link her to the Bride of Canticles, who was commonly interpreted during the Middle Ages and the Renaissance as an allegorical figure for Holy Church. Accordingly, St. Bernard of Clairvaux, in his eighty-four sermons on Canticles, treats the Bride variously as the church, the individual soul, and the Virgin Mary.[19]

Assumed into heaven and crowned by Christ, the Virgin Mary serves simultaneously as his matronly queen and youthful bride. The vision of the New Jerusalem as the Bride at the wedding feast of the Lamb (Rev. 21:2) further links her with the Woman Clothed with the Sun, who has the moon at her feet and wears a crown of twelve stars (Rev. 12:1). Viewed as the model for the apocalyptic woman who flees into the wilderness pursued by the Seven-headed Beast, the Virgin Mary may be seen as a figure for Holy Church under persecution by agents of Antichrist. Epithalamic imagery supplies yet another link to the figures for ideal womanhood found in Christ's nuptial parable of the Wise and Foolish Virgins (Matt. 25:1–13). Although the bride here remains mysteriously absent, those virgins who fill their lamps with oil are wise in their preparedness for the Last Day.

[18] On Udall's career as an Edwardian playwright and polemicist, see *ERL*, pp. 130–31, 301–309.
[19] *Missale ad usum Sarisburiensis* (Rouen, 1554), G2v–3v. See Bernard's *Sermones super Cantica Canticorum* (Rostock, 1481).

Because late medieval royal iconography declared queens to be types of the Virgin Mary as Queen of Heaven, coronation ritual and pageantry for queens often praised them as contemporary reflections of the Spouse of Canticles. Such typology was particularly appropriate prior to the Tudor age, because queens were exclusively consorts who never ruled in their own right. They were viewed traditionally as royal mediators, who, like the Blessed Virgin, governed indirectly by means of mercy or a mother's love. Civic pageantry conferred upon them a conventional role as intercessor between king and subject that mirrored Mary's role as mediator between Christ the King and individual Christians.[20]

In the earliest surviving pageantry for an English queen, which is part of the 1392 London entry of Richard II, Anne of Bohemia formally plays the role of mediator for a penitent citizenry, which makes petition to an offended sovereign for mercy and forgiveness. Richard Maydiston's commemorative poem in Latin reports how this stylized reconciliation between Richard and the City of London confers upon the queen the type role of Esther, whose pleading with Ahasuerus on behalf of the Jews (Esther 7:2–6) furnishes the major biblical model for intercession by a devout consort.[21] York followed this precedent in staging a pageant of the Assumption on 20 April 1486, in which the Blessed Virgin Mary, serving as the "meane" or mediator between Henry VII as a Christian prince and citizens repentant for their recent support of Richard III, says:

> Henry, sith [since] my Sone as thy Souveraigne hath the[e]
> so[o]thly assigned
> Of his Grace to be Governor of his People's Protection
>
>
>
> The[e] his Knight he hath chosen victoriously
> To convok and conceede this thy Country condigne.[22]

Just as Richard II's queen had appeared as a type of St. Anne, the mother of the Blessed Virgin, in her role as mediator, so Anne Boleyn,

[20] Protestants were hostile to the conception of Mary as "mediatrix nostra, et interventrix ad Filium" (Peter of Blois, *Sermones*, 12, in *Patrologiae cursus completus. Series latina*, ed. J. P. Migne, 221 vols. [Paris, 1844–64], vol. 207, col. 597). See Marina Warner, *Alone of All Her Sex: The Myth and Cult of the Virgin Mary* (New York, 1976). pp. 93, 122–24, 129, and ch. 8, passim; and Gordon Kipling's forthcoming study of royal entries and civic triumphs.

[21] Richard Maydiston, *Concordia Facta Inter Regem Riccardum II et Civitatem Londinie*, ed. Smith, ll. 433–52, 465–500, and pp. 104–105, 107. See Glynne Wickham, *Early English Stages 1300 to 1660*, 3 vols. in 4 pts. (1959–), 1: 64, 71.

[22] Leland, *Collectanea*, 4: 189; and see above, pp. 27–28.

despite the "Protestant" context of pageantry celebrating her 1533 entry into London, was praised as the Virgin Crowned and as a type of Saint Anne.[23]

Henry VI's consort, Margaret of Anjou, provides an even more instructive example of a queen as royal mediator, for Henry's reign marks the first recorded occurrence of speeches in civic pageants. The coronation triumph following the couple's wedding on 23 April 1445 used a variety of tag phrases from the Vulgate Bible to associate Margaret with Peace (one of the Four Daughters of God), the Wise Virgins of the parable of the Wise and Foolish Virgins, the Bride of Canticles, and the Blessed Virgin as Queen of Heaven. Like the Virgin Mary, whom she imitates, she is seen as a mediator who will bear a godly royal heir.[24] (Civic triumphs in honor of Anne Boleyn would later pay her the same compliment.) Pageantry for the 1456 royal entry into Coventry again stressed Queen Margaret's intercessory role by presenting her in the dragon-killing function of St. Margaret, a female analogue of the traditional dragon-slayer and British royal icon, St. George.[25]

The iconography of the Blessed Virgin was well suited to Mary Tudor who, from the time she was a young princess, received compliments comparing her with the mother of Christ, after whom she was named. Imagery of the Coronation of the Virgin, for example, could readily be adapted in compliments presenting England's monarch as a queen specially inspired by God or eligible for a celestial crown. William Forrest's broadside ballad on the queen's accession thus exclaims:

> Shee, may be calde Marigolde well,
> Of *Marie* (chiefe) Christes mother deere;
> That as in heaven shee doth excell,
> And *golde* in earthe to have no peere.[26]

John Proctor's 1549 attack against schismatics, *The Fal of the Late Arrian*, contains a woodcut of the Annunciation facing his address to the princess as the "hygh resemblaunce and perfect imitacion" of the Virgin Mary (A1v–2v). It had originally appeared in Lydgate's *Lyfe of our Lady* (1531; Hodnett, no. 1476). The symbolism of the two Marys

[23] Nicholas Udall's verses on the coronation of Anne Boleyn are reprinted in John Nichols, ed., *The Progresses and Public Processions of Queen Elizabeth*, 3 vols. (1788–1805), 1: ix–xi. See above, pp. 50–52.
[24] Gordon Kipling, "The London Pageants for Margaret of Anjou: A Medieval Script Restored," *Medieval English Theatre* 4 (1982), ll. 9–16, 36–40, 85–98, 148–55.
[25] Anglo, *Spectacle*, p. 54.
[26] *Harl. Misc.*, 10: 253–54. See Robert Lemon, *Catalogue of a Collection of Printed Broadsides in the Possession of the Society of Antiquaries of London* (1866), no. 36.

is interchangeable, according to Proctor: ". . . in some mans head, wytte myght well gather, and reason conclude not a misse, one, and the same soule to be of bothe, the bodyes onely chaunged accordyng to Pythagoras lawe" (A4). A pen-and-ink drawing of the Madonna and Child conflates the figure of Mary as Queen of Heaven, wearing a crown and holding a scepter, with the Woman Clothed with the Sun in the frontispiece of a set of pious translations that Henry Parker addressed to Princess Mary as a New Year's gift (c. 1528–47).[27] His presentation copy of a translation of Erasmus's *Laude or prayse to be saide unto the virgyn mary mother of chryste Jesu* (B.L. MS Royal 17 A. XLVI, fol. 3) praises the princess as "the secunde mary of this wo[r]lde" and invokes the Blessed Virgin to intercede for her "to accompany Mary the mother of god in heuyn."

Comparisons to the Blessed Virgin were particularly appropriate before Mary's marriage. Thomas Martin, for example, dedicated his defense of clerical celibacy to the queen because "I knew not to whom I might so conveniently dedicat this my booke conteinyng the defense of virginitie, as to so worthy a virgine."[28] Hugh Watson praised her as Mary the Virgin in a speech made before the convocation of bishops in October 1553. Henry Parker considered Mariological treatises by Sts. Anselm and Aquinas to be appropriate gifts to give to a queen whose virginity was said to mirror the exceptional state of Christ's mother (B.L. MS Royal 17 C. XVI, fol. 7). Thomas Tallis evidently celebrated Mary Tudor's accession in "Gaude gloriosa Dei mater," an antiphon that revived votive formulas from pre-Reformation church music. Phrases like "Virgo Maria vere honorificanda, quae . . . adepta es thronum" and "omnes . . . a potestate diabolica liberati" ("Virgin Mary truly to be honored, thou who has attained the throne" and "all [having been] freed from the devil's power") had a topical application to the new queen.[29]

Imagery of the Annunciation (Luke 1:26–38) was adapted to the praise of England's monarch as a virgin queen specially chosen by God. As princess or queen, Mary was seen to parallel the Blessed Virgin as a channel for divine grace, a means of fulfilling God's plan, both

[27] B.L. MS Royal 17 C. XVI. Such writings evidently circulated within royal circles, for Parker refers on fol. 2ᵛ to Mary's own translation from Latin: "I have sene one prayer translatyd of your doynge of sayncte Thomas Alquyne [i.e., Aquinas] . . . I have one of the exemplar of yt." This work by the eleven-year-old princess is inscribed on fol. 192ᵛ of a book of hours containing other royal autographs (B.L. MS Add. 17,012).

[28] *A Traictise declaryng and plainly provyng, that the pretensed mariage of Priestes, and professed persones, is no mariage* (May 1554), A4ᵛ.

[29] Paul Doe, "Tallis's 'Spem in Alium' and the Elizabethan Respond-Motet," *Music and Letters* 51 (1970): 2–3.

in the ring that she received at the time of her 1536 submission to her father's supremacy—its inscription came from the Magnificat (Luke 1:46–55)—and in Cardinal Pole's comment that the same text was suitable for Mary "to magnify and praise God in the words of his [Christ's] blessed mother, whose name the Queen bears."[30] Pole saluted her on his return from Rome with the words of the angel Gabriel, "Hail Mary full of grace," a devotional formula that was also turned into the broadside ballad, "An Ave Maria, in commendation of our Most vertuous Queene" (1553); the successive stanzas of this poem commence with the words of salutation "Haile Marie full of Grace, our Lorde is with thee. Blessed art thou among Women and blessed is the fruyte of thy wombe, Jesus."[31] The same formula was woven into a Latin nuptial song sung by the boys of Winchester College:

> Ave Maria corporis,
> Mentisque clara dotibus,
> Virtute plena caelica
> Et singulari gratia.[32]

Frances Yates and Roy Strong rightly view Elizabethan iconography as an adaptation of newly forbidden praise of the Blessed Virgin, because suppressed religious images were incorporated into praise of Elizabeth as a Virgin Queen.[33] According to Strong, this "position was thus a somewhat peculiar one, for on the one hand the use of religious images was denounced as popish superstition, while on the other, the sacred nature of the royal portrait image was to be maintained." Praise of the queen as a Virgin giving birth to the gospel and as a Virgin Mother of the English people created a political buttress when religious dissidence undercut public order.[34]

Claims that Mariological images survive in Spenser's Faerie Queene in a more or less undiluted form are overstated in the face of the Elizabethan eradication of such vestiges. The "Catholic" element in the poem is not a "survival," but a pointed redefinition or parody of tra-

[30] CSP, Venetian, V, no. 766 (p. 385). See Carolly Erickson, Bloody Mary (1978), p. 309.

[31] Lemon, Catalogue, no. 35. See Jasper Ridley, The Life and Times of Mary Tudor (1973), p. 162.

[32] "Hail Mary [who is] distinguished with gifts of body and mind, full of heavenly virtue and singular grace" (B.L. MS Royal 12 A. XX, fol. 2).

[33] Yates notes that the Virgin Mary's symbols of the Rose, Moon, Phoenix, Ermine, and Pearl were attributed to Elizabeth, and that memorial poems appearing after the queen's death praised her in terms of "a kind of Assumption of the Virgin, followed by a Coronation of the Virgin in heaven" (Yates, Astraea, pp. 78–79). See also Strong, Cult, p. 125.

[34] Strong, Elizabeth, pp. 36–39. See Phillips, Reformation of Images, pp. 119–24.

ditional images that counters the iconoclastic destruction of religious art. By way of analogy to Spenser's procedure, Robin Headlam Wells interprets as a thinly concealed Tree of Jesse the woodcut border of John Stow's *Annales of England* (1600), which portrays the genealogy of the house of Tudor as a rose tree rising from its stock, the sleeping figure of Edward III, to Queen Elizabeth, described as "the royal flower 'enraced,' like the Blessed Virgin, in 'stocke of earthly flesh' " (3.5.52). This image does superimpose a biblical figure for pious monarchy upon the native English iconography of the Tudor rose, with its overlapping images of the white rose of York and red rose of Lancaster. The culminating figure of Elizabeth as the flower of Jesse is not likened to Mary, however, but to Christ as the descendant of the House of David. According to longstanding tradition, it is not the flower but the "rod" growing out of the "stocke" of Jesse (Isa. 11:1) that symbolizes the Blessed Virgin. The Jesse Tree discovered by Wells is actually a redefinition of the Tudor rose tree from the title page of Edward Hall's *Union . . . of Lancaster and York* (1550; 2nd ed.); that plant grows upward from the recumbent figure of John of Gaunt to Henry VIII. The absence of a culminating image comparable to the Madonna on the Hall title page makes it clear that both genealogies are dedicated to the praise of Tudor monarchs as Christlike rulers.[35]

Elizabethan apologists did, however, adapt medieval iconography in support of the Protestant regime. The title-page border of Richard Day's *Christian Prayers and Meditations* (1569; later reused in Day's 1578 *Booke of Christian Prayers*), for example, portrays an unambiguous Jesse Tree whose ramifying branches "bear" the line of Old Testament kings culminating in the Christ Child held by the Virgin Mary; the dynastic devices of the Tudor rose and Beaufort portcullis decorate the border (Fig. 31). The text is generally known as "Queen Elizabeth's Prayer Book" because of its incorporation of prayers tailored for the queen and its frontispiece portrait of "Elizabeth Regina," who has laid down her scepter and sword as she kneels to pray in her privy chapel (Fig. 30). The application of traditional Christian imagery to Elizabeth emphasizes her descent from a line of pious kings, just as the royalist symbol of the Sword and the Book marks her as a "godly" queen. Taken as a pair, these woodcuts portray the historical Mary of the scriptures as a paradigm for Elizabeth, who combines the traditional

<hr />

[35] Robin Headlam Wells, *Spenser's "Faerie Queene" and the Cult of Elizabeth* (1983), pp. 32, 86, 89, and esp. pp. 14–21. The 1600 border is reused from the 1580 edition of Stow's *Chronicles*; see above, p. 24. On the allegorical interpretation of the Jesse Tree, see Emile Mâle, *The Gothic Image: Religious Art in France of the Thirteenth Century*, trans. Dora Nussey (New York, 1958), pp. 165–70.

roles of the Blessed Virgin and earthly monarchs as intercessors between the human and the divine. Although the borders of the Day collections resemble forbidden Catholic prayer books, both texts are distinctively Protestant in their subordination of the images of both the Virgin Mary and Elizabeth to the text of the prayer book open before the queen. Although the books incorporate Mariological iconography, they avoid the "blasphemous" associations of late medieval Mariology (see above, pp. 112–13).

 The Protestant belief that Christ is the sole intercessor between the human and the divine, combined with the doctrine of the priesthood of all believers, led the Protestant Tudors— Henry VIII, Edward VI, and Elizabeth I—to suppress devotional observances involving veneration of images of the Virgin Mary and saints. Nevertheless, traditional iconography often survived iconoclastic attacks, albeit in a "desanctified" form that altered or disguised its relationship to medieval prototypes. Biblical figures such as the Five Wise Virgins and the Woman Clothed with the Sun could therefore be treated as generic examples of faith accessible to any woman, for the reformers insisted upon the potential sainthood of all Christians.

The doctrine of the priesthood of all believers received support from Erasmian educational theories in qualifying medieval assumptions concerning the intellectual inferiority of women, for Erasmus went back to the patristic counsel of St. Jerome when he advocated translation of the Bible into the vernacular so that "even the lowliest women" could study the scriptures on their own.[36] The Dutch humanist conceived of a series of new "Vulgate" (i.e., "popular") translations available in the language of ordinary men and women. This program of religious education was seized as one means of making England a Protestant country after the breach with Rome.

Accordingly, the congregational scene at the bottom of the title page of the Great Bible, which includes women among the hearers of scriptural texts (Fig. 14), was revised to depict the thoroughly Protestant worship service introduced during the reign of Edward VI and reestablished under Queen Elizabeth. The central location of the solitary woman in the portrayal of Hugh Latimer preaching before King Edward focuses attention on her reading from the Bible during the sermon (Fig. 52). This scene embodies an implicit appeal for the literacy

[36] Desiderius Erasmus, *Christian Humanism and the Reformation: Selected Writings*, ed. John C. Olin (New York, 1965), p. 97.

62. *The Image of "True" Religion*, from John Foxe,
Actes and Monuments, 1st ed. (1563)

of women as well as men so that all people may understand the scrip-
tures for themselves. The woodcut allegory of Edward VI's reign from
the 1570 edition of the "Book of Martyrs" positions three Bible-read-
ing women at the same location at the base of the pulpit (p. 1483; Fig.
28).

Both of the Edwardian worship scenes are variations of a vignette
set into the lower left corner of the title page of Foxe's *Actes and Mon-
uments* (Fig. 62), where the religion of the Book is expounded by a
minister who preaches the divine Word to a congregation of the faith-
ful beneath the Tetragrammaton. The parodic inset to the right inverts
Protestant gospel worship by portraying the allegedly false Roman ser-
vice, in which illiterate men and women tell their rosary beads opposite
a Corpus Christi procession followed by a throng of vain worldlings
(Fig. 63). Foxe's preface contrasts his martyrologies, which he styles as
stirring accounts of the religious persecutions of ordinary men and
women, with traditional collections of miraculous saints' lives, from
which the friar in the illustration might read.

The complicated patterns of Elizabethan iconography contained not
only evangelical imagery, but also medieval "royal theology" that sur-

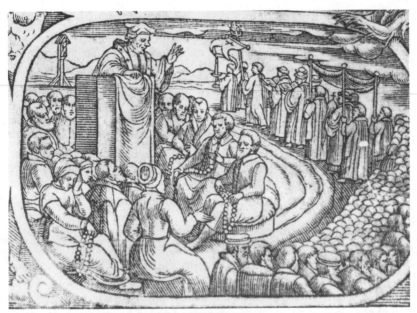

63. *The Image of "False" Religion*, from John Foxe,
Actes and Monuments, 1st ed. (1563)

vived the Reformation along with pietistic *topoi* for praising mon-
archs. Although explicit references to the Blessed Virgin were effaced
by Protestants hostile to the Mariological cult, Elizabeth I took over
many of the Virgin's epithets as part of an effort to channel traditional
devotional forms in support of her regime. These titles include Virgin,
Bride, Mother, and Queen. Coincidence permitted celebration of the
queen's birthday on September 7 to supplant the feast of the Nativity
of the Blessed Virgin on the next day. Similarly, the patriotic celebra-
tions on Accession Day, November 17, displaced the traditional festi-
val of St. Elizabeth of Hungary (November 19).[37] The many vestiges
of Catholic iconography in the praise of Queen Elizabeth as a wise and
faithful queen incorporate a critique of Catholic ritualism, the vener-
ation of the Blessed Virgin Mary, and even the Marian regime associ-
ated with those practices.

The commonplace reading of Revelation as a prophecy of the Ref-
ormation underlies the Protestant interpretation of both the Woman

[37] Strong, *Cult*, p. 125; and Wells, *Spenser and the Cult of Elizabeth*, p. 18. One
prayer in *Horae ad usum Romanum* (Paris, 1497) honors the Blessed Virgin as "Impe-
ratrix regina," "Excellentissima regina c[a]elorum," and "Mediatrix dei et hominum"
(L7ᵛ).

Clothed with the Sun and the Bride of Canticles as figures either for the "true" church in general or for any faithful Christian, because the apocalyptic woman is seen to fulfill millennial expectations discovered in Canticles. In a woodcut at the end of John Bale's commentary on Revelation, *The Image of Both Churches* (Antwerp, c. 1545), the Woman Clothed with the Sun appears under attack by the Seven-headed Beast, a figure for Antichrist (Fig. 64). In the facing illustration, the Whore of Babylon rides the same beast as a demonic parody of the Woman of Faith (Fig. 65). This visual postscript personifies contemporary religious turmoil, because Bale's glosses identify the dualistic figures as the "poore persecuted churche of Christe, or immaculate spowse of the lambe" and the "proude paynted churche of the pope," respectively.[38]

Just as reformers found in the Woman Clothed with the Sun a prototype for living, contemporary faith, they readily adapted the Scarlet Whore into a figure for the alleged falsity of the Church of Rome. Thus her crown was transformed into a papal tiara in woodcuts by Lucas Cranach, Hans Holbein, and other Reformation artists (Fig. 66). Rising in triumph on the back of the Seven-headed Beast, she brandishes the "golden cup . . . replete with magick artes" that Spenser attributes to Duessa (*FQ* 1.8.14). The elaborate ornamentation of the harlot's goblet and its associations with the Roman-rite mass invert the simplicity of the Protestant communion cup (Fig. 32 contrasts these versions of the cup). The imagery of this scene also redefines and inverts familiar patterns associated with the Virgin Mary in late medieval art. Mary's status is frequently indicated by a crown, notably in the depiction of her coronation in heaven. The abasement of the crowned "kings of the earth" before the Babylonian Harlot (Rev. 18:3) is related iconographically to the pontifical claim to political supremacy over kings and emperors (see Figs. 47–48).

John Proctor emphasized orthodox ecclesiology, however, when he reversed the Revelation paradigm under Queen Mary to castigate Protestant heretics for turning "from an heavenly church, to a malignaunt

[38] In *The Canticles or Balades of Salomon* (1549), William Baldwin interprets the Song of Songs in line with the contemporary reading of Revelation as a prophecy of the Protestant Reformation by Martin Luther, Heinrich Bullinger, John Bale, and many others. The twenty cuts in Bale's *Image* are crude descendants of the Northern European tradition of Revelation illustration that goes back to medieval manuscripts of the Apocalypse, Dürer's magnificent series of pre-Reformation woodcuts (Nuremberg, c. 1498), and Lucas Cranach the Elder's adaptations of Dürer's pictures for Luther's "September Testament" (Wittenberg, 1522). See Kenneth A. Strand, *Woodcuts to the Apocalypse in Dürer's Time: Albrecht Dürer's Woodcuts Plus Five Other Sets from the 15th and 16th Centuries* (Ann Arbor, 1968), pts. 1 and 3.

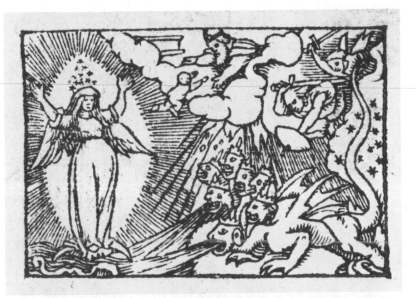

64. *The Woman Clothed with the Sun*, from John Bale, *Image of Both Churches* (Antwerp, c. 1545)

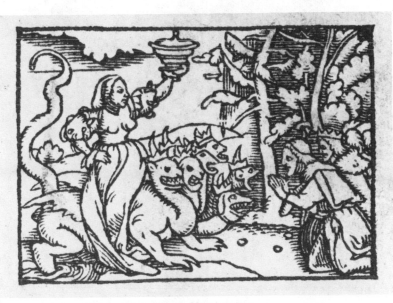

65. *The Whore of Babylon*, from John Bale, *Image of Both Churches* (Antwerp, c. 1545)

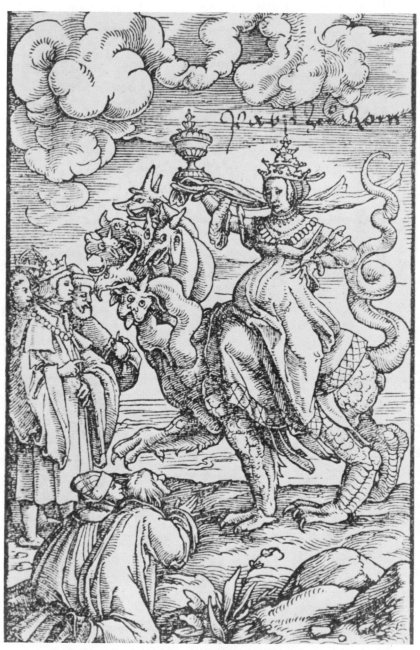

66. Hans Holbein the Younger, *The Whore of Babylon*,
German New Testament (Basel: T. Wolff, 1523)

church, from a lovinge mother to a flatteryng harlote." He associated
Mary Tudor with both Ecclesia and the Blessed Virgin, calling the re-
formers to recant in the name of a "faithful and heavenlie virgin," be-
cause "to this mother [the Church], Mary the mother of her countrye
calleth you." He buttressed this Counter-Reformation appeal by ref-
erence to the typology of *sponsa* and *sponsus*: "If ye be not one with
the spousesse, the spouse and you must nedes be two. The spouse and
the spousesse shalbe one in heaven, you and the devil shalbe one in
hell."[39]

Alongside the use of the apocalyptic woman as a generic embodi-
ment of faith, medieval saints' imagery often survived to fulfill new
purposes during the Reformation. The Protestants did, however, re-
turn sainthood to its early Christian association with martyrdom. In
Greek koine, the word μάρτυς, from which "martyr" is derived, de-
notes a "witness," specifically one who has been "faithful unto the
death" (Rev. 2:10). For the reformers, sainthood inhered in the will-
ingness to risk even life itself to testify to one's faith, rather than in the
working of miracles emphasized in medieval collections of saints' leg-
ends like Voragine's *Golden Legend*.

The title-page woodcut of Anne Askew's firsthand account of her
judicial examination and torture during Henry VIII's reign accordingly
presents her experience as a contemporary version of the flight of the
apocalyptic woman into the wilderness (Fig. 67). With the Bible in her
right hand, she stands triumphant before the Roman dragon wearing
its papal tiara. As the commentator on this text and the likely designer
of its woodcut, John Bale identifies the Henrician martyr with the ap-
ostolic traditions of the early church through the presence of the mar-
tyr's palm frond and a book (an ancient Christian symbol for the Four
Evangelists), and through comparisons to Eusebius's account of per-
secutions by Emperor Diocletian. Blandina, Bale's specific model for
Anne Askew, is presented in *Ecclesiastica historia* as a type of the
Spouse of Christ (5.1.41–56). Bale ostensibly follows the imperial
model for the examination and torture of martyrs, which was em-
ployed in early Christian iconography, rather than the sensational
martyrologies in fashion during the later Middle Ages. His epigraph
also cites the Virtuous Woman of Proverbs 31:10–31 as a prototype
for wisdom and prophetic inspiration: "Favoure is disceytfull and
bewtye a vayne thynge. But a woman that feareth the lorde is worthye
to be praysed. She openeth her mouthe to wysdome, and in her lan-

[39] From *The waie home to Christ and truth* (22 October 1554; STC 24754), A7, A8ᵛ,
C7; a translation of St. Vincent of Lerins's *Pro catholicae fidei antiquitate libellus vere
aureus*.

The first examinacy-
on of Anne Askewe, latelye mar-
tyred in Smythfelde, by the Ro-
mysh popes vpholders, with
the Elucydacyon of
Johan Bale.

Psalme 116.

The veryte of the lorde endureth foreuer.

Anne Askewe stode fast by thys veryte of God to the ende.

Fauoure is disceytfull/and bewtye is a vay
ne thynge. But a woman that feareth the
lorde/is worthye to be praysed. She ope-
neth her mouthe to wysdome/and in her lan
guage is the lawe of grace. Prouerb. xxxj.

67. *Anne Askew Confronting the Papal Dragon,* from
The First Examinacyon of Anne Askewe (1546)

guage is the lawe of grace."[40] As additional biblical models for female wisdom, Bale cites Elizabeth and the widow Anna (Luke 1–2), as well as Mary in her capacity as the mother of Christ rather than as a miraculous saint (I, B2ᵛ).

It is notable, however, that although Bale claims to turn from traditional saints' lives to the examples of "the martyrs of the prymatyve or Apostles churche" (I, ✠4ʳ), his woodcut of Anne Askew recasts the well-known iconography of St. Margaret of Antioch, the medieval dragon-slayer. The survival of traditional imagery goes beyond the martyr's palm, because it is standard to portray St. Margaret standing over or atop the dragon in precisely the same way Bale shows his martyr. In a simple exchange, Anne Askew defeats the dragon using a book rather than St. Margaret's defense, the sign of the cross. (Often Margaret, too, carries a book.)[41]

When Bale edited Marguerite de Navarre's *A Godly Medytacyon of the Christen Sowle* (1548), he eulogized the youthful translator, Princess Elizabeth, as an intellectual descendant of Anne Askew, the martyr who "hath strongly troden downe the head of the serpent, and gone hence with most noble vyctory over the pestyferouse seede of that vyperouse worme of Rome, the gates of helle not prevaylynge agaynst her" (F6ᵛ). The appearance of the princess in the title-page woodcut as a faithful woman, kneeling before Christ with Bible in hand (Fig. 68), anticipates praise of Elizabeth as a learned queen in the poetry and pageantry of her reign. Anne Lake Prescott proposes, moreover, an intriguing goal that may have underlay Bale's enumeration of a line of worthy British women preceding the princess (F2ᵛ–6ᵛ). Following Geoffrey of Monmouth as his biographical authority, Bale includes many queens who governed in their own name or served as regents during their sons' minorities—Gwendolyn, Cordelia, Cambra, and Martia—as well as Hylda, the opponent of Saxon prelates who is also cited in Bale's commentary on the Askew examinations. Prescott suggests that Bale is offering implicit praise for and support of a role in

[40] Anne Askew, *Examinations*, ed. John Bale, 2 vols. (Marburg [i.e., Wesel, in the County of Cleves], 1546–47; *STC* 848, 850). On Bale's role in the design and transmission of woodblocks, see *ERL*, pp. 97–98.

[41] See *Golden Legend* (1493), fols. 182ᵛ–184; and Hodnett, no. 277. Iconographic variations of St. Margaret piercing the dragon or issuing from its back, and often carrying a cross, recur in stained-glass windows, rood screens, carved pews, and manuscript books of hours. Typical woodcuts of St. Margaret defeating the dragon illustrate the *Golden Legend* (fol. 182ᵛ) and Roman-rite books of hours such as *Horae ad usum Romanum* (Paris, c. 1489), 1rᵛ; and *Hor[a]e intemerat[a]e virginis Mari[a]e secundum usum Romanum* (Paris, 1497), n1ᵛ. Those images adapt conventional illustrations from manuscript books of hours and the original Latin version of Voragine's *Legenda Aurea* (e.g., Huntington Library MSS HM 1088, fol. 8ᵛ, and HM 3027, fol. 76ᵛ).

A Godly Medytaty

on of the christen sowle, concer-
ninge a loue towardes God and
hys Christe, compyled in frenche by lady
Margarete quene of Nauerre, and apte-
ly translated into Englysh by the
ryght vertuouse lady Elyzabeth
doughter to our late souerayne
Kynge Henri the .viij.

Inclita filia, serenissimi olim Anglorum
Regis Henrici octaui Elizabeta, tam Græ-
cæ quam latine fœliciter in Christo
crudita.

68. *Princess Elizabeth as Translator,* from Marguerite de Navarre,
A Godly Medytacyon of the Christen Sowle (1548)

government for the only queen in the land during the reign of Edward VI, the pious reformer Catherine Parr, widow of Henry VIII.[42] Bale's sympathy for learned queens leads him to mention Lady Margaret Beaufort and Elizabeth of York, who were respectively the mother and wife of Henry VII.

A contemporary portrait of Elizabeth is closely related to the woodcut of the princess as a bookish Protestant saint. Painted by a member of the circle of William Scrots, or possibly by Scrots himself, who succeeded Holbein as King's Painter, *Elizabeth I when Princess* suggests that Reformation iconography was an enduring element in court portraiture prior to the death of Henry VIII (Fig. 69; c. 1546). This picture of the princess as a piously learned girl was completed for the king as a companion to a likeness of Prince Edward by the same hand.[43] Nothing is unusual about the princess's elaborately jeweled red dress and headdress, nor her black cross in gold filigree, but the viewer's eye is drawn to the two books in the possession of the thirteen-year-old girl. Elizabeth holds her place in one book (possibly the New Testament) as she stands beside a lectern that bears what may be an open Bible. This folio volume occupies a focal point akin to that of the Bible in evangelical images of her father and brother (Figs. 8, 14, 22, 51). The prominent inclusion of an open folio Bible in court portraits at this time tends to identify English royalty with a commitment to disseminating the scriptures in the vernacular and to continuing the progress of religious reform. This portrayal may have been influenced by the princess's stepmother, Catherine Parr, the Protestant sympathizer who controlled the education of Elizabeth and Edward and who had a reputation for both bookishness and piety. Elizabeth's likeness bears a particular resemblance to a title-page woodcut that shows Edward VI as a studious king standing at a lectern as he receives a presentation copy of Bale's *Illustrium maioris Britanniae scriptorum summarium* (see *ERL*, fig. 6). Although it is quite conventional to portray a subject with a single book, the appearance of two or more books is unusual. Given the reformist tenor of Edward's reign and Bale's career, the open folio from which the king reads most likely represents the Bible.

[42] Anne Lake Prescott, "The Pearl of the Valois and Elizabeth I: Marguerite de Navarre's *Miroir* and Tudor England," in *Silent But for the Word: Tudor Women as Patrons, Translators, and Writers of Religious Works*, ed. Margaret P. Hannay (Kent, Ohio, 1985), p. 73.

[43] Oliver Millar, *The Tudor, Stuart, and Early Georgian Pictures in the Collection of Her Majesty the Queen*, 2 vols. (1963), vol. 1, no. 46, and vol. 2, frontispiece; the companion portrait of Prince Edward is described in vol. 1, no. 45. See also Strong, *Icon*, no. 11; Strong, *Elizabeth*, Paintings, nos. 1 and pl. III. Paintings nos. 3, 9, and 18 in Strong, *Elizabeth*, portray Elizabeth holding a single book.

 The fundamental issue of late Tudor iconography is the constitutional problem of the capacity of a queen to govern. Mary I's iconography never successfully presented her as an independent monarch, however, because her image was joined after marriage with that of her consort, Philip, who adopted the style of an uncrowned King of England. Their early coinage referred to the Hapsburg prince as king.[44] The portrayal of both king and queen on the great seal of England created the impression that they governed the kingdom jointly, even though on it Mary carried the scepter symbolic of sovereign royal authority; the sword carried by her consort signified his titular authority as king (Fig. 70). The possibility that England might eventually be incorporated among Hapsburg domains should the royal couple bear issue is suggested by the heraldic shield, on which the Spanish royal arms impale those of Mary.[45] In contrast to her sister, the unmarried Elizabeth is portrayed elsewhere in possession of the scepter and/or the sword (see Figs. 29, 50, 75, 86–87). Both Mary and Elizabeth refused to emulate their father and brother as "heads" of the English church, but Elizabeth's positon as "Supreme Governor" of that body marshaled reformist support for her authority. Although the settlement of religion was the chief issue facing both queens at the outset of their respective reigns, Elizabeth's joint control of both church and state enabled her to govern by means of a thorough fusion of politics and religion.

The marriage negotiations between Mary and Philip of Spain, the heir to the most powerful domain in Europe, evoked chauvinistic fears colored with religious anxiety akin to those stirred by Elizabeth's courtship by the Duc d'Alençon twenty-five years later. In order to further the match, Charles V delegated his court portraitist, Antonio Mor,

[44] Herbert A. Grueber, *Handbook of the Coins of Great Britain and Ireland in the British Museum*, rev. ed. J.P.C. Kent et al. (1970), nos. 482 and 489. See *Statutes of the Realm*, 9 vols. in 10 pts. (1810–28), 1 Mar. 1, st. 3, c. 1, 2; and David M. Loades, *The Reign of Mary Tudor: Politics, Government, and Religion in England, 1553–1558* (1979), ill. 25, facing p. 245.

[45] See Alfred B. Wyon, *The Great Seals of England from the Earliest Period to the Present Time* (1887), nos. 109–110, and pl. XXI. Lois Schwoerer discusses the political difficulties that faced the regnant married queens of the Stuart dynasty in "Women and the Glorious Revolution," *Albion* 18 (1986): 195–218. In a step beyond the constitutional theory established in the marriage treaty of Mary I and Philip of Spain, the revolutionary settlement in 1689 created a dual monarchy in which Mary II shared power with her husband, William III, Prince of Orange, who alone possessed the autonomous exercise of regal authority. Her sister Anne followed the Elizabethan precedent of governing as sole queen despite her marriage to Prince George of Denmark. According to *DNB*, "Anne," p. 472, Anne's assumption of Elizabeth's motto, "Semper Eadem, " acknowledged this connection.

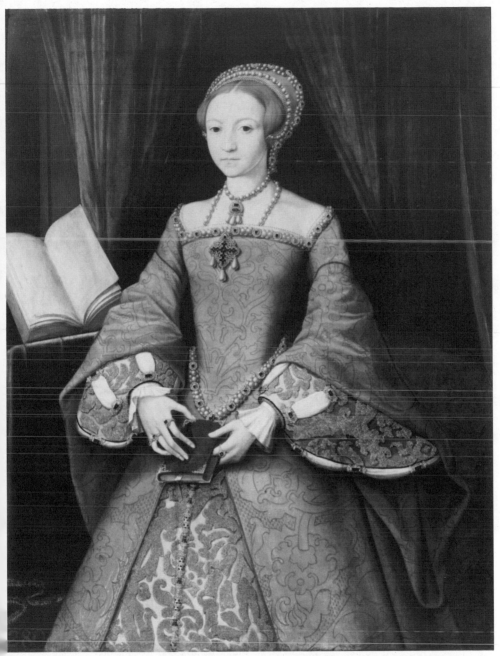

69. Circle of William Scrots (or possibly by Scrots),
Elizabeth I When Princess, c. 1546

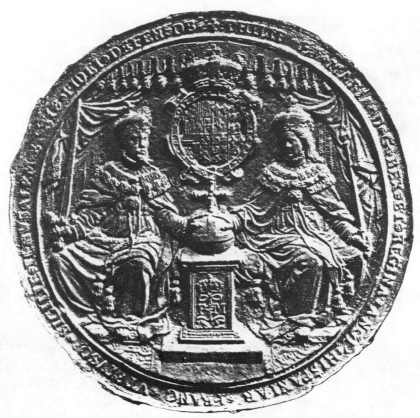

70. *The Great Seal of Philip and Mary, 1554–58*

to paint Mary's image as his son's future bride (Fig. 71). The naturalistic detail of this representational portrait differs sharply from the allegorical mode that characterizes the later portraits of Elizabeth (e.g., Fig. 76). The single symbolic feature in this image of the stern-looking queen is the Tudor rose in her right hand. The emperor always maintained cordial relations with Mary (his English cousin as the daughter of Catherine of Aragon), and two versions of Mor's portrait remained in the Escorial until the nineteenth century.[46] It was to avoid the danger of foreign entanglement and control that support emerged very early for a match between Queen Mary and her British cousin, Edward

[46] Strong, *Icon*, no. 65; see also G. R. Elton, *Reform and Reformation England, 1509–1558* (1977), pp. 379–81. On the scarcity of Mary's portraits, see above, p. 136.

214

Courtney, Marquis of Exeter and recently-restored Earl of Devonshire, who was "of the blood royal and the last sprig of the White Rose." Courtney was released by Mary after long imprisonment in the Tower of London because of his father's plot to kill Henry VIII. Although Courtney was of suitably high birth as Edward IV's great-grandson, he held no appeal for Mary.[47]

Despite England's yearning for an heir to the throne, ideally a male heir, Mary's marriage to Philip necessarily diluted her authority and created an iconographical problem. Not only was a precedent lacking for depicting a male consort with a regnant queen, but that consort's status as heir to a foreign throne raised the specter of external domination. The pair governed as "Philip and Mary, by the Grace of God King and Queen of England, Spain, France, both Sicilies, Jerusalem and Ireland, Defenders of the Faith, Archdukes of Austria, Dukes of Burgundy, Milan, and Brabant, Counts of Hapsburg, Flanders and Tyrol."[48] Cardinal Pole joined Mary's papal title of Defender of the Faith to Philip's role as Defender of the Catholic Church in a document concerning the restoration of the priories in England.[49] The queen's promotion to genuinely imperial status (her claim went beyond her father's assertion of absolute authority within the borders of his own realm) diminished the importance of her British domains and raised the possibility of a Catholic succession and dynastic "conquest" by the Hapsburgs. Although Philip had no personal claim to the English throne in the event of the queen's death, the marriage treaty stipulated that any issue of their union could succeed her.[50] Crusading overtones associated with Mary's ancestors Ferdinand and Isabella, "los Reyes Catolicos" ("the Catholic Kings") who expelled the Moors and Jews from Spain as nonbelievers, colored her reputation for religious piety and the restoration of pristine religion.

Genealogies of Mary and Philip depicted a long line of cousinage going back to Edward III in order to offset the obvious fact that the daughter of Catherine of Aragon ruled with a Hapsburg consort; their marital union held out the very real threat of a further "dilution" of the native descent of English royalty through an infusion of Hapsburg blood. Thus the frontispiece of a Latin nuptial song by the boys of Winchester College, *Carmen nuptiale ad Phillippvm et Mariam Reges*,

[47] *CSP, Spanish*, 11: 166.

[48] Translated from the legends in the seal shown in Fig. 70 and its counterseal.

[49] *Of the Grand Priories of England and Ireland*, trans. F. J. King, Order of St. John of Jerusalem, Library Committee, Hist. Pamphlets, no. 7 (1935), p. 8.

[50] Loades, *Mary Tudor*, pp. 135 and 244. See *Statutes of the Realm*, 1 Mar. 1, st. 3, c. 2.

celebrates the royal marriage in 1554 by outlining the couple's descent from Edward III and his son John of Gaunt.[51] (Once again we may note the incessant Tudor claim to Lancastrian descent.) John Heywood's ballad on the marriage inadvertently raises the question of a woman's fitness to govern the realm by attributing mildness to the queen and transforming the gender of the British lion into a crowned lioness:

> But marke, this lion so by name,
> Is properlie a lamb t'assyne [to assign],
> No lion wilde, a lion tame,
> No rampant lion masculyne,
> The lamblike lion feminyne,
> Whose milde meeke propertie aleurth [i.e., allureth]
> This birde to light, and him asseurth [i.e., assureth].

Although Heywood may evoke the messianic image of the Peaceable Kingdom (Isa. 11:6–9, 65:25), the alighting of the crowned eagle of Spain "on the rose, both red and whight" to build his nest in "the lions bowre" also suggests the imposition upon England of the double eagle of the Hapsburgs.[52]

Because Mary Tudor married at thirty-eight, an old age by sixteenth-century standards, normally there would have been little likelihood that she would bear live issue. To counter this impression, chaplains of the royal court transmitted the official position that providential intervention would resolve this dynastic problem. Richard Smith, who was also the Queen's Reader in Divinity at Oxford University, accordingly cited the scriptural precedents of Sarah, Rachel, and other "verye aged women" who were able to conceive through God's intervention. John Christopherson likened her to the aged biblical mothers Sarah, Anna, and Elizabeth, as did James Cancellar, who argued that God would choose her as an instrument of divine grace, "as he did in just and good Hanna . . . [who] broughte forthe a sonne, which afterward reigned over the people of Israel."[53] Comparisons to the Old Testament women Sarah, Rebecca, Leah, and Rachel as types for the fertility es-

[51] B.L. MS Royal 12 A. XX. See also *STC* 17560; and p. 46, above.

[52] Heywood, "A Balade specifienge partly the maner, in the most excellent meetyng and lyke Mariage betwene our Soveraigne Lord and our Soveraigne Lady, the Kynges and Queenes highness" (July 1554), in *Harl. Misc.*, 10: 255–56; Lemon, *Catalogue*, no. 37.

[53] Smith, *A bouclier* [i.e., buckler] *of the catholike fayth* (1554), 2¶4ʳ⁻ᵛ; Christopherson, *An exhortation to all menne to take hede and beware of rebellion* (1554), 2F2ᵛ; and Cancellar, *The pathe of Obedience* (c. 1553), E6.

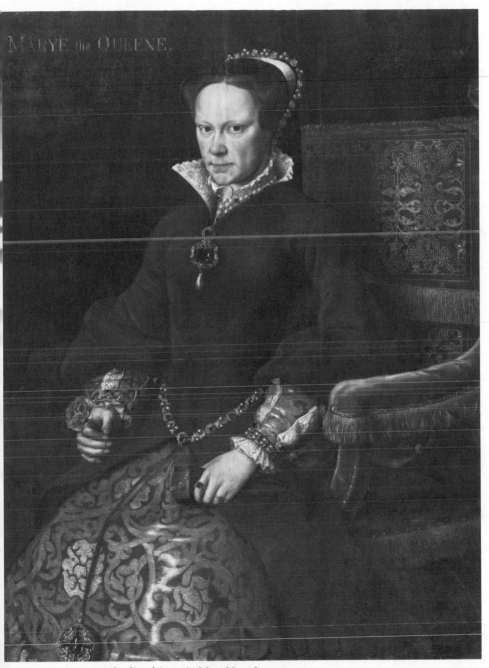

MARYE the QUEENE.

71. Studio of Antonio Mor, *Mary I*, 1554

sential to produce royal heirs were conventional in the iconography of medieval queens.[54]

Maternal imagery took an important place in Mary's iconography after the November 1554 privy council announcement that she had conceived. In actual fact the queen experienced a false pregnancy and never bore a child. A broadside ballad nevertheless praised the queen as a sweet marigold that "springeth so fayre" in a poem beginning "Nowe singe, nowe springe, oure care is exild, / Oure vertuous Quene is quickned with child."[55] John Stow reported that continual prayers were said at St. Paul's Cathedral "for the Queenes Maiestie which was conceived and quicke with child." After Doctor Chadsey had compared Mary's pregnancy with the Annunciation in a sermon on the Vulgate text, "Ne timeas Maria, invenisti enim gratiam apud Deum" (Luke 1:30), a "Te Deum was sung, and solemne procession was made of Salve festa dies, all the circuit of the Church."[56] Thomas Tallis also invoked the virgin birth in "Puer natus est nobis et filius datus est nobis cuius imperium super humerum eius," a cantus firmus that reflected praise upon the queen's pregnancy. No precedent existed for extolling an English ruler in a composition of this kind.[57] John Boxall joined other publicists when he acclaimed Mary's supposed delivery of a son in a Latin oration lauding the royal couple (B.L. MS Royal 12 A. XLIX).

Praise of Mary as a type of aged but fertile biblical women was subsidiary to the broader defense of religious orthodoxy in the new Israel of Counter-Reformation England, where Mother Holy Church constituted an Ark for the deliverance of "true" believers.[58] John Proctor clearly suggests the existence of a connection between fertility and faith when he uses Mariological imagery, in a manner anathema to the reformers, to advocate abandonment of a "whorish" Protestant creed:

> Come, come, lovinge countree men, For the passion of Christ make hast[e] and come. . . . Beholde your lovinge mothers armes are open to receive you, her bosome unlased, her brestes bare to feede you with the swete milke of true knowledge, althoughe ye have ungentlie delte with her in forsakinge her.[59]

[54] For example, the coronation prayers for Jeanne de Bourbon (1338–78), consort of Charles V, in The Coronation Book of Charles V of France (B.L. MS Cotton Tiberius B. VIII), ed. E. S. Dewick, Henry Bradshaw Soc., vol. 16 (1899), fol. 67, col. 45.

[55] STC 17561, ll. 1–2, 7–10.

[56] Annales, 3F6. See C.U.L. MS Mm. I. 45, p. 169.

[57] Doe, "Tallis's 'Spem in Alium,' " p. 4.

[58] Smith, Bouclier, 2¶1, 3.

[59] Proctor, Waie home to Christ, C8ᵛ.

Publicists praised "constant catholikes," but they lodged unflattering comparisons of "murmuringe" Protestants to Dathan and Abiram, the idolatrous opponents of Moses whom the earth swallowed alive (Num. 16, Deut. 11:6), or to the "rebelious Israelites . . . condemned by the mouth of Christ."[60]

The most successful attempts to capitalize on Mary's femininity to produce powerful political iconography came in applications of traditional types for strong leaders and rulers. Compliments to this "newe Judith, by whose godlines the trewe light and knowledge of Goddes worde is nowe by her broughte agayne," compare the queen to the heroine of the Old Testament Apocrypha who rescued her people from the Assyrian enemy. Judith's victory over Holofernes, who was seen at this time as a type for tyrannical Protestantism, embodies uncompromising strength traditionally assigned to kings.[61] Esther furnishes another biblical precedent for queenly defense of the "true" church. It is important to recognize that the application of scriptural types for powerful women to Mary Tudor followed longstanding iconographical tradition. Henry Parker, who praises Mary as "the other Iudythe" in a New Year's gift dedicated to her as a princess (B.L. MS Royal 17 C. XVI, f. 9ᵛ), had even compared Henry VIII to Judith.[62]

Nevertheless, exiled Protestants denied iconographical claims, based upon "ether Debora, or any other godlie woman," that Mary governed as a pious queen. Instead they argued, in the words of John Knox's *First Blast of the Trumpet against the Monstruous Regiment of Women*, that "Debora did usurpe no such power nor authoritie, as our quenes do this day claime." The Scottish cleric was more concerned with attacking Mary, Queen of Scots, than he was Mary Tudor: "how unlike our mischevous Maryes be unto Debora" (F1ᵛ, 4ᵛ–5). Knox's full-scale critique of the validity of "the examples of Debora, and of Hulda the prophetesse" as prototypes for regnant queens presented Deborah not as a civil but as a religious governor (E7). Because, according to Knox, government by woman violates divine law, he altered the royalist device of the Sword and the Book to deny Deborah—or

[60] James Cancellar, *The pathe of Obedience*, B8ᵛ; and Miles Hogarde's dedication to Queen Mary in *The displaying of the Protestants*.

[61] *Oratio Leonhardi Goretii Equitis Poloni de Matrimonio serenissimi ac potentissimi, serenissimae potentissimaeque Dei gratia Regis ac Reginae Angliae, Hispaniae, etc.* (1554), A2–4ᵛ. See also *The agrement of the holye Fathers, and Doctors of the churche, upon the chiefest articles of Christian religion* (1555), A3, by the royal chaplain John Aungell, and John Seton's *Panegyrici in victoriam Illustrissimae D. Mariae* (1553), B1ᵛ.

[62] Gender is irrelevant in *The Exposition and declaration of the Psalme, Deus ultionum Dominus* (1539), in which the courtier praises the Reformation king for liberating England "from the captivite Babylonical, so that we may say plainly as the Jewes dydde to Judith: You are our beautie, you are oure honour, you are our glorie" (A3).

Mary—any real political power: "But all this, I say, she [Deborah] did by the spirituall sworde, that is, by the worde of God, and not by any temporall regiment or authoritie, which she did usurpe over Israel" (F5). Deborah's exceptional status lacks any power of precedent,[63] according to Knox and other radical exiles:

> God by his singular priviledge, favor, and grace, exempted Debora from the common malediction geven to women in that behalf: and against nature he made her prudent in counsel, strong in courage, happie in regiment, and a blessed mother and deliverer to his people. (F2)

The exiles countered the Marian iconography of the godly and faithful woman with an alternate array of biblical precedents that presented Mary Tudor as "a wicked woman, yea . . . a traiteresse and bastard." The queen came under attack by Knox and many others as Pharaoh or the "cursed Jesabell" of England (A2, D6), which meant that England was not the new Israel of David or Solomon, but the backsliding and idol-worshiping land of Jeroboam and Ahab. When an anonymous tract vilified the queen's union with Philip of Spain as an incestuous cousin marriage forbidden by God, the establishment of this "strang[e, i.e. foreign] king to raygne over us" was taken as an analogue to the "whoring after strang[e] gods" into which England, like Israel, had been led. Even at the peak of the burnings of Protestants as heretics, however, some blame was displaced from Mary onto Bishop Gardiner and other members of her government:

> false prophets had seducid the quene Jesabell, and had cawsid her to sley and distroy all gods holy prophetts. . . . Read the text [2 Kings 9:33–37], and you shal plainly perceive that the quene was cast down out of a window wher[e] she brake her neke and was eaten up of dogs, as the prophet of god had before said, and all here false prophetts and preastes were utterly distroied.[64]

"Following false prophets" and "whoring after strange gods" provided types for obeying Catholic prelates and accepting the dictates of the Roman church.

The Jezebel precedent furnished a powerful weapon for the Protestant reply to Mary because it could be developed in John Ponet's

[63] See Norbrook, "Panegyric of the Monarch," p. 22.

[64] *A supplicacyon to the quenes majestie* (Strasbourg, 1555), A1ᵛ, A5; see also A3, A5ᵛ–6ᵛ. The circumstances of W. Rihel's publication of this anonymous polemic are concealed by a satirical imprint ascribing the edition to the London press of the Queen's Printer, John Cawood.

Shorte Treatise of Politike Power (Strasbourg, 1556) into one of the earliest arguments against royal absolutism and in favor of the right of subjects to resist tyrants. These challenges to the queen could take on a more violently partisan turn when, for example, dissidents broke in to leave satirical verses "in Queen Mary's Closet upon her Desk, against her coming unto her Prayers" (*A & M* [1877], 8: 717–18). Protestants violated the royal presence chamber at Whitehall to stage a mock execution of a friar by depositing a dead dog that had its fur clipped like a tonsure and a noose around its neck.[65] John Stow records that another mock execution was staged on 8 April 1554 when

> a Cat with her head shorne, and the likenesse of a vestment cast over her, with her fore-feete tyed together, and a round peece of paper like a singing cake [the wafer used in celebrating the mass] betwixt them, was hanged on a gallowes in Cheape, neere to the Crosse, in the Parish of S. *Mathew*, which Cat being taken downe, was caried to the Bishop of London, and he caused the same to be shewed at *Paules* Crosse by the Preacher D. *Pendleton*. (*Annales*, 3F5)

 At Mary's death on 17 November 1558, royalist iconography underwent its second reversal in seven years. When he preached at Mary's interment, Bishop John White applied to the Protestants an evangelical formula based upon Christ's admonition against "false prophetes, which come to you in shepes clothing" (Matt. 7:15):

> I see the wolfe comming towards the flock; as at this p[oin]t I warne you the wolfes be comming oute of Geneva and other places of Germany, they have sent their bookes before theim full of pestilent doctrine, blasphemy, and heresie to infect the people.[66]

Protestants had directed the same trope against Catholics in their anticlerical tracts. White's outcry acknowledged the failure of England's brief but bloody Counter-Reformation, as did Elizabeth's refusal to honor the request in her sister's will for a memorial to the late queen, her mother, Catherine of Aragon. Mary's burial without a monument constituted an act of dynastic erasure, as did her reinterment beneath the funerary effigy of her half-sister at Westminster Abbey. For two hundred years the anniversary of Mary's death was commemorated

[65] Ridley, *Life and Times*, p. 142.

[66] Bodl. MS Top. Oxon. e. 5, p. 248. James Aske restores the reformist thrust of this biblical trope in *Elizabetha Triumphans* (1588; fasc. ed., The English Experience, no. 423 [Amsterdam, 1969]) by praising Elizabeth as the Protestant deliverer who drives the "ravening *Wolfe*, this foule deceiptfull *Pope*" out of the fold (B1v–2).

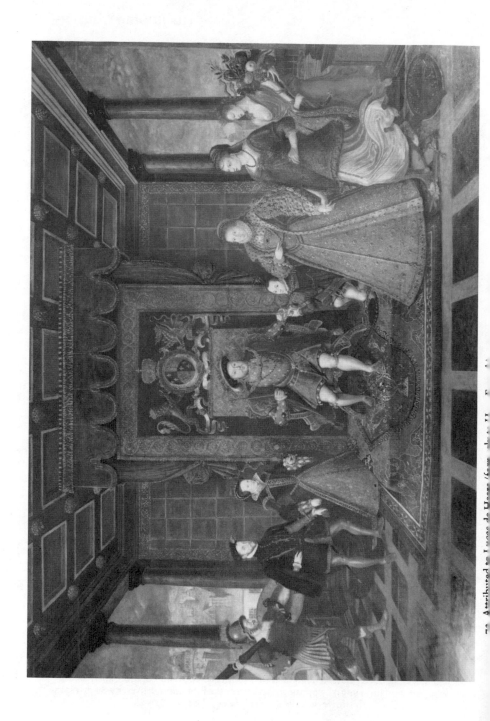

70. Attributed to Lucas de Heere (from detail). From the...

not with mourning, but with the national holiday of Accession Day in honor of the advent of England's Protestant queen. Those who believed that government by Antichrist had run full circle now acclaimed Elizabeth as a millennial ruler.[67]

The deliberate undoing of Marian iconography may be noted in the *Allegory of the Tudor Protestant Succession* that Elizabeth presumably commissioned as a gift for Sir Francis Walsingham (Fig. 72); formerly attributed to Hans Eworth, it is now ascribed to Lucas de Heere, a Flemish artist who was active in England during the second decade of Elizabeth's reign. The oversize figure of the queen stands at the viewer's right in a direct line of succession passing from Henry VIII, who sits enthroned at the center as he hands the sword of justice to the kneeling figure of Edward VI. While the presentation of Elizabeth, her father, and her brother offers a conventional image of Protestant succession (compare Fig. 22), the allegorical focus of the tableau is the stark contrast between the antithetical Tudor queens. The isolation of Philip and Mary at the viewer's left suggests that Mary's reign represented a deviation from the course of Tudor religious and dynastic history; their companion, warlike Mars, defines the Marian Counter-Reformation as a divisive time of bloodshed and rancor (Fig. 73). Elizabeth's reign is envisioned as a time of domestic tranquillity, on the other hand, as Peace, who tramples upon "weapons of discord" that include the sword, spear, and shield of Mars, is led in by the queen. The cornucopia held by Plenty, who attends Peace, lodges a claim that the tranquil reign of Queen Elizabeth has brought an end to a period of privation (Fig. 74). Verses inscribed on the picture frame interpret this dynastic allegory:

A Face of muche nobillitye loe in a litle roome,
Fowr states with theyr conditions heare shadowed in a showe,
A father more then valyant, a rare and vertuous soon [i.e., son],
A zeal[o]us daughter in her kynd what els the world doth knowe,
And last of all a vyrgin queen to Englands joy we see,
Successyvely to hold the right, and vertues of the three.

Elizabeth is seen to inherit the respective virtues of her predecessors, including her father's valor, her brother's virtue, and even her sister's zeal.

By commissioning this allegory, Elizabeth involved herself in the fashioning of her own image as a peaceful Protestant ruler. The painting was made at about the time that Pius V's 1570 bull, "Regnans in

[67] See Strong, *Cult*, pp. 117–28.

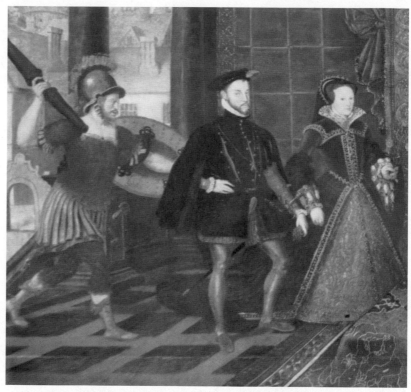

73. *Mary I and Philip with Mars*, detail from *Allegory of the Tudor Protestant Succession* (Fig. 72)

Excelsis," stirred up a Catholic peril by excommunicating the queen and urging her overthrow. The Northern Rebellion of the previous year had demonstrated the strength of sentiment to return to her late sister's Counter-Reformation settlement in religion. The inscription at the base, "The Quene to Walsingham this Tablet sente / Marke of her peoples and her owne contente," suggests that the portrait may have functioned as an admonition to those like Walsingham who advocated militant English support for the Huguenots and the Protestant cause in the Low Countries. It may embody the queen's assurance to a staunch reformer and one-time Marian exile that her cautious brand of Protestantism was better served by a policy of peace than one advocating military intervention.[68] This painting may therefore represent a re-

[68] Strong, *Icon*, no. 95. The likely creation of this portrait c. 1570 argues against the

sponse to the "unofficial" cult of Protestant queenship that, as Wallace MacCaffrey notes, was already "being built up without the approval of the goddess herself. Indeed, the role of Protestant champion which it assigned to her was one deeply repugnant to the secular-minded Queen."[69]

Most Protestant apologists had little difficulty praising female rule under Elizabeth. A ballad beginning "O Dere Lady Elysabeth" lauded her accession as a godly and faithful queen because she had supplanted the "idolatrous" government of Mary Tudor:

> Then God sent us your noble grace,
> as in dede it was highe tyme,
> Whiche doth all popery cleane deface,
> and set us forth Gods trewe devine.[70]

For John Bale, Elizabeth's accession as the ideal Christian prince marked a return to true religion, justice, and virtue after the "yoke of the wicked tyrant." His eulogy anticipated the labyrinthine praise of Elizabeth as the just virgin Astraea, as did an epigram on the transition from the tyrant Jezebel to the true and victorious Deborah ("Nam Iesabel quondam tortrix, sed Debbora vindex").[71] The application to the new queen of the latter precedent exemplifies the tendency of Elizabethan iconoclasm to assimilate rather than destroy the orthodox iconography of the Roman church and its adherents.

John Knox was an exception in giving great insult to Queen Elizabeth. Although he concerned himself largely with Scottish affairs and government by Mary Stuart, his attack on female government was published so inopportunely as to appear to attack Mary Tudor's successor. John Aylmer interpreted the text in this way when he announced his intention to vindicate the new queen from Knox's attack in *An Harborowe* [Harbor] *for Faithfull and Trewe Subjectes, agaynst the late blowne Blaste, concerning the Government of Wemen* (Strasbourg [or London?], 1559): "Wherfor chaunsing upon a boke, about a yere past, intitled the first blast, conteining new broched doctrine to

suggestion in Strong, *Elizabeth*, Paintings, no. 82, that the "peace theme of the picture may link it with the Treaty of Blois (1572) concluded between England and France in which Walsingham took a leading part." The horn of plenty is also associated with Elizabeth's reign as a Protestant queen in Fig. 50.

[69] Wallace MacCaffrey, *Queen Elizabeth and the Making of Policy, 1572–1588* (Princeton, 1981), pp. 265–66.

[70] *Harl. Misc.*, 10: 263; see Lemon, *Catalogue*, no. 48.

[71] Laurence Humphrey supplied the epigram for a unique special issue of Volume 1 of Bale's *Scriptorum Illustrium maioris Brytanniae . . . Catalogus*, with added leaves foliated α2–4[r-v], [α5] and dated 4 March 1559; B.L. G 6026.

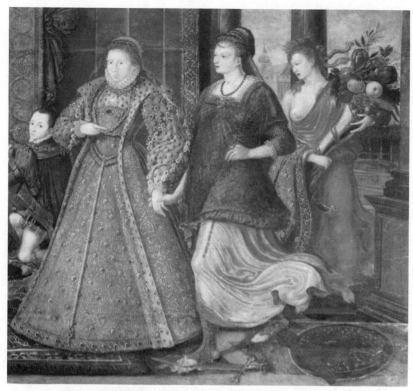

74. *Elizabeth I with Peace and Plenty*, detail from *Allegory of the Tudor Protestant Succession* (Fig. 72)

disprove the regiment of women: After I had red it, I wished that some notable learned man, wold have answered it" (A3). This early defense of Elizabeth's government as a woman refurbishes the use of three heroines of the Old Testament and Apocrypha—Deborah, Esther, and Judith—as precedents for female government as part of the order of nature, thus providing a normative model for later apologists (D2ᵛ, G3ᵛ).[72] Esther was a traditional type for queens as consorts and mediators, as in the 1392 pageantry for Anne of Bohemia, but the emphasis on Deborah and Judith represents a step toward resolving the Eliza-

[72] See Norbrook, "Panegyric of the Monarch," p. 22. William Haller states in *Foxe's "Book of Martyrs,"* p. 87, that Aylmer fashioned the image of Elizabeth as "the faithful godly princess saved from martyrdom only in the nick of time for England's sake by divine intervention. This story, based probably on information supplied by Ascham, anticipated the classic version of the same legend to be set in circulation by John Foxe."

226

bethan iconographical problem. Judith, in her victory over Holofernes (now considered a type for militant Catholicism), and Deborah, as the sole female judge and rescuer of Israel from pagan idolatry, embody triumphal power conventionally relegated to kings. In defeating Israel's enemies under divine guidance, they conform more closely to the traditional role of kings as leaders in government and war rather than to the subordinate role of queens as mediators.[73]

Deborah in particular fuses the mediatory symbolism of medieval queens with the claim of kings to rule as divine agents or little "gods." The Hebrew prophetess, as the divinely inspired rescuer of Israel from Canaanite idolatry, is a figure for Elizabeth in the traditional regal role of intermediary between God and humanity rather than the queenly role of intercessor between king and people. This biblical device for government by woman recapitulates claims to providential governance by prophets that trace back to Moses. Many themes of early Elizabethan iconography like the New Jerusalem and the suffering of the elect, were commonplace in Protestant Europe, but only in England did they focus on biblical women as bearers of salvation.

Deborah occupied a major place in royalist propaganda as early as Elizabeth's progress through the City of London on 14 January 1558/9, the day before her coronation. Elizabeth was greeted at the conduit in Fleet Street by the pageant figure of Deborah as a crowned queen in Parliament, which applied to the new queen the chief biblical precedent for government by a powerful and godly woman (Judges 4–5). The ambiguity of this image mirrored the untested status of the queen's authority at the beginning of the reign. Deborah's robes, described as a monarch's parliamentary attire, emphasized Parliament in a manner absent in later Elizabethan and Jacobean pageantry. A key to interpreting this very complicated spectacle may be suggested by the regal crown that Deborah wore instead of the closed headpiece of the imperial crown, because her open and spiked crown symbolizes limited sovreignty. Not only does Elizabeth as Deborah lack absolute power, but she is presented "consulting for the good government of Israel" with personifications of the estates represented in Parliament: nobility, clergy, and commonalty. The published account of this entry observes "that it beho[o]veth both men and women so ruling to use advise of good counsell." The tableau anticipated the gathering of a reform-minded Parliament barely more than one week later.[74] The pageant,

[73] Elkin C. Wilson discusses the praise of Elizabeth as Judith in broadside ballads and as Deborah in royal progresses of her reign in *England's Eliza*, chs. 1–2.

[74] Mulcaster, *Quenes Majesties Passage*, D3ᵛ–4 (pp. 54–55); see Anglo, *Spectacle*, p. 352. Pageantry for the 1578 royal entry into Norwich recalled the coronation tableau

reflecting the thinking of returned Protestant exiles, emphasized the exceptional status of Deborah. Richard Grafton explained its significance in his *Abridgement of the Chronicles of Englande* (1570) by saying it was designed "to encourage the Queene not to feare though shee were a woman: For women by the Spirite and power of almightie God, have ruled both honorably and pollitiquely" (Z3).

A previous tableau presented Truth as an explicitly Protestant figure by appropriating *Veritas Temporis Filia*, the motto of Elizabeth's late sister. Her official progress carried Elizabeth before a masquelike representation of that phrase at the Little Conduit in Cheapside. Two artificial hills, which were respectively either "cragged, barreyn, and stonye" or "fayre, freshe, grene, and beawtifull," comprised the allegorical topography of this pageant. (Related images of sterility and harvest are incorporated into Walsingham's allegory of the Protestant succession; compare Figs. 73 and 74.) The opposed sites symbolized the transition from the state of the commonwealth under the late queen (*Ruinosa Respublica*) to the anticipated glory of Elizabeth's reign (*Respublica bene instituta*). From an artificial cave between these hills emerged a scythe-bearing actor playing aged Father Time, who led a girl costumed as Veritas and wearing the inscription "*Temporis filia*, the daughter of Tyme." This girl, clad in white silk, presented Elizabeth with an English Bible or "*Verbum veritatis*, the woorde of trueth."[75] *Veritas Temporis Filia* gained currency and underwent many variations as an Elizabethan slogan, even in the posthumous praise of the queen in Shakespeare's *Henry VIII*, where Cranmer utters a prophecy concerning the newborn princess whom "Time shall nurse":

> This royal infant—heaven still move about her!—
> Though in her cradle, yet now promises
> Upon this land a thousand thousand blessings,
> Which time shall bring to ripeness. (5.4.17–20, 28)

Although both queen and actors participated in the fiction that her coronation pageantry was spontaneous, official documents show that Elizabeth actively involved herself in preparations for such spectacles, selection of costumes, and payments to actors. The accounts of the Revels Office document the loan of costumes, thus proving that the queen was "not only recipient of the pageant, spectator of and 'actor'

when five costumed women, including Deborah (whom God had appointed "for the judge of his elect") and Judith, greeted Elizabeth. See Nichols, *Progresses*, vol. 2, Anno 1578, pp. 13–16.

[75] Mulcaster, *Quenes Majesties Passage*, C3ᵛ–4ᵛ (pp. 46–48).

in it," but also "part patron of this drama."[76] Her collaboration in the precoronation tableau, with its reflexive encounter between the queen and the personified virtue attributed to her, was but the first instance of the kind of self-theatricalization that would characterize her entire reign. The serious political purpose of dramatizing her accession to the throne as a Protestant queen bears out Stephen Greenblatt's observation that "Elizabeth's exercise of power was closely bound up with her use of fictions."[77]

The queen's active participation in the Cheapside tableau was intended to break down any division between the real world and symbolic ideals. In Elizabeth's response to the *Veritas Temporis Filia* pageant, she identified herself as Truth: "Tyme hath brought me hether [*sic*]." By kissing and embracing the scriptures—a response that was actually written into the scripted account that appeared in print only ten days after the event—Elizabeth also played the role of Faith, whose conventional attribute is an open Bible (see Fig. 29, upper right). The queen thus provided a living enactment of the eulogistic iconography incorporated into so many woodcuts of her reign: "But she as soone as she had received the booke, kyssed it, and with both her handes held up the same, and so laid it upon her brest, with great thankes to the citie therfore." The queen's enthusiastic response to an appeal lodged by the Interpreter of this pageant—"We trust O worthy quene, thou wilt this truth embrace"—revealed her as one of the Four Daughters of God (Ps. 85:10), as the restorer of "true" religion through the unification of temporal authority with knowledge of the divine Word.[78]

The pageant series was staged according to custom by the City of London and its guilds. Richard Grafton's inclusion among the four devisers is noteworthy, because less than five years earlier he had designed the censored tableau that was to have shown Henry VIII displaying the Bible during the London entry of Philip and Mary (see above, p. 102). The presentation of Elizabeth as Truth may have referred obliquely to the Marian pageant, but the allusion that most observers would have recognized is to the woodcut showing Henry VIII transmitting *Verbum Dei* on the title page of the 1539 Great Bible (Fig. 14); Grafton had published the work in collaboration with Edward Whitchurch. At the Cheapside tableau, Elizabeth may have em-

[76] David Bergeron, "Elizabeth's Coronation Entry (1559): New Manuscript Evidence," *English Literary Renaissance* 8 (1978): 6. See also Bergeron's *English Civic Pageantry*, pp. 15 and 20.
[77] Greenblatt, *Renaissance Self-Fashioning*, p. 166.
[78] Mulcaster, *Quenes Majesties Passage*, C2ᵛ, C4ʳ⁻ᵛ (pp. 44, 47–48). On the interconnection of the "two Protestant pageant series" for the coronation entries of Edward VI and Elizabeth, see Anglo, *Spectacle*, p. 355; and above, pp. 93–94.

braced an edition of that text, which would soon be reauthorized for use in England. In effect, Truth returned to her alter ego, the queen— and to England—the translation of the scriptures once authorized by her father and containing his powerful image.

The explications of the pageant series provided by Grafton and Richard Mulcaster show that these Protestant ideologues conceived of the spectacles as allegorical scenes conveying a fully developed political program. They incorporated overtly reformist sentiment into most of the tableaux. Grafton explains, for example, that the portrayal of Elizabeth as Time depicts the effort "to restore us to Gods veritie, and to put away all dregges of Papistry." Even though the pageant series incorporates the ubiquitous theme of how "the ii. houses of Lancaster and Yorke were united together" by the Tudor dynasty, a new note is added by Grafton's interpretation of the marriage of Henry VII and Elizabeth of York as a symbol for "the conjunction and coupling together of our soveraigne Lady [i.e., Queen Elizabeth I] with the Gospell and veritie of Goddes holy woord, for the peaceable governement of all her good subjectes."[79]

Grafton's Protestant zeal was well known, as was that of Mulcaster, the composer of verses for the 1559 entry and author of the published account in *The Quenes Majesties Passage* that appeared within two weeks of the event. Mulcaster had studied under Nicholas Udall, who collaborated with John Leland on the 1533 entry for Anne Boleyn. As a London schoolmaster, Mulcaster belonged to the traditional profession of pageant devisers. The handiwork of Grafton and Mulcaster is a prominent example of a Reformation adaptation of a traditional form, because it assimilated Protestant ideology and iconography into a medieval dramatic mode instead of looking to the classical models that Leland and Udall had infused into Queen Anne's pageantry. The stridency of this pageantry represented a throwback to the kind of propaganda nurtured by Thomas Cromwell and Protector Somerset.[80]

Comparison between Elizabeth's heraldic devices and pageantry and those for both Mary Tudor and Mary, Queen of Scots, makes it clear that apologists for the Protestant queen were engaged in a thorough reinterpretation of traditional royalist iconography. Their treatment of

[79] Richard Grafton, *Abridgement of the Chronicles of Englande*, rev. ed. (1570), Z2ᵛ–3. See Anglo, *Spectacle*, pp. 350–51, 354.

[80] Detailed discussions of the 1559 London entry may be found in Bergeron, *English Civic Pageantry*, pp. 11–22; Norbrook, "Panegyric of the Monarch," pp. 21–25; Roy Strong, "Elizabethan Pageantry as Propaganda," Ph.D. Diss., University of London (1962), p. 38, and above, pp. 174–75. Strong observes in *Art and Power: Renaissance Festivals, 1450–1650* (1984), p. 11, that this entry "was a triumph for the Protestant Reformation and yet in style it was wholly a child of the preceding Gothic ages."

Mary Tudor's motto is a case in point, for the Elizabethan pageant subordinates ecclesiastical tradition to the fundamental Protestant commitment to biblical authority.[81] John Knox had already parodied the motto by including *Veritas Temporis Filia* as an epigraph on the title page of his *First Blast of the Trumpet*. No small irony underlies the fact that Elizabethan iconography returned to that slogan the Protestant values first associated with it during the heyday of the Henrician Reformation. It may be that Elizabeth chose her own motto, *Semper Eadem* ("Always the Same"), as a variation of her sister's. The phrase suggests that her embodiment of the timeless Truth of Protestant England represents a rediscovery of the pure faith of the gospels that remains ever the same. The Earl of Essex made clear its application to the religious settlement of 1559 when he commented that *Semper Eadem* was the queen's typical response " 'whatever changes soever she sees round about her.' "[82] The queen believed that her compromise between Protestant doctrine and Catholic ritual represented a return to an enduring state of religious purity.

Elizabeth's kissing and embracing of the English Bible could not have announced her religious sympathies more boldly. Books symbolizing Reformation ideology likewise played a prominent role in the mock "triumph" prepared for the 1561 entry of Mary, Queen of Scots, into Edinburgh, a spectacle that inverted the apotheosis traditionally used in praise of medieval queens by presenting Mary as a hellish governor rather than a heavenly mediator. Its enactment only two years after Elizabeth embraced the scriptures in London may have suggested to members of the audience a contrast between England's "godly" queen and Scotland's "demonic" government by a latter-day Whore of Babylon. A boy costumed as an angel was lowered on a device "as yt were from heaven owte of a rownde globe" to present the Scottish queen with a Bible, the Psalms (a text favored by Protestants), and "the keeyes of the yates [i.e., gates]" of the city. These books dramatically rendered an admonition from the Presbyterian citizens of Edinburgh to their Catholic ruler that the scriptures constitute a *speculum principis* providing instruction on how to govern her land and subjects. The description of this lurid entry is contained in a letter of 7 September from William Cecil's agent in Edinburgh, Thomas Randolph, who commented that verses recited by the child lodged "terrible significa-

[81] See Fig. 61, and pp. 191–92 and 229 above.

[82] From an August 1595 letter to Maitland, as quoted by Haugaard, "Elizabeth Tudor's *Book of Devotions*," p. 104. See also Lynn Staley Johnson, "Old Wine in New Bottles: Thomas Blenerhasset's Elizabethan Shepherds' Pageant," *Journal of the Rocky Mountain Medieval and Renaissance Association* 5 (1984): 113.

tions of the vengeance of god upon Idolaters." Some citizens also wanted to stage a pageant showing "a priest burned at the Auter at the elevation" of the Host, but that plan was stayed by the Earl of Huntley.[83]

In place of the show of fealty conventional in traditional pageantry, the biblical books presented by the citizenry of Edinburgh symbolized political dissension and a demand made by subjects upon the ruler to countenance their Protestant faith. The reformist tableaux were notable for their incorporation of scriptural texts and iconography. According to John Knox, the queen "for schame . . . could not refuise" the Bible, but she frowned and passed the gift on to a retainer notorious for his Catholic orthodoxy. The citizens of Edinburgh would be satisfied, however, with nothing less than the kind of faith symbolized by the neighboring English queen's enthusiastic embrace of the Bible. The remaining pageants lodged explicit attacks against the Scottish queen and her religion. Another report supplements Randolph's version of these events by reporting that at one tableau, the burning of a wooden image of a priest in "the maner of ane sacrifice" followed a speech calling for the abolition of the mass. This scenario clearly defames the Catholic doctrines of transubstantiation and the mass as a continuing sacrifice. One witness reports that the queen openly disapproved of this display. Another pageant predicted infernal punishment for Mary's alleged idolatry when it was eventually ignited into flames that consumed a dragon hanging from a scaffold. In all likelihood, that spectacle alluded to the apocalyptic beast that the reformers identified with the church of Rome, thus forcing Mary to play the role of its rider, the Whore of Babylon, who is consigned by God to hellish flames (Rev. 18:8). As if to drive home the hostile Protestant sentiments of the Scottish citizenry, the singing of a Psalm preceded the queen's departure for Holyroodhouse, where a man in a cart "maid some speitche [speech] concernyng the putting away of the mess [mass], and thairefter sang ane psalme."[84]

By reigning as England's virgin queen, Elizabeth escaped the political compromises necessitated by the marriages of her sister Mary Tudor and cousin Mary, Queen of Scots. She did so, however, by sacrificing her own yearning to continue the Tudor line, as suggested by the protracted negotiations for her engagement to the Duc d'Alençon.

[83] B.L. MS Cotton Caligula, B. X. fol. 1–208, "Transacta inter Angliam et Scotiam, 1558–1567," fol. 160ᵛ.

[84] Anna J. Mill, *Mediaeval Plays in Scotland*, St. Andrews University Publications, no. 24 (Edinburgh and London, 1927), pp. 189–91 and notes. See also Bergeron, *English Civic Pageantry*, pp. 23–25; and Gordon Kipling's forthcoming study of royal entries and civic triumphs.

After the dangers of foreign Catholic entanglement subsided with the failure of the proposed French match in 1579–80, in the view of David Norbrook, ardent Protestants could acclaim "this virgin queen with all the greater enthusiasm, and her virginity became a symbol of national independence." That this shift coincided with an increased emphasis on classical mythology in royalist panegyric may be seen in Thomas Blenerhasset's *A Revelation of the True Minerva* (1582) and George Peele's *The Araygnement of Paris* (1584), a "pastoral" performed before Queen Elizabeth by the children of the Chapel Royal.[85] The portrayal of the queen as a new Minerva in the Blenerhasset pageant "epitomizes the ideals of Protestant England" by fusing classical pastoral with the native variety found in the shepherds' plays of the medieval mystery cycles.[86] One may note the importance of classical imagery in earlier depictions of Elizabeth in works like the *Judgment of Paris* (1569) by the Monogrammist HE, the *Allegory of the Tudor Protestant Succession* (Fig. 72), which the queen gave to Walsingham, and *The Princelye Pleasures at the Courte at Kenelwoorth* that George Gascoigne and others composed in 1575 for performance before the queen.

Queen Elizabeth's precoronation pageantry established a precedent for renewed imitation of her father's use of the English Bible as a symbol for governance by a "godly" monarch. When the Bishops' Bible succeeded the Great Bible as the official translation of Elizabethan England, its allegorical title pages looked back to the Henrician Bibles by using the sovereign as a nexus for symbols of authorship, authority, and authorization. Visible at the front of Bibles available by law in every parish church, the entire series of monarchical figures must have been thoroughly familiar to the English population as images of royal permission and control. The first edition of the Bishops' Bible portrayed the queen as Hope, as the embodiment of the possibility of institutionalizing a Protestant religious settlement in England (Fig. 29; see above, pp. 105–7). A woodcut allegory introduced in the 1569 quarto edition (Fig. 75) praises royal authority over church and state by fusing a figure of the queen as the Woman of Faith with the royalist iconography of the Sword and the Book. Adopting the conventional monarchical pose established in the Coverdale Bible (Fig. 8), Elizabeth in her royal magnificence appears as the summation of the virtues personified in the corners of the woodcut: Justice, Mercy, Prudence, and Fortitude.

With the transposition of Temperance into Mercy, this modification

[85] Norbrook, "Panegyric of the Monarch," p. 58.
[86] Johnson, "Old Wine in New Bottles," pp. 107, 111.

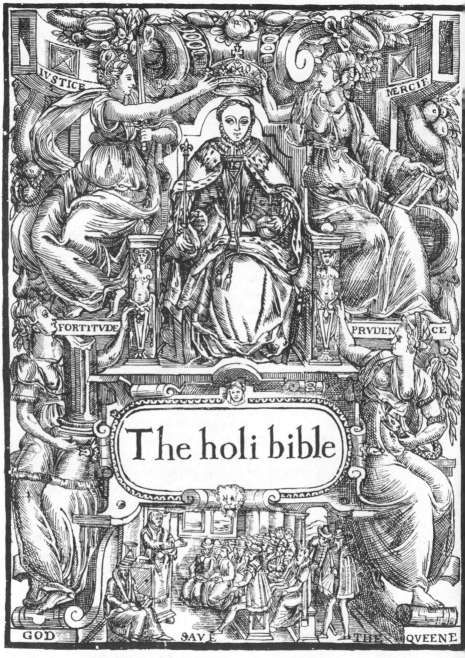

The holi bible

75. *Elizabeth I and the Four Virtues,*
Bishops' Bible (1569)

of the four cardinal virtues of the classical world is particularly appropriate to Elizabeth because it associates the imperial virtues of Justice and Mercy, portrayed in the act of crowning the queen, with symbols of divine revelation. Thus Justice, at the queen's right side, carries the sword linked by the reformers to the Holy Spirit. Explained by Spenser as the "sacred pledge of peace and clemencie," the scepter carried by Elizabeth weights the tableau in the favor of Mercy, who is identified by the Bible in her hand as the preeminent virtue.[87] Fortitude, at the lower left of the woodcut, carries a broken pillar, possibly alluding to Samson's destruction of the Philistine Temple (Judges 16:29–30); whether broken or whole, the pillar is the traditional image of fortitude. If the bough behind Prudence bears laurel leaves, it may call attention to the synthesis of pagan and divine inspiration. A disparity therefore existed between the queen's public image, as it was fashioned by Protestant apologists for propagandistic purposes, and claims that Elizabeth made on her own behalf: In one speech she laid claim to the virtues of Justice and Temperance, while acknowledging that the remaining regal virtues—Prudence and Magnanimity—were appropriate only to men.[88]

All of the details of the Bishops' Bible title page coalesce to identify the queen with divine Truth, by analogy to the Four Daughters of God derived from Psalm 85:8–13: Truth, Mercy, Righteousness (or Justice), and Peace. The interpretation of that Psalm as "a figure of Christs kingdome, under the which shulde be perfite felicitie," according to the headnote in the Geneva Bible, easily permitted Protestants to apply the text to the new Israel of Elizabethan England. The imagery is traditional and well known, however, through medieval literary works (like *Piers Plowman*), mystery plays (*Ludus Coventriae*), and moralities (*The Castle of Perseverance*). Elizabethan royal apologists retained the apocalyptic associations of a figure that had been used frequently in pageantry for queens such as Margaret of Anjou. The personifications of Veritas, Iustitia, Misericordia, and Pax even appear in Udall's *Res-*

[87] *FQ* 5.9.30. The *Sieve Portrait* (c. 1580) attributed to Cornelius Ketel is an important example of the redefinition of an attribute of temperance (or intemperance) as a symbol for imperial majesty. This image of Queen Elizabeth as a Roman Vestal holding a sieve in her left hand alludes to the legend of Tuccia, the vestal virgin who disproved allegations of unchastity by carrying water in a sieve without spilling a drop (see Strong, *Cult*, pl. III and p. 153). Contrast "Nimis Nequid" ("Not Too Much") with its image of a woman pouring water through a sieve as emblem of immoderation, in George Wither, *A Collection of Emblemes, Ancient and Moderne* (1635), bk. 4, ill. 34.

[88] Norbrook, *Poetry*, p. 114. He observes in "Panegyric of the Monarch" that Elizabethan iconographers enjoyed the advantage of accommodating "praise of a female ruler to a system of allegorical representation in which virtues were depicted as female" (p. iii).

publica as attributes of Queen Mary (see p. 192, above). Analogy to the Four Daughters of God on the title page of the officially authorized Elizabethan Bible translation takes on a special political resonance because personifications of Mercy, Truth, Justice, and Peace traditionally pleaded on behalf of humanity before the Trinity (e.g., the Egerton Hours, B.L. MS Egerton 2045, fol. 25).

The iconography of the Bishops' Bible was adapted to defend Elizabeth's authority as a divine agent and governor of the Church of England. She retained the role of intercessor between God and humanity that had been claimed by kings and emperors in a tradition going back to the Carolingian age (Figs. 1–2). The strong association between spiritual truth and Christian queenship extends to the inset beneath the cartouche containing the title "The holi bible." The divine revelation claimed for the English church service "descends" on an axis from heaven above through the queen to the people below. The title page personifies the queen's endorsement of the free reading and preaching of the vernacular Bible, as portrayed in the inset. The inset's conventional congregational scene is a variation of the vignettes that are set into the base of the Great Bible title page, the title-page border of Foxe's "Book of Martyrs," and the portrayal of the Edwardian worship service in the latter text (Figs. 14, 28, 62); the major difference is the replacement of Henrician apparel with Elizabethan garb.

The Bishops' Bible identifies Elizabeth as the personification of wisdom through her association with Prudence, whose serpent symbolizes Christian wisdom by allusion to Matthew 10:16: "Be ye therefore wise as serpentes, and innocent [i.e., harmless] as doves." As unlikely as this compliment may seem, a remark by George Puttenham in *The Arte of English Poesie* indicates that the serpent gained currency as a symbol for the queen: "So we commending her Majestie for wisedome . . . likened her to the Serpent . . . because by common usurpation, nothing is wiser then the Serpent."[89] Toward the very end of her reign, a jeweled serpent on whose head rests an armillary sphere was embroidered as a symbol of wisdom on Elizabeth's left sleeve in the *Rainbow Portrait* attributed to Marcus Gheeraerts the Younger (Fig. 76; c. 1600). Frances Yates traces the queen's glorification in this painting to Cesare Ripa's *Iconologia* (Rome, 1593), in which eyes and ears like those which appear on the queen's robe are taken to be attributes of Fame.

[89] George Puttenham, *The Arte of English Poesie*, ed. Gladys D. Willcock and Alice Walker (Cambridge, 1936), p. 243. Federigo Zuccaro attributes the serpent of Prudence to Elizabeth in a 1575 drawing; see Strong, *Elizabeth*, Drawings and Illuminations, no. 5, and pl. IX. For variations of the theme of Divine Wisdom or Prudence as a serpent, see Wither's *Collection of Emblemes*, bk. 2, ill. 12; bk. 3, ills. 8 and 17.

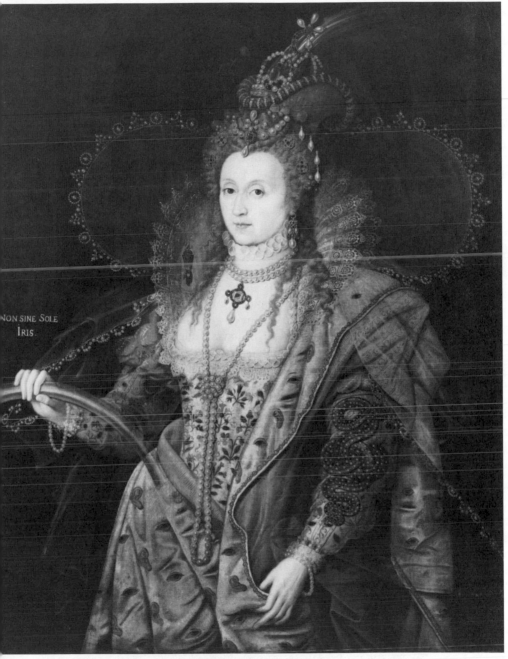

NON SINE SOLE
IRIS.

76. Attributed to Marcus Gheeraerts the Younger,
Elizabeth I: The "Rainbow Portrait," c. 1600

Further, according to Ripa, "Intelligenza," or Wisdom, is symbolized by a woman holding a serpent in one hand and a celestial sphere in the other.[90] Although the sophisticated *Rainbow Portrait* contains no explicit Christian elements, the serpentine figure may incorporate a layer of evangelical symbolism. Despite the many negative connotations of serpents in the Bible, Protestants also identified them with the doctrine of justification by faith in their interpretations of the Brazen Serpent (see above, p. 85) and the incident in which St. Paul miraculously escaped death from a viper's bite when he threw a poisonous serpent back into a fire (Acts 28:1–6). Portrayal of the latter event on the reverse of a 1572 medal suggested that the queen's recent recovery from smallpox was due to providential intervention. The obverse portrays Queen Elizabeth with a motto from Romans 8:31: "Si Deus nobiscum quis contra nos?" ("If God be on our side, who can be against us?").[91]

The Protestant conviction that Elizabeth's accession to the throne was a direct result of divine intervention in an apocalyptic battle against Antichrist provided a means of shaping public perceptions of the queen as a living embodiment of godliness and zeal. The allegory of the initial C in the "Book of Martyrs" (Fig. 50) implies accordingly that images have power. The woodcut links the representation of authority in the realm of politics and religion—the autonomy affirmed for the English *imperium* and church by Henry VIII—with the ability to appeal for preferment and reward, which is the only channel to power in a courtly society. Although the queen was notoriously reluctant to extend patronage, she rewarded her apologists. Those who were loyal to her before she came to the throne, especially during the dangerous days of her sister's reign, often received support through the crown after she came to power. John Foxe and John Bale both received prebendaries through the good offices of such courtiers as William Cecil, Matthew Parker, or Thomas Norton, even though Foxe always eschewed a public career.[92]

The title-page woodcut of John Dee's *General and Rare Memorials Pertayning to the Perfect Arte of Navigation* (1577) is an expanded version of the C initial in the "Book of Martyrs" (Fig. 77; see Fig. 50). Here the queen is again flanked by three men as she navigates a ship identified as Europe by its Greek inscription and the mythical figure of Europa riding the bull (see Fig. 78). Occasion, personified as a woman,

[90] Yates, *Astraea*, pp. 216–18. See also Strong, *Elizabeth*, Paintings, no. 100; and *Cult*, pl. I, fig. 28 (detail of the sleeve), and pp. 50–52.

[91] Strong, *Elizabeth*, Medals, no. 2; see also Haugaard, "Elizabeth Tudor's *Book of Devotions*," p. 95.

[92] *ERL*, pp. 427, 435–36; see above, p. 156.

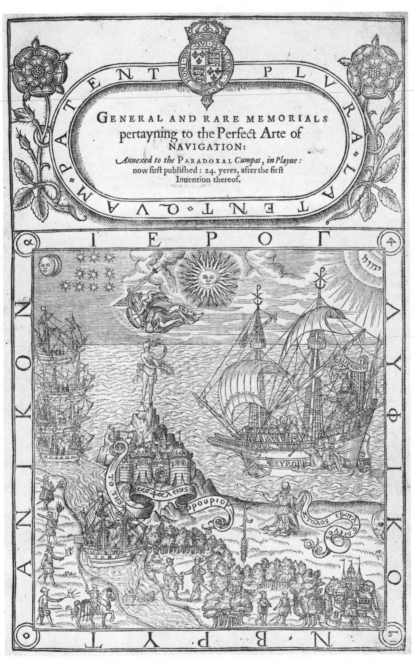

77. *Elizabeth I as Imperial Navigator*, from John
Dee, *General and Rare Memorials* (1577)

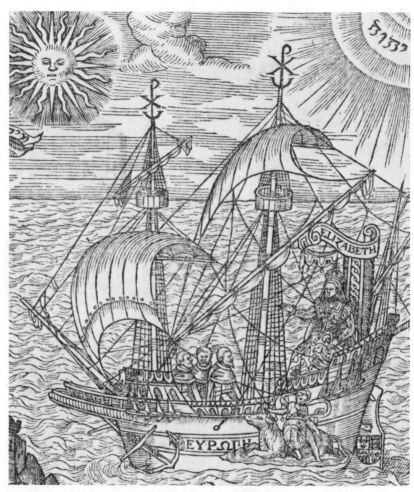

78. *The Ship of State*, detail from *Elizabeth I as Imperial Navigator* (Fig. 77)

stands on the fortress, while the apocalyptic angel, St. Michael, descends with the royalist device of the sword of justice and the shield of faith that bears the bloody cross of Christ (the cross also appears on the Tudor battle flag). The royal arms above the title and the Tudor roses at either side underscore these claims to dynastic legitimacy and imperial authority. The Tetragrammaton in the upper right corner bestows divine blessings on the ship, whose masts are surmounted by the Chi-Rho monogram. The first two letters of the Greek form of Christ's name, which are also an abbreviation for χϱηστός ("propitious"),

240

were first adopted as an imperial device when Emperor Constantine added them to the Roman standard. France Yates observes that the allegory urges Britain to "seize Occasion by the forelock and grow strong at sea to strengthen Elizabeth's 'Imperiall Monarchy' and perhaps even to make her the pilot of the 'Imperiall Ship' of Christendom."[93]

Although the iconography of the first half of Elizabeth's reign was heavily biblical, Frances Yates rightly observes that the classical figure of Astraea-Virgo underwent early adaptation to praise of Elizabeth as a Reformation queen. Despite Yates's overstatement that Astraea symbolism was used "from the very beginning of her reign" (Yates, *Astraea*, p. 59), the syncretic impulse to amalgamate Christian and pagan imagery may be noted not long after Elizabeth's accession. The first known application of Astraea symbolism to Elizabeth is found in the tribute paid in *A Theatre for Worldlings* (1569) by Jan van der Noot, a Brabantine exile resident in London:

> good kings and princes which feare the Lord, shal have peace and comfort bothe in this worlde, and in the worlde to come . . . at this day most evidently in the realmes and countryes under youre Majesties dominion, whiche God hath blessed in suche sort, that it may truly be sayd, that the kingdome of *Saturne*, and the Golden worlde is come againe, and the Virgin *Astraea* is descended from heaven to builde hir a seate in this your moste happie countrey of *England*. (A6)

By appending Astraea to a longer list of biblical types for queenly majesty, van der Noot infused classical symbolism into evangelical piety. The main thrust of his dedication, however, is to praise the queen as a peer of Joshua, Judah, Gideon, David, and Josiah (A6–7).

The reformist sympathies of London authorities led to portrayal of the journey of the classical goddess of Justice as yet another triumph of the Crown over the Tiara in *Descensus Astraeae*, the 1591 Lord Mayor's Show, where George Peele recreated the victory of Pure Religion over Ignorance and Superstition; Elizabeth's coronation pageantry had dramatized this conflict three decades earlier. The Presenter explains the spectacle of Astraea as a shepherdess looming victorious above a priest personifying Ignorance:

[93] Yates, *Astraea*, pp. 49–50. She also notes that the Dee frontispiece "takes the picture from the C initial and expands it to cover the theme of his book." For further explication of the political symbolism of this woodcut and its motto, "PLURA LATENT QUAM PATENT" ("More things are concealed than are revealed"), see Margery Corbett and Ronald Lightbown, *The Comely Frontispiece: The Emblematic Title-Page in England 1550–1660* (1979), pp. 48–56.

> Nor lets blind superstitious ignorance,
> Corrupt so pure a spring: O happie times
> That do beget such calme and quiet daies,
> Where sheep and shepheard breath in such content.

Peele follows the example of Spenser, in the religious satires of *The Shepheardes Calender* (1579), and other poets, like Blenerhasset, in his incorporation of the language of biblical pastoral into classical Arcadianism as a formula for Protestant allegory. Elizabeth appears in the guise of Astraea with her shepherd's crook, flanked by the Three Graces and Three Theological Virtues, as the anointed builder of "the temple of triumphant Truth" in the peaceful and happy land favored by "Great Israels God."[94]

Triumphal themes were particularly appropriate following the 1588 defeat of the Spanish Armada, whose destruction was interpreted not simply as an event of local and national significance, but more importantly as evidence of divine sanction for England and the European Protestant cause. William Rogers's 1589 engraving, *Eliza Triumphans*, memorializes the event by picturing Victory and Plenty bestowing favor on the queen, whose olive branch identifies her as Pax. Frances Yates suggests that the queen's crown combines the circlets of palm and oak leaves proferred by the female personifications to form "the triple crown of empire,"[95] but the scene may also preserve a remote parody of the tiara toppled from the pope's head in so many allegorical portraits of the Tudors (Figs. 22, 51, and 53).

Antipapal satire is explicit in James Aske's *Elizabetha Triumphans* (1588), a poetic account of the "damned practizes, that the divelish Popes of Rome have used ever sithence her Highnesse first comming to the Crowne, by moving her wicked and traiterous subjects to Rebellion and conspiracies." The account focuses on the great nationalistic events of the queen's speech at Tilbury, where "her excellency was entertained by her Souldyers into her Campe Royall," and the ensuing defeat of the Spanish Armada. Accordingly, the providential "overthrow had against the Spanish Fleete" constitutes only one of many "wondrous overthrowes had against the *Pope* by this our royall Queene," who, as a Protestant deliverer, has driven the "ravenous *Wolfe*" of papal Rome out of the English fold (A4, B1v–2, C1v).[96] Aske

[94] George Peele, *The Life and Minor Works of George Peele*, ed. David H. Horne, vol. 1 of *The Life and Works*, ed. Charles T. Prouty et al., 3 vols. (New Haven, 1952–70), pp. 214–19, ll. 24–27, 50–51, 54–59, 60–65, and 80–82. See Yates, *Astraea*, pp. 60–62.

[95] Yates, *Astraea*, p. 58. See also Strong, *Elizabeth*, Engravings, no. 17; and Hind, vol. 1, pl. 139a.

[96] Satires on clerical "wolves" (and "foxes") are also contained in Spenser's *Shep-*

envisioned queen and pope, in the manner of the initial C in the "Book of Martyrs," as an antithetical pair: "And with your Queene beloved of our God, / Turne to Gods word, and shunne the divelish *Pope*" (F2). An anonymous Frenchman similarly discovered evidence of divine intervention in "la myracvlevse deffaicte de ceste redoutable (escriée jnvincible) Armée navale du Roy d'Espagne," in "Le Merveillevx Exploict, & ouevre de la main de Dieu, advenu l'an 1588 sur l'Armée navale de Ph[i]lippe d'Austrice Roy d'Espagne" (B.L. MS Sloane 1603, fols. 3–50ᵛ).

Lodowick Lloyd parodied the papal tiara in *The Triplicite of Triumphes* (1591), where he perceived intricate patterns of threes as a sign of divine favor celebrated in the great national holidays of Elizabethan England "by the name of *Triplicia Festa*": the queen's birthday (7 September), Accession Day (17 November), and the anniversary of her coronation (15 January). Lloyd even discovered a pun on *tri-umph* in praising these "three most happy, joyfull and triumphant daies." He celebrated Accession Day in particular, with its jousting, bonfires, and feasting, as a Protestant holiday that the English "enjoy for Christ his sake our saviour" (A2ᵛ). It should come as no surprise, then, to note that Lloyd found a reversal of the truly "imperiall" imagery of the Adoration of the Magi in the coronation of Holy Roman Emperors, notably Charles V, who, "standing on the left side of the Popes horse, gave the styrrup to the Popes foot, and then . . . tooke still the left hand of the Pope" (D3, E3ᵛ).

 Thomas Bentley gathers together traditional images for praising queens, and their Elizabethan variations, in his encyclopedic collection of scriptural works on prayer, meditation, and ethical counsel written either by women or for a female readership: *The Monument of Matrones* (1582). His organization of the collection into sections entitled the "seven severall Lamps of Virginitie" amalgamates imagery of divine wisdom and spiritual illumination drawn from Christ's parable of the Wise and Foolish Virgins (Matt. 25:1–13) and the Book of Revelation. The parable contrasts the five maidens who filled their oil lamps (λαμπάδες) with the foolish five whose lamps remained empty; only the former were prepared to meet Christ, the Bridegroom, and celebrate the apocalyptic marriage feast. The vision of seven lampstands (λυχνίαι) in Revelation 1:20–2:1 refers literally to the seven-branched lampstand that stood in the outer

heardes Calender and *Mother Hubberds Tale*, as well as the more violently antipapal beast fables by John Bale and William Turner. See Norbrook, *Poetry*, pp. 72–73; and John N. King, "Was Spenser a Puritan?" *Spenser Studies* 6 (1985): 6–7.

room of the Temple in Jerusalem. This lampstand, or menorah, appears in Hebrew prophetic visions of heaven.[97] The opposition of the Woman Clothed with the Sun to the great red dragon, whose seven heads parody the vision of the seven lampstands (Rev. 12), fuses her with the Five Wise Virgins in a complex skein of apocalyptic imagery that has its origin in the union of the Bridegroom and Spouse celebrated in Canticles. The seven golden lampstands of Revelation ("candlesticks" according to the Tudor translations) and related imagery from Canticles are hardly Tudor, but Bentley and the illustrator of his book assumed contemporary readings of both texts as Reformation prophecies in applying such imagery to Queen Elizabeth as a figure for providential guidance and wisdom.[98] It may be that the parable of the Wise and Foolish Virgins carried special topical relevance at this time, because Hans Eworth's 1570 allegory on this theme might have been painted as a "flattering peace offering to Elizabeth"; a foolish virgin in the right foreground holds a rosary instead of tending to her oil lamp.[99]

The symbolic title leaves introducing the first five sections of Bentley's collection, all of which concern "praier and meditation," employ iconographic lamps related to the prophetic lampstand. With the royal arms at the top, the border for volume one (Fig. 79) praises Queen Elizabeth, the recipient of the author's dedication, as a contemporary embodiment of the Spouse of Canticles, who stands at the bottom carrying the menorah and an open Bible. The entire collection and its iconography was designed as an appeal for court patronage by Bentley, a student at Gray's Inn. Allusion to the Bride's virginity pays a compliment to Elizabeth and her unmarried state that echoes the reference in his title to the seven "Lamps of Virginitie." The upper insets flanking the title portray the paradigmatic women, Eve and Mary, while the lower insets depict the Five Wise Virgins initially greeting the Bridegroom, and then standing among celestial flames. The epigraph ("Watch," "Praye," "Take Heede") refers to the Wise Virgins' preparedness for the Second Coming. The many symbolic lamps and allusions to scriptural lamps throughout the illustration represent the light of faith.

Succeeding woodcuts develop Bentley's compliment to the queen by juxtaposing her with outstanding women from the Bible and recent

[97] A. E. Harvey, *Companion to the New Testament* (Oxford and Cambridge, 1970), pp. 791–92.
[98] See Fig. 64 and Dürer's engravings for Revelation (Nuremberg, 1498). The Geneva Bible includes an illustration of a seven-branched candlestand at Exodus 25:31.
[99] Strong, *Icon*, p. 9 and pl. 43.

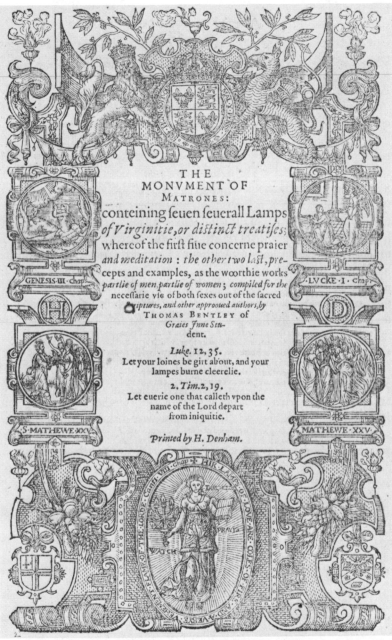

THE
MONVMENT OF
MATRONES:
conteining seuen seuerall Lamps
of Virginitie, or distinct treatises;
whereof the first fiue concerne praier
and meditation : the other two last, pre-
cepts and examples, as the woorthie works
partlie of men, partlie of women; compiled for the
necessarie vse of both sexes out of the sacred
Scriptures, and other approoued authors, by
THOMAS BENTLEY of
Graies Jnne Stu-
dent.

Luke. 12, 35.
Let your loines be girt about, and your
lampes burne cleerelie.

2. Tim. 2, 19.
Let euerie one that calleth vpon the
name of the Lord depart
from iniquitie.

Printed by H. Denham.

GENESIS·III·chap LVCKE·I·chap
S·MATHEWE·XXV MATHEWE·XXV

79. *Title-page Border*, from Thomas Bentley, *The
Monument of Matrones* (1582)

history. By way of introduction to prayers and meditations "made by sundrie vertuous Queenes," the border for the "Second Lampe of Virginitie" (Fig. 80) associates Elizabeth at the upper left with Queen Hester (Esther) from the Old Testament and the queenly authors of contemporary devotional works drawn out of the scriptures: Catherine Parr and Marguerite de Navarre. The enthroned skeleton at the bottom symbolizes the universality of death, the leveler of queens and commoners (Fig. 81), just as the skeleton rising from the grave at the base of the succeeding border (Fig. 82) epitomizes the Christian promise of salvation. The title leaf of the "Third Lampe" links Elizabeth with the familiar types for regnant queens: Deborah and Judith (Fig. 83). Although Bathsheba receives a place of honor as King David's wife and mother of King Solomon, her appearance in Elizabethan iconography is most unusual. The general absence of references to this Hebrew queen doubtlessly results from the corrupt associations of the acts of adultery and murder with which David won her from her husband, Uriah the Hittite (2 Sam. 11:2–17). Nevertheless, medieval commentators interpreted this episode typologically as a prefiguration of the union of Christ and the church. The last two illustrations vary the formula of the preceding title leaves. The "Fourth Lampe" associates the queen with the prophetesses Huldah and Anna. The inclusion here of Susanna, who was unjustly accused of adultery and thus prefigured for Christians the tribulations of the "true" church, suggests a possible allusion to Elizabeth's mother, Anne Boleyn, through association with St. Anne, the mother of Mary. Protestant apologists like Aylmer and Foxe rehabilitated Henry VIII's second wife because of her alleged friendship and support of reformers. Praise of Anne Boleyn as the divine instrument for the break with Rome therefore became a conventional reformist compliment to her daughter, the reigning monarch who resumed use of her mother's falcon crest as a personal badge.[100] The "Fift Lampe" includes Elizabeth among biblical women associated with spiritual renewal and resurrection: Martha, Abishag, and the widow of Zarephath.

[100] The crowned white falcon appears in the lower corners of an illuminated portrait of Queen Elizabeth in Georges de la Mothe, "Hymne A Tres-Haute . . . Elizabeth Royne D'Angleterre" (Bodl. MS Fr. e. 1, fol. 7), reproduced in Strong, *Elizabeth*, Drawings and Illuminations, no. 10. Aylmer states: "Was not Quene Anne the mother of this blessed woman, the chief, first, and only cause of banyshing the beast of Rome, with all his beggerly baggage?" (*Harborowe for Faithfull Subjectes*, B4ᵛ). Foxe likewise attributes the pope's loss of "authoritye and jurisdictyon in this realme of England . . . [to] the most vertuous and noble lady, Anne Bullen," in *A & M*, (1563), p. 508. Maria Dowling demonstrates that the queen deserved her reputation as a patron of reformers and the free circulation of the vernacular Bible, in "Anne Boleyn and Reform," pp. 30–46.

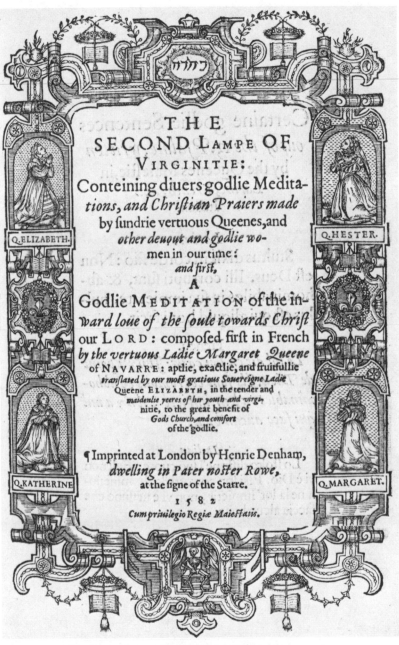

THE
SECOND Lampe OF
VIRGINITIE:

Conteining diuers godlie Medita-
tions, *and Chriſtian Praiers made*
by ſundrie vertuous Queenes, and
other deuout and godlie wo-
men in our time:
and firſt,
A

Godlie MEDITATION of the in-
ward loue of the ſoule towards Chriſt
our LORD: compoſed firſt in French
by the vertuous Ladie Margaret Queene
of NAVARRE: aptlie, exactlie, and fruitfullie
tranſlated by our moſt gratious Souereigne Ladie
Queene ELIZABETH, in the tender and
maidenlie yeeres of hir youth and virgi-
nitie, to the great benefit of
Gods Church, and comfort
of the godlie.

¶ Imprinted at London by Henrie Denham,
dwelling in Pater noſter Rowe,
at the ſigne of the Starre.
1 5 8 2
Cum priuilegio Regiæ Maieſtatis.

Q. ELIZABETH. Q. HESTER. Q. KATHERINE. Q. MARGARET.

80. *The Second Lamp of Virginity,* from Thomas
Bentley, *The Monument of Matrones* (1582)

81. *Memento Mori,* detail from *The Second Lamp of Virginity* (Fig. 80)

82. *The Resurrection of the Dead,* detail from *The Third Lamp of Virginity* (Fig. 83)

Bentley demonstrates the existence of a Reformation tradition of learned queens through the sequential publication, in the "Second Lampe," of Princess Elizabeth's "A Godlie Meditation of the inward love of the soule towards Christ our Lord," her translation of Marguerite de Navarre's *Miroir de l'âme pécheresse*; two devotional texts by Catherine Parr; and a set of deathbed writings or "last words" by Lady Jane Dudley (née Grey). Of particular interest because of their allusion to the iconography of feminine piety are the homiletic writings of Jane Grey, the nine-day queen whose aborted reign was intended to preserve the Protestant hegemony imposed under Edward VI; these writings include a prayer uttered before her execution, an exhortation to her sister written in a New Testament, devotional verses, and a version of Psalm 51 spoken as a prayer at the time of her beheading.

Lady Jane's writings had originally appeared in a separate edition of yet another evangelical text, *An Epistle of the Ladye Jane to a Learned Man* (London?, 1554), where she fashioned herself in the image of "a true Christian woman," self-consciously assimilating her own experience with the experiences of the Spouse of Canticles and the Woman Clothed with the Sun. Jane Grey's committal of her New Testament to her sister as a model for true faith on the night before her beheading accommodates the counsel of apocalyptic readiness from the parable of the Five Wise Virgins (lest "for lacke of oyle ye bee founde like the five folishe wemen" [A2, A8ᵛ, B5, B7–8]) to Catherine Grey's experience, and by extension to that of any faithful Christian. The weaving of so many references to the Wise Virgins, the Woman Clothed with the Sun, and the Spouse of Canticles into both Jane Grey's writings and the symbolic title pages of Bentley's *Monument* demonstrates the wide currency of scriptural iconography for queens in Reformation England.[101]

Catherine Parr's place of honor in the "Second Lampe" and the *Monument* as a whole pays an indirect compliment to her stepdaughter, Queen Elizabeth. As Henry VIII's last wife and dowager queen, Catherine Parr developed a reputation for learning and piety through works reprinted by Bentley: *Prayers Stirryng the Mynd unto Heavenlye Medytacions* (1545) and *The Lamentacion of a Sinner* (1547). Drawn respectively from Thomas à Kempis's *Imitation of Christ* and the scriptures, these meditative manuals functioned as supplements to

[101] In a related example, verses that celebrate Marguerite de Navarre as a Wise Virgin receiving Christ's kisses in the ecstasy of the heavenly bridal couch are contained in *Annae, Margaritae, Janae, sororum virginum, heroidum Anglarum, in mortem divae Margaritae Valesiae, Navarrorum reginae, Hecatodistichon* (Paris, 1550). This collection of 104 Latin distichs memorializing Marguerite's death was prepared by the daughters of staunchly Protestant Edward Seymour, Duke of Somerset and one-time Protector of the Realm under Edward VI. See Prescott, "Pearl of the Valois," pp. 73–74.

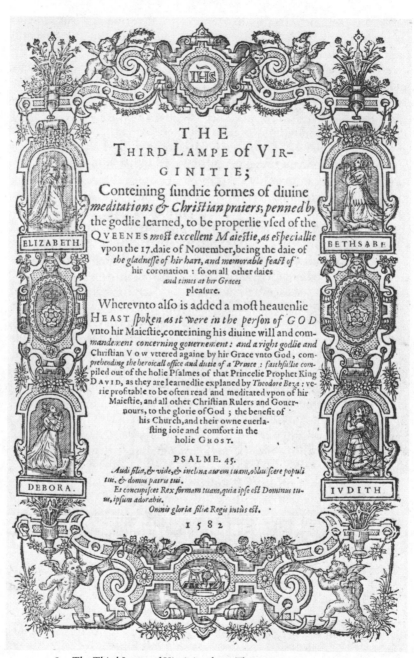

THE
Third Lampe of Vir-
GINITIE;

Conteining ſundrie formes of diuine
meditations & Christian praiers, penned by
the godlie learned, to be properlie vſed of the
QVEENES *most excellent Maiestie, as especiallie*
vpon the 17.daie of Nouember, being the daie of
the gladneſſe of hir hart, and memorable feaſt of
hir coronation : ſo on all other daies
and times at hir Graces
pleaſure.

Wherevnto alſo is added a moſt heauenlie
HEAST *ſpoken as it were in the perſon of* GOD
vnto hir Maieſtie, conteining his diuine will and com-
mandement concerning gouernement : and a right godlie and
Chriſtian VOW vttered againe by hir Grace vnto God, com-
prehending the heroicall office and dutie of a Prince : faithfullie com-
piled out of the holie Pſalmes of that Princelie Prophet King
DAVID, as they are learnedlie explaned by *Theodore Beza* : ve-
rie profitable to be often read and meditated vpon of hir
Maieſtie, and all other Chriſtian Rulers and Gouer-
nours, to the glorie of God ; the benefit of
his Church, and their owne euerla-
ſting ioie and comfort in the
holie GHOST.

PSALME. 45.

Audi filia, & vide, & inclina aurem tuam, obliuiſcere populi
tui, & domus patris tui.

Et concupiſcet Rex formam tuam, quia ipſe eſt Dominus tu-
us, ipſum adorabis.

Omnis gloria filiæ Regis intùs eſt.

1582

ELIZABETH.

DEBORA.

BETHSABE.

IVDITH.

83. *The Third Lamp of Virginity,* from Thomas
Bentley, *The Monument of Matrones* (1582)

Bible study. More than anyone else, Catherine Parr was responsible for Elizabeth's humanistic education in classical languages and the Bible.

The princess reciprocated by dedicating to her stepmother a holograph translation of Marguerite de Navarre's *Miroir*, which she entitled "The Glasse of the Synneful Soule" (Bodl. MS Cherry 36, dated 31 December 1544). In this work Elizabeth seems to show greater affection for her stepmother than for her father, because the relatively few mistranslations in her otherwise careful text introduce personal animus against Henry VIII for executing Anne Boleyn and other wives. Elizabeth's substitution of "mother" for the word "Pere" in the original text, for example, accommodates Marguerite's "impassioned evocation of God as a great king and judge who is kind to daughters and does not execute adulterous wives" to her father's treatment of Anne Boleyn.[102]

In 1545, Elizabeth dedicated to Henry VIII a holograph translation into Latin, French, and Italian of Catherine Parr's *Prayers and Medytacions*, which she entitled *Precationes sev meditationes* (B.L. MS Royal 7 D. X). These translations form part of a cycle of New Year's gifts to close relatives from the princess that concluded with the holograph copy of her own translation from Italian into Latin of Bernardino Ochino's *De Christo Sermo* (Bodl. MS Bodley 6); the motto written on the flyleaf, "Dominus mihi adiutor," resembles the proverbs that Elizabeth inscribed and embroidered onto personal copies of devotional texts (see above, pp. 109–10). Elizabeth's dedication of this text to King Edward conformed to the contemporary vogue for the works of immigrant Protestant theologians. Princess Mary was conspicuously absent as a recipient of any part of Elizabeth's cycle of sacred texts.

Catherine Parr's preparation of texts for use in the meditations of noble women places her in the tradition of Marguerite, just as her affirmation in *The Lamentacion of a Sinner* of the doctrine of justification by faith alone lends an evangelical tenor to her thought.[103] Catherine's praise of Henry VIII as "our Moyses," who has led an Exodus

[102] Prescott, "Pearl of the Valois," pp. 68–70. Tradition holds that the princess bound this text and embroidered the initials KP on the cover as the queen's monogram. See Barber, *Textile and Embroidered Bindings*, pl. 6. Margaret H. Swaim discusses Elizabeth's "Glasse of the Synneful Soule" and her other manuscript gifts in a well-illustrated article, "A New Year's Gift from the Princess Elizabeth," *Connoisseur* 183 (1973): 258–66. See p. 184, above, for evidence that Mary Tudor shared Elizabeth's dislike of their father. On the relationship of Princess Elizabeth and Queen Catherine, see James K. McConica, *English Humanists and Reformation Politics under Henry VIII and Edward VI* (Oxford, 1965), pp. 215–16; and King, "Patronage and Piety: The Influence of Catherine Parr," p. 51.

[103] McConica, *English Humanists and Reformation Politics*, pp. 229–30.

out of the "captivitie and bondage of Pharao" (i.e., the pope), implies that he initiated a continuing process of religious reform (E1). Such praise incorporates royalist iconography connected with the title page for the Coverdale Bible, which associates the king with the inset wood-cut showing Moses receiving the Law from God (Fig. 7). The interplay between queenly text and kingly image suggests that the symbolic vision of England as God's elect nation, Israel, was commonplace at the Reformation court (see above, pp. 75–76). When the reformers transferred this typological conceit to Queen Elizabeth, they combined it with the popular comparison to Deborah, who interpreted the Law as the only female Judge to succeed Moses and Joshua.

The existence of a special relationship between Elizabeth and her stepmother is suggested at the end of Bentley's "Third Lampe" by an image of the apotheosis of Catherine Parr (Fig. 84) that modifies the royal iconography of the Four Virtues found in the 1569 Bishops' Bible (Figs. 75). At the same time, the illustration returns to the funereal imagery characteristic of pageantry for late medieval queens; the 1445 coronation triumph of Margaret of Anjou, for example, concluded with a prophecy of her posthumous coronation by Christ that was modeled on the Coronation of the Virgin.[104] The elaborate woodcut of the Assumption of Catherine Parr contains, in clockwise order from the upper left, the four Cardinal Virtues personified as women: Justice, Prudence (or Wisdom), Fortitude, and—instead of Elizabeth's Imperial Virtue of Mercy—Temperance. The scene within the cartouche represents the iconographic fulfillment of the parable of the Five Wise Virgins and the prophecy of the Woman Clothed with the Sun; underneath is portrayed the fall of the Roman Babylon at the time of the ascent into heaven of Catherine Parr, which is shown above. At the top, Catherine receives a crown of glory as the Spouse of Christ while trumpeting angels and the Wise Virgins salute her. On either side of Christ are the traditional symbols of the Four Evangelists—winged ox and lion, cherub, and eagle—and above Christ's head are the seven lamps of Revelation alluded to in the subtitle of Bentley's *Monument of Matrones*. This woodcut recreates the vision of Christ enthroned in Revelation 4:2–8.

Although the praise of learned queens may have no apparent connection to King David and King Solomon, who appear at the left and right of the woodcut, above the Wise Virgins, both figures refer to the power of divine inspiration and wisdom evoked by the symbols of the Evangelists as well as the lamps in the *Monument*'s woodcuts. David and Solomon are common types for kings in medieval iconography

[104] Kipling, "London Pageants for Margaret of Anjou," ll. 148–63.

84. *The Apotheosis of Catherine Parr*, from Thomas Bentley,
The Monument of Matrones (1582)

and in courtly art celebrating Henry VIII and Edward VI as monarchs sympathetic to the Reformation (above, pp. 76–88, 90–93). Many of the prayers and meditations throughout Bentley's collection are drawn directly from the Psalms, symbolized by the lyre with which David was said to accompany his own songs of divine praise (see Figs. 8, 16). The book in Solomon's hand alludes to his reputation as the author of biblical wisdom literature including Proverbs, Ecclesiastes, and the Apocryphal books of Wisdom and Ecclesasticus. Solomon's alleged authorship of Canticles, or the Song of Solomon, is particularly important because it supplies the figure of the Spouse, which plays such a prominent role in Elizabethan iconography of the "godly" woman.

Bentley not only praised Elizabeth as a new Solomon, in a recapitulation of her antecedents' style as types of Solomon, but also identified her with the Bride of Christ or the Church.[105] The sexual ambiguity in such imagery is clarified when one notes that "Bride of Christ" referred to queens, who until the mid-Tudor period had been no more than consorts, whereas Solomon was a prototype for kings. This doubling of gender roles reflects the concept of "the king's two bodies,"[106] whereby Elizabeth mirrors the Spouse in her private capacity as a woman at the same time that she projects the Solomonic role of king as a powerful ruler. Such imagery accords with the debate between John Aylmer and John Knox, which shows that Elizabethan apologists stressed her status as an exception to the norm of male supremacy. The queen made this assertion herself, as may be noted in her 1588 speech at Tilbury, where she affirmed " 'I know I have the body of a weak and feeble woman, but I have the heart and stomach of a king, and of a king of England too.' "[107]

Elizabeth's anomalous position as a female ruler helps to explain gender confusions in her panegyrics. When Princess Cecilia of Sweden journeyed to London in 1565, she found herself, according to James Bell, in the position of "the Quene of Saba [i.e., Sheba] . . . for that (enflamed w[i]th Love of Wisdome), She trauailed in comparison a shorte iourneye to visytte the Courte of Salomon, there to enioye the presence of so wyse a Kynge." Bell praised Elizabeth as the equal of

[105] See above, pp. 35–36, 81–88 and 93. James I was also seen as a new Solomon, as in Francis Bacon's dedications to *Certaine Considerations touching the better pacification and Edification of the Church of England* (1604) and *Instauratio magna* (1620), as well as the text of *A Briefe Discourse, Touching the Happie Union of the Kingdomes of England, and Scotland* (1603), C4. Florence Sandler sets forth the biblical bases for the Stuart cult of sacral kingship in "Icon and Iconoclast," in *Achievements of the Left Hand: Essays on the Prose of John Milton*, ed. Michael Lieb and John T. Shawcross (Amherst, Mass., 1974), pp. 160–84.

[106] On the redefinition of this famous constitutional *topos* during Elizabeth's reign, see Axton, *Queen's Two Bodies*, ch. 7, passim.

[107] As quoted in Norbrook, *Poetry*, p. 114.

Solomon "in estate, Renowme, and in effectuall arte."[108] Boys of West-
minster dramatized the Visitation of the Queen of Sheba before Eliza-
beth and Cecilia in a tragicomedy entitled *Sapientia Solomonis*, a Latin
play that dramatized both Solomon and the Arabian queen as figures
for England's Protestant queen. The presence of Sapientia, Iustitia, and
Pax as Solomon's attendants makes it clear that Solomon provides a
prototype for Elizabeth as an exemplar of regal wisdom, justice, and
peace. The iconographical link between the submission of the Queen
of Sheba and the English Reformation, which was established soon
after Henry VIII's assumption of ecclesiastical authority as Supreme
Head of the Church (see above, pp. 81–83), is extended in this play
to both the Judgment Solomon (1 Kings 3:16–28) and his erection of
the Temple in Jerusalem.[109] The latter application was widespread in
Protestant apologetics.

Comparison of Elizabeth to Solomon developed into a popular say-
ing: "As a woman journeyed to see a man, so now men journey to see
a woman."[110] Yet Elizabeth was also compared to the Queen of Sheba,
as seen in the Latin play just discussed. Shakespeare made this analogy
in *Henry VIII*, a play that involved a nostalgic throwback to the Prot-
estant fervor associated with Tudor iconography. Thus Cranmer's pro-
phetic speech at Elizabeth's christening foresees greatness for the
"royal infant":

> Saba [Sheba] was never
> More covetous of wisdom and fair virtue
> Than this pure soul shall be. (5.4.23–25)

Bentley's *Monument of Matrones* includes a prayer for Elizabeth not
only as England's Solomon but also as its Queen of Sheba (2A7ᵛ). The
author intermingles male and female models for the queen, such as
Hezekiah and Josiah, Deborah and Judith, when he praises Elizabeth
both for joining "with David and Salomon [to] finish and consecrate
to eternitie thy glorious Temple among thy people" and for styling her-
self "like a loving mother, and a tender nursse, giving my foster milke,
the foode of thy [God's] word and Gospell aboundantlie to all" (2B4ᵛ).

Idealization of Elizabeth as a latter-day Solomon began as early as
the 1560 appeal in the prefatory epistle of the Geneva Bible that she

[108] B.L. MS Royal 17 C. XXIX, fol. 3ʳ⁻ᵛ.

[109] B.L. MS Add. 20,061, fols. 2ᵛ–4, 33ʳ⁻ᵛ. The limp parchment binding of this presen-
tation copy is stamped with the queen's monogram and arms. Thomas Butler also ap-
plied the Judgment of Solomon as a type for Elizabeth's government in rhetorical exer-
cises in Latin that he dedicated to her as a New Year's gift, c. 1603 (B.L. MS Royal 12
A. LI).

[110] As cited in Lynn Staley Johnson, "Elizabeth, Bride and Queen: A Study of Spenser's
April Eclogue and the Metaphors of English Protestantism," *Spenser Studies* 2 (1981):
78.

follow the biblical king's example by erecting God's "spiritual Temple" in England; the Temple of Solomon was a common Christian figure for the "true" church. The portrait of "Elizabeth Regina" in Richard Day's *Booke of Christian Prayers* (Fig. 30) styles her as a "godly" monarch along the lines of Solomon, who acknowledged divine overlordship in prayer: "O Lord God of Israel, there is no God like thee in heaven nor in earth, which kepest covenant, and mercie unto thy servants, that walke before thee with all their heart" (2 Chron. 6:14; see above, p. 113). Day's epigraph cites the Vulgate version of this text. Accordingly, the section of the *Monument of Matrones* that Bentley entitled "The Kings Heast [hest, i.e., behest], or Gods familiar speech to the Queene" (2D5ᵛ) presents Elizabeth as the Daughter of God, Bride of Christ, and millennial ruler under whom England will flourish in justice and peace, which are traditional attributes of Solomon's reign along with his fabulous wealth, wisdom, and devotion to true religion. Mention of the Heavenly City reflects longstanding apocalyptic imagery: "I will bring to passe that thou shalt enjoie a stable peace, and sure tranquillitie, and that thou shalt see Jerusalem flourishing so long as thou doest live" (2E2ᵛ). Drawn out of the Psalms of David, "The Queenes Vow, or selfe-talke with God" (2E4ᵛ) completes this dialogue between human and divine in yet another example of prayer and meditation associated with a pious queen.

The use of David and Solomon as models for princely conduct remained current throughout Elizabeth's reign, for she was praised repeatedly as a ruler possessed of their extraordinary power, wisdom, and judgment. Thomas Rogers's dedication of *A Golden Chaine, taken out of the rich Treasurehouse of the Psalmes of King David: also, The pretious Pearles of King Salomon* (1579) pointed out ways in which David prefigured Elizabeth's experience as a Protestant princess and queen:

> as his foiling of Goliath with your Majesties overthrowing the Pope; His rooting out of the Philistines with your Majesties suppressing the Papistes; his affliction with your imprisonment; his persecution with your trobles; his singing of godlie songs with your godlie bookes; his love of his God, with your promoting his glorie and defending of pure religion.

Solomon, on the other hand, prefigured the queen's wisdom and wealth. Woodcuts of these kings kneeling in prayer illustrate this cento from Psalms and Proverbs (A5ʳ⁻ᵛ, A12, and L2). Thomas Morton's *Salomon or A Treatise Declaring the State of the Kingdome of Israel, as it was in the daies of Salomon* (1596) contains a woodcut frontispiece portraying crowned figures of Elizabeth and Solomon side by side as

"Reg[ina]. Pacis" and "Rex Pacis" (Fig. 85). The legend indicates that the new Israel of Elizabethan England is a throwback to the Solomonic kingdom: "Regni Angloisraelitici typus" ("Type of the Anglo-Israelite monarchy"). Just as Solomon prefigures Christ as the Prince of Peace, Elizabeth governs as a Christlike queen who reigns as "Flos de Iesse" ("Flower of Jesse"), an allusion to the prophecy of Christ as the fruit of the Tree of Jesse (Isa. 11:1, 10), an Old Testament type for the dynastic succession of Christian kings in late medieval and Renaissance royal iconography (see Fig. 31). Solomon is the Messianic "Leo de Iuda" ("Lion of Judah"), who figures in Jacob's prophecy in Genesis 49:8–9 that

> The sonnes of thy father shall bowe themselves unto thee:
> *Judah* my sonne a Lions whelp, thou hast come up from the
> spoile.
> Thou hast couched like a Lion, yea as a great Lion: and who shal
> raise him up?

The Geneva Bible gloss indicates that this prophecy "was verified in David and Christ." The lion presented at the base of the Morton woodcut as the supporter of both monarchs is a symbol both for Solomon and for Britain's queen, in whose coat of arms heraldic lions reappear. The caption "Bellum de Pace" ("War from Peace") indicates that the peacefulness of these "godly" monarchs results from the restraint of power that can always be exercised in just warfare (A1ᵛ).[111]

The portrayal of Queen Elizabeth as a Christlike Prince of Peace is an extension of standard royalist iconography. The rainbow held by the queen in the *Rainbow Portrait* accordingly symbolizes the arrival of peace following stormy weather; its motto, "NON SINE SOLE IRIS" ("No rainbow without the sun"), pays a compliment to Elizabeth as a sun-queen (Fig. 76). The queen appears as *Pax* in William Rogers's *Eliza Triumphans*. The olive branch of Peace is an appropriate device for the queen according to Colin's blazon on Eliza in the April Eclogue of Spenser's *Shepheardes Calender* (1579):

> *Chloris*, that is the chiefest Nymph of al,
> Of Olive braunches beares a Coronall:
> Olives bene for peace,
> When wars doe surcease:
> Such for a Princesse bene principall. (ll. 122–26)[112]

[111] Cardinal Pole had applied the Solomonic epithet of *Rex pacificus* to Philip of Spain. As quoted in Elder, *Copie of a letter sent in to Scotlande*, D8. The woodcut in Thomas Morton's *Salomon or A treatise* is uncatalogued.

[112] Quotations from *The Shepheardes Calender* follow the text of Spenser, *Works: A Variorum Edition*, ed. E. A. Greenlaw, C. G. Osgood, F. M. Padelford et al., 10 vols. in

Regni Angloisraelitici typus.

Flos de Iesse

Leo de Iuda

Reg. Pacis

Rex, Pacis.

Bellum de Pace.

85. *Elizabeth I and King Solomon*, from Thomas
Morton, *Salomon or a Treatise Declaring the State
of the Kingdome of Israel* (1596)

Pax also joins personifications of Sapientia and Iustitia in *Sapientia Salomonis*, the play performed in honor of Elizabeth and Princess Cecilia in 1565.

Peace is an important theme in the illuminated frontispiece of "Regina Fortunata" by Henry Howard, Earl of Northampton (B.L. MS Egerton 944, fol. 1ᵛ; c. 1580), where the docile white lions at the queen's feet may convey messianic overtones of the Peaceable Kingdom (Fig. 86; Isa. 11:6, 65:25). The inscription of the open book on her lap—"Pax tibi ancilla mea" ("Peace unto you my maid-servant")—likens the queen to the Virgin Mary by allusion to the Annunciation. "Ecce ancilla Domini" had been Mary's response to Gabriel's prophecy that she would conceive of the Holy Spirit (Luke 1:38). By her *Fiat*, Mary submitted herself as a humble instrument of Providence. Elizabeth accordingly assumes yet another of her late sister's roles, that of divine handmaid (see Fig. 59). The ambiguous sexuality of Howard's image diverges from the iconography of the previous reign, however, by fusing the ideal chastity of the Blessed Virgin with the paradigmatic fertility of Venus. The banderole at the queen's feet contains a variation of the Virgilian phrases with which Aeneas greeted his mother Venus when she appeared to him in the guise of Diana, the virgin huntress: "[O quam te] memore[m] uirgo. O Dea digna deo." This illustration is poised at a liminal moment in the development of Elizabethan iconography, because its representation of the queen as a new Venus enhances her standing as an eligible woman at the last possible moment when she is still capable of marriage and child-bearing, even as her affinity with the Virgin Mary calls attention to the likelihood that she will retain her unwedded state.

At virtually the same time that Howard commissioned this manuscript for presentation to the queen, Spenser incorporated this famous Virgilian commonplace into his April Eclogue, a work that praises Elizabeth as a marriageable queen who is on the verge of a decision to remain unmarried. The anonymous commentator, E.K., correctly interprets the "emblems" spoken by Thenot and Hobbinol as words spoken "in the person of Aeneas to his mother Venus, appearing to him in likenesse of one of Dianaes damosells: being there most divinely set forth." Although these words, "O quam te memorem virgo?" and "O dea certe" ("By what name should I call thee, O maiden? . . . O goddess surely!"), provide a notable "prophetic" compliment to the perpetual innocence of Elizabeth as Venus-Virgo, the *Calender*'s publica-

11 pts. (Baltimore, 1932–57), vol. 7, pt. 1. On the importance of Christ as the "Prince of Peace" during the Reformation, see Pelikan, *Jesus through the Centuries*, pp. 168–81.

86. *Elizabeth I as Venus-Virgo*, from Henry
Howard, "Regina Fortunata," c. 1576

tion during the 1579–80 controversy over whether the queen should marry François, Duc d'Alençon, creates a delicate ambiguity about whether the phrase emphasizes Elizabeth's virginity, her potential maternity, or both qualities.[113]

The biblical iconography of the Woman of Faith and its royalist companion, the Sword and the Book, had an enduring impact on the literature and art of the Elizabethan period. In the April Eclogue in *The Shepheardes Calender*, for example, Spenser assimilated imagery of the Wise Virgins and attributes of Prudence or Wisdom into praise of Eliza as a figure for the queen. E.K.'s commentary cites the bay branches and olive boughs borne by her retinue as symbols for the imperial virtues of Justice and Mercy that respectively bring the triumphs of "myghty Conquerors" and government in "Peace and quietnesse" (glosses to ll. 104, 123–24). Spenser applied zealously biblical language to the conventions and language of classical pastoral through allusions to Canticles that link England's Eliza to the Spouse of Christ. The April Eclogue "was a seminal work in creating the image of the Virgin Queen," one that "transfers to Elizabeth much of the imagery traditionally associated with the Virgin Mary."[114] Later praise of the queen as Diana, Astraea, or a Vestal Virgin contained vestigial imagery of the Blessed Virgin.

The recurrent royal figures in *The Faerie Queene* contain several variations of the Woman of Faith, including Fidelia (the personification of Faith), Una, Britomart, and Mercilla. Despite her bare knees and noticeable breasts, even Belphoebe embodies evangelical typology, for, like the portrait of Cynthia in the Mutability Cantos, she assimilates a syncretic fusion of pagan Diana with biblical imagery.[115] Spenser's dedication to Elizabeth, the Letter to Raleigh, and his various proems make it clear that these idealized females, above all Gloriana,

[113] See Virgil, *Aeneid* 1.327–28, in *Works*, ed. and trans. H. Rushton Fairclough, 2 vols. (Cambridge, Mass., 1940); and Spenser, *Variorum*, vol. 7, pt. 1, 41, 45. Although Strong dates Howard's "Regina Fortunata" c. 1576 in *Elizabeth*, Drawings and Illuminations, no. 7, the allusion to the queen as Venus-Virgo suggests that c. 1580 is a more likely date. Strong notes in *Cult*, pp. 47–48, that "it is not until the last decade of the reign that we find overt celebrations of Elizabeth as 'Queen of Love' and 'Queen of Beauty.' " On the transition from Elizabeth's early praise as a marriageable virgin to her later style as a goddess whose virginity is perpetual, see my essay, "The Cults of the Virgin Queen," forthcoming in *Renaissance Quarterly*.

[114] Norbrook, *Poetry*, p. 84; see also Johnson, "Elizabeth, Bride and Queen," pp. 81–83.

[115] Wells, *Spenser and the Cult of Elizabeth*, pp. 52–53. A similar fusion may be noted in a Dutch engraving of Elizabeth as bare-breasted Diana defeating the pope; reproduced in Yates, *Astraea*, pl. 11a.

represent different images of England's queen and her virtues. Susanne Woods concludes that *The Faerie Queene* suggests that Spenser "finds potential for rule inherent in women, not exceptional to them."[116]

As the embodiment of Truth, Una looms in the foreground as Spenser's archetype for a faithful princess or queen.[117] When he designed the Reformation allegory found in Book One ("The Legend of Holiness"), Spenser patterned Una after the Woman Clothed with the Sun, while her demonic parody, the harlot Duessa, is modeled on the Whore of Babylon.[118] Una's specifically royal associations are enhanced by her companionship with a knight immediately recognizable as St. George, the patron saint of England, whose image appeared on the badge of the Order of the Garter; the St. George's Day celebration was the annual focus of the cult of sacral monarchy.[119] John Dixon's glosses show how Spenser's earliest commentator interpreted Una as a type for the recent duress of the Church of England under attack from Catholic forces identified with Mary Tudor or Mary Stuart (1.2.9, 1.12.18, 1.12.28). Dixon viewed the union of Una and the Redcrosse Knight as a figure for the marriage of Christ and the Church (1.12.36).[120]

The primacy of individual faith in Protestant devotional life is readily apparent at the House of Holiness (1.10), where Una receives special greetings from Fidelia, who personifies faith as it is interpreted by the Church of England. This allegorical house is the site of the Redcrosse Knight's indoctrination by Fidelia, who is older than her sisters Speranza ("hope") and Charissa ("charity"). The order of their births reflects the Protestant reordering of charity and faith in accordance with St. Paul's Letter to the Romans, whereby Martin Luther determined that the elect are justified on the basis of inward spiritual belief

[116] Susanne Woods, "Spenser and the Problem of Women's Rule," *Huntington Library Quarterly* 48 (1985): 146. For alternative views that Spenser treats Elizabeth as an exception to the norm of masculine government, see James E. Phillips, Jr., "The Woman Ruler in Spenser's *Faerie Queene*," *Huntington Library Quarterly* 5 (1942): 211–34; and Pamela J. Benson, "Rule, Virginia: Protestant Theories of Female Regiment in *The Faerie Queene*," *English Literary Renaissance* 15 (1985): 292.

[117] John M. Steadman argues, in "Una and the Clergy: The Ass Symbol in *The Faerie Queene*," *Journal of the Warburg and Courtauld Institutes* 21 (1958): 134–37, that allusion to the device of *asinus portans mysteria* associates the veiled figure of Una "upon a lowly Asse" (1.1.4) both with the Bible as the revealed word of God and with true gospel ministry. See also Thomas H. Cain, *Praise in "The Faerie Queene"* (Lincoln, Neb., 1978), pp. 58–63.

[118] *FQ* 1.2.13, 1.7.16, and 1.8.14. See also Hankins, "Spenser and the Revelation of St. John," pp. 364–81; Figs. 64–66; and glosses to Rev. 17 in the Geneva Bible.

[119] On the Protestant redefinition of this "popish saint," see Strong, *Cult*, pp. 164–65; and above, pp. 99–101.

[120] Dixon, *First Commentary on "The Faerie Queene."*

rather than good works in the outward world, which were the foundation of medieval salvation theology.

The symbolic book found in earlier portraits of faithful women—Anne Askew, Catherine Parr, and Elizabeth as both princess and queen—survives as an attribute of some of Spenser's godly women. Instead of carrying an actual Bible, Una characteristically voices proverbs and admonitions drawn from the scriptures. The Reformation insistence on the accessibility of vernacular translations of the Bible as the basis of spiritual education is symbolized both by continual allusion to biblical texts throughout "The Legend of Holiness" and by the relation between two symbolic books. Although Redcrosse presents Prince Arthur with "his Saveours testament" (evidently the New Testament), the former warrior is as yet unable to read and understand the scriptures as a model for human action (1.9.19). He must first undergo the course of instruction at the House of Holiness, where only Fidelia, bearing the same "sacred Booke," can tutor him in fundamental truths: "Of God, of grace, of justice, of free will" (1.10.19). Rather than undermining the Protestant belief in the priesthood of all believers, this allegory personifies the role of individual faith in the unmediated relationship between believers and God. The role of Faith as the "bearer" of the open Bible may be noted on the title page of the 1568 Bishops' Bible (Fig. 29).

The description of Mercilla in Book Five of *The Faerie Queene* ("The Legend of Justice") personifies the Imperial Virtue of Mercy as the defining trait of the government of Elizabeth as an idealized ruler. The description of the enthroned queen and her regalia reduplicates the image of the devout queen in her presence chamber, which appeared incessantly in woodcuts, seals, and on coins of the realm:

> Thus she did sit in soverayne Majestie,
> Holding a Scepter in her royall hand,
> The sacred pledge of peace and clemencie,
> With which high God had blest her happie land,
> Maugre so many foes, which did withstand.
> But at her feet her sword was likewise layde,
> Whose long rest rusted the bright steely brand;
> Yet when as foes enforst, or friends sought ayde,
> She could it sternely draw, that all the world dismayde. (5.9.30)

This image of Elizabethan majesty is a literary analogue of visual images like the illustrated capital C in Foxe's *Actes and Monuments* and the Bishops' Bible. Although Mercilla's appearance incorporates some aspects of the portrayal of Reformation monarchy in the Coverdale

Bible (Fig. 8), the symbolic book is absent and the sword displaced to the queen's feet. This rusted weapon typifies a peaceful and godly reign (compare the discarded weapons in Figs. 30 and 74).[121] Like all such symbols, of course, the image is an idealized fiction of sovereign power, and like Elizabeth's histrionic kissing and embracing of the Bible during her precoronation procession, it conceals the political deliberation lying behind the outward display of royal benevolence. Mercilla weeps, yet Duessa stands condemned and dies. The queen of Mercy can always wield her sword of justice, despite its rust. Duessa, who was thought by James VI of Scotland (later James I of England) to represent his mother, Mary Stuart, is condemned "for vyld treasons, and outrageous shame, / Which she against the dred *Mercilla* oft did frame" (5.9.40). James's view was not original, because John Dixon interpreted Duessa elsewhere as a "fiction" for the Scottish queen. Dixon's 1597 commentary recognizes the fluidity of Spenser's allegory, however, because he also glosses Duessa as both the "Romish harlot" and Mary Tudor.[122]

A memorial portrait of Queen Elizabeth by Crispin van de Passe the Elder (Fig. 87) represents a final revision of the Woman of Faith as a Tudor royalist device. The coat of arms and the complete regalia of the gem-encrusted queen—crown, orb, and scepter—refer to her secular authority and might, just as the motto "Posui Deum Adiutorem Meum" ("I have made God my help") alludes to her role as a divine instrument. Her personification of the Imperial Virtues of Justice and Mercy mirrors the biblical iconography of the Sword and the Book to her left, which are respectively termed "IUSTITIA" and "VERBUM DEI." The placement of the sword of justice on the Bible may be a variation of the representation of Faith with a cross resting upon an open book in Counter-Reformation art. Although the conjunction of these symbols suggests the equivalence of Justice and Mercy, the reference to "Misericordia" in the inscription at the queen's right implies that the latter is the preeminent royal virtue. The capital letters in this phrase, "Mortua anno MIserICorDIae" ("Died in the year of Mercy"), contain an anagram for the year of Elizabeth's death: MDCIII, or 1603. The balanced reference to the date of her birth at Greenwich (6 Id. Sept. [*sic*], or 7 September 1533) to the left completes a portrait sym-

[121] See Nelson, "Queen Elizabeth, Spenser's Mercilla, and a Rusty Sword," pp. 113–17. According to Leslie, *Spenser's "Fierce Warres and Faithfull Loves,"* pp. 65–68, the presentation of Mercilla is modeled specifically on the seal of the Court of Common Pleas.

[122] Spenser, *Variorum*, 5:244; and Dixon, *First Commentary on "The Faerie Queene,"* glosses on 1.7.1, 1.12.18, and 1.12.26.

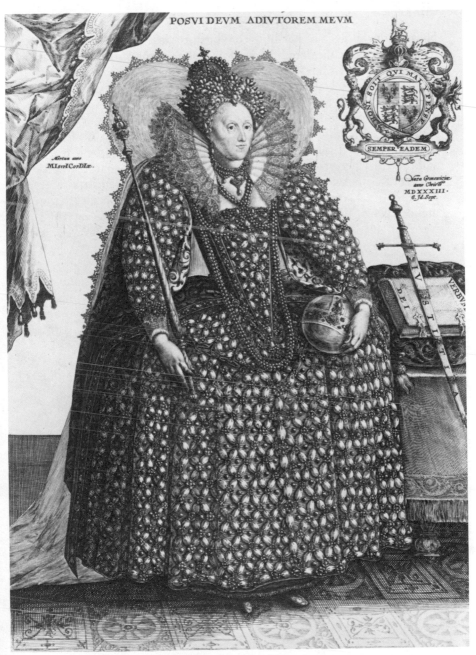

87. Crispin van de Passe I, after Isaac Oliver,
Elizabeth I Memorial Portrait, c. 1603–4

bolizing the entirety of her life, from birth to death, and a reign that throughout was considered the worldly embodiment of the millennial virtues of Justice, Mercy, Truth, and Peace. That the queen was born on the eve of the Nativity of the Blessed Virgin and then died on 24 March, the eve of Mary's Assumption into heaven, was to reformers an incontrovertible mark of providential intervention. Fittingly, this royal image recapitulates iconographical themes that can be traced back to the precoronation pageantry welcoming the "godly" queen and to her earlier praise as a pious princess. Even more than the apotheosis of Catherine Parr, this lifelike image of Elizabeth incorporates the *topos* of resurrection and second life in a manner appropriate to the immortality of the monarch's royal body. Elizabeth appears as if she were still alive and at the center of power. In her official capacity as head of state, the image implies, neither the queen nor the regal Justice that she embodies can ever die.[123]

Powerful ideological and political forces resulted in the subsuming of scriptural archetypes for faithful and powerful women into symbols of imperial majesty and the principle of government by an autonomous virgin queen. It is important to recognize how such idealizations of Elizabeth incorporated a reincarnation of the iconography of the Virgin Mary as Queen of Heaven, the sacred imagery of Mary I and preceding queens consort, and the carefully orchestrated manipulation of the doctrine of royal supremacy by the writers, artists, and preachers who operated under the aegis of Henry VIII and Edward VI. Despite the introduction of classical themes and devices, Elizabethan iconography never lost its connection to the partisanship that flourished during earlier phases of the English Reformation. The biblical style of Christian majesty endured until the end of the Tudor epoch in conjunction with the increasingly convoluted veneration of Elizabeth as a latter-day Astraea, Diana, or even the Roman Vestal.

[123] See Wells, *Spenser and the Cult of Elizabeth*, pp. 19–20; Kantorowicz, *King's Two Bodies*, pp. 418–19. Fig. 87 may be a source for Simon van de Passe's engraved frontispiece in the 1619 edition of the *Workes* of James I, in which the Sword and the Book are crowded into the background as a vestigial monarchical symbol. See Hind, vol. 2, pl. 154; and Graham Parry, *The Golden Age Restor'd: The Culture of the Stuart Court, 1603–42* (1981), ill. on p. 28.

Select Bibliography

PLACE OF PUBLICATION IS LONDON UNLESS OTHERWISE STATED.

Primary Sources

Aske, James. *Elizabetha Triumphans* (1588). Facsimile ed., The English Experience, no. 78. Amsterdam, 1969.

Askew, Anne. *Examinations*. Edited by John Bale. 2 vols. Marburg (i.e., Wesel), 1546–47. Includes Bale's commentary.

Aylmer, John. *An Harborowe for Faithfull Subjectes* (Strasbourg [or London?], 1559) Facsimile ed., The English Experience, no. 423. Amsterdam, 1972.

Bacon, Francis. *Works*. Edited by James Spedding et al. 14 vols. 1857–74.

Bale, John. *King Johan*. Edited by Barry B. Adams. San Marino, Calif., 1969.

——. *Scriptorum Illustrium maioris Brytanniae . . . Catalogus*. 2 vols. Basle, 1557–59.

Bevington, David, ed. *Medieval Drama*. Boston, 1975.

Cavendish, George. *The Life and Death of Wolsey*. Edited by Richard S. Sylvester. EETS, o.s., 243. 1959.

——. *Metrical Visions*. Edited by A.S.G. Edwards. Renaissance English Text Society, vol. 9. Columbia, S.C., 1980.

Crowley, Robert. *Philargyrie of Greate Britayne*. Edited by John N. King. *English Literary Renaissance* 10 (1980): 46–75.

Day, Richard. *A Booke of Christian Prayers* (1578). Facsimile ed., The English Experience, no. 866. Amsterdam, 1977.

Dewick, E. S., ed. *The Coronation Book of Charles V of France*. Henry Bradshaw Society, vol. 16. 1899.

Dixon, John. *The First Commentary on "The Faerie Queene."* Edited by Graham Hough. Stansted, 1964.

Erasmus, Desiderius. *Christian Humanism and the Reformation: Selected Writings*. Edited by John C. Olin. New York, 1965.

Feuillerat, Albert W., ed. *Documents Relating to the Office of the Revels in the Time of Queen Elizabeth*. Materialen zur Kunde des älteren Englischen Dramas, vol. 21. Louvain, 1908.

——. *Documents Relating to the Revels at Court in the Time of King Edward VI and Queen Mary*. Materialen zur Kunde des älteren Englischen Dramas, vol. 44. Louvain, 1914.

Foxe, John. *Actes and Monuments of these Latter and Perillous Dayes*. 1563.

Foxe, John. *Actes and Monumentes of Thynges Passed in Every Kynges Tyme in this Realme.* 2nd ed., rev. and enlarged. 2 vols. 1570.

——. *Acts and Monuments.* Edited by S. R. Cattley. Rev. and corrected by J. Pratt. 8 vols. 1877.

The Geneva Bible. Facsimile of the 1560 edition. Introduction by Lloyd E. Berry. Madison, Wis., 1969.

Grafton, Richard. *Abridgement of the Chronicles of Englande.* Rev. ed. 1570.

Grosjean, Paul, ed. *Henrici VI Angliae regis miracula postuma.* In *Subsidia Hagiographica*, no. 22. Brussels, 1935.

Hall, Edward. *Union . . . of Lancaster and York.* 1548.

The Harleian Miscellany. Edited by William Oldys and Thomas Park. 10 vols. 1808–13.

Heywood, John. *A Dialogue of Proverbs.* Edited by Rudolph Habenicht. University of California English Studies, vol. 25. Berkeley and Los Angeles, 1963.

Houle, Peter. "A Reconstruction of the English Morality Fragment *Somebody and Others.*" *Papers of the Bibliographical Society of America* 71 (1977): 259–77.

Jewel, John. *An Apology of the Church of England.* Edited by J. E. Booty. Ithaca, N.Y., 1963.

Knox, John. *The First Blast of the Trumpet against the Monstruous Regiment of Women* (Geneva, 1558). Facsimile ed., The English Experience, no. 471. Amsterdam, 1972.

Knox, Ronald, and Shane Leslie, eds. *The Miracles of King Henry VI.* Cambridge, 1923.

Leland, John. *De rebus Britannicis Collectanea.* Edited by Thomas Hearne. 3rd ed. 4 vols. 1774.

Letters and Papers, Foreign and Domestic, of the Reign of Henry VIII. Edited by John S. Brewer, revised by J. Gairdner and R. H. Brodie. 21 vols. in 37 pts. Reprinted. Vaduz, 1965.

Luther, Martin. *Works.* Edited by Jaroslav Pelikan et al. 55 vols. St. Louis, 1958–76.

Marlowe, Christopher. *Doctor Faustus.* Edited by John D. Jump. Cambridge, Mass., 1962.

——. *Tamburlaine the Great.* Edited by J. S. Cunningham. Manchester and Baltimore, 1981.

Maydiston, Richard. *Concordia Facta Inter Regem Riccardum II et Civitatem Londinie.* Edited with intro. and notes by Charles R. Smith. Ph.D. Diss., Princeton, 1972.

More, Thomas. *The Complete Works of St. Thomas More.* Edited by Richard S. Sylvester et al. 10 vols. in 15. New Haven, 1963–. Vol. 2: *The History of King Richard III*, ed. Richard S. Sylvester.

Mulcaster, Richard. *The Quenes Majesties Passage.* Facsimile ed. James M. Osborn. New Haven, 1960.

Nichols, John, ed. *The Progresses and Public Processions of Queen Elizabeth.* 3 vols. 1788–1805.

Nichols, John Gough, ed. *The Chronicle of Queen Jane, and of Two Years of Queen Mary, and Especially of the Rebellion of Sir Thomas Wyatt.* Camden Society, 1st ser., vol. 48 (1850).

——. *Literary Remains of King Edward the Sixth.* Roxburghe Club, 2 vols. 1857.

Peele, George. *The Life and Minor Works of George Peele.* Edited by Charles T. Prouty et al. 3 vols. New Haven, 1952–70.

Petrarch. *Lord Morley's "Tryumphes of Fraunces Petrarcke": The First English Translation of the "Trionfi."* Edited by D. D. Carnicelli. Cambridge, Mass., 1971.

Puttenham, George. *The Arte of English Poesie.* Edited by Gladys D. Willcock and Alice Walker. Cambridge, 1936.

Records of Early English Drama. Toronto, 1979–.

Shakespeare, William. *The Riverside Shakespeare.* Edited by G. B. Evans et al. Boston, 1974.

Spenser, Edmund. *The Faerie Queene.* Edited by A. C. Hamilton. 1977.

——. *Works: A Variorum Edition.* Edited by E. A. Greenlaw, C. G. Osgood, F. M. Padelford et al. 10 vols. in 11 pts. Baltimore, 1932–57.

Stow, John. *Annales, or a Generall Chronicle of England.* 1631. Continued by Edmund Howes.

——. *Chronicles of England.* 1580.

Udall, Nicholas. *Respublica.* Edited by W. W. Greg. EETS, o.s., 226. 1952. Attributed to Udall.

Vergil, Polydore. *Anglica Historia* (1534). Edited and translated by Denys Hay. Camden Society, 3rd ser., 74 (1950).

Wither, George. *A Collection of Emblemes, Ancient and Moderne.* 1635.

Secondary Sources

Anglo, Sydney. "An Early Tudor Programme for Plays and Other Demonstrations against the Pope." *Journal of the Warburg and Courtauld Institutes* 20 (1957): 176–79.

——. *Spectacle, Pageantry, and Early Tudor Policy.* Oxford, 1969.

Axton, Marie. *The Queen's Two Bodies: Drama and the Elizabethan Succession.* 1977.

Barber, Giles. *Textile and Embroidered Bindings.* Bodleian Picture Books, Special Series, no. 2. Oxford, 1971.

Baskervill, C. R. "William Lily's Verse for the Entry of Charles V into London." *Huntington Library Bulletin,* no. 9 (April 1936): 1–14.

Battenhouse, Roy W. "Protestant Apologetics and the Subplot of 2 *Tamburlaine.*" *English Literary Renaissance* 3 (1973): 30–43.

Bawcutt, N. W. "Marlowe's *Jew of Malta* and Foxe's *Acts and Monuments.*" *Notes and Queries* 213 [n.s., 15] (1968): 250.

Beard, C. R. "Tomb and Achievements of King Henry VI at Windsor." In *Fragmenta Armentaria*, ed. Francis Henry Cripps-Day, II, pt. 1. 1936.

Bennett, Josephine W. *The Evolution of "The Faerie Queene."* Chicago, 1942.

Benson, Pamela J. "Rule, Virginia: Protestant Theories of Female Regiment in *The Faerie Queene*." *English Literary Renaissance* 15 (1985): 277–92.

Beny, Roloff, and Peter Gunn. *The Churches of Rome*. New York, 1981.

Bergeron, David. "Elizabeth's Coronation Entry (1559): New Manuscript Evidence." *English Literary Renaissance* 8 (1978): 3–8.

————. *English Civic Pageantry 1558–1642*. Columbia, S.C., 1971.

Bevington, David. *Tudor Drama and Politics: A Critical Approach to Topical Meaning*. Cambridge, Mass., 1968.

Bland, David. *A History of Book Illustration: The Illuminated Manuscript and the Printed Book*. 1958.

Bradbrook, Muriel C. *English Dramatic Form: A History of Its Development*. 1965.

Brann, Noel L. "Pre-Reformation Humanism in Germany and the Papal Monarchy: A Study in Ambivalence." *Journal of Medieval and Renaissance Studies* 14 (1984): 159–85.

Brooke, Rosalind, and Christopher Brooke. *Popular Religion in the Middle Ages: Western Europe 1000–1300*. 1984.

Brown, William J. "Marlowe's Debasement of Bajazet: Foxe's *Actes and Monuments* and *Tamburlaine, Part I*." *Renaissance Quarterly* 24 (1971): 38–48.

Busch, Wilhelm. *England under the Tudors*. Translated by Alice M. Todd. 2 vols. 1895.

Butterworth, Charles C. *The English Primers (1529–1545): Their Publication and Connection with the English Bible and the Reformation in England*. Philadelphia, 1953.

Cahn, Walter. "The Tympanum of the Portal of Saint-Anne at Notre Dame de Paris and the Iconography of the Division of the Powers in the Early Middle Ages." *Journal of the Warburg and Courtauld Institutes* 32 (1969): 55–72.

Cain, Thomas H. *Praise in "The Faerie Queene."* Lincoln, Neb., 1978.

Calkins, Robert G. *Illuminated Books of the Middle Ages*. Ithaca, N.Y., 1983.

Chew, Samuel C. "The Iconography of *A Book of Christen Prayers* (1578) Illustrated." *Huntington Library Quarterly* 8 (1945): 293–305.

Chrimes, S. B. *Henry VII*. 1972.

Collinson, Patrick. "If Constantine, Then Also Theodosius: St. Ambrose and the Integrity of the Elizabethan *Ecclesia Anglicana*." *Journal of Ecclesiastical History* 30 (1979): 205–229.

Corbett, Margery, and Ronald Lightbown. *The Comely Frontispiece: The Emblematic Title-Page in England 1550–1660*. 1979.

Cox-Rearick, Janet. *Dynasty and Destiny in Medici Art: Pontormo, Leo X, and the Two Cosimos*. Princeton, 1984.

Curtius, Ernst R. *European Literature and the Latin Middle Ages.* Translated by Willard R. Trask. New York, 1953.

Davisson, Darrell. "The Iconology of the S. Trinita Sacristy, 1418–1435: A Study of the Private and Public Functions of Religious Art in the Early Quattrocento." *Art Bulletin* 57 (1975): 315–34.

Demus, Otto. *Romanesque Mural Painting.* 1970.

Dickens, A. G. *The English Reformation.* Rev. ed. 1967.

Dictionary of National Biography. Edited by Leslie Stephen and Sidney Lee. 63 vols. 1885–1900.

Doe, Paul. "Tallis's 'Spem in Alium' and the Elizabethan Respond-Motet," *Music and Letters* 51 (1970): 1–14.

Doernberg, Erwin. *Henry VIII and Luther: An Account of Their Personal Relations.* Stanford, 1961.

Dorsten, Jan van. *The Radical Arts: First Decade of an Elizabethan Renaissance.* Leiden and London, 1970.

————. "Steven van Herwyck's *Elizabeth* (1565)—A Franco-Flemish Political Medal." *Burlington Magazine* 111 (1969): 143–47.

Dowling, Maria. "Anne Boleyn and Reform." *Journal of Ecclesiastical History* 35 (1984): 30–46.

Erikson, Kai. *Wayward Puritans: A Study of the Sociology of Deviance.* New York, 1966.

Foucault, Michel. *Power/Knowledge.* Edited by Colin Gordon. New York, 1980.

Gilbert, Allan H., and Edgar Wind. "The Monarch's Crown of Thorns." *Journal of the Warburg and Courtauld Institutes* 3 (1939–40): 156–61.

Gordon, Donald. " 'Veritas Filia Temporis': Hadrianus Junius and Geoffrey Whitney." *Journal of the Warburg and Courtauld Institutes* 3 (1939–40): 228–40.

Grabar, André. *Christian Iconography: A Study of Its Origins.* Princeton, 1968.

Greenblatt, Stephen. *Renaissance Self-Fashioning: From More to Shakespeare.* Chicago, 1980.

Greene, Richard L. "The Meaning of the Corpus Christi Carol." *Medium Aevum* 29 (1960): 10–21.

Grueber, Herbert A. *Handbook of the Coins of Great Britain and Ireland in the British Museum.* Rev. ed. J.P.C. Kent et al. 1970.

Guillén, Claudio. *Literature as System: Essays Toward the Theory of Literary History.* Princeton, 1971.

Hageman, Elizabeth. "John Foxe's Henry VIII as *Justitia*." *Sixteenth Century Journal* 10, no. 1 (1979): 35–44.

Haigh, Christopher, ed. *The Reign of Elizabeth I.* 1984.

Hall, James. *Dictionary of Subjects and Symbols in Art,* rev. ed. 1979.

Haller, William. *Foxe's "Book of Martyrs" and the Elect Nation.* 1963.

Hanham, Alison. *Richard III and His Early Historians, 1483–1535.* Oxford, 1975.

Hankins, John E. "Spenser and the Revelation of St. John." *PMLA* 60 (1945): 364–81.

Hannay, Margaret P., ed. *Silent But for the Word: Tudor Women as Patrons, Translators, and Writers of Religious Works.* Kent, Ohio, 1985.

Harvey, A. E. *Companion to the New Testament.* Oxford and Cambridge, 1970.

Haugaard, William P. "Elizabeth Tudor's *Book of Devotions*: A Neglected Clue to the Queen's Life and Character." *Sixteenth Century Journal* 12, no. 2 (1981): 79–106.

Hind, Arthur M. *Engraving in England in the Sixteenth and Seventeenth Centuries.* 3 vols. Cambridge, 1953–64.

Hodnett, Edward. *English Woodcuts: 1480–1535.* 1935.

———. *Marcus Gheeraerts the Elder of Bruges, London, and Antwerp.* Utrecht, 1971.

———. *Image and Text: Studies in the Illustration of English Literature.* 1982.

Janssen, Carole A. "A Waytes of Norwich and an Early Lord Mayor's Show." *Research Opportunities in Renaissance Drama* 22 (1979): 57–64.

Johnson, Lynn Staley. "Elizabeth, Bride and Queen: A Study of Spenser's April Eclogue and the Metaphors of English Protestantism." *Spenser Studies* 2 (1981): 75–91.

———. "Old Wine in New Bottles: Thomas Blenerhasset's Elizabethan Shepherds' Pageant." *Journal of the Rocky Mountain Medieval and Renaissance Association* 5 (1984): 107–117.

Kantorowicz, Ernst H. *The King's Two Bodies: A Study in Mediaeval Political Theology.* Princeton, 1957.

———. *Laudes Regiae: A Study in Liturgical Acclamations and Mediaeval Ruler Worship.* University of California Publications in History, vol. 33. 2nd ed. Berkeley and Los Angeles, 1958.

———. *Selected Studies.* Locust Valley, N.Y., 1965.

Katzenellenbogen, Adolf. *The Sculptural Programs of Chartres Cathedral.* Baltimore, 1959.

Kermode, Frank. *Shakespeare, Spenser, Donne: Renaissance Essays.* 1971.

Kershaw, S. W. *Art Treasures of the Lambeth Library.* 1873.

King, John N. *English Reformation Literature: The Tudor Origins of the Protestant Tradition.* Princeton, 1982.

———. "Patronage and Piety: The Influence of Catherine Parr." In *Silent But for the Word: Tudor Women as Patrons, Translators, and Writers of Religious Works,* ed. Margaret P. Hannay, pp. 43–60. Kent, Ohio, 1985.

———. "Was Spenser a Puritan?" *Spenser Studies* 6 (1985): 1–31.

Kipling, Gordon. In "Henry VII and the Origins of Tudor Patronage." In *Patronage in the Renaissance,* ed. Guy Lytle and Stephen Orgel, pp. 117–64. Princeton, 1981.

———. "The London Pageants for Margaret of Anjou: A Medieval Script Restored." *Medieval English Theatre* 4 (1982), 5–27.

————. *The Triumph of Honour: Burgundian Origins of the Elizabethan Renaissance.* Leiden, 1977.

Knowles, David. *The Religious Orders in England.* 3 vols. Cambridge, 1948–59.

Leedy, Walter C., Jr. *Fan Vaulting: A Study of Form, Technology, and Meaning.* 1980.

Legg, J. Wickham. "The Gift of the Papal Cap and Sword to Henry VII." *Archaeological Journal* 57 (1900): 183–203.

Lemon, Robert. *Catalogue of a Collection of Printed Broadsides in the Possession of the Society of Antiquaries of London.* 1866.

Leslie, Michael. *Spenser's "Fierce Warres and Faithful Loves": Martial and Chivalric Symbolism in "The Faerie Queene."* Cambridge, 1983.

Levey, Michael. *Painting at Court.* New York, 1971.

Lewalski, Barbara K. *Protestant Poetics and the Seventeenth-Century Religious Lyric.* Princeton, 1979.

Loades, David M. *The Reign of Mary Tudor: Politics, Government, and Religion in England, 1553–1558.* 1979.

MacCaffrey, Wallace. *Queen Elizabeth and the Making of Policy, 1572–1588.* Princeton, 1981.

MacMullen, Ramsey. *Christianizing the Roman Empire (A.D. 100–400).* New Haven, 1984.

Macray, William D. *Annals of the Bodleian Library, Oxford.* 2nd ed. Oxford, 1890.

Mâle, Emile. *The Gothic Image: Religious Art in France of the Thirteenth Century.* Translated by Dora Nussey. New York, 1958.

Marks, Richard, and Ann Payne. *British Heraldry: From Its Origins to c. 1800.* Exh. cat. 1978.

Martin, Joseph W. "Miles Hogarde: Artisan and Aspiring Author in Sixteenth-Century England." *Renaissance Quarterly* 34 (1981): 359–83.

McConica, James K. *English Humanists and Reformation Politics under Henry VIII and Edward VI.* Oxford, 1965.

McKerrow, R. B., and F. S. Ferguson. *Title-page Borders Used in England and Scotland: 1485–1640.* 1932.

Mill, Anna J. *Mediaeval Plays in Scotland.* St. Andrews University Publications, no. 24. Edinburgh and London, 1927.

Millar, Oliver. *The Tudor, Stuart, and Early Georgian Pictures in the Collection of Her Majesty the Queen.* 2 vols. 1963.

Mozley, J. F. *John Foxe and His Book.* 1940.

Neale, J. E. *Queen Elizabeth.* 1934.

Nelson, William. "Queen Elizabeth, Spenser's Mercilla, and a Rusty Sword." *Renaissance News* 18 (1965): 113–17.

Nichols, Stephen G., Jr. *Romanesque Signs: Early Medieval Narrative and Iconography.* New Haven, 1983.

Nohrnberg, James. *The Analogy of "The Faerie Queene."* Princeton, 1976.

Norbrook, David. "Panegyric of the Monarch and Its Social Context under Elizabeth I and James I." D.Phil. Diss., Oxford University, 1978.

———. *Poetry and Politics in the English Renaissance*. 1984.

O'Connell, Michael. *Mirror and Veil: The Historical Dimension of Spenser's "Faerie Queene."* Chapel Hill, 1977.

Oliver, Leslie M. "Rowley, Foxe, and the *Faustus* Additions." *Modern Language Notes* 60 (1945): 391–94.

Orgel, Stephen. *The Illusion of Power: Political Theater in the English Renaissance*. Berkeley and Los Angeles, 1975.

Panofsky, Erwin. *Albrecht Dürer*. 2 vols. Rev. ed. Princeton, 1945.

———. *Early Netherlandish Painting: Its Origins and Character*. 2 vols. Cambridge, Mass., 1953.

———. *Studies in Iconology: Humanistic Themes in the Art of the Renaissance*. Oxford, 1939.

Pelikan, Jaroslav. *Jesus through the Centuries: His Place in the History of Culture*. New Haven, 1985.

Pevsner, Nikolaus. *The Buildings of England: Worcestershire*. Harmondsworth, Middlesex, 1968.

———. *The Englishness of English Art*. Harmondsworth, Middlesex, 1978.

Phillips, James E., Jr. "The Woman Ruler in Spenser's *Faerie Queene*." *Huntington Library Quarterly* 5 (1942): 211–34.

Phillips, John. *The Reformation of Images: Destruction of Art in England, 1535–1660*. Berkeley and Los Angeles, 1973.

Prescott, Anne Lake. "The Pearl of the Valois and Elizabeth I: Marguerite de Navarre's *Miroir* and Tudor England." In *Silent But for the Word: Tudor Women as Patrons, Translators, and Writers of Religious Works*, ed. Margaret P. Hannay, pp. 61–76. Kent, Ohio, 1985.

Queen's Gallery, Buckingham Palace. *Holbein and the Court of Henry VIII*. Exh. cat. 1978.

Redworth, Glyn. "A Study in the Formulation of Policy: The Genesis and Evolution of the Act of Six Articles." *Journal of Ecclesiastical History* 37 (1986): 42–67.

Ridley, Jasper. *The Life and Times of Mary Tudor*. 1973.

Rosenberg, Eleanor. *Leicester, Patron of Letters*. New York, 1955.

Rozett, Martha. *The Doctrine of Election and the Emergence of Elizabethan Tragedy*. Princeton, 1984.

Sandler, Florence. "Icon and Iconoclast." In *Achievements of the Left Hand: Essays on the Prose of John Milton*, ed. Michael Lieb and John T. Shawcross, pp. 160–84. Amherst, Mass., 1974.

Saxl, Fritz. "Veritas Filia Temporis." In *Philosophy and History: Essays Presented to Ernst Cassirer*, ed. Raymond Klibansky and H. J. Paton, pp. 197–222. Oxford, 1936.

Scarisbrick, J. J. *Henry VIII*. 1968.

Scattergood, V. J. and J. W. Sherborne, eds. *English Court Culture in the Later Middle Ages*. New York, 1983.

Schiller, Gertrud. *Iconography of Christian Art*. Translated by Janet Seligman. 2 vols. New York, 1971–72.

Schwoerer, Lois. "Women and the Glorious Revolution," *Albion* 18 (1986): 195–218.

Scribner, R. W. *For the Sake of Simple Folk: Popular Propaganda for the German Reformation*. Cambridge Studies in Oral and Literate Culture, no. 2. Cambridge, 1981.

A Short-Title Catalogue of Books Printed in England, Scotland, and Ireland, and of English Books Printed Abroad, 1475–1640. First compiled by A. W. Pollard and G. R. Redgrave. 2nd ed., rev. and enlarged, begun by W. A. Jackson and F. S. Ferguson, completed by Katharine F. Pantzer. 2 vols. 1976–86. Vol. 3 is forthcoming.

Smith, Macklin. *Prudentius' "Psychomachia": A Reexamination*. Princeton, 1976.

Somers Cocks, A. G., ed. *Princely Magnificence: Court Jewels of the Renaissance, 1500–1630*. 1980.

Steadman, John M. "Una and the Clergy: The Ass Symbol in *The Faerie Queene*." *Journal of the Warburg and Courtauld Institutes* 21 (1958): 134–37.

Strand, Kenneth A. *Woodcuts to the Apocalypse in Dürer's Time: Albrecht Dürer's Woodcuts Plus Five Other Sets from the 15th and 16th Centuries*. Ann Arbor, 1968.

Strong, Roy C. *Art and Power: Renaissance Festivals, 1450–1650*. 1984.

———. *The Cult of Elizabeth: Elizabethan Portraiture and Pageantry*. 1977.

———. "Elizabethan Pageantry as Propaganda." Ph.D. Diss., University of London (1962).

———. *The English Icon: Elizabethan and Jacobean Portraiture*. 1969.

———. *Holbein and Henry VIII*. 1967.

———. *Portraits of Queen Elizabeth I*. Oxford, 1963.

———. *Tudor and Jacobean Portraits*. 2 vols. 1969.

Strong, Roy C., and V. J. Murrell. *Artists of the Tudor Court: The Portrait Miniature Rediscovered, 1520–1620*. 1983.

Summerson, John. *Architecture in Britain: 1530 to 1830*. Harmondsworth, Middlesex, 1953.

Swaim, Margaret H. "A New Year's Gift from the Princess Elizabeth." *Connoisseur* 183 (1973): 258–66.

Tait, Hugh. "Historiated Tudor Jewellery." *The Antiquaries Journal* 42 (1962): 226–45.

Thomas, Keith. *Religion and the Decline of Magic: Studies in Popular Beliefs in Sixteenth- and Seventeenth-Century England*. Harmondsworth, Middlesex, 1973.

Thompson, Edward M. "The Revision of the Statutes of the Order of the Garter by King Edward the Sixth." *Archaeologia*, 2nd ser., 4 (1895): 173–98.

Thulin, Oskar. *Cranach-Altäre der Reformation*. Berlin, 1955.

Trapp, J. B., and Hubertus S. Herbrüggen. *"The King's Good Servant": Sir Thomas More, 1477/8–1535.* Exh. cat. 1977.

Tudor-Craig, Pamela. *Richard III.* Exh. cat. 1973.

Ullman, Walter. " 'This Realm of England Is an Empire.' " *Journal of Ecclesiastical History* 30 (1979): 175–203.

Underwood, Malcolm G. "The Lady Margaret and Her Cambridge Connections." *Sixteenth Century Journal* 13, no. 1 (1982): 67–81.

The Victoria History of the Counties of England: Worcestershire. Edited by J. W. Willis-Bund, H. Arthur Doubleday et al. 4 vols. Westminster, 1901–24.

Warner, Marina. *Alone of All Her Sex: The Myth and Cult of the Virgin Mary.* New York, 1976.

Wayment, Hilary. "The Stained Glass in the Chapel of the Vyne." In *National Trust Studies 1980,* edited by Gervase Jackson-Stopes, pp. 35–47. 1979.

———. *The Stained Glass of the Church of St. Mary, Fairford, Gloucestershire.* 1984.

———. *The Windows of King's College Chapel Cambridge. Corpus Vitrearum Medii Aevi: Great Britain,* supplementary vol. 1. 1972.

Wells, Robin Headlam. *Spenser's "Faerie Queene" and the Cult of Elizabeth.* 1983.

White, Beatrice. *Mary Tudor.* 1935.

Wickham, Glynne. "The Dramatic Structure of Shakespeare's *King Henry the Eighth*: An Essay in Rehabilitation." *Proceedings of the British Academy* 70 (1984): 149–66.

———. *Early English Stages 1300 to 1660,* 3 vols. in 4 pts. 1959–.

William Caxton: An Exhibition to Commemorate the Quincentenary of the Introduction of Printing into England. British Library. Exh. cat. 1976.

Wilson, Elkin C. *England's Eliza.* Cambridge, Mass., 1939.

Withington, Robert. *English Pageantry: An Historical Outline.* 2 vols. Cambridge, Mass., 1918.

Wolffe, Bertram. *Henry VI.* 1981.

Wooden, Warren. *John Foxe.* Boston, 1983.

Woodman, Francis. *The Architectural History of King's College Chapel and Its Place in the Development of Late Gothic Architecture in England and France.* 1986.

Woods, Susanne. "Spenser and the Problem of Women's Rule." *Huntington Library Quarterly* 48 (1985): 140–58.

Wyon, Alfred B. *The Great Seals of England from the Earliest Period to the Present Time.* 1887.

Yates, Frances A. *Astraea: The Imperial Theme in the Sixteenth Century.* 1975.

Index

BIBLICAL TEXTS CITED

Page numbers are given in italics.

277

INDEX

GENERAL INDEX

Princeton Essays on the Arts

Guy Sircello, *A New Theory of Beauty* (1975)

Rab Hatfield, *Botticelli's Uffizi "Adoration": A Study in Pictorial Content* (1976)

Rensselaer W. Lee, *Names on Trees: Ariosto Into Art* (1976)

Alfred Brendel, *Musical Thoughts and Afterthoughts* (1977)

Robert Fagles, *I, Vincent: Poems from the Pictures of Van Gogh* (1978)

Jonathan Brown, *Images and Ideas in Seventeenth-Century Spanish Painting* (1978)

Walter Cahn, *Masterpieces: Chapters on the History of an Idea* (1979)

Roger Scruton, *The Aesthetics of Architecture* (1980)

Peter Kivy, *The Corded Shell: Reflections on Musical Expression* (1980)

James H. Rubin, *Realism and Social Vision in Courbet and Proudhon* (1981)

Mary Ann Caws, *The Eye in the Text: Essays on Perception, Mannerist to Modern* (1981)

Morris Eaves, *William Blake's Theory of Art* (1982)

E. Haverkamp-Begemann, *Rembrandt: The Nightwatch* (1982)

John V. Fleming, *From Bonaventure to Bellini: An Essay in Franciscan Exegesis* (1982)

Peter Kivy, *Sound and Semblance: Reflections on Musical Representation* (1984)

John N. King, *Tudor Royal Iconography: Literature and Art in an Age of Religious Crisis* (1989)